Saved!
100 years
of the
National Art
Collections
Fund

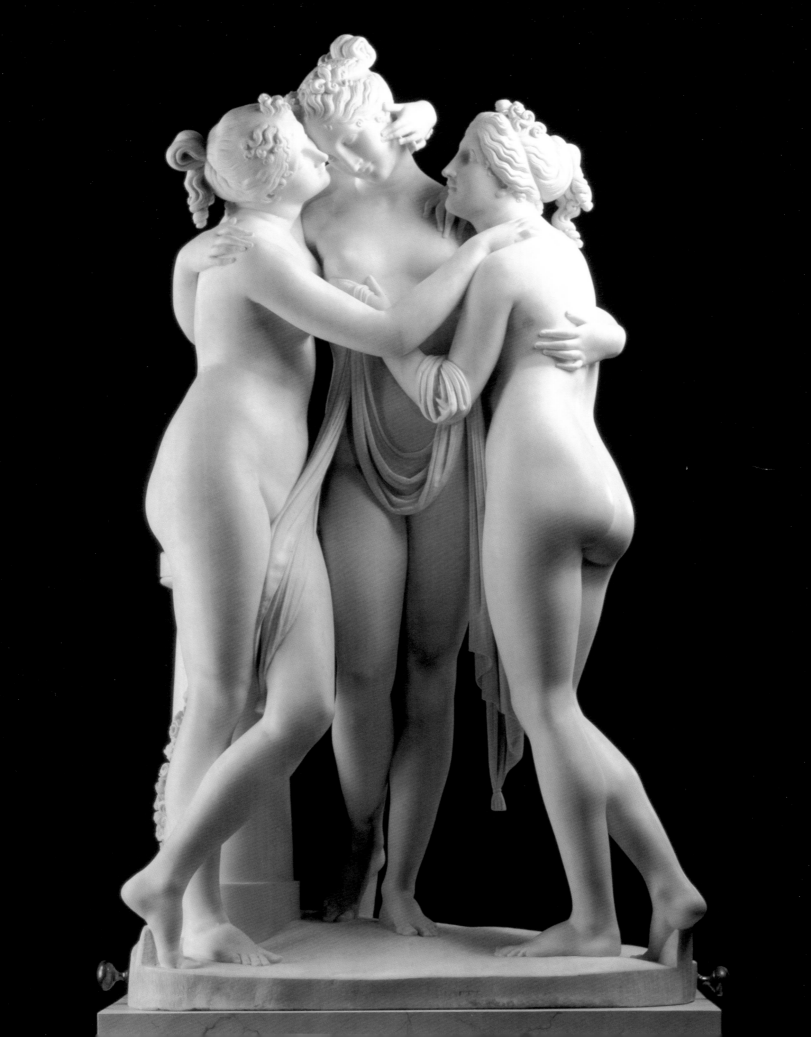

Saved!
100 years of the National Art Collections Fund

Richard Verdi

with contributions by:
Martin Bailey
Philip Conisbee
Juliet Gardiner
Flaminia Gennari Santori
James Hall
Lynda Nead
Robert Sténuit
Polly Toynbee
Roderick Whitfield

Exhibition sponsored by:

Hayward Gallery and the National Art Collections Fund
in association with Scala Publishers

SCALA

THE
NATIONAL
ART
COLLECTIONS
FUND

Artfund100
1903–2003

Hayward Gallery

sbc

Published by the Hayward Gallery and the National Art Collections Fund in association with Scala Publishers on the occasion of the exhibition *Saved! 100 years of the National Art Collections Fund*, Hayward Gallery, London, 23 October 2003 – 18 January 2004.

Sponsored by

Media partners: *The Independent* and *Classic FM*

Exhibition:
Exhibition curated by Richard Verdi, Director of the Barber Institute of Fine Arts, University of Birmingham
Exhibition special advisor: Michael Craig-Martin
Exhibition organiser: Helen Simpson
Assistant exhibition organisers: Caroline Hancock and Jessica Fisher
Curatorial team: David Barrie, Martin Caiger-Smith, Alison Cole, Michael Craig-Martin, Susan Ferleger Brades, Piers Gough, Caroline Hancock, Helen Simpson and Richard Verdi
Executive Committee: David Barrie, Martin Caiger-Smith, Alison Cole, Susan Ferleger Brades and Helen Simpson
Installation designers: Piers Gough, Emily Manns and Stephen Rigg of CZWG Architects

Catalogue:
Editing and production: Caroline Bugler, Alison Cole and Caroline Wetherilt, assisted by Juliet Hardwicke
Publishing Co-ordinator: Jonathan Jones
Picture research: Jessica Fisher and Debbie McDonnell
Catalogue research: Christopher Wright
Exhibition and catalogue research, chronology and biographies: Tania Adams
Index: Paul Holberton
Grants research: Mary Yule
Sales: Deborah Power

Designed by Herman Lelie
Typeset by Stefania Bonelli
Printed in England by PJ Print

The catalogue section is dedicated to Godfrey John Brooks in lifelong gratitude for a journey that began thirty-five years ago at the Queen Elizabeth Hall and now continues at the Hayward Gallery...
Richard Verdi

Front cover: Diego Velázquez, *The Toilet of Venus ('The Rokeby Venus')*, 1648–51 (detail) (cat. 4)
Back cover: Anish Kapoor, *Turning the World Inside Out*, 1995 (installation shot) (cat. 200)
Frontispiece: Antonio Canova, *The Three Graces*, 1814–17 (cat. 176)

Published by Hayward Gallery Publishing, Belvedere Road, London SE1 8XX, UK and the National Art Collections Fund, Millais House, 7 Cromwell Place, London, SW7 2JN, UK in association with Scala Publishers, Gloucester Mansions, 140a Shaftesbury Ave, London, WC2H 8HD, UK

ISBN 1 85332 234 2 (paperback) (Hayward Gallery and the National Art Collections Fund edition)
ISBN 1 85759 304 9 (hardback) (Scala edition)

Contents

JPMorgan Foreword

It is with great pleasure that I introduce this catalogue accompanying the *Saved!* exhibition. JPMorgan is proud to sponsor *Saved!* in partnership with the National Art Collections Fund (Art Fund) and the Hayward Gallery. The exhibition, celebrating one hundred years of the Art Fund, serves to explore the ways in which historical events, personalities and sheer chance have helped to shape Britain's art collections over the past century. The works embrace 4,000 years of artistic achievement, from ancient Egyptian sculpture to twentieth-century pop art. The exhibition articulates the sweep of art history and provides a commentary on the impulse to collect and preserve art. It also provides an opportunity to see cherished works of art in new contexts. Old juxtaposed with new. The tastes and passions of particular eras captured together in a single space.

JPMorgan is pleased to be able to work with two organizations that share its values and a common passion for extending the benefits of art to all. The Hayward Gallery is known for its innovation and for championing new ideas in the manner in which art is displayed and enjoyed. The Art Fund has a deserved reputation as an investor in cultural capital, for the benefit of all. Both institutions share our passion for excellence. The result is plain to see in this wonderful exhibition.

As one of the world's leading financial institutions, JPMorgan has long been a supporter of the arts. We believe art plays a vital role in society and we have, for many years, sponsored a number of exhibitions throughout Europe, helping to bring art to as wide an audience as possible. But our role goes beyond financial support, important as that is. We also have a role to play as a collector, as commercial patrons have done throughout history. Our own art collection comprises nearly 20,000 works, on display in 350 locations around the world. Art must have an audience, and we feel privileged that our own collection is being enjoyed so widely.

In our recent sponsorships, JPMorgan has striven to find exciting ways to draw in all parts of our community, particularly young people. Here again, we are investing our ideas as well as our resources; *Saved!* is accompanied by an education programme offering children an entry to the world of art, an opportunity to learn and the freedom to express themselves creatively. Children are uniquely placed to look back at where we have come from artistically, and look forward and imagine where we can go. This exhibition represents the past we have saved. Our children, and their ideas, are the future we must nurture. We are proud to play a part in both.

We hope that you enjoy this exhibition, and feel as much excitement as we do to be part of such an important artistic event.

Walter Gubert
Chairman, JPMorgan Investment Bank

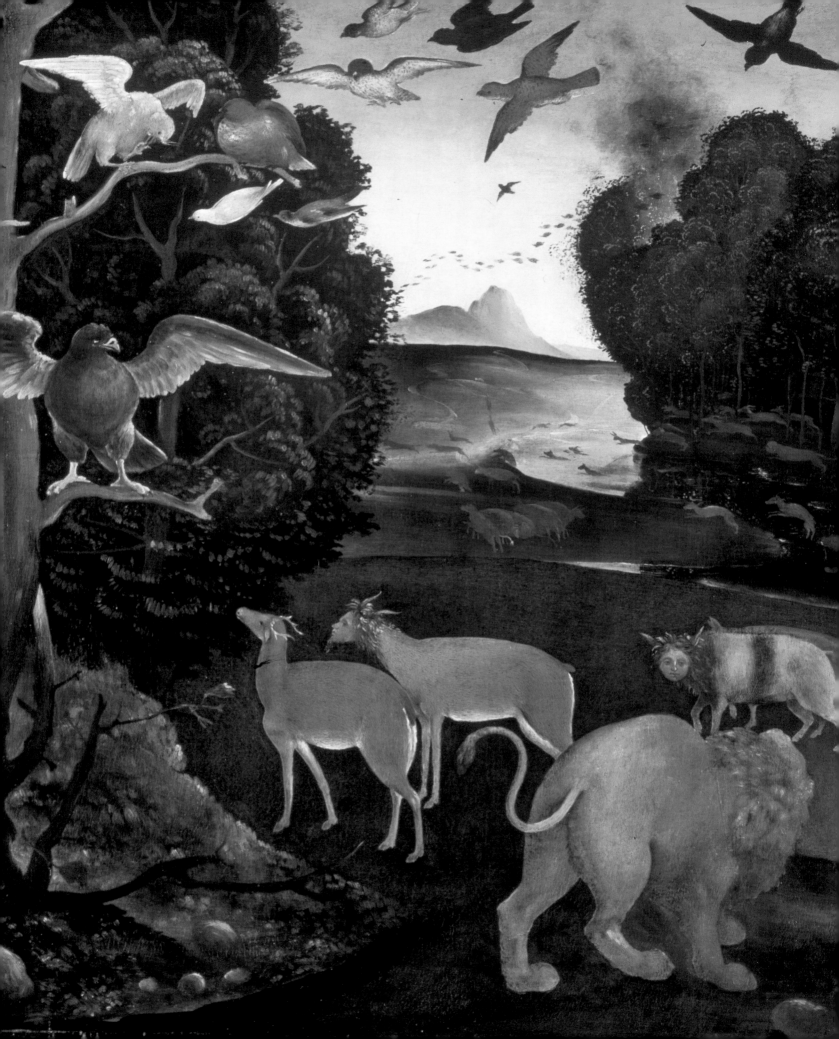

Preface

The National Art Collections Fund (Art Fund) has, since its establishment as an independent charity in 1903, helped public collections in the United Kingdom acquire 500,000 works of art, of almost every conceivable kind. *Saved! 100 years of the National Art Collections Fund* brings together nearly 400 of these works from over seventy lenders in an exhibition that spans more than 4,000 years of history. It provides an astonishing overview of the richness of world culture represented within public collections in the UK.

When we first discussed, four years ago, the possibility of holding the Art Fund's centenary exhibition at the Hayward, we knew we faced a daunting prospect. With so many objects to choose from, among them some of the world's greatest masterpieces and the nation's best-loved treasures, the over-riding question was how to select from such an *embarras de richesse*s. It was, on the one hand, every curator's dream and, on the other, an almost impossible task.

We moved some way toward answering this question when Professor Richard Verdi, Director of the Barber Institute of Fine Arts at the University of Birmingham, responded enthusiastically to our invitation to curate the centenary exhibition. Curator of acclaimed exhibitions, most notably *Cézanne and Poussin; the Classical Vision of Landscape* (National Gallery of Scotland, Edinburgh, 1990), *Nicolas Poussin, Tancred and Erminia* (Birmingham Museum and Art Gallery, 1992), *Nicolas Poussin* (Royal Academy of Arts, London, 1995) and co-curator of *Art Treasures of England: the Regional Collections* (Royal Academy of Arts, London, 1998), we knew Richard Verdi possessed an encyclopaedic knowledge of British public collections. Even more importantly perhaps, his passion for art, his commitment to the Art Fund, and his fervent championship of the work of the UK's regional museums and galleries, were vital assets. Richard has shouldered the heavy responsibility of curating this exhibition with scholarly purpose and dedication, as well as with flair and imagination. He has led us on an unforgettable voyage, travelling, as he has, the length and breadth of the country, in his pursuit of known and unknown treasures, seeking opportunities for new discoveries and enthusiastically sharing all he has learned.

Together with Richard Verdi, we established early on that the exhibition should reflect the diversity and quality of the acquisitions that the Art Fund has supported, and should demonstrate the huge impact it has had in almost every sphere of collecting across the entire country. The work of the Art Fund is far-reaching, and there is hardly a museum or gallery in any town or city in the UK that has not benefited from an Art Fund grant or gift. Having established a set of selection criteria, the way in which such an unusual gathering of work should be presented was almost as taxing a challenge as the selection itself. The curatorial team eventually developed a presentational structure that places works in a broadly chronological sequence according to the year in which they were acquired by public collections. Walking through the exhibition is like walking through one hundred years of collecting history.

In arriving at this approach, we have benefited from the involvement of the artist Michael Craig-Martin, who has helped not only to hone the selection but also to deploy the chosen works to best effect in the Hayward's spaces. He has been instrumental in defining the structure of the exhibition and in expanding our thinking about the revelatory ways in which objects from diverse periods and cultures could interact with each another. We owe an immense debt of thanks to him, as we do to the exhibition's architect Piers Gough. Having transformed the Hayward Gallery in 1981 with his installation of the *Lutyens* exhibition, his engagement with the design of the Art Fund's centenary exhibition has been crucial. His sensitivity to the purpose of the show and to the needs of individual works, coupled with his understanding of our desire to make this exhibition look like no other, has resulted in a wonderful environment in which works of art of so many kinds can all come to the fore.

Our thanks also go to the host of authors and researchers who have lent their expertise to this book, helping to create a publication in which the fascinating story of the Art Fund comes to life. We are also grateful

cat. 45
Piero di Cosimo, *The Forest Fire*, *c.*1505 (detail)

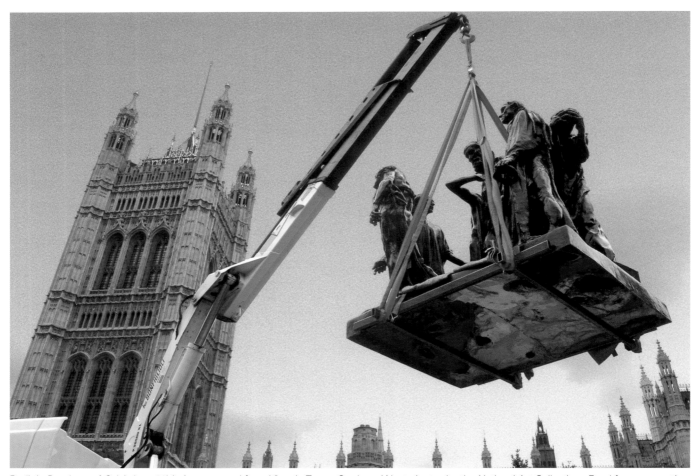

Rodin's *Burghers of Calais* (cat. 11) being removed from Victoria Tower Gardens, Westminster, by the National Art Collections Fund for conservation

to the entire catalogue team for their hard work bringing this publication to fruition. Particular thanks go to Caroline Bugler, Alison Cole and Juliet Hardwicke at the Art Fund, and to Caroline Wetherilt and Jonathan Jones at the Hayward Gallery. It has been a privilege to work with Herman Lelie on the production of this catalogue and, as always, he has designed a book that stands out for its clarity and beauty. We are also grateful to Stefania Bonelli for her expert typesetting and to all the staff at PJ Print for their scrupulous attention to the book's printing needs.

We are enormously grateful to the lenders who have made it possible for this exhibition to happen. Museums up and down the country have been asked to part with some of the most important and prized works in their collections, sometimes, in the case of recent acquisitions, before they have even had a chance to display them. The selection process was a long and demanding one, and we thank especially those lenders who allowed us to submit our loan requests in stages. We have been overwhelmed by the generosity of the responses we received to our requests. It is a testimony to the esteem in which the Art Fund and the Hayward Gallery are held that we have been able to bring so many of these remarkable treasures together.

Underpinning our work on the exhibition has been the support of our sponsor, JPMorgan. We were extremely fortunate that JPMorgan became involved with this project very early on. Consequently, our relationship has evolved in parallel with the exhibition, allowing us to align our aims and objectives from the outset; they have additionally supported the Public Programmes which will broaden the reach of the exhibition in exciting and innovative ways. JPMorgan has admirably extended the

traditional boundaries of arts sponsorship through their offer to the Victoria and Albert Museum through the Art Fund of a work from their collection, which will first be displayed in the show. At a time when museums and galleries find it harder than ever before to make purchases, JPMorgan's inspired gift of Cindy Sherman's *Untitled, #199* (cat. 245) is all the more welcome.

We have also been pleased to have had *The Independent* and *Classic fM* as media partners on this project, and we thank them for their interest and involvement.

Within our respective organizations, the exhibition project has been sustained by a number of key advocates. At the South Bank Centre, the support in particular of the Board's Chairman, Lord Hollick, and of the Board itself, alongside that of SBC's Chief Executive, Michael Lynch, has been deeply appreciated. We are also grateful to Sir Nicholas Goodison, Chairman of the Art Fund from 1986 to 2002. Sir Nicholas saw many of the objects in this exhibition pass through the Art Fund Committee meetings he chaired, and he championed the exhibition from its infancy. Professor Brian Allen, his successor, has led the Art Fund during a year of unprecedented activity. His commitment to the centenary exhibition has been crucial.

Creating an exhibition of the scale and complexity of *Saved!* involves a large team of people. Martin Caiger-Smith, the Hayward's Head of Exhibitions, has overseen the exhibition from its beginnings and has kept abreast of every development, bringing to the project his characteristically sharp eye and keen questioning. Alison Cole, the Art Fund's Communications Director, has also played a vital role as part of the curatorial team in the development of the exhibition. Helen Simpson, the Exhibition's Organiser, has handled every stage of the project with incomparable patience and commitment,

as have our Assistant Exhibition Organisers, Caroline Hancock and Jessica Fisher. We thank them as well for their invaluable help with the preparation of this catalogue. Emily Manns, who assisted Piers Gough on the plans and drawings, has been a source of support and skill throughout.

One of the aims of *Saved!* is, of course, to celebrate the achievements of the Art Fund. Another is to raise questions and provoke debate, as well as to broaden people's understanding of what the Art Fund does and especially to attract more members to join. This is not the first exhibition devoted to the history of this unique organization, but it is by far the largest and most comprehensive. The Art Fund originated in the midst of a funding crisis, and in that respect little has changed since 1903. One hundred years later there is hardly a museum or gallery that can make an important purchase without the help of the Art Fund. This exhibition highlights some of the challenges facing museums and galleries as they strive to expand their collections in the twenty-first century.

The Art Fund's work, made possible by the loyal support of its members, has touched the lives of millions. It has made a profound impact upon cultural life in the UK over the last one hundred years. But this exhibition is not just a record of extraordinary past achievements, it also raises questions about the future. Above all, it asks: how can so much be achieved in the century that lies ahead?

Susan Ferleger Brades
Director, Hayward Gallery

David Barrie
Director, National Art Collections Fund

Introduction:
How the National Art Collections Fund Works

People often ask how the National Art Collections Fund decides which works of art to support, and, in particular, what are our grant-giving criteria. In essence, there is one overriding criterion: 'quality', a highly subjective term that defies precise definition. Sometimes one is struck by the sheer physical beauty of an object, such as Xie Chufang's *Fascination of Nature* (cat. 206), which produced unanimous gasps of admiration from the Art Fund's Committee. More often, there is room for debate, and many factors can shape the decision-making process – the relevance, for example, of a work to a particular collection and especially any local or regional associations are important, as is an object's national or historical significance.

So how does the system work in practice? Museums normally approach us when an opportunity arises to acquire a work of art that would significantly enhance their collection. If physically possible, the work is brought to one of our Committee meetings, which are held ten times a year in the Studio at Millais House, London. We are probably the only grant-giving body that insists on seeing all the objects that we are asked to support. The consequences are unpredictable: sometimes a work of art that sounds promising on paper can turn out to be disappointing in reality. Conversely, works often exceed our expectations. Firsthand examination is vitally important in judging the condition of a work under consideration, not least because we are usually reluctant to support an object too fragile to display. When works are about to be auctioned, members of the Committee view them in the saleroom. From the applicants' standpoint, our system is extremely simple and relatively unbureaucratic. We can, if necessary, turn an application around in a matter of days to enable a museum to use our grant to bid at auction.

And what about those who make the decisions? In order to avoid conflicts of interest, the National Art Collections Fund does not include serving museum professionals on its Committee. Instead, we rely on a combination of art historians, retired museum curators, and other experts with wide experience of art and the museum world. Candidates are chosen to ensure that the Committee (which currently has seventeen members, including the Chairman, Treasurer and Director) embraces a range of expertise. This is essential as the term 'work of art' has a very wide application, effectively embracing any artefact of aesthetic interest, ranging from prehistoric antiquities to contemporary video installations. When confronted with an application that falls outside the Committee's range of expertise, we can call on the advice of an extensive panel of advisors.

Over the last two decades there have been significant changes to the legal and ethical framework within which museums and galleries operate. This is especially true of acquisitions, where there is a far greater awareness of the need to check the provenance of an object, particularly in the cases of archaeological objects and ethnographic material. The Art Fund strongly supports the emphasis upon provenance-checking, and our grant-giving requirements were tightened in May 2003 to ensure that the objects we support have not been unlawfully acquired or looted. There is now an onus on museums and galleries to exercise due diligence in clarifying the provenance of an object for which they are seeking a grant. Provenance has also assumed a far greater significance as a result of the recommendations of the Spoliation Advisory Panel, the government body set up to examine whether works acquired in good faith by museums and galleries were taken unlawfully from their owners by the Nazis.

When seeking to make a purchase, museums normally approach us first, before other grant awarding bodies, not least because a grant from the Art Fund is often seen as a vital endorsement for a wider fundraising appeal. We are also prepared to cajole and lobby behind the scenes and have sometimes mounted major media campaigns in support of crucial acquisitions such as Leonardo's magnificent cartoon of *The Virgin and Child with Saint Anne and Saint John the Baptist* (fig. 31)

or *The Becket Casket* (cat. 188). If an appeal is running out of time (when, for instance, an export deferral is about to expire) we can sometimes step in at the last minute to top up our original grant and close the funding gap, as was the case with Botticelli's *Virgin Adoring the Sleeping Christ Child* (cat. 209). Other funding bodies, such as the Heritage Lottery Fund, take serious account of the position adopted by the Art Fund, and we maintain a lively dialogue with them. Since the establishment of the Heritage Lottery Fund in 1995, we have jointly funded 194 acquisitions.

Last year we offered grants totalling £5.6 million. This money comes primarily from the museum and gallery-goers and art lovers who form our membership. They pay subscriptions, make donations and on occasion leave us substantial legacies. Thanks to such acts of generosity, we have built up an endowment which generates a good income and also guarantees our independence. We are one of the very few cultural organizations in the UK that receives absolutely no government funding.

Of the half a million works supported by the Art Fund in its first hundred years, 56,000 have been given to museums and galleries as gifts or bequests. One of the main reasons that people make gifts through the Art Fund, or bequeath us works of art in their wills, is because they know that not only will we find suitable homes for them, but we will also keep a watchful eye on them in perpetuity.

As this magnificent exhibition and its accompanying catalogue demonstrate, the Art Fund has, in its first century, dramatically transformed the holdings of hundreds of museums and galleries throughout the UK. It has achieved its declared objective of enabling everybody to experience great art at first hand. We have no doubt that art has the power to transform lives and to stimulate the imagination. We will continue to enrich the collections of museums and galleries with the support of our members, who are at the very core of what we do.

Professor Brian Allen
Chairman, National Art Collections Fund

cat. 142
Nicolas Poussin, *The Ashes of Phocion collected by his Widow*, 1648 (detail)

Rebels and Connoisseurs

Juliet Gardiner

Little more than a decade elapsed between the death of Queen Victoria in 1901 and the outbreak of the First World War in 1914, but the Edwardian era – the last age to be named for its monarch – has come to have a particular currency in Britain's narrative. 'Golden', the word that is usually used to describe it, conjures up sunlit lawns on long tranquil afternoons, as well as the period's unprecedented wealth and ostentatious display. Such a view is perfectly captured by the opulent, self-confident portraits of John Singer Sargent (see cat. 29), who had the supreme ability 'to give new money a good opinion of itself'.[1] In an age when money was reconfiguring Britain's relation with the world through Empire, trade and banking, it was also rearranging social hierarchies, and was acting as a stimulus to art, architecture and literature.

The age of innocence and of expansion, of an excess of consumption (for some), the exotic coda to the Victorian period of rectitude and restriction, the Edwardian age was to be brought to account by the Armageddon of the First World War. Nostalgia is a word often associated with these years, a wistful regret for a gentler, more leisurely, surer-footed age of elegance, calm certainties and a natural order. But nostalgia simplifies: it flattens the contours of complexity and veils the tensions of change. The seeds of what we think of as the modern world were firmly planted in England before 1914:[2] typewriters, aircraft, radio-telegraphy, psychoanalysis, internal combustion engines, Underground trains, electric lighting, cinemas, cheap mass-circulation newspapers, the Labour Party, Post-Impressionism. Ezra Pound, Virginia Woolf, James Joyce, D.H. Lawrence and T.S. Eliot all published in the Edwardian era; Jacob Epstein sculpted and Ernest Rutherford won the Nobel Prize for his work on radiation. However, in the words of the social historian José Harris, 'the other face of Edwardian modernity ... reveals a lurking grief at the memory of a lost domain – a sense that change was inevitable, and in many respects desirable, but that its gains were being

purchased at a terrible price.'[3] Looking back from the vantage point of 1914, H.G. Wells observed that 'the first decade of the twentieth century was for England a decade of badly strained optimism. Our Empire was nearly beaten by a handful of farmers amidst the jeering contempt of the whole world – and we felt it acutely for several years ... And close upon the South African trouble came the extraordinary new discontent of women with women's lot.'[4]

To this characterization of uneasy times, Wells could have also notched up the jaggedly acute gap between rich and poor. As the aptly named economist Sir Leo Chiozza Money put it, 'More than one third of the entire income of the United Kingdom is enjoyed by one thirtieth of its people ... in an average year eight millionaires die leaving between them three times as much wealth as is left by 644,000 poor persons who die in one year ... the wealth left by a few rich people who die approaches in amount the aggregate property possessed by the whole of the living poor.'[5] The 1906 election at which the Conservatives, the 'natural' party of late Victorian government, were ejected by a landslide Liberal victory, presaged a programme of political change with increasing radical social and economic reform and the consequent reduction of the political influence of land. This would both reflect and influence other slow-burning change. There was a growing disquiet about the efficacy of individual philanthropy and a burgeoning realization that the State was required to play a more active and interventionist role in society. At the same time working men were demanding greater political representation, as well as rights and rewards in the workplace.[6] The decline of agricultural prosperity and the value of land exacerbated by a new tax regime that squeezed the few to fund the many coincided with the rise of a powerful new class with new money to spend.

Indeed 'new' was a potent word – a new century, new ideas, a new realignment of the classes, a new aesthetic, the 'new woman', and a new king, seemingly perfectly

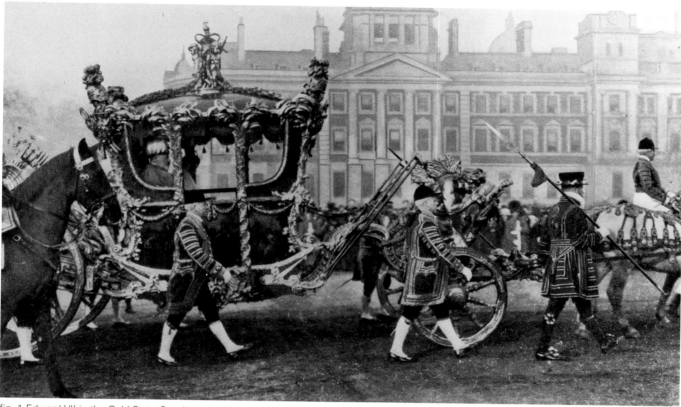

fig. 1 Edward VII in the Gold State Coach on the day of his coronation, 9 August 1902

in harmony with his age – the values (and sometimes tawdriness) of which he epitomized. Edward VII was nearly sixty when he came to the throne and expectations of him were not high. 'What will become of the poor country when I die?',[7] his mother Queen Victoria sighed as she contemplated her playboy son, whom she had denied a proper apprenticeship by keeping him removed from matters of state and whose greatest enjoyment seemed to be had at the baccarat table and the race course. Yet, like his age, his ways were contradictory. Edward was a less hard-working but more acute politician than his mother; his diplomacy still depended on kinship, but he was modern European-minded and had visited America. He was a skilful linguist, and, though wary of German intentions, was as much at home in Germany as in Austria and Denmark (from where his wife, the beautiful Alexandra, came). He adored Paris and sought closer alliance with France. He was an adulterer, yet a respectful husband and an averagely devoted father. He moved with ease in the circles of the 'establishment' but mapped new circuits too, including men who had made

their money in trade and finance. Several of his closest friends were Jews, who, until his reign, had been largely excluded from Court.

Edward revelled in the life of a country squire, hosting lavish shooting parties at his estate at Sandringham in Norfolk, which he had bought primarily to get away from his mother. When it came to the arts, he could frequently be found in a box at the opera. He rarely opened a book, yet he was able to articulate how truly awful was England's 'worst-ever' poet laureate, Alfred Austin. As far as the visual arts were concerned, though he had the reputation of being something of an unschooled philistine with a penchant for yachting and battle scenes and pictures of pretty women without a great deal on, his instinct could be sound, and he came close to an understanding of the role that art plays in society. Lionel Cust, the Surveyor of the King's Pictures and Director of the National Portrait Gallery, recalled that in the task of redistributing the Royal Collection that had lain largely untouched since the death of Prince Albert in 1861, Edward was an active participant: he 'liked to supervise everything

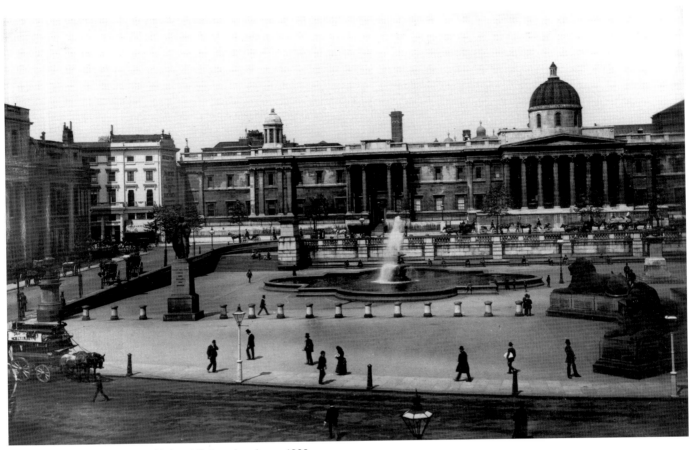

fig. 2 Trafalgar Square and the National Gallery, London, *c.* 1900

himself ... "I do not know much about Ar-r-r-t," he would say with characteristic rolling of his Rs, "but I think I know something about Ar-r-r-r-angement." [8]

It was Cust who managed to interest the King in an Edwardian institution that was the locus of a number of Edwardian preoccupations – the National Art Collections Fund (Art Fund), founded in 1903. The King's intervention was to prove decisive in the first major acquisition battle that the Art Fund fought in 1906, and his formal association as a patron began the same year.

Inspiration for the Art Fund came from the Société des Amis du Louvre in Paris and the Kaiser-Friedrich-Museum Verein in Berlin, a body of 'wealthy and knowledgeable art lovers' to whom the director could turn 'as soon as any work of stature came onto the market'. [9] The Art Fund's objectives were to save great art for the nation by allying private munificence to public access and to educate the artistic general public. These aims drew the praise of Prime Minister H.H. Asquith, who

was to say of the Art Fund in 1911, 'I cannot imagine a more fruitful or enlightened form of disinterested public service ... than safeguard[ing] the nation against irrecoverable losses.' [10]

The idea of creating such a body was not entirely new. In 1857 John Ruskin had delivered a lecture in which he called for the establishment of a 'great National Society' to purchase works of art for 'the various galleries in our great cities ... watching there over their safety.' [11] In 1884 *The Times* had pointed out that 'the nation had every right to ask whether some part at least of the treasures cannot and must not come into national keeping.' [12] By then various works of art – for example paintings by Burne-Jones and Madox Brown – had been acquired for the nation as a result of public subscription. But the moving spirit behind the initiative, the influential art critic D.S. MacColl, called, in a series of articles, for 'a permanent body of subscribers [to] secure from time to time works of art that the officials and the Treasury

cannot give us.'[13] Unlike other European countries such as France and Germany, Britain had never committed itself to a programme of state patronage for the arts.

It was an issue of some moment, for the agricultural depression of the 1880s had hit the great landowners hard. Agricultural output, land values and rentals had all fallen, and, as the historian David Cannadine explains, the solution seemed to be to sell off parcels of ancestral land. 'When agricultural acres were hard to sell (as they often were) and when sentiment dictated that they should be retained at all cost (as it sometimes did), many landowners preferred to realise alternative assets, which could find more ready buyers and also realise a much better price: collieries and minerals, docks and harbours, building estates and market halls, country houses and London mansions, works of art and family heirlooms ... the great accumulators had become the great dispensers.'[14]

When works of art did come on the market there was certainly no shortage of buyers, as German, French and, increasingly, American galleries and museums bid against each other. A great deal was at stake in the exodus of art from Britain, since 'great works of art, if saved for the national collections, could inspire English artists, educate the public, and confer international standing. Their dispersal abroad only increased British cultural parochialism ... art in the *national* collections belonged to the *nation*; a nation was made up of individuals and nothing would change until there was a larger body of informed public opinion.'[15] Edwardian critics were concerned with the 'striking imperfections of the National Gallery' and the 'ludicrous deficits and gaps in every school'.[16]

This desire to ensure that the finest art was still available to be appreciated was the reason why, in 1903, Christiana Herringham, an artist, art scholar and woman of independent means, wrote in response to MacColl's call, intimating that 'if he really meant it' she would like to contribute '£200 for initial expenses of the Art Fund'.[17] Herringham was the eldest of the nine children of Thomas Powell, a Leeds lawyer turned prosperous stockbroker who had settled a substantial amount of money on his children.[18] He had hoped that they would use their legacies to further the philanthropic enterprises that he had financed in his lifetime in the belief that 'many people can walk far if helped over stiles'.[19]

MacColl was grateful, recognizing that 'it is easy to make suggestions. Herringham, by this act, became the real Founder of the Art Fund. The fiery cross was at once sent out.'[20] Recruited to the cause was Roger Fry, a painter and critic who, like MacColl, later championed the acceptance of French contemporary art in Britain. Fry helped to enlist the support of Sir Claude Phillips (Keeper of the Wallace Collection from 1897 to 1911 and art critic for the *Daily Telegraph*), who had written vigorously and often about the drain of masterpieces from the British Isles. The original four (Herringham, MacColl, Fry and Phillips) were soon joined by Sir Sidney Colvin (Keeper of Prints and Drawings at the British Museum) and C.J. Holmes (one of the first editors of *The Burlington Magazine* and later Director successively of the National Portrait Gallery and the National Gallery).

The founders decided to invite David Lindsay, Lord Balcarres (later Lord Crawford) – an art collector and connoisseur and Conservative MP – to be the Art Fund's Chairman. At thirty-two, he was 'the ideal choice',[21] since his family was one that the editor of Balcarres' journals described as 'the Medici of Britain ... No other family has sustained its interests [in literature and the arts] over four generations so fruitfully, or combined collection, scholarship, and innovation with such impact upon the development of whole subjects. They showed what aristocracy might have meant, and what, in nineteenth-century Britain, it usually failed to mean.'[22] Balcarres', own philosophy mirrored the philosophy of the Art Fund: 'We should share our artistic patrimony with all who can benefit from our possessions',[23] he was to write to his son several years later.

A group meeting to constitute the National Art Collections Fund took place at Christiana Herringham's house in Wimpole Street on 7 July 1903 with John Postle Heseltine, Charles Holroyd, John Bowyer Buchanan Nichols, Lord Balcarres and Robert Witt. Having set up the fund (and it was decided to call it a 'fund' rather than the other canvassed option 'league', since, as Christiana Herringham shrewdly remarked 'the name emphasizes the need for money which is the great need'),[24] the annual subscription was set at a guinea. This sum made it avowedly inclusive of those of limited means – the

'widow and her mite' and the impecunious artist – as well as the wealthy. However, a number of issues presented themselves. To the alarm of Roger Fry, it appeared that the democratic intentions might be diluted by the desire of some committee members to invite 'influentials' – big names who might add prestige to the Art Fund's notepaper, but might also prove to be 'ornamental' rather than working 'stalwarts'. Their presence might suggest to potential 'ordinary' members that this was not a club for them since it was dominated by a coterie of connoisseurs and gallery owners that currently had the art scene in its grip. Arthur Wellesley Peel, son of the great Tory Prime Minister Sir Robert Peel and himself a trustee of the British Museum and the National Portrait Gallery, saw the point: 'The thing to be aimed at is the number of subscribers … Rich men may come to the rescue in special cases, but the rank and file should feel they have done enough in subscribing their small sum to swell the general aggregate of the Fund.'[25]

Was the Art Fund to be administered primarily by collectors and connoisseurs? And what role were artists themselves to play in the protection and promotion of their country's artistic heritage? As Christiana Herringham explained in a letter to Balcarres: 'For about a year I had been trying to get various people I knew to start an Amis du Louvre in England. They all said it would be impossible in England because of cliques and jealousies.'[26] Charles Ricketts, an artist and craftsman in the William Morris tradition, with scant regard for organized coteries and networks, recognized that tendency at the first General Meeting held on 11 November 1903, when the Chairman was able to announce that the Art Fund had 308 members (the number was to double within two years) and £700 in its account. Balcarres read out the names of the proposed Executive Committee but failed to include the four founding members – Herringham, MacColl, Fry and Phillips. Christiana Herringham (whom Ricketts described as 'a nervous woman') objected to the exclusion of the original committee who had set up the scheme – it seemed the triumph of the 'influentials'. 'She brought this out with one or two snaps at the polite but entirely futile meeting. "How like England in miniature … ," Ricketts concluded of the gathering, "pompous nobodies nobbling everything."'[27]

In addition to an Executive Committee of eighteen, a Council was appointed comprising forty-nine distinguished public figures, among them the Archbishop of Canterbury, Lord Curzon and several MPs, as well as the artists Sir Lawrence Alma-Tadema and Sir Edward Poynter (Director of the National Gallery from 1894 to 1905 and President of the Royal Academy from 1896 to 1918) and other museum officials. Two sub-committees of experts were also constituted to advise on acquisitions, one concerned with pictures and prints and drawings, the other with objects.[28]

There were other considerations too. What works was the Art Fund to buy? Was it to save masterpieces from previous ages, or to purchase contemporary works and thus encourage living artists? How were decisions to be made? And by whom? An existing 'art fund' was clearly not doing a satisfactory job. The sculptor Sir Francis Chantrey had left a bequest of more than £100,000 for the acquisition of 'works of fine Art of the highest merit in painting and sculpture that can be obtained'.[29] But contrary to Chantrey's intentions, the Royal Academy (RA) Council that administered it purchased from a narrow range of works in the RA itself and 'other unwanted odds and ends'[30] from the National Gallery (many members of the RA Council were also trustees of the National Gallery). The result was a collection of 'accumulated dreariness'[31] housed in the Tate Gallery, the recent gift to the nation of the sugar magnate Henry Tate.

Christiana Herringham may have secured for herself and her co-founders a place on the Committee, but she was the only woman until 1906.[32] The exclusion mirrored women's under-representation in political and economic life. Despite the extension of the franchise, no woman had the vote in general elections until after the First World War. The Women's Social and Political Union (WSPU) was founded in 1903 by Emmeline and Christabel Pankhurst. It was significant, if perhaps a little ironic, that when in March 1914 a suffragist, Mary Richardson, slashed the Art Fund's first landmark purchase, Velázquez's 'Rokeby Venus' (cat. 4), in the National Gallery, she informed the startled onlookers, 'Yes, I am a suffragette. You can get another picture, but you cannot get a life as they are killing Mrs Pankhurst'[33] (who was weakened by her hunger strikes in prison). Richardson

was followed by another suffragist, Mary Wood, who justified *her* act of vandalism in taking a knife to John Singer Sargent's [34] *Portrait of Henry James* (fig. 25), on view at the Royal Academy, with the statement: 'I have tried to destroy a valuable picture because I wish to show the public that they have no security for their property nor their art treasures until women are given political favour.'[35]

As women were largely excluded from the country's political processes, so they were to some extent marginalized in its artistic endeavours. Although women did have access to artistic training at the Royal Academy and the Slade, Christiana Herringham confined her own artistic endeavours to copying and also developed an intense scholarly and practical interest in tempera as it had been used in fifteenth-century Italy. She translated Cennini's *Il libro dell'arte*, written in around 1390,[36] and in 1901 was instrumental in founding the Society of Painters in Tempera, with which she exhibited.[37]

The first acquisition made through the Art Fund was an early eighteenth-century repeating watch by Daniel Quare (cat. 1), which was donated to the British Museum by Max Rosenheim. *Fête Champêtre*, then attributed to Watteau (now to Pierre-Antoine Quillard) was the first painting that the fund supported. This was in 1904 for the National Gallery of Ireland in Dublin. The next year Whistler's *Symphony in Grey and Green: The Ocean* came onto the market. According to the *Daily Mail* this went straight to the heart of the Art Fund's 'express purpose of taking advantage of the opportunity for acquiring notable works of art for the nation'.[38] Whistler had died in 1903 and although one example of his work had entered a public collection in Glasgow in 1891, the London galleries had shunned him and the Chantrey Fund had not acquired a single one of his works for England.[39] Whistler's *The Peacock Room* had been sold to America and his *Arrangement in Grey and Black: The Artist's Mother* was now in the Musée du Luxembourg in Paris. The Art Fund did not intervene in the sale of *Symphony in Grey and Green*, but that was because it was negotiating to buy another Whistler, his *Nocturne: Blue and Gold – Old Battersea Bridge* (cat. 3), which it secured in July 1905.

In 1910, seven years after the establishment of the National Art Collections Fund, the Contemporary Art

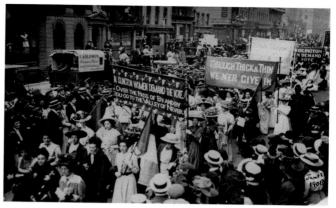

fig. 3 Suffragettes *en route* to 'Women's Sunday', held in Hyde Park, London, 21 June 1908

Society was founded. Roger Fry (who had served on the Executive Committee of the Art Fund until 1906, when he took up a curatorial position at the Metropolitan Museum of Art, New York) was a leading light. Alongside him were two other members of the Bloomsbury Group of writers and painters – Clive Bell and Lady Ottoline Morrell – as well as the Art Fund stalwarts MacColl and Holmes. The Society's intention was to purchase contemporary works of art, since it was clear that the Art Fund had its gaze directed mainly towards masterpieces from past ages and was conforming to Christiana Herringham's misgiving: 'I don't think the National Art Collections Fund can do both jobs, old and new – the old one's hard enough, but the buying of works of living men does bristle with difficulties.'[40] Originally it had been proposed that the Art Fund should have a third sub-committee concerned with the purchase of contemporary works, but this proposal was shelved.[41]

For progressive souls such as George Bernard Shaw, the playwright and Fabian pamphleteer, [42] the Art Fund was not only about making good the neglect of the Treasury when it came to Britain's 'artistic defence', it was about the responsibility that wealth incurred. Speaking to the third Annual General Meeting of the fund in 1907, Shaw upbraided the moneyed section of society. 'Though our public collections of Art in this country are almost wholly dependent on what are called private donations, that is to say donations made by private people with money which they undoubtedly are in the habit of regarding as private money, but which

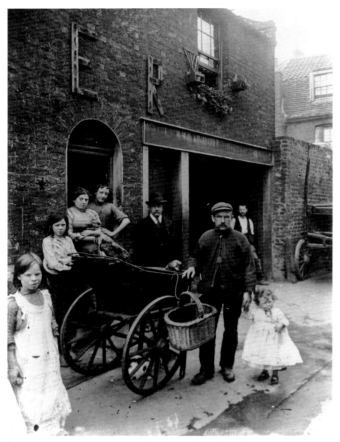

fig. 4 John Galt, *Cat's Meat Man in an East End Street, c.* 1902.
The decoration on the house celebrated the coronation of
Edward VII in 1902

I regard as money held in trust for the nation … We
must continually remind our rich classes not only that
we want more money, but that they owe it to us. How
else can we face the overwhelming competition of the
American millionaires who are stripping us of Art
treasures more ruthlessly than Napoleon stripped Italy
and Spain?'[43]

In 1906, the incoming Liberal Prime Minister, Sir
Henry Campbell-Bannerman, had promised that Britain
would become 'less of a pleasure ground for the rich and
more of a treasure house for the nation'.[44] This accorded
with the move of art from the private sphere to the
public space (providing it could be stopped from being
lost abroad), but it was also a metaphor for a wider
concern: the redress of the glaring inequality between
rich and poor that had been revealed by such social
surveys as Charles Booth's *Life and Labour of the People
of London*, published in 1902. Art was indeed becoming

more accessible to a wider audience. There were
opportunities for the public to appreciate paintings and
sculpture in the splendid new provincial galleries that
were the civic pride of Liverpool (1877), Manchester
(1883), Birmingham (1885) and Glasgow (1901), as well
as in the more rarefied atmosphere of the small new
commercial galleries in London, such as Robert Ross at
the Carfax in Bury Street, which joined others including
the redoubtable Agnew, Tooth and Colnaghi to offer a
wide range of paintings, sculpture and the decorative
arts to view.

In 1908 Herbert H. Asquith replaced Campbell-
Bannerman as Prime Minister and appointed David Lloyd
George as Chancellor of the Exchequer. Lloyd George,
who could 'kindle an audience into flame' with his
soaring rhetoric, had the upper classes in his sights. His
intention was 'to rob the hen roost' of the wealthy in
order to 'raise money to wage implacable warfare against
poverty and squalidness'.[45] The Old Age Pensions Act of
1908 introduced pensions 'as of right' (though they were
means-tested) to everyone over seventy (less than half
the population lived beyond sixty-five): in the words of
Beatrice Webb, the Fabian social reformer, it guaranteed
the very old 'an enforced minimum of civilised life'.[46]
In 1911 Lloyd George introduced proposals for a
contributory insurance scheme by which 'the employer
and the State should enter into a partnership with the
working man in order as far as possible to mitigate the
burden [of unemployment and sickness] which falls upon
him'.[47] However, at the same time as it was introducing
such sweeping social reforms, the Liberal Government,
with some reluctance, was entering into an escalating
naval arms race with Germany.

All this posed a stark choice: either cut spending on
social welfare or raise taxation. The Chancellor was in
no doubt as to which it should be: he required money
for his new insurance schemes; child allowances were
to be introduced; there were plans to open labour
exchanges for the unemployed; and the growth in car
ownership necessitated an ambitious road-building
programme. In his so-called 'People's Budget' of 1909,
Lloyd George increased the top rate of death duties to
15 per cent, income tax rose from 1 shilling to 1 shilling
and 2 pence, and a supertax on annual incomes over

£5,000 was introduced for the first time, as was a capital gains tax on land. The latter was not particularly successful in raising revenue, since the value of land had not risen significantly since the 1880s, but it was of enormous symbolic significance – and the landed classes and their representatives prepared to fight back. The House of Lords threw out the budget, although the Commons had passed it. 'Savage strife between class and class' would ensue, predicted the young Winston Churchill.[48]

This political crisis, combined with the wave of industrial unrest, the growing militancy of the suffragettes, the sombre portents from Ireland and the darkening skies over Europe, provided a backdrop to the continuing debate. In Britain it was played out as the debate on what wealth was *for* and was an issue that preoccupied politicians and commentators. A few years earlier, in 1906, when Velázquez's '*Rokeby Venus*' was on sale at Agnew for £40,000 (plus £5,000 for insurance and transportation), Isidore Spielmann, a wealthy art connoisseur who had advised the Board of Trade on art exhibitions and had generously offered his services as Honorary Secretary to the Art Fund free of charge, approached a wealthy friend. The friend responded by saying that 'all the money he could spare would be given to a fund for the unemployed in the East End [of London] and to the families of the Jews massacred in Russia long before he thought of pictures'; he 'preferred to buy bread for the starving rather than cake for the comfortable classes'. Spielmann thought that that might well be 'a view a great many will take at the moment'.[49]

As the battle over redistributive taxes and the power of old money raged, the author Henry James, in *The Outcry*, a story about 'a Yankee on the spend', used the art market to probe questions of commodification, the objectification of art, the 'value' put on heritage, and whether that 'value' could be priced. His American art collector, Breckenridge Bender, travels to England hoping to 'traffick' in pictures. He cares not for the provenance, the authenticity or even the aesthetic qualities of the 'masterpiece' that he wants to purchase; what he seeks is 'an *ideally* expensive thing'.[50] In a telling exchange, one of the daughters of the house asks Bender if he would care to see the park. 'Are there any pictures in the park?', queries the American. 'We find our park itself

rather a picture', Lady Grace reproves.[51] This parable can be seen to express a wider trepidation about a new world and Britain's place in it – a world in which the spectre of the purse strings of the immensely wealthy and 'modern' United States, combined with other threats from overseas to challenge Britain's traditional values.

The concerns of the Art Fund's early years not only illuminate Edwardian culture and society but mirror situations that still affect us today. In 1912, following the export of three major paintings by (or attributed to) Rembrandt, it became obvious that the prices of Old Masters were beyond the pocket of the National Gallery and that the British government's annual purchasing grant to the gallery was derisory in the context of spiralling costs. Lord Curzon[52] was appointed by the National Gallery to chair a committee to look 'into the Retention of Important Pictures in the Country and other matters concerned with the National Art Collections'.[53] MacColl, whose views on the National Gallery's problems had been published the previous year, was called as a witness.

While the inquiry was in progress, the Great War broke out; all national galleries and museums were closed immediately and many works of art removed to safe storage. In June 1915 the Curzon Committee made its thirty-five recommendations, including the advice that the annual grant to the National Gallery from the Treasury should be increased five-fold to £25,000[54] (though it would have to be suspended for the duration of the war). The Committee doubted that MacColl's suggestion for a government 'credit of at least a million' would be forthcoming and was also dubious that legislation or export taxes could staunch the outward flow of Old Masters. In his analysis of the report, MacColl was realistic: 'it may be well to repeat that it is no part of our hopes or plans to stop all export of artistic treasures, or to safeguard for the public a very large part of it: that would be both too greedy and too costly.'[55] As far as the Art Fund was concerned, MacColl always had more modest plans. He stated to the Committee, 'The original intention [of the Art Fund] was that they should get rather out-of-the-way interesting pictures that might be missed by the National Gallery, and not that they should make those enormous efforts from time to time to do what the State ought to do.'[56]

With the help of such distinguished art historians as Anthony Blunt, Kenneth Clark, John Pope-Hennessy and Ellis Waterhouse, the Art Fund has lived up to MacColl's ambitions. It has supported unusual works such as Piero di Cosimo's *Forest Fire* (cat. 45) for the Ashmolean Museum, Oxford, and campaigned to save Leonardo da Vinci's Cartoon of *The Virgin and Child with Saint Anne and Saint John the Baptist* (fig. 31) for the nation in 1962 and Canova's *Three Graces* (cat. 176) in 1994. These campaigns surely qualify as 'enormous efforts to do what the State ought to do'. Besides painting, the Art Fund has also helped to acquire a variety of beautiful, decorative objects and artefacts from cultures all over the world, including earthenware from Peru and Japan, ancient sculpture from China, Greece and India, Renaissance coins and medals, prints and drawings, medieval manuscripts, furniture, jewellery and costumes.

In 1953, on the fiftieth anniversary of the founding of the National Art Collections Fund, the art critic Denys Sutton wrote 'as the nation does not take sufficient action to safeguard its treasure, the [Art Fund] as the nation's conscience must continue to perform its splendid role.'[57] Nothing has changed in the intervening half century to modify that verdict.

Juliet Gardiner is a historian who has written on late nineteenth- and twentieth-century social and cultural history. Her books include *The Edwardian Country House* (2002) and she is also the editor of the *Penguin Dictionary of British History* (2000).

Notes

1
John Russell, 'Art', in Simon Nowell-Smith (ed.), *Edwardian England: 1901-1914*, Oxford, 1964, p. 333. Sargent's great patron was not a landed aristocrat, as he would have been in past centuries, but Asher Wertheimer, a Bond Street art dealer, who commissioned him to paint various members of his family. Roger Fry found something quite new 'in the history of civilization that such a man should venture to have himself and the members of his numerous family portrayed on the scale and with the circumstances of a royal or ducal family' (quoted in James Lomax and Richard Ormond, *John Singer Sargent and the Edwardian Age*, Leeds Art Gallery at Lotherton Hall, National Portrait Gallery, London, and Detroit Institute of Art, 1979, p. 64.).

2
Samuel Hynes, *The Edwardian Turn of Mind*, Princeton, 1968, p. 5.

3
José Harris, *Private Lives, Public Spirit: Britain, 1870-1914*, London, 1994, p. 36.

4
H.G. Wells, *The Wife of Sir Isaac Harman*, London, 1914, pp. 258-59.

5
L.G. Chiozza Money, *Riches and Poverty*, London, 1905, pp. 42 and 52.

6
For instance, in the 1906 Work Men Compensation Act and Trade Disputes Act. Other prominent issues involved were the insistence of Ireland on national self-determination, Ulster's rejection of Home Rule, and titanic struggles to reform and modernize the Army (which had come near to losing the Boer War) and comparable battles for the Navy.

7
Quoted in Juliet Gardiner, *Queen Victoria*, London, 1997, p. 113.

8
John Russell, in Nowell-Smith (ed.), pp. 330-31.

9
Quoted in Mary Lago, *Christiana Herringham and the Edwardian Art Scene*, London, 1996, p. 62.

10
Art Treasures for the Nation: Fifty Years of the National Art-Collections Fund, introduced by the Earl of Crawford and Balcarres, London, 1953, p. 18.

11
John Ruskin, 'The National Gallery: A Preface', in E.T. Cook and Alexander Wedderburn (eds), *The Works of John Ruskin*, London, 1903-12, vol. 34, 39 vols., pp. 451-54.

12
The Times, 14 February 1884, p. 9.

13
Quoted in Lago, p. 62.

14
David Cannadine, *The Decline and Fall of the British Aristocracy*, New Haven and London, 1990, p. 112.

15
Cannadine, p. 69.

16
Fortnightly Review, November 1904.

17
D.S. MacColl, 'Twenty-One Years of the National Art-Collections Fund',
in *The Burlington Magazine*, no. 44, 1924, pp. 175-79.

18
Christiana received £31,000 in 1888 and an additional £12,000 when
her father died in 1897 – though he made this disposition only after the
passing of the Married Women's Property Act in 1882 ensured that any
inheritance his daughter received could remain in her control rather
than that of her husband.

19
Quoted in Lago, p. 15.

20
MacColl, pp. 175-79.

21
MacColl, p. 73.

22
John Vincent (ed.), *The Crawford Papers: The Journals of David Lindsay,
Twenty-Seventh Earl of Crawford and Tenth Earl of Balcarres, 1871-1940*,
Manchester, 1984, pp. 3-4.

23
Quoted in Lago, pp. 8-9.

24
Quoted in Lago, p. 78.

25
Quoted in Lago, p. 84.

26
15 June 1906, quoted in Lago, p. 140.

27
Charles Rickett's diary, 11 November 1903, quoted in Lago, p. 96.

28
This arrangement continued until 1955, when the committees, also
known as the 'A Committee' (pictures and prints and drawings) and the
'B Committee' (objects), were replaced by an Advisory Panel of experts
who could be consulted individually as required.

29
Quoted in Lago, p. 78.

30
Hynes, p. 317.

31
Hynes, p. 317.

32
Eugenie Strong, widow of Arthur Strong (Librarian of Chatsworth and
friend of Lord Balcarres), was invited to join the Executive Committee
in 1906. She stayed on the Committee until 1914 and remained on the
Council until her death in 1943.

33
The Times, 11 March 1914, quoted in Maureen Borland, *D.S. MacColl:
Painter, Poet and Art Critic*, Harpenden, 1995, p. 209.

34
Sargent served on the Art Fund Executive Committee from 1907 to 1925.

35
The Times, 5 May 1914.

36
*The Book of the Art of Cennino Cennini: A Contemporary Practical Treatise on
Quattrocento Painting*, translated by Christiana Herringham, London, 1899.

37
Lago, pp. 31-51.

38
Quoted in Lago, pp. 127-28.

39
Maureen Borland, p. 136.

40
Christiana Herringham to William Rothenstein, 25 October 1905,
quoted in Lago, p. 125.

41
In the early years, however, some works were purchased from living
artists, for example, Rodin and Alfred Stevens.

42
The Fabian Society was founded in 1884. Its first members included
Beatrice and Sidney Webb and George Bernard Shaw. The peaceful and
democratic revolution that the Fabian Society's members favoured was
to be achieved by educating public opinion and securing the gradual
adoption of socialist policies through the infiltration of local government.
Though the success of Fabian programmes and policies has been much
exaggerated (not least by the Fabians themselves), they exerted a consid-
erable influence on the Labour Party, and the Society remains influential
in information gathering and policy formulation to this day.

43
*Report of the Third Annual General Meeting Held in the Rooms of the Society
of Antiquaries, Burlington House, Piccadilly, on Thursday Afternoon, 25th April
1907*, pp. 10-11.

44
Quoted in Cannadine, p. 69.

45
Quoted in Asa Briggs, 'The Political Scene', in Nowell-Smith (ed.), p. 81.

46
Briggs, p. 89.

47
Briggs, p. 89.

48
Quoted in Juliet Gardiner, *The Edwardian Country House*, London, 2002,
p. 215.

49
Letter from Spielmann to Balcarres, 15 November 1905, quoted in
Lago, *Christiana Herringham and the Edwardian Art Scene*, p. 130.

50
Henry James, *The Outcry*, New York, 1911; ed. with an introduction by
Toby Litt, London, 2001, p. 61.

51
James, p. 22.

52
In 1904, Lord Curzon had chaired a Parliamentary Select Committee to
'inquire into the administration of the Chantrey Trust, and if necessary,
make recommendations' (Borland, *D.S. MacColl*, p. 138).

53
Borland, pp. 194-95.

54
It had been reduced from £10,000 to £5,000 in 1889.

55
Borland, p. 214.

56
Borland, pp. 196 and 214-15.

57
Country Life, 21 May 1953.

The Ones That Got Away

Philip Conisbee

In 1857 John Ruskin gave a lecture in Manchester on the occasion of the city's magnificent *Art Treasures of the United Kingdom* exhibition. Euphoric at the sight of so many great Old Master paintings, he exhorted his audience to 'stand, nationally, at the edge of Dover cliffs – Shakespeare's – and wave blank cheques in the eyes of the nations on the other side of the sea, freely offered, for such and such canvases of theirs.'[1] The mere material stuff of money should be no object, he thought, for British collectors could never accumulate too many great works to fill the nation's storehouses of art. The Manchester exhibition of country house treasures arguably marked the high point of British collecting over the preceding hundred years. The collecting trend was begun by aristocrats on the Grand Tour, boosted by the division of spoils of the French Revolution – notably the dispersal of the Orléans Collection in London in the 1790s – and consolidated by the barons of industry, commerce and colonialism in the first half of the nineteenth century.

In 1857 there was not a thought that all might change within a few decades. By 1907, however, Sidney Colvin, Keeper of Prints and Drawings at the British Museum and a founding member of the National Art Collections Fund (Art Fund), estimated with dismay that in the fifty years since the Manchester exhibition about half the works on show there had been sold out of the British Isles. In retrospect, we can see that there was more than a hint of complacency in a Treasury minute of 1856, which advised the Trustees of the National Gallery only to purchase pictures abroad, for 'as regards the finer works of art in this country, it may be assumed that although they may change hands, they will never leave our shores.'[2] But the Manchester exhibition had been an inadvertent shop window of sorts, its catalogue of works and owners a potential shopping list. It was amply supplemented by the monumental three volumes of *Treasures of Art in Great Britain*, the remarkable survey and virtual inventory of public and private collections

fig. 5 Rembrandt van Rijn, *The Mennonite Preacher Anslo and his Wife*, 1641, oil on canvas, 176 x 210 cm, Staatliche Museen, Berlin

compiled by Gustav Waagen, director of the Royal Gallery of Pictures in Berlin, published in 1854.

In the 1850s no one could have predicted the fall in land values and the agricultural crisis of the 1870s and 1880s, nor the introduction of an 8 per cent levy on death duty on estates with the Settled Lands Act of 1882; this hit landowners hard but allowed them to part with their possessions by breaking the legislation that made estates and heirlooms inalienable. In a pattern that has not changed much today – land, works of art and whole collections were sold off when a roof had to be fixed or a heavy estate duty paid. No more expected was the rapid rise of the powerful German Empire, declared in 1871, with its wealthy military and industrial economic base, nor the social and economic boom that began in the United States after the end of the Civil War in 1867. Germans in the east and Americans in the west now had books of blank cheques to wave – not on, but at, the white cliffs of Dover – as the economic balance of the western world shifted dramatically.

Wilhelm von Bode, who began his career in the Berlin museums in 1872, rising to the post of Director-General

fig. 6 Titian
The Rape of Europa, c. 1575–80,
oil on canvas, 58 x 96 cm,
Isabella Stewart Gardner Museum, Boston

in 1905, played a major role in developing the old Prussian royal collections into a world-class showplace of European painting and sculpture worthy of the new German Empire. Bode was a powerful force, and a leading scholar of both Italian Renaissance and seventeenth-century Dutch and Flemish art. He had an ally in the scholar Max J. Friedländer, a great connoisseur of early Netherlandish and German art, who was in charge of the Imperial print room. Bode was instrumental in the creation of the Kaiser-Friedrich-Museum, which opened its doors in 1904 to display his ambitiously expanding collections. Well-primed by his predecessor Waagen on the rich pickings to be had in Britain, Bode was also able to take advantage of declining British fortunes and rising German ones. We are not talking here of foreign rapacity, but of British economic reality.[3]

By the end of the nineteenth century the Berlin museums included some thirty pictures formerly in British collections, in addition to many others Bode purchased on the London art market and elsewhere. The centrepiece of Bode's display of Dutch paintings (as it is still today in the new Gemäldegalerie in the Kulturforum, Berlin) was *The Mennonite Preacher Anslo and his Wife* (fig. 5), purchased from Lord Ashburnham

in 1894[4] – one of no less than six works by Rembrandt that Bode acquired for the museum. The purchase of this masterpiece was part of an ambitious and sustained international acquisitions policy.[5] Two of Berlin's greatest works by Rubens came from Britain: a *Bacchanal* (destroyed in 1945) acquired at the Blenheim sale in 1886, and *St Sebastian*, bought from the Munro of Novar Collection in 1879. In 1914 Bode purchased Giotto's *Dormition of the Virgin* in London – although in this case it had been offered at the auction of the Davenport Bromley Collection as early as 1863, when Sir Charles Eastlake had failed to purchase it for the National Gallery through lack of sufficient funds (however, he successfully acquired several other early Italian masterpieces at this sale). Inadequate government funding as well as a discouraging system of taxation were blamed, then as now, for the departure of works abroad and the parlous prospects of maintaining the national heritage. In 1889 the National Gallery's annual purchase grant was reduced from £10,000 to only £5,000, at which modest sum it remained until 1923.

While the acquisitions by Bode for Berlin were probably noted and regretted by his colleagues in London – and their loss was certainly a factor in the creation of

fig. 7 Thomas Gainsborough, *Jonathan Buttall: The Blue Boy*, c.1770, oil on canvas, 179.3 x 124 cm, The Huntington Library, Art Collections, and Botanical Gardens

the Art Fund – they seem not to have caused great public controversy at the time and took their place in the course of business in London's very active art market. In any case the First World War and the fall of the German Empire in 1918 brought Bode's collecting activities to an end. Public attention was more readily drawn to the increasing activity of American collectors, whose fabled fortunes attracted more attention than Bode's discriminating and scholarly taste, and whose penchant for the work of celebrated English masters more readily piqued patriotic concerns about the national heritage. In particular, Isabella Stewart Gardner of Boston was slightly ahead in collecting European Old Masters. She was already purchasing major paintings in the 1890s on the advice of the connoisseur Bernard Berenson.[6] She matched Bode by acquiring Rembrandt's *Portrait*

of a Married Couple from Lord Francis Pelham-Clinton-Hope in 1898, leaving *The Shipbuilder and his Wife* in the Royal Collection as the one example in Britain of the master's early double portraits. A true gem of British patrimony was Rubens' *Portrait of Thomas Howard, Earl of Arundel* that Stewart Gardner acquired from Lord Warwick the same year. More typically 'Berensonian' were her purchases of Fra Angelico's *Dormition and Assumption of the Virgin*, from Lord Methuen at Corsham Court, and the crowning glory of her collection at her home, Fenway Court – Titian's late *Rape of Europa* (fig. 6), which came from Lord Darnley at Cobham Hall.

However, the financier Junius Spencer Morgan had caused the first sensation, in 1876, when he expended the enormous sum of 10,100 guineas – more than the National Gallery's annual purchase grant of £10,000 at the time – on Gainsborough's *Georgiana, Duchess of Devonshire* from the Wynn Ellis Collection.[7] It was to be the first in a long succession of masterpieces of British eighteenth- and early nineteenth-century portraiture – Gainsborough, Reynolds, Lawrence, Romney and Raeburn being the favourite masters – to cross the Atlantic during the next fifty years. There they graced the walls of many a grand town house or palatial country home, often in purpose-built picture galleries, where they lent an aura of wealth, social standing (even a hint of ancestry) and taste to their proud possessors. Now they are mostly to be seen in America's great art museums, or in the 'house museums' founded by their collectors, from New York to Cincinnati, from Boston to Washington, from Philadelphia to San Marino, California.

Perhaps the most controversial sale of a British picture was that of Gainsborough's *Jonathan Buttall: The Blue Boy* (fig. 7), from the collection of the Duke of Westminster, sold by the dealer Joseph Duveen to Henry Edwards Huntington in 1921 for a phenomenal £182,200 – a record price for any painting at the time.[8] Duveen did more than any other dealer to endow British paintings of this type with a certain mystique of high-class elegance. Huntington, who specialized in collecting them, was his most willing client. There was public outcry and protest in the press, and some 90,000 people queued to see *The Blue Boy* in 1922 during the three weeks it was exhibited at the National Gallery, before it

left the country. Duveen wrote to Huntington describing the 'crowds round the picture with uncovered heads … It is interesting to know that British people do not usually remove their hats when visiting British art galleries.' There were several reports in the London press of the almost religious awe surrounding this event.[9] Later that year *The Blue Boy* was joined at Huntington's splendid residence in San Marino by Reynolds's *Sarah Siddons as the Tragic Muse*, also from the Westminster Collection. Reynolds' masterpiece was surely in every sense a national treasure. Perhaps it was too academic for popular consumption, as it left the country with much less fuss than the much promoted *Blue Boy*, but it was the loss of this painting that appeared to cause greater consternation among the committee members of the Art Fund.[10]

Duveen, knighted in 1919, and made Lord Duveen of Millbank in 1933, was arguably the most important intermediary for works of art passing from British collections to American ones in his lifetime, supplying major paintings to both Arabella and Henry E. Huntington, Henry Clay Frick, Andrew Mellon and Samuel H. Kress, to name only his most significant clients across the Atlantic. He was the most flamboyant and self-promoting of the many dealers attracting public attention in his day and, well-documented as his activities are,[11] the focus of increasing scholarly attention in our time. Curiously, Duveen was also a great benefactor of art in Britain. He was a life member of the Art Fund, and presented Sargent's *Study of Madame Gautreau* (cat. 29) and Augustus John's *Madame Suggia* to the Tate Gallery through the fund in 1925, and gave generous contributions towards several other acquisitions. He also financed new galleries at the Tate Gallery, the National Portrait Gallery and the British Museum. But we should also note, at least in passing, the names Agnew, Colnaghi and Knoedler, as Duveen's most prominent rivals in trade.

The financier and railway magnate John Pierpont Morgan, son of Junius, was one of the early big spenders on English and European Old Master paintings, some of which were bequeathed to the Metropolitan Museum of Art, New York (founded in 1870), of which he was President of the Board from 1904. Since the early 1890s he had been amassing a collection of Old Master paintings at his London house in Prince's Gate, with a large part placed on loan to the Victoria and Albert Museum. His collection included four portraits by Gainsborough, five by Reynolds, four by Romney, three by Lawrence and Constable's six-foot *The White Horse*, purchased through Agnew's in 1894 (and sold to Henry Clay Frick in 1913). It is interesting to notice in the 1907 catalogue of the Pierpont Morgan Collection that certain works are given titles that indicate the prestigious former ownership; for example, one landscape by Meindert Hobbema, purchased from Sir George Lindsay Holford in 1901, is called *The Holford Landscape*.[12] This was later sold to Mellon and is now in the National Gallery of Art, Washington. Another Hobbema is described as *The Trevor Landscape*, as in the eighteenth century it had belonged to the 4th Baron Trevor, Viscount Hampden. Morgan's concept of a private picture gallery, shared by compatriots such as Huntington, Frick and Mellon, was modelled on the example of the magnificent collection of the 4th Marquess of Hertford and his son Sir Richard Wallace at Manchester (now Hertford) House, London,[13] which all four magnates had visited long before the collection entered the public domain in 1897. Another model was the country house collection – not only the aristocratic eighteenth-century type, but a different kind purchased with newer money, such as that belonging to Ferdinand de Rothschild, assembled in 1889 at Waddesdon. Like Richard Wallace, Rothschild collected major European Old Masters, as well as British glamour portraits by Gainsborough and Reynolds. John Pierpont Morgan's philanthropy also extended to British museums and galleries; he was made a life member of the Art Fund in recognition of his contribution to the purchase of Jan Gossaert's *Adoration of the Magi* for the National Gallery, London, in 1911. His son, John Pierpont Morgan Junior ('Jack'), confirmed the family tradition of art collecting and philanthropy. He played a crucial role in helping secure *The Luttrell Psalter* (cat. 38) and the *Bedford Hours* for the British Museum in 1929 and 1930 (both now in the British Library). The four panels from Giovanni di Paolo's *Life of St John the Baptist* in the National Gallery were also purchased from his collection.

Both John Pierpont Morgan and Henry Clay Frick initially assembled their picture collections in London, doubtless to avoid the 20 per cent import tax on

important works of art, which had been brought in by the 1897 US Revenue Act.[14] It may have been the spectre of taxation that led Morgan to focus in New York (and Huntington in California before 1909) on collecting books and manuscripts – hence his great foundation, the Pierpont Morgan Library – because they could be designated as of religious and educational value, and were exempt from the duty. However, the Payne-Aldrich Tariff Bill, introduced in 1909, repealed the import tariff on works of art over one hundred years old, and presented a golden opportunity for American private collectors and public museums, while posing an even greater threat to collections in the British Isles. Already in 1904 a rather condescending editorial had appeared in *The Burlington Magazine* (which had been co-founded by Art Fund stalwarts Charles Holmes and Roger Fry). Entitled 'The Consequences of the American Invasion',[15] the piece decried American collectors, who 'with characteristic impetuosity entered the market bent on acquiring the greatest number of examples in the shortest

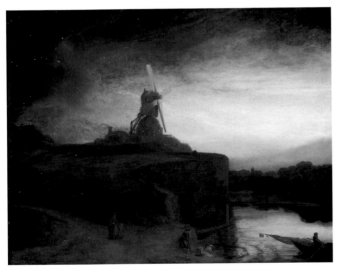

fig. 8 Rembrandt van Rijn, *The Mill*, 1645–48, oil on canvas, 87.6 x 105.6 cm, National Gallery of Art, Washington, DC, Widener Collection

possible time', thus pushing up prices beyond the reach of most of their British and Continental European counterparts. The new US legislation drew praise in the American press, but there was to be a public outcry in London when Pierpont Morgan's collection was finally shipped to New York in 1912. The situation in Britain

had not been helped when, in 1909, Lloyd George, the Chancellor of the Exchequer, significantly raised income, land and inheritance taxes in his 'People's Budget'. Two years later Lord Lansdowne sold Rembrandt's *The Mill* (fig. 8) to the Philadelphia collector Peter Widener. One of the most famous Dutch landscapes in the Orléans Collection and subsequently much admired by Constable and Turner, *The Mill* was thought by Bode to be 'the greatest picture in the world'.[16] The £100,000 masterpiece was exhibited for two weeks at the National Gallery, where it attracted 11,000 mournful visitors. Although the Art Fund was concerned at the loss of the painting, it was decided that it would not be possible to launch a public appeal. The outbreak of the First World War had brought its own financial crises; taxation was increased to pay for it, and it severely diminished every aspect of life on the grand country estates.

Widener, who had amassed his fortune from coal and steel, and had built a house next to Central Park in New York in which to keep his art collection, competed in collecting with his Pittsburgh and New York counterpart Henry Clay Frick. Two of the highlights of Frick's collection were Giovanni Bellini's *Ecstasy of St Francis* – much admired in the Manchester exhibition of 1857, when it was in the Dingwall Collection, and acquired by Frick in 1915, three years after it had been offered to the National Gallery in London – and Gainsborough's *The Mall in St James's Park*, bought in 1916 from the collection of Sir Audrey Neeld. Through Duveen Widener acquired Raphael's *Cowper Madonna*, inherited by Lady Desborough with the Panshanger Collection, and Mantegna's *Judith and Holofernes* from Wilton House. In 1925 the same collector bought Giovanni Bellini's *Feast of the Gods*, which had been in the collection of the Duke of Northumberland. These three masterpieces and *The Mill* are now in the National Gallery of Art in Washington, along with many other works acquired by Widener from British sources.

A New York journalist reporting in 1925 on several major estate sales in England observed that 'The raid of the American dollar on European art has probably been more successful this year than ever before. One of the big transactions of the year has been Duveen's purchase for American customers of six famous paintings

from the late Earl Spencer – three Reynoldses, a Gainsborough, a Van Dyck and a Frans Hals.'[17] And so the story would go on, with Samuel H. Kress buying masterpieces of Italian Renaissance painting for his New York town house – including Filippo Lippi's tondo *The Adoration of the Magi* from the collection of Sir Herbert Cook in Richmond, and Lord Cowper's Giorgione/Titian *Adoration of the Shepherds* from Panshanger – and then forming collections of remarkable variety destined purely for the public domain across the United States, in whichever town supported both an art museum and a Kress dime-store. The American story continues into our own time with Andrew W. Mellon, the Pittsburgh financier and founder of the National Gallery of Art, and his children Paul Mellon and Ailsa Mellon Bruce, who followed their father in funding, or themselves making, important acquisitions, frequently of works formerly in British collections. Paul Mellon also created the museum and study centre that bears his name at Yale University in New Haven, acquiring enormous quantities of British paintings, prints, drawings and books, especially during the 1960s and 1970s. Thus one of Turner's major 'statements,' *The 'Dort' or 'Dortrecht' Packet-Boat from Rotterdam Becalmed* (fig. 9), acquired from Farnley Hall in 1966, now hangs in New Haven, while the great Albert Cuyp that inspired it, *The Maas at Dordrecht*, acquired by his father through Duveen from the 3rd Earl of Brownlow, has been hanging in Washington since 1940.

While recording yet another great loss – Velázquez's portrait of *Juan de Pareja* to New York's Metropolitan Museum of Art in 1970 – it is salutary to remember that North America was not the only destination for so much of what was once considered British heritage. In 1913 the Louvre acquired Rogier van der Weyden's *Braque Triptych* from Lady Theodora Guest, a daughter of the Duke of Westminster, while *Three Marys at the Tomb* by Jan or Hubert van Eyck left the Cook Collection for the Boymans van Beuningen Museum, Rotterdam, on the eve of the Second World War. Again in the 1930s, Lord Spencer would part with Holbein's *Portrait of King Henry VIII* (fig. 10), an indisputable item of English patrimony, to Baron Heinrich Thyssen-Bornemisza in Lugano (now in the Thyssen-Bornemisza Museum,

fig. 9 Joseph Mallord William Turner, *The 'Dort' or 'Dortrecht' Packet-Boat from Rotterdam Becalmed*, 1817–18, oil on canvas, 157.5 x 233.7 cm, Yale Center for British Art, New Haven, Paul Mellon Collection

Madrid). In more recent times, the late Baron Hans Heinrich Thyssen-Bornemisza, son of Baron Heinrich, acquired from the Morrison Collection in 1990 Constable's *The Lock*, a picture that had hung at Basildon Park ever since James Morrison purchased it from the artist. Other great pictures have left Basildon Park (Rubens's *The Miracles of St Francis of Pola* in 1991 and Poussin's *Landscape: Calm* in 2000, both to the J. Paul Getty Museum), Lennoxlove (Van Dyck's *First Duke of Hamilton* in 1991, to Vaduz, Liechtenstein), Chatsworth (Poussin's *Finding of Moses* in 1996, shared by the Getty and the Norton Simon Museum, Pasadena) and Firle Place (Fra Bartolommeo's *Holy Family with Infant St John* to the Getty).

Since the foundation of the Art Fund one hundred years ago, and in spite of the establishment in 1952 of the Waverley Committee to review the export of works of art, many important paintings have nevertheless left Britain. Yet the successes of the Art Fund, together with other charities and bodies such as the National Heritage Memorial Fund and the Heritage Lottery Fund, some government support, the application of Private Treaty and *in lieu* tax arrangements and so on, have also saved many an artistic treasure for the nation. We should certainly not forget the vital role of the National Trust, founded in 1895, which, with the Country House Scheme (devised to preserve country houses with their chattels, including many significant collections of paintings), saved works of art that otherwise might have been

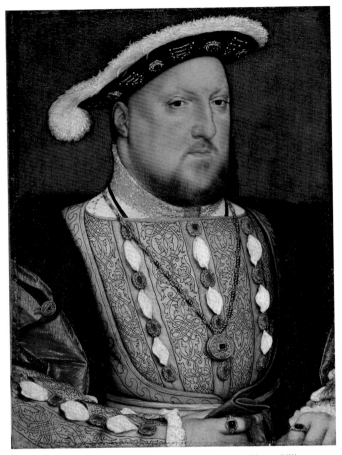

fig. 10 Hans Holbein the Younger, *Portrait of King Henry VIII*, *c.* 1534–36, oil on panel, 28 x 20 cm, Thyssen-Bornemisza Museum, Madrid

J. Paul Getty Museum. Whenever I am in the National Gallery in London, I go to look at it and like to reflect indulgently that I paid for one of those magical flecks of paint. I would do it again, because I still think that *The Death of Actaeon* belongs in London. It makes an incomparable late, painterly response to the National Gallery's earlier Titian mythology *Bacchus and Ariadne*. At the 1798 sale of the Orléans Collection it was acquired by Sir Abraham Hume, who sent it for exhibition at the British Institution in 1819. I am convinced that its influence lies behind the new drama of handling and *chiaroscuro* in Constable's 1820 full-sized sketch (at the Victoria and Albert Museum) for *The Hay Wain*.

Yet the heritage case can be overstated. A quite different masterpiece, Antonello da Messina's *Christ at the Column*, sold from the Cook Collection and understandably stopped for a time by the Export Reviewing Committee in 1991, looks as at home in the Louvre as it would have in Trafalgar Square or in any one of the other museums in Europe and America which coveted it in the salesroom. Real economic pressures exist, on owners, museums and galleries, governments and noble charitable bodies such as the Art Fund. The economic balance of power has shifted throughout history, but financial strength can help foster a well-educated public with certain cultural expectations. Money can also provide the means to fulfil those expectations and ambitions. Building a collection of European painting might be one (but just one) of them – after all, it is without doubt one of the great visual artistic traditions in our culture.

But our world is a much smaller one than it was in 1903; travel is easier – witness the growth of mass tourism – and electronically the world can come into our living rooms or studies. For the devotee of Old Master paintings, it is a great pleasure to visit the Huntington in San Marino, where *The Blue Boy* is justifiably considered part of the heritage of Southern California, as it was once part of England's, and where it has been enjoyed by far more people than it ever would have been if sequestered in a ducal house. Who now objects to seeing *The Mennonite Preacher Anslo and his Wife* (and the other Rembrandts) at the Gemäldegalerie in Berlin, where it has so long been an iconic work of the collection and is a lasting tribute to the eye and mind

dispersed: one thinks of Ascott, Attingham, Belton, Ickworth, Kingston Lacy, Polesden Lacey, Uppark, Upton, Tatton, to name a few of these treasure houses of Old Master paintings.[18] In 1976 the Art Fund amended its charter to permit grants to the Trust for the purchase of works of art.

To introduce a personal note, as an expatriate and curator of European paintings employed in one of America's great art museums, I continue to be awed on my return visits to Britain's museums and country houses by the riches still displayed there. Long may they remain! Long may public and private efforts keep them there! As a student I was proud to make a contribution from my paltry resources to the collecting box when the Art Fund launched an appeal to save Titian's *Death of Actaeon* (fig. 12) for the nation in 1971, when it was sold by Lord Harewood via Christie's to the

of the great director and Rembrandt scholar Bode? Marvellous as it would be to see Titian's *Rape of Europa* in London's National Gallery, along with the other great mythologies *Bacchus and Ariadne* and *The Death of Actaeon*, who can deny the aesthetic thrill of encountering Isabella Stewart Gardner's crowning acquisition at Fenway Court in Boston, with its Venetian architecture and Renaissance paintings. This essay – the mere outline of an even more chastening story that needs to be told in much greater detail – has been a melancholy one to write. But perhaps with our sophisticated historical perspective and our developing knowledge of the history of collecting, so inspired by the work of the late Francis Haskell, we have reached an understanding that tempers any resentment. Surely now in our globalized world, our pluralistic society, more than ever it is a question of determining the meaning of heritage and setting priorities, and the issue increasingly at stake is, whose patrimony is a work of art?

Philip Conisbee is Senior Curator of European Paintings at the National Gallery of Art, Washington, DC.

Notes

1
John Ruskin, 'A Joy Forever', in E.T. Cook and Alexander Wedderburn (eds), *The Works of John Ruskin*, London, 1903-12, vol. 16, 39 vols., p. 78. On *Art Treasures of the United Kingdom* and other Old Master exhibitions, see Francis Haskell, *The Ephemeral Museum: Old Master Paintings and the Rise of the Art Exhibition*, New Haven and London, 2000.

2
Brinsley Ford, 'Pictures Lost to the Nation', in *The Magazine of the National Art Collections Fund*, Christmas 1985, pp. 9-23. I am considerably indebted to this article by the late Brinsley Ford, who was Chairman of the Art Fund, 1975-80. Here too I am speaking only of Old Master paintings, and indeed it would take all of this short article just to draw up an inventory of all those that have left the British Isles since the turn of the nineteenth and twentieth centuries. I can only cite a few examples of ones that got away, before and after the foundation of the Art Fund in 1903, while noting with surprise that there has been no definitive publication devoted to this fascinating, if at times, melancholy theme.

3
Witness such major estate sales as that of the Duke of Hamilton in 1882 and that of the Duke of Marlborough at Blenheim in 1886.

4
Most of the Ashburnham Collection, however, had been sold at auction in 1850, when the Rembrandt was bought in.

5
In 1874 Bode had established the basis of a great Dutch seventeenth-century collection by acquiring *en bloc* the Suermondt Collection from Aachen, and he encouraged and advised local collectors and future benefactors, such as Edouard and James Simon and Oskar Huldschinsky.

6
Bernard Berenson (1865-1959) was an American art historian, critic and collector, who is still recognized as one of the leading scholars on Renaissance art.

7
This portrait was recently sold to the Duke of Devonshire by Morgan's descendants. On this painting and Gainsborough's *Blue Boy* see Robyn Aseleson, 'Blue Boy Blues', in *Art Quarterly*, Spring 2002, pp. 42-45, an article to which I am indebted.

8
I am indebted for this discussion of American collectors of British paintings to Shelley M. Bennett, 'The Formation of Henry E. Huntington's Collection of British Paintings', in Shelley M. Bennett, et al., *British Paintings at the Huntington*, London and San Marino, 2001, pp. 1-15.

9
Bennett, pp. 8 and 14, notes 58-59.

10
Art Fund AGM, 14 July 1919.

11
On Duveen, see Bennett; S.N. Behrman, *Duveen*, reprinted with a new introduction, Boston and Toronto, 1972; and Colin Simpson, *Artful Partners: Bernard Berenson and Joseph Duveen*, New York, 1986. The relative accessibility of the Duveen Papers at the Getty Research Institute, Los Angeles, will facilitate further research.

12
T. Humphrey Ward, *Pictures in the Collection of J. Pierpont Morgan at Prince's Gate and Dover House, London*, London, 1907.

13
Hertford House is now the home of the Wallace Collection.

14
This was also the case with the collections of Isabella Stewart Gardner, Senator W.A. Clark (whose collection would go to the Corcoran Gallery in Washington) and Collis (Arabella) Huntington – aunt and later wife *en secondes noces* of Henry E. Huntington (her collection temporarily sequestered in Paris would go to the Metropolitan Museum of Art).

15
Editorial, *The Burlington Magazine*, July 1904, pp. 353-55.

16
See Arthur Wheelock, *Dutch Paintings of the Seventeenth Century: The Collections of the National Gallery of Art*, New York and Oxford, 1995, p. 231.

17
New York City Times, 27 September 1925, cited by Bennett, p. 12, note 23.

18
The National Trust was founded to act as a guardian for the nation in the acquisition and protection of threatened countryside and buildings, and in response to the government's indifference to the dangers that threatened the nation's inheritance. The National Trust Act of 1937 set up a Country House Scheme, which enabled country house owners to hand over their houses to the Trust. See the exhibition catalogue by Alastair Laing, *In Trust for the Nation: Paintings from National Trust Houses*, National Gallery, London, 1995, with a small but choice selection of seventy-two paintings from over 8,000 in the Trust's care; and the Editorial in *The Burlington Magazine*, December 1995.

A Century's Achievement: Celebrating 'the greatest collectors of all'*

Richard Verdi

By the end of its first full year, in 1904, the National Art Collections Fund (Art Fund)[1] had already functioned in three of the major ways it was destined to act in future. It purchased outright a painting for the National Gallery,[2] contributed towards the cost of a Greek bronze relief for the British Museum,[3] and accepted and allocated four additional works donated by members of the fund to the same institution.[4] Refusing to be typecast, this was to be an organization that would be alternately active or reactive and also serve as a conduit through which private donations could be directed towards the nation's museums and safe-guarded for the future. In retrospect, this flexibility and breadth of interest – and influence – has been among the Art Fund's greatest sources of strength.

The following year saw the Art Fund's first major achievement, the purchase of a painting by Whistler (cat. 3), an artist who had been the *bête noire* of the Victorian cultural establishment but was increasingly gaining international recognition. Yet this pales into insignificance compared with its heroic struggle to acquire *'The Rokeby Venus'* by Velázquez (one of Whistler's greatest heroes) for the National Gallery just one year later (cat. 4). Launching a public appeal for the purchase of this picture (see Nead, pp. 74–79) – a fourth major way in which the fund was to function in future – it gained the last-minute support of King Edward VII, who swung the balance in its favour, earning the monarch the title of patron of the fund ever since. This tremendous achievement was as timely as it was poetically just. In the age of John Singer Sargent (see cat. 29) and R.A.M. Stevenson[5] – both of whom idolized Velázquez – there could not have been a more fashionable artistic cause. Nor could there have been a greater one. For, if the export of Titian's *Rape of Europa* (fig. 6) to America in 1896 had provided that country with what is still perhaps its supreme Old Master picture, the securing of *'The Rokeby Venus'* for Trafalgar Square had granted the UK in turn what is arguably *its* greatest Old Master painting.

Already during the campaign for the Velázquez, doubts arose about its authenticity. Though wholly unjustified, they raise the crucial question of the nature and extent of the expertise upon which the fund could draw in its early years. In the fields of Western painting and sculpture, this resided almost entirely in the curatorial department of the relevant museums, the history of art not being taught at an academic level in the UK until some thirty years later. Claude Phillips and D.S. MacColl, founding members of the Art Fund, were instrumental here, the former serving as Keeper of the Wallace Collection and the latter as Keeper of the National Gallery of British Art at Millbank.[6] Both men also served on the fund's Executive Committee, as did Sidney Colvin, Keeper of Prints and Drawings at the British Museum, and Charles H. Read, Keeper of the Department of British and Medieval Antiquities in the same museum, one of whose trustees – the collector and financier Max Rosenheim – was to prove an important early benefactor of the Art Fund (see cat. 1). In the fields of archaeology and classical art, the nation also boasted some academic expertise, not merely at the British Museum but at the universities of Oxford, Cambridge and elsewhere. Indeed, it was the fund's financial support for archaeological excavations by the University of Liverpool that led to its most spectacular early acquisition of classical art, the Roman *Head of Augustus* (cat. 7). In the field of Oriental art, however, expertise was much more rudimentary, with none of the keepers in this department of the British Museum being trained in the languages or culture of the Orient, nor having a first-hand knowledge of its countries until after the Great War.[7]

In its early years, the Art Fund acquired many more objects than paintings and deliberately set itself the goal of filling gaps in the national collections. Recognizing that, by the end of the nineteenth century, public collections in Britain were magnificently well endowed with the art of ancient Egypt, Greece and the early

* Queen Elizabeth, the Queen Mother, addressing the Annual General Meeting on the fiftieth anniversary of the National Art Collections Fund, 23 June 1953.

Italian Renaissance, it concentrated elsewhere, on non-Western art, sixteenth-century northern and southern art, and what might today be termed 'heritage' items, such as the last letter of Mary Queen of Scots (cat. 14) or the grille that originally surrounded her tomb in Westminster Abbey.[8] A significant proportion of these works were donations by private individuals, some of them (such as Max Rosenheim) with close links with the fund. Although such benefactions remain an aspect of the fund's activity, gifts of individual objects have dwindled considerably in recent years. However, the allocation to the nation of entire collections – from that of Herbert A. Powell, brother of Christiana Herringham, founder of the Art Fund, to that of the twentieth-century artist Cecil Collins[9] – has steadily increased, as private collecting has become concentrated in a handful of enterprising and generous individuals.

After the success of the Velázquez appeal, the fund wisely decided to concentrate its efforts and resources on securing a selective number of 'sensibly' priced masterpieces rather than attempting to rescue all major works from going abroad, a policy that would have been bound to fail. Thus, in 1909, it launched another public appeal to secure Holbein's *Christina of Denmark* (fig. 23; see Gennari Santori, pp. 92–97) for the nation but, two years later, it acceded to the loss of Rembrandt's *The Mill* (fig. 8) – fortunately, as it turned out; for whereas the former is a key masterpiece, the latter is no longer universally accepted as autograph and, even if by Rembrandt, does little credit to his reputation. During the next twenty or so years, the Art Fund also helped to acquire major works by Gossaert, Masaccio (fig. 11) and Bruegel (cat. 20) for the National Gallery.[10] But this must be seen against the far larger number of equally important pictures lost during the same period – and thereafter. Velázquez and Holbein, the fund's early 'heroes', are a case in point. In the past century, it has secured a total of five paintings by the former and three by the latter, one of them a miniature. But the country itself has lost more than a dozen paintings each by these masters during the same years. Here – as elsewhere in its history – the fund has succeeded in stemming the tide; but it could not altogether halt the flow.

During the first twenty-five years of its existence, the

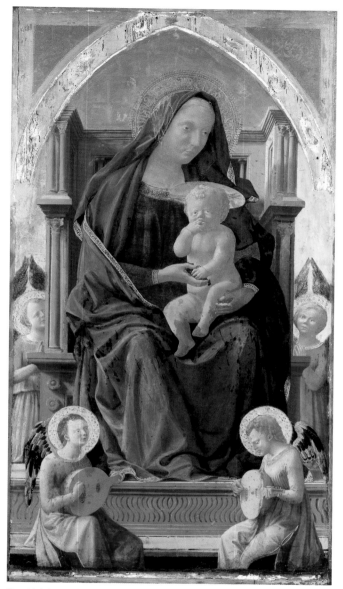

fig. 11 Masaccio, *The Virgin and Child*, 1426, tempera on wood, 135.5 x 73 cm, National Gallery, London. Art Fund assisted 1916

overwhelming majority of the Art Fund's efforts were directed towards major museums in London – not surprisingly since, soon after it was created, it had amalgamated with the Friends of the British Museum.[11] Thus, when it published a list of acquisitions on its twenty-fifth anniversary in 1928, nineteen pages were given over to works in the capital and only six to those throughout the rest of the kingdom.[12] Many of these were closely associated with key individuals, always the crucial arbiters in shaping a nation's taste. One of them was Campbell Dodgson, the brilliant Keeper of Prints

and Drawings at the British Museum, whose taste for works of the early German school ensured that major works by Altdorfer (cat. 28), Dürer (cat. 39) and others were added to the collection during these years.[13]

Whereas the collecting pattern of the Art Fund has remained broadly consistent throughout the century where works of non-Western art are concerned, in the field of European painting and sculpture it has changed dramatically, often (again) spurred by key individuals or institutions. The early 1930s marked a turning point in its history as a result of both of these. In 1932, the Courtauld Institute of Art was created, granting official status to the academic study of the history of art in Britain and destined within a generation to transform the levels of expertise that existed throughout the country in all areas of Western art. During the same years, Kenneth Clark, who was later to serve on the Executive Committee of the Art Fund, became a Keeper at the Ashmolean Museum and set out to acquire idiosyncratic and often challenging pictures befitting a university collection. For Oxford, the fund purchased outright the phantasmagoric *Forest Fire* by Piero di Cosimo (cat. 45) in 1933; and, to the fledgling Courtauld Institute it donated an unfinished work ascribed to Fra Bartolomeo 'of special interest to students … showing the actual methods of painting used in constructing a sixteenth-century picture'.[14] A further diversification of the fund's activities in the years between the wars was its support for Jewish objects for the newly founded Jewish Museum (see cat. 43, 55), its embrace of archaeological material with the acquisition of the Curle Collection of Swedish Viking jewellery (1921) and the Cesena Treasure (1933), a sixth-century hoard from Ostrogothic Italy, and its increased involvement with ethnographic art (see cat. 59), which culminated in the purchase of thirty works from the collection of W.O. Oldman in 1949 (cat. 67–72). Other signs of the Art Fund's rapidly increasing strength and influence are the number of major bequests it attracted during these years and its surprising success in wooing wealthy American collectors such as J. Pierpont Morgan to assist in funding acquisitions for this country, rather than their own (see cat. 38).

Though membership of the Art Fund increased considerably throughout the 1910s and 1920s – from 1,178 in 1910 to 12,503 in 1930 – with the annual subscription remaining at one guinea for the first sixty years (!), the onslaught of the Depression and the coming of the Second World War inevitably took its toll upon the numbers joining.[15] But the fund itself remained remarkably enterprising during the war, single-handedly purchasing works of art and allocating them to museums, which had other concerns and greatly reduced funds in such troubled times. A Niccolò dell'Abate given to the National Gallery was intended to 'reinforce one of the Gallery's weakest sections';[16] a cache of Italian fifteenth-century drawings purchased for the British Museum (see cat. 62) to complement its existing strengths in Raphael and Michelangelo; a major Constable for Edinburgh to bring this great Suffolk master north of the border;[17] and a cup associated with Sir Francis Drake (cat. 61) bought outright for Plymouth.

Singularly absent from the early activities of the Art Fund – save for *'The Rokeby Venus'*, one painting by Rembrandt, and a handful of works by lesser Dutch Masters – is any representation of the great artists of the seventeenth century, Italian, Flemish and French painting of this period being decidedly out of vogue. To be sure, in 1936, the fund helped the National Gallery acquire Rubens's *Watering Place*; but this was based as much on its importance for Gainsborough's picture of this theme as on its own intrinsic merits. During the same period, however, the nation lost countless masterpieces by Poussin and Claude; and, in the same years, the fund was presented with any number of works by Ribera, Salvator Rosa and Rubens, which it repeatedly rejected, perhaps as too wild and uncouth.

In 1944 the scholar of seventeenth-century art, Anthony Blunt, joined the Committee of the fund and, thereafter, Baroque art was regularly acquired for the nation's museums, beginning with Poussin's *Adoration of the Golden Calf* (1945) and Murillo's *Healing of the Paralytic*, which was bought outright by the fund for the National Gallery in 1950. In the same year, the Art Fund contributed one-third of the cost of Bernini's *Neptune and Triton* for the Victoria and Albert Museum; and its engagement with the extremes of seventeenth-century art culminated in its support for Rembrandt's *Belshazzar's Feast* (cat. 111) in 1964. This picture may be seen as a

landmark acquisition for the fund, which had hitherto not been drawn to such violent and dramatic works. Other innovations of the post-war years were a gradual acceptance of Italian Gothic sculpture (cat. 107) and French eighteenth-century sculpture (cat. 66), neither of which would have been regarded as sufficiently mainstream in the early years of the fund. French art of *c.* 1700–80, for instance, was largely confined to the Wallace Collection – where it still dominates the holdings – until well after the Second World War, with the National Gallery not beginning to extend its collections seriously in this area until the 1960s, under the keepership and (later) directorship of Michael Levey.

In 1953 the Art Fund took the 'daring' step of supporting its first work of art for the National Trust, which might have been seen as its rival, though in truth it is its ideal complement, the one securing works of art and the other preserving them and the historic properties to which they belong. Though the first acquisition – a set of embroideries for Oxburgh Hall – was relatively modest, the association between the two institutions was long overdue; for, in 1903, the Art Fund had 'borrowed' the National Trust's charter as a template for its own and, by 1953, the Chairman of the fund – the 28th Earl of Crawford – was also serving on the Board of the National Trust. Thus, in its fiftieth anniversary year, the fund initiated an allegiance which, since an amendment to its Charter in 1976, has resulted in the rescue of more than 200 works of art for National Trust properties throughout the United Kingdom, including such spectacular purchases as the Powis Castle Bellotto (cat. 137) and *The Chirk Cabinet* (cat. 169).

Another notable development of the post-war years was the fund's greatly increased support for museums and galleries in the regions. Admittedly, as early as 1919, the fund had been made one of the guardians of the National Loan Collection Trust, the most important part of which was a bequest of fifty-four paintings (largely of the Dutch and Flemish schools) which was intended to tour the country and Commonwealth and did both of these before settling into Cannon Hall, Barnsley, in 1976. In 1936 and 1939 Herbert A. Powell bequeathed ninety-four British drawings and watercolours through the fund to galleries throughout the United Kingdom –

from Edinburgh to Plymouth – having already (in 1929) deposited a further 130 such works on loan to the National Gallery, Millbank (now Tate Britain). The latter collection was exhibited widely throughout Britain and the Commonwealth before being distributed permanently in 1967, the vast majority of the works going to the Tate Gallery and the Victoria and Albert Museum. In other ways, too, the fund assisted with acquisitions and bequests for museums outside London. One of the most extraordinary of these was the gift of more than 200 etchings by Hedley Fitton from his widow in 1939, which was distributed to no fewer than sixty-two museums around the country. Bizarrely, this almost certainly ensures that the little-known Hedley Fitton is the most ubiquitously represented of all artists in the museums and galleries of the United Kingdom.[18]

But it was only in 1955 that the regions became a central concern of the fund. In that year Ernest E. Cook, grandson of Thomas Cook, bequeathed 413 works – paintings, drawings, furniture, ceramics, silver, tapestries and manuscripts – to the Art Fund with the express wish that they be allocated around England (cat. 84–89).[19] In the end, nearly one hundred institutions benefited from this bequest. Also in this year, F.D. Lycett Green donated 137 paintings (see cat. 90–92) through the Art Fund to York Art Gallery, at a stroke transforming it into one of the most representative in the country.[20] These bequests were part of a golden age for Britain's regional museums, when great directors and curators like Hugh Scrutton in Liverpool and Mary Woodall and Trenchard Cox at Birmingham were attracting major acquisitions (see cat. 103, 105, 106, 110) that would be the pride of any national museum and, in the present climate of local government, seem destined to remain a distant memory.

During these same years, the fund began flexing its political muscle once again as it launched its first campaign since the Holbein appeal of 1909 to save a major masterpiece for the nation. This was for the Leonardo Cartoon, *The Virgin and Child with Saint Anne and Saint John the Baptist* (fig. 31), sold in 1962 by the Royal Academy for £800,000 and destined to go abroad but for the energy and initiative of the fund, which mounted a nation-wide appeal that, in a little over four months, secured the work for the National Gallery. Rightly

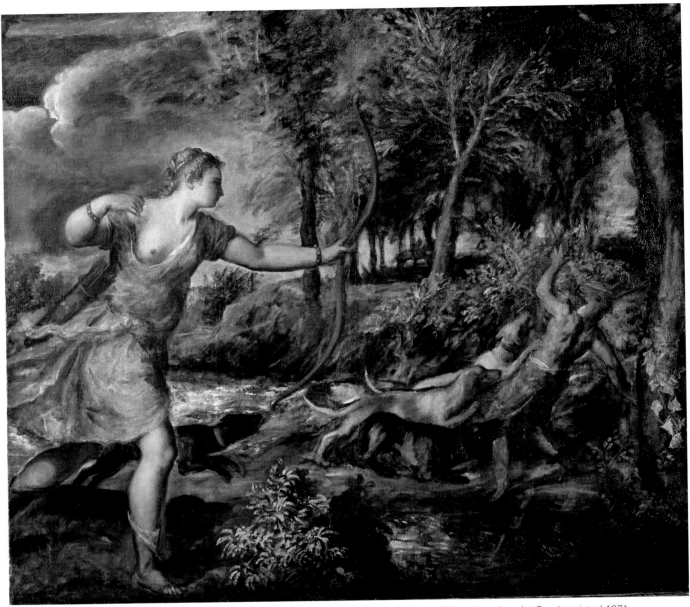

fig. 12 Titian, *The Death of Actaeon*, c.1565–76, oil on canvas, 178.4 × 198.1 cm, National Gallery, London. Art Fund assisted 1971

regarding the Cartoon as 'the greatest work of art which has come to the market for generations', the fund itself financed the expenses of the appeal, which was launched from headquarters provided by the National Gallery, issuing leaflets to 105,000 groups throughout the country, including schools, churches, women's organizations and the general public. By the time it had ended, more than one million people had come to see 'the greatest drawing in the world' in the National Gallery and more than 24,000 subscriptions had been pledged to ensure its preservation for the nation.[21]

Along with the Velázquez and Holbein appeals of the fund's early history, this was among its greatest successes – and is perhaps its single most heroic achievement, given the sum of money involved and the severe time limit. But it was not to be the last. Nine years later, Titian's great *Death of Actaeon* (fig. 12) was sold to the Getty Museum for £1,763,000, whereupon a public appeal was again launched to save the painting for the nation. Like that for the Leonardo Cartoon, this was also successful, in both cases thanks to a last-minute grant from the government – yet another 'distant memory'?

The success of the Titian campaign of 1971 itself came at a cost – one which, with 'fearful symmetry', recalled the very earliest days of the fund, when a Velázquez had been saved after the loss of a Titian. For *The Death of Actaeon* was only made salvageable by the 'sacrifice' the previous year of the greatest Velázquez ever to leave these shores, the portrait of *Juan de Pareja*, bought by the Metropolitan Museum of Art in New York in 1970 for £2,300,000. As was acknowledged at the time, it was a case of either/or...

The purchase of the Whistler in 1905 and of Rodin's *Burghers of Calais* (cat. 11) six years later might have heralded a long-term support for modern art by the Art Fund. Alas, this was not to be the case. Despite the crucial championing of D.S. MacColl – who was early urging it to acquire works by Manet and Monet – this was to remain the most problematic area of the fund's activities throughout all but its most recent history.

But this must ultimately be seen as a reflection of British taste. Notwithstanding the pioneering efforts of the Davies sisters of Wales, Samuel Courtauld (who served on the fund's Executive Committee), Sir William Burrell of Glasgow and a mere handful of others, modern foreign art especially was shunned by the art establishment until well after the Second World War, when many of its greatest masterpieces had already found permanent homes elsewhere. Disappointingly, even during the earliest years of its life, the fund could do little to reverse this. Though it repeatedly agonized about the matter, when it came to support works of 'modern' art, these were invariably by such artists as Puvis de Chavannes, Boudin, Alfred Stevens, Wilson Steer, Sickert and Degas, who was regarded as Sickert's French counterpart. As late as 1926, with the opening of the Modern Foreign Galleries at the National Gallery, Millbank (now Tate Britain), the fund's contribution to this inauguration was the outright purchase of two Monets, a Corot and Courbet and a sculpture by Carpeaux [22] – hardly 'cutting edge' in the age of Beckmann and Mondrian.

Already in these years there were two other organizations whose primary purpose was to collect contemporary art: the Chantrey Bequest, administered since 1876 by the Royal Academy, and the Contemporary Art Society, founded in 1910 to do for contemporary art what the

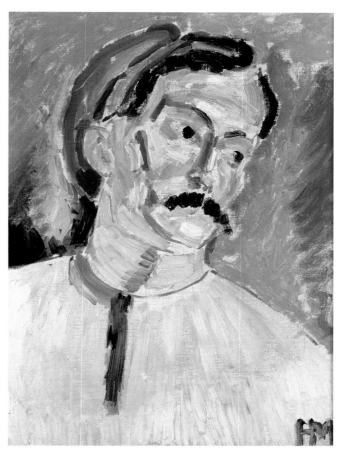

fig. 13 Henri Matisse, *Portrait of André Derain*, 1905, oil on canvas, 39.4 x 28.9 cm, Tate. Art Fund assisted 1954

Art Fund was doing for that of earlier periods. Although the Chantrey Bequest was intended to buy 'works of fine Art of the highest merit' by artists of any period or nationality providing those works were executed in the British Isles, in practice it rarely looked beyond the Royal Academy's annual exhibitions for purchases, buying works by living British artists only – a fact that roused D.S. MacColl's ire as early as 1903, when he charged the Chantrey trustees with maladministration and the misuse of public money. [23] Though the creation of the Contemporary Art Society seven years after the birth of the Art Fund might understandably have absolved the latter of its obligations to acquire modern works of art, like the Chantrey Bequest the Society has confined itself almost exclusively to modern British art, further reinforcing the nation's cultural insularity when compared with the great collections of modern art to be found throughout continental Europe. [24]

fig. 14 Bill Viola, *Nantes Triptych*, 1992, video/sound installation, dimensions variable, Tate. Art Fund assisted 1994

But this cannot entirely excuse the fund, which as late as the 1960s (!) was rejecting major works by Manet, Van Gogh, Picasso, Kokoschka and Klee[25] and is notable by its absence from almost all of the acquisitions of the few icons of modern art found within these shores. Cézanne's *Bathers*, Picasso's *Three Dancers*, Matisse's *Snail*, anything German and anything to do with Cubism – all of these were for its first seventy years outside the fund's chosen remit. Just how much this remained a blind spot may be gleaned from the fact that, when the Art Fund paused to survey its achievements on its seventy-fifth anniversary in 1978, it devoted a section of its *Report* to Modern British Art but there was no mention of its foreign counterpart.

In 1954, the fund took its first step towards embracing the avant-garde art of earlier in the century with the purchase of Matisse's *Portrait of André Derain* (fig. 13) for the Tate Gallery. Despite the fact that both artists had died in that year, which presumably granted them a measure of respectability, this acquisition caused a furore among many members of the fund, some of whom denounced the work as a 'nightmare of a picture' and 'a monstrous example of modern art'.[26] Certainly it did not provoke an avalanche of further applications from the Tate Gallery or anywhere else. Instead, nearly a quarter of a century was to elapse before British collections would begin to acquire major masterpieces by Grosz,[27] de Chirico (cat. 147), Beckmann (cat. 138), Mondrian (cat. 211) and Picasso (cat. 154), who remain so poorly represented in this country when compared with continental Europe or the United States. Among the key developments of early twentieth-century art, only

Surrealism may be adequately studied in British collections both in London and Edinburgh – in the latter thanks to the recent acquisition of the Penrose (see cat. 154, 161, 181, 197) and Gabrielle Keiller collections.[28] The remaining gaps in the nation's holdings of early modern art can no longer be filled, but the reasons for this are the policies adopted by past directors and trustees of the Tate Gallery, rather than those of the fund. This is not to say that the Art Fund did not harbour its own suspicions of such works. In 1946, when the Victoria and Albert Museum held a joint exhibition of Picasso and Matisse and another of Constable, the Earl of Crawford and Balcarres, Chairman of the fund, confessed to finding the latter 'far more sensational'.[29]

Happily, there are many other areas of the nation's collections that have benefited immeasurably through the diversification of the Art Fund's activities since the Second World War. One of the greatest of these is the funding of archaeological remains and treasure trove, whether it be the early Iron Age objects ploughed up at Snettisham, Norfolk in 1950 (cat. 77), the Spanish Armada treasures recovered from the wreck of the *Girona* off the Antrim Coast between 1967 and 1999 (cat. 117), or the extensive collection of Roman antiquities excavated from the ancient town of Silchester, which was acquired by the Museum of Reading in 1978 and 1980 (cat. 127). Many of these works are fundamental to our understanding of the nation's history and cultural heritage and, as such, have greatly enriched British collections. Further innovations during the past half century have included the increased support for arms and armour, costumes, furniture, musical instruments and (especially) ethnographic art, the last of which began as a peripheral concern of the fund in its earliest years and is now of central importance.

Other changes in the collecting profile of the Art Fund in recent years have arisen in response to market forces and to the increasingly ethical concerns of museums themselves about the objects entrusted to their care. Since the early days of the fund, for instance, there has been a noticeable decline in support for portable antiquities with an unknown provenance and a steep increase in the number of paintings. The rise in the latter probably relates not only to growing expertise in this field but to the significantly greater financial strength of the fund, paintings being typically the most costly of all works of art. In keeping with British taste, history pictures, portraits and landscapes fare best among these, with genre and animal paintings featuring less prominently and largely confined to works by British artists. And when one turns to the field of still life, the national antipathy towards such works becomes apparent, and the fund reflects this, having supported not a single major work of this type in its first century. The few early masterpieces by Kalf, Baschenis, Mélendez,[30] and Chardin to have reached the nation's collections during this period arrived there by other routes, as have the mere handful of later examples by Cézanne and Matisse.

Since the early 1990s the fund has also turned its attentions towards the more speculative and problematic area of collecting contemporary art, as museums throughout the country strive to avoid the mistakes of previous generations in this regard. This has led to the acquisition

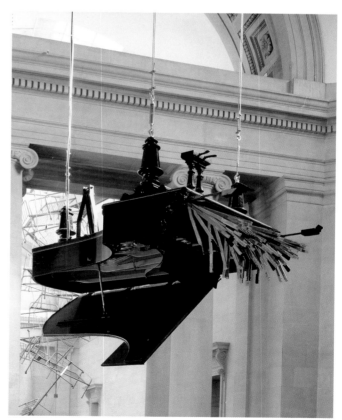

fig.15 Rebecca Horn, *Concert for Anarchy*, 1990, painted wood, metal and electronic components, approx. 150 x 106 x 155.5 cm, Tate. Art Fund assisted 1998

of some major works for the nation, among them Bill Viola's moving video installation, *Nantes Triptych* (fig. 14) and Rebecca Horn's *Concert for Anarchy* (fig. 15), neither of which could be included in the present exhibition for display reasons.[31] Collecting in this area is a calculated risk on the part of both museum directors and the fund. It will undoubtedly lead down some blind alleys that might prove just as embarrassing to the fund in 2103 as its early mania for Alfred Stevens appears now. But it should also ensure that what comes to be regarded as the great art of the past quarter-century is more generously represented in the nation's collections than is that of 1901–25.

Though it is impossible to commend the Art Fund's achievements over its first century too highly, it is not difficult to discover their roots. Foremost among these is its utter selflessness – one which led it to spend only £576 on internal expenses during its first twenty-five years, to have only three permanent members of staff for its first fifty years, and one which has cost it dearly in lack of public plaudits. It is certainly time *that* changed – and what better catalyst than a centenary? – though the selflessness is likely to remain.

Even more remarkable than this, however, is the fund's resourcefully pragmatic nature and its refreshing lack of bureaucracy. These were seen in action, in 2001, when the Elizabethan panelling of a room at 229 High Street, Exeter, one of the city's grandest merchant houses, suddenly came up at auction 6,000 miles away. Having been sold abroad in 1930, this was eventually donated to the Fine Art Museums of San Francisco, which decided that it was superfluous to its collections and put it up for sale locally. With less than two weeks to go, Exeter was alerted to this sale and contacted the fund, which arranged for the museum to be present and able to bid at auction. Its efforts were successful and the panelling has now been repatriated and will soon be re-installed in Exeter.[32] How many (if any?) other organizations, one wonders, would have been prepared to sever so much red tape in just twelve days?

And what of the fund's ultimate significance to this nation? This is easy. As long ago as 1926, the Chairman, Robert Witt, reported that the eminent German museum director, Wilhelm von Bode, predicted that in due course America would become the greatest repository of works of art in the world.[33] It is not – and never will be; nor is any other one country – though the United Kingdom is certainly among the very greatest, thanks in part to the Art Fund, not least when it has been active – rather than reactive – in responding to a national emergency. The appeals for Velázquez, Holbein, Leonardo and Titian; the campaign for free admission to museums (see Toynbee, pp. 298–301); and the impressive number of outright purchases it has made throughout the century – all of these show the fund doing what it does best: responding rapidly to a crisis with energy, ingenuity and flair, to serve the nation's cultural good. 'One of the most successful ventures of the kind ever inaugurated in the United Kingdom' was how the *Spectator* greeted the fund's arrival in 1903.[34] A century on, it has become the greatest art charity in the world.

Richard Verdi is Curator of the exhibition *Saved! 100 years of the National Art Collections Fund*. He is also Director of the Barber Institute of Fine Arts, University of Birmingham.

Notes

1
Originally the National Art-Collections Fund, the hyphen was dropped in 1989.

2
'Madonna and Child, by Lazzaro Sebastiani', in *National Art-Collections Fund, First Annual Report, 1903-04*, 1905, p. 16.

3
'Greek Bronze Relief', in *National Art-Collections Fund, First Annual Report, 1903-04*, 1905, p. 14.

4
'Old English Repeating Watch, by Daniel Quare' (cat. 1); 'Volume of Rare Engravings and Etchings'; '*The Martyrdom of S.S. Peter and Paul*, by Girolamo Francesco Mazzola (known as Parmigianino)'; 'Plate of Rhodian Faience', in *National Art-Collections Fund, First Annual Report, 1903-04*, 1905, pp. 9 and 11–13.

5
R.A.M. Stevenson (1847-1900), first cousin of Robert Louis Stevenson, published *The Art of Velázquez* in 1895. Republished in 1899 and 1962, and translated into German in 1904, it remains one of the supreme

accounts of Velázquez's technical prowess and did much to further the reputation – and emulation – of the great Spanish master among artists like Sargent. A painter and critic by profession, Stevenson studied in Paris in the 1870s and returned there frequently thereafter. He was a great admirer of Corot, Manet and Monet, and regarded Velázquez as the first Impressionist. His book on the artist is based entirely on notes taken in the Prado Museum in Madrid, where he was mesmerized by Velázquez's painterly skill. Among the founding members of the Art Fund, both D.S. MacColl and Roger Fry were admirers of Stevenson's purely aesthetic approach to art, in which he encouraged his readers to look at pictures 'with your head empty and all life in your eyes'.

6
It is a measure of how uncharted the history and connoisseurship of Old Master painting was at this time that, despite the fact that Phillips presided over a collection containing seven Watteaus at Manchester Square and wrote a book on the artist in 1895, the 'Watteau' that the Art Fund assisted the National Gallery of Ireland in acquiring in 1904 – a *Fête Champêtre* – has not stood the test of time and is now attributed to Pierre-Antoine Quillard (1701-33).

7
David M. Wilson, *The British Museum, A History*, London, 2002, pp. 228-31.

8
'Grille of Mary Queen of Scots' Tomb', in *National Art-Collections Fund, Seventeenth Annual Report 1920*, 1921, p. 35.

9
Further to the Powell Bequest, see p. 37. That of Cecil Collins (1908-89) consisted of 535 paintings, drawings and prints by the artist bequeathed through the Art Fund in 2001 and subsequently allocated to fifty-two museums in the United Kingdom.

10
Gossaert, *Adoration of the Kings*, 1500-15 (purchased 1911); Masaccio, *Virgin and Child*, 1426 (purchased 1916).

11
For which, see Wilson, p. 217.

12
Twenty-five Years of the National Art-Collections Fund, 1903-28, Glasgow, 1928, pp. 59-83.

13
Wilson, pp. 202, 232-23.

14
'The Holy Family with the Infant St John, ascribed to Fra Bartolomeo', in *National Art-Collections Fund, Twenty-Ninth Annual Report, 1932*, 1933, p. 20 (p. 12 for the quotation cited here). The picture is now attributed to Perino del Vaga (1501-47).

15
By 1939 the membership had dropped to 9,890 and in 1945 it was only 6,013.

16
'*Landscape*, by Niccolò del'Abbate', in *National Art-Collections Fund, Thirty-Ninth Annual Report, 1941*, 1942, p. 14. The reference is presumably to the absence from the collection of any works by the School of Fontainebleau and the poor representation of Mannerism in general. The correct title of the picture is the *Death of Eurydice*.

17
'*The Vale of Dedham*, by John Constable', in *National Art-Collections Fund, Forty-First Annual Report, 1944*, 1945, p. 4.

18
'Etchings, by Hedley Fitton', in *National Art-Collections Fund, Thirty-Sixth Annual Report, 1939*, 1940, p. 55.

19
'E.E. Cook Collection', in *National Art-Collections Fund, Fifty-Second Annual Report, 1955*, 1956, pp. 20-37.

20
'The Lycett Green Collection', in *National Art-Collections Fund, Fifty-Second Annual Report, 1955*, 1956, p. 38.

21
'*The Virgin and St. Anne with the infant Christ and St. John*, by Leonardo da Vinci', in *National Art-Collections Fund, Fifty-Ninth Annual Report, 1962*, 1963, pp. 12-14 (for a full account of the appeal).

22
National Art-Collections Fund, Twenty-Third Annual Report, 1926, 1927, pp. 34-38.

23
Mary Lago, *Christiana Herringham and the Edwardian Art Scene*, London, 1996, pp. 64-69.

24
For an overview of the Society's collecting history in its first eighty years, see Alan Bowness et al., *British Contemporary Art 1910-1990: Eighty years of Collecting by The Contemporary Art Society*, London, 1991.

25
The works in question are Manet's *Le Déjeuner sur l'Herbe* (reduced version, now Courtauld Gallery London; rejected 1927), Van Gogh's *The Postman Roulin* (1934) and *Les Rochers* (1961), Picasso's *La Belle Hollandaise* (1933), Modigliani's *Portrait of a Boy* (1934), Kokoschka's *Prague, View of the Moldau* (1963) and Klee's *Voice from the Ether* (1964). The last of these was acquired anyway by the Victoria and Albert Museum and remains the only significant late work by the artist in the country.

26
Quoted in Nicholas Goodison, 'Taste and Patronage: Ninety Years of the National Art Collections Fund', in *Art Quarterly*, no. 17, Spring 1994, pp. 29-30.

27
The first of these is George Grosz's *Suicide* (1916), acquired for the Tate Gallery in 1976 (see *National Art-Collections Fund, 73rd Annual Report*, 1976, p. 25).

28
Of these, only works from the Penrose Collection came to the nation via the Art Fund, the majority of them in 1995 ('12 Works from the Penrose Collection', in *National Art Collections Fund, Review 1985*, pp. 167-70).

29
National Art-Collections Fund, Forty-Third Annual Report, 1946, 1947, p. 6.

30
The still life by Mélendez is not the one exhibited here (cat. 92) but the much more ambitious *Still Life with Oranges and Walnuts* of 1772, acquired by the National Gallery in 1986. The Kalf is his *Still Life with the Drinking Horn of the Saint Sebastian Archers' Guild, Lobster and Glasses*, c. 1653 (National Gallery); and the Baschenis a *Still Life with Musical Instruments* c. 1660 (Barber Institute of Fine Arts, The University of Birmingham).

31
'Bill Viola, *Nantes Triptych*', in *National Art Collections Fund, Review 1994*, 1995, p. 144; 'Rebecca Horn, *Concert for Anarchy*', in *1998 Review*, National Art Collections Fund, 1999, pp. 136-37.

32
'Panelled Room and Two Overmantels', in *2001 Review*, National Art Collections Fund, 2002, p. 108.

33
National Art-Collections Fund, Twenty-Third Annual Report, 1926, 1927, p. 9.

34
Quoted in Lago, p. 92.

The Future of Collecting

Martin Bailey

Saved! 100 years of the National Art Collections Fund provides a unique opportunity to enjoy some of the most important works of art acquired by UK museums and galleries over the past century. It is also a timely reminder of the importance of collecting – and the challenges that lie ahead. Finding money for acquisitions has never been easy, but what may come as a surprise is how small a contribution now comes in the form of government grant-in-aid to national museums – probably less than 5 per cent of acquisition costs in a typical year.

Meanwhile, art market prices continue to spiral upwards, while general funding for museums becomes increasingly difficult, squeezing the money available for purchases. When Rubens' *Massacre of the Innocents* sold for £49.5 million in July 2002, there was no way that any UK gallery could even consider trying to match the price. Although there are hopes that Tate will acquire Reynolds' *Portrait of Omai* (£12.5 million) and that the National Gallery will keep Raphael's *Madonna of the Pinks* (fig. 16) (originally valued at £35 million),[1] neither sale had been finalized at the time of going to press. It is masterpieces such as these that future generations will thank us for bringing into public ownership.[2]

fig. 16 Raphael, *The Madonna of the Pinks*, probably 1507–08, oil on wood, 29 x 23 cm. On loan to the National Gallery, London, from the Trustees of the 10th Duke of Northumberland Wills Trust

Why collect?

Museums must add to their collections if they are to remain living institutions.[3] Acquisitions are often needed to 'fill gaps', and thereby tell a story – whether it is the evolution of Bronze Age weaponry in Britain or the development of fifteenth-century Italian painting. Some areas of art now regarded as important were not collected by earlier generations of curators, so museums have to catch up with changing tastes. Obvious examples are Impressionist and Post-Impressionist works, which were virtually ignored by Britain's public galleries until the 1920s. Museums also need to acquire 'discoveries' – in the sense of newly found objects (possibly from an archaeological dig), items that have been 'lost' in private collections for generations, or known works with new

attributions. For institutions that collect contemporary works of art, acquisitions are self-evidently essential. New additions also encourage repeat visitors to museums, provide material for special displays and stimulate scholarship – a good example was the National Gallery of Scotland's purchase of Botticelli's *Virgin Adoring the Sleeping Christ Child* in 1999 (cat. 209).

Collecting is very much about seizing opportunities, and taking advantage of what comes onto the market. Family circumstances change – death, divorce or simply the need to raise money often forces private collectors to sell. Discoveries are made and finders want to profit from their good fortune. Administrative procedures bring opportunities for museums to buy – as with works of art for which export licences are being deferred or privately

excavated antiquities which fall under the recently revised 2002 Treasure Act. The difficulty for curators is that they usually have to make quick decisions and raise money fast. Museums tend to be cautious institutions, but collecting requires a nimble approach. Making acquisitions is never easy – and it was just as difficult for the National Art Collections Fund (Art Fund) to raise £45,000 to buy Velázquez's 'Rokeby Venus' (cat. 4) for the National Gallery in 1906 as it was for the National Gallery to raise £21 million in 2003 for Raphael's *Madonna of the Pinks*.

Current crisis

The most difficult challenge is to raise money for great masterpieces. This point is emphasized by the latest results of the Export Reviewing Committee, which oversees the system under which export licences for important objects are deferred to allow UK buyers to match the price offered by a foreign buyer. In 2001–02, export licences were deferred on eighteen objects, valued at £19 million. UK institutions succeeded in buying seven of these objects, but they were worth only £3.1 million. The remaining eleven items, worth nearly £16 million, went abroad.[4] In emphasizing that it was mainly the expensive items that were lost, the Export Reviewing Committee issued a stark warning. As a consequence of a lack of funding, the formal system to save masterpieces from going abroad 'has failed totally to achieve this objective' – strong words, from an official report.

Since the Export Reviewing Committee's report was published in December 2002, a series of expensive masterpieces have come onto the market. At its February 2003 meeting the Art Fund committee examining grant applications was faced with objects worth a staggering £58 million after tax remission. For these objects, it had to consider requests for grants totalling £2.6 million.[5] At this one monthly meeting alone, the Art Fund was therefore having to deal with requests for half of what it would normally allocate in an entire year.

The details of exactly what came up at February's meeting remain confidential, but the applications did include Raphael's *Madonna of the Pinks* (then valued at £29.5 million), Titian's *Venus Anadyomene* (cat. 230; £11.5 million), Reynolds' *Portrait of Omai* (£12.5 million), the 1480 helmet of Emperor Maximilian I (£1.6

fig. 17 Anonymous Roman, *Venus* ('*The Jenkins Venus*' also known as '*The Barberini Venus*'), *c*. late 1st – mid 2nd century, Greek Parian marble, height 162 cm. From Newby Hall

million) and a Babylonian plaque known as the Burney Relief (£1.5 million). Although most of these particular objects are now likely to be saved (only the helmet has already gone abroad), museums have had a major element of good fortune in trying to acquire them.

There are also a number of other expensive masterpieces coming up which museums would dearly like to acquire. First, '*The Jenkins Venus*' (fig. 17), a Roman statue from Newby Hall in North Yorkshire, which was sold at Christie's on 13 June 2002; it went for £7.9 million, the highest price ever paid at auction for an antiquity. An export licence application was recently made. The licence has been deferred until 7 October, at a price of £8.1 million, to enable a UK buyer to match the price. Secondly, a set of nineteen newly discovered Blake

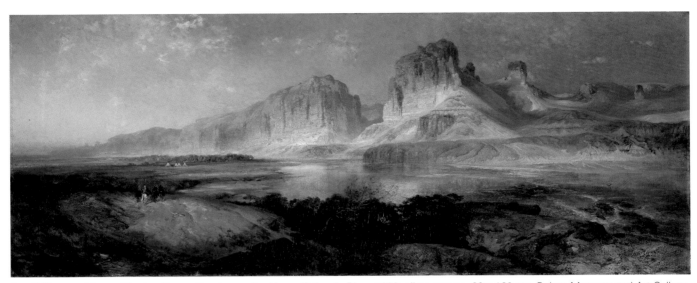

fig. 18 Thomas Moran, *Nearing Camp, Evening on the Upper Colorado River*, 1882, oil on canvas, 66 x 160 cm. Bolton Museum and Art Gallery. Art Fund assisted 1998

watercolour illustrations for Robert Blair's poem *The Grave*. Tate tried to acquire the Blakes in 2002, when it made a formal offer of £4.2 million (it still would have had to raise most of the funds, although it did have a pledge from the Art Fund). However, the watercolours were instead sold privately, apparently to an American collector, and their value is now being estimated at £6–10 million. An export licence application is expected shortly, and Tate will then probably try to match the price.[6] Finally, the Church Commissioners have announced their intention to sell the set of Zurbarán paintings of *Jacob and his Twelve Sons* from Auckland Castle. The Bowes Museum at nearby Barnard Castle hopes to acquire them, but the cost may well be around £10 million. Raising this sum would be daunting for any museum, let alone for one funded by a local authority (Durham County Council) rather than by central government.[7]

Challenge for the regions

If acquisitions are difficult for government-funded national museums, the situation is dire for regional museums, supported by local government or universities, and for independent museums. The October 2001 report *Renaissance in the Regions* dealt in considerable detail with the plight of the regional museums, and this has now led to the introduction of a system of 'hub' museums,

which receive some funds from central government. But what is noticeably missing from *Renaissance in the Regions* is any detailed consideration of acquisitions, presumably on the grounds that collecting has become a luxury. The report simply noted that in many museums, 'collecting has stopped and there are no funds for acquisitions'[8] – and said little more. Sometimes, however, regional museums are able to make major acquisitions. One example is Thomas Moran's landscape *Nearing Camp, Evening on the Upper Colorado River* (fig. 18), acquired by Bolton Museum and Art Gallery in 1998 for £1.4 million, with assistance from the Heritage Lottery Fund and the Art Fund.

One option is for regional museums to go into partnership with national museums, in order to make joint acquisitions. For instance, in 1999 Sheffield's Graves Art Gallery joined with Tate to buy Stanley Spencer's *Zacharias and Elizabeth* (cat. 210) for £1.1 million. A more recent example is William Parry's *Portrait of Omai, Sir Joseph Banks and Dr Daniel Solander* (fig. 19), which was acquired in August 2003 for £950,000 by three museums: the Captain Cook Memorial Museum in Whitby, London's National Portrait Gallery and the National Museums and Galleries of Wales. Joint purchases may make specific purchases easier, but they do not usually increase the total amounts available for acquisitions, since the participating galleries will have

less money available for other works. Such purchases also involve more complicated and burdensome arrangements over display, conservation and loans to other venues.[9]

At present there is one source of funding for acquisitions specifically for regional museums in England and Wales, the Resource/V&A Purchase Grant Fund, which distributes £1 million of government money annually – 33 per cent less than was available from this source in 1994. The National Fund for Acquisitions performs a similar function in Scotland and disburses £200,000 a year. But considering that there are 1,800 registered regional museums (with 600 larger institutions receiving over 20,000 visitors a year), these remain tiny sums.

The future

There is no easy solution to the acquisitions crisis, but perhaps I could conclude with a few personal observations:

• National museums should avoid the temptation unduly to reduce spending on acquisitions from their government grant-in-aid. In 2002–03, the National Gallery allocated nothing from its grant-in-aid for acquisitions, because financial circumstances meant it had to trim its budget. True, it does have the Getty Endowment – but would Sir Paul Getty have donated the original £50 million if he had known that his money was effectively to replace what the government had provided? The cash-strapped British Museum allocated just £100,000 for purchases, to cover all its curatorial departments. In the short term, cutting money for acquisitions seems an easy solution, but external funding organizations may hesitate to support museums that take this way out.

• Regional museums deserve the opportunity to collect. This can be difficult, particularly at a time when the government has provided only a third of the amount requested by Resource for the first phase of the 'hub' scheme. The hope must be that the government will invest enough in the second phase of the 'hub' scheme to enable the main regional museums in England to operate efficiently and develop their curatorial expertise – and that this in turn will eventually increase their potential to acquire.

fig. 19 William Parry, *Portrait of Omai, Joseph Banks and Dr David Solander, c.* 1775–76, oil on canvas, 150 x 150 cm. National Portrait Gallery, London. Art Fund assisted 2003

• Private generosity must be encouraged. At present, there are tax incentives to donate works of art after death (the Acceptance in Lieu scheme), but not during an owner's lifetime. The Art Fund and others have been pressing for tax reforms to extend Gift Aid, a 'tax-free' scheme which covers gifts of cash, land, buildings and shares, to include works of art. Similar systems in the United States, Canada, Australia and the Republic of Ireland work well. Chancellor of the Exchequer Gordon Brown is now exploring the possibility of such a move. In his Budget speech of 9 April 2003, he promised to 'review the incentives, reliefs and exemptions available to help national and regional museums make acquisitions of works of art and culture, which should not be lost to the nation but, instead, should be accessible to the people of Britain'. Then in July the Treasury set up a review under Sir Nicholas Goodison, former Chairman of the Art Fund, which will examine how the government can support national and regional museums in their efforts to acquire important works of art.[10] Tax reforms are expected to figure prominently in his recommendations.

• There should be more public debate on the criteria that should be applied when deciding on acquisitions. The Lottery and the government, for example, are

(continues on p. 50)

Sources of funding for acquisitions: a brief guide

There is no simple way of purchasing a work of art, so museums have to look to a range of sources. To take a recent example, Titian's *Venus Anadyomene* was, in March 2003, transferred from the Duke of Sutherland to the National Galleries of Scotland. Although the open-market value of the painting has not been revealed, it is believed to be around £20 million.[13] In a complicated package deal, there was a £2.4 million Acceptance in Lieu element to cover the family's tax liabilities. £11.6 million was paid in cash – £7.6 million from the Heritage Lottery Fund, £2.5 million from the Scottish Executive (government), £1 million from the National Galleries of Scotland's own resources and £500,000 from the Art Fund. Any very large acquisition, such as this, nearly always requires multiple sources of funding.

Listed below are the main sources of money and assistance for acquisitions in the UK:

Government grant-in-aid	Until 1993 the government allocated three sums of grant-in-aid to national museums: for running costs, capital costs and acquisitions. Since then, the grant has been amalgamated, leaving museums free to decide their own priorities. Acquisitions have suffered badly. Twenty years ago the five major art museums in England received £7,897,000 in grant-in-aid which was allocated for acquisitions. But in 2002–03, when they could decide what to spend, these five museums allocated just £855,000 for purchases from their government grant.[14] During this period art prices have probably tripled, which means that government grant-in-aid for acquisitions was effectively nearly thirty times higher two decades ago than it is today.
Lottery	The major development in recent years has been the establishment of the National Lottery in 1995, and specifically the Heritage Lottery Fund (HLF), which assists with acquisitions. It allocates around £10 million a year for acquisitions (about 3 per cent of its total grants), although the figure varies from year to year – and may well be higher in 2003–04 because of the £11.5 million award offered for Raphael's *Madonna of the Pinks*. In a typical year, it might give around twenty grants, ranging in value from a few thousand to several million pounds. Theoretically, the Lottery money should not replace government funding, under the principle of 'additionality'. Looking towards the future, there are concerns that Lottery income is falling and that there will be increasing pressure to spend Lottery money on more 'populist' causes.
National Heritage Memorial Fund	This was set up in 1980, but its government grant-in-aid fell from £12 million in 1993/04 to £2 million in 1998–99, and was later increased to £5 million a year. A considerable number of its grants are for museum acquisitions, but in the short term its ability to assist has been weakened by its £17.4 million grant in June 2002 to save Tyntesfield for the National Trust.
Resource/V&A Purchase Grant Fund	This fund receives government grant-in-aid through Resource, the Council for Museums, Archives and Libraries. It currently distributes £1 million a year for acquisitions by regional museums in England and Wales. A similar scheme in Scotland distributes £200,000 a year.
National Art Collections Fund (Art Fund)	An independent charity, and by far the most important non-official funder of acquisitions, last year the Art Fund provided £4.3 million to museums, in the form of 131 grants to eighty-six institutions (a further twenty-two grants went unclaimed, often because the museum was outbid at auction).

Contemporary Art Society	Also a charity, the Contemporary Art Society spends around £100,000 a year on works of art for public galleries.
Private donations of money	Donations of money from individuals, charitable trusts and companies are vital. Among the largest donations in the recent past, two should be singled out for notice: the late Sir Paul Getty gave the National Gallery a £50 million endowment in 1985 (the interest on this typically provides the gallery with several million pounds a year for acquisitions); and in March 2003 an anonymous donor pledged £12.5 million to Tate for the purchase of Reynolds' *Portrait of Omai*.
Private donations of works of art	Generous individuals have long played an important role in donating works of art, often as bequests. Some have channelled donations through the Art Fund, and probably the most generous future bequest is that promised by Sir Denis Mahon. He has lent fifty-eight seventeenth-century Italian paintings to six UK galleries. On his death they will pass into the ownership of the Art Fund, which will leave them where they are – on condition that the institutions concerned never dispose of any works of art from their collections (these pictures are probably worth over £25 million).[15] Modern British works are due to be given by Professor Sir Colin St John Wilson through the Art Fund to Pallant House, Chichester, in 2004 (see cat. 246).
Acceptance in Lieu (AIL)	This is a tax scheme that enables UK public collections to acquire works of art and archives in settlement of inheritance tax. The total value of the objects acquired was £35.1 million in 2001–02 (twenty-seven cases) and £39.9 million in 2002–03 (thirty-seven cases). The figures for both these years were exceptional because of two particular cases, furniture from Houghton Hall and Titian's *Venus Anadyomene* (cat. 230). Ultimately the burden falls on the Treasury, because AIL represents tax which is not collected.
Other sources of income for acquisitions	These include money from museum funds, friends organizations, local government, etc.

becoming increasingly keen on 'public access' – and this has caused some concern among more traditional museum curators. For instance, when in 2001 the National Gallery of Scotland applied for Lottery money to buy Michelangelo's drawing *Study for a Mourning Woman* for £5.5 million,[11] it was told that the acquisition would not be supported. Among the reasons cited was that it was a work on paper and for conservation reasons could therefore only be shown for a short period each year – not allowing the requisite public access for such an expensive item.[12] Works are normally purchased for perpetuity, and arguably a more long-term view should be applied.

• A sensitive issue that needs to be publicly addressed is whether the same efforts should be put into trying to 'save' art that would otherwise go to a foreign museum rather than a private collector. At present the government's Export Reviewing Committee treats all foreign buyers alike – whether they are individuals who are going to hide a masterpiece away or museums that will normally have it on permanent display.

• The Art Fund has an importance much greater than its financial clout. In financial terms, it normally pays out around £3 to £4 million in grants a year, but it probably offers a contribution towards over 80 per cent of museum purchases costing over £100,000. As an independent body, not dependent on government, the Art Fund is uniquely well placed to encourage museums to acquire and to help persuade other funding bodies to contribute.

Martin Bailey is a correspondent on *The Art Newspaper*. He is also the author of books on Van Gogh, Dürer and Vermeer, and most recently, *The Folio Society Book of the 100 Greatest Paintings* (2002).

Notes

1
The price to the National Gallery would be lower for tax reasons. At the time of going to press, the sum was not clear, but would probably be between £21 million and £29.5 million. The Art Fund has offered £400,000 towards both the Raphael and the Reynolds.

2
In this essay, the term 'museums' is taken to include art galleries. Although the primary focus is on works of art (defined widely to include antiquities and decorative art), the situation for other museum artefacts, such as historical and scientific objects, is very similar (some statistical data cited also includes non-art museum acquisitions). Many figures are rounded to the nearest £100,000.

3
There are a few museums that are legally unable to make acquisitions or for which it would usually be inappropriate (such as London's Wallace Collection and Sir John Soane's Museum).

4
Strictly speaking, licences on thirty-one objects were deferred, but of these, fourteen were individual photographs by Lewis Carroll – for simplicity, I have counted these photographs as a single item. See *Export of Works of Art 2001-02*, Department for Culture, Media and Sport, 2002, pp. 17 and 21.

5
Art Quarterly, Spring 2003, pp. 5 and 17.

6
The Art Newspaper, May 2003, p. 42.

7
The Art Newspaper, September 2001, p. 1. The situation has not changed significantly since this article.

8
Renaissance in the Regions, Resource, 2001, p. 11.

9
There has also been one example of an international acquisition – by Tate, the Pompidou Centre in Paris and New York's Whitney Museum. The 2002 arrangement involved Bill Viola's *Five Angels*. This is appropriate for a video-based work, which museums may only want to show for limited periods, but not necessarily for other works of art.

10
Goodison Review: Saving Art for the Nation, Treasury, 2003. The consultation period ended on 1 October and Sir Nicholas's report is expected to be completed in November 2003.

11
The price at which it was originally offered was £7.5 million, but with tax advantages the costs to the gallery would have been £5.5 million. It ultimately sold at Sothebys on 11 July for £6 million.

12
The Art Newspaper, June 2001, p. 71.

13
The Art Newspaper, February 2003, p. 5.

14
The Art Newspaper, July 2002, p. 16. The sums allocated from grant-in-aid by the five institutions were: National Gallery (£0), Tate (£0, although £1.7 million was spent from trading income), British Museum (£100,000), Victoria and Albert Museum (£450,000) and National Portrait Gallery (£305,000).

15
This valuation was given in *The Art Newspaper*, December 1996, p. 10.

cat. 93
Diego Velázquez, *An Old Woman Cooking Eggs*, 1618 (detail)

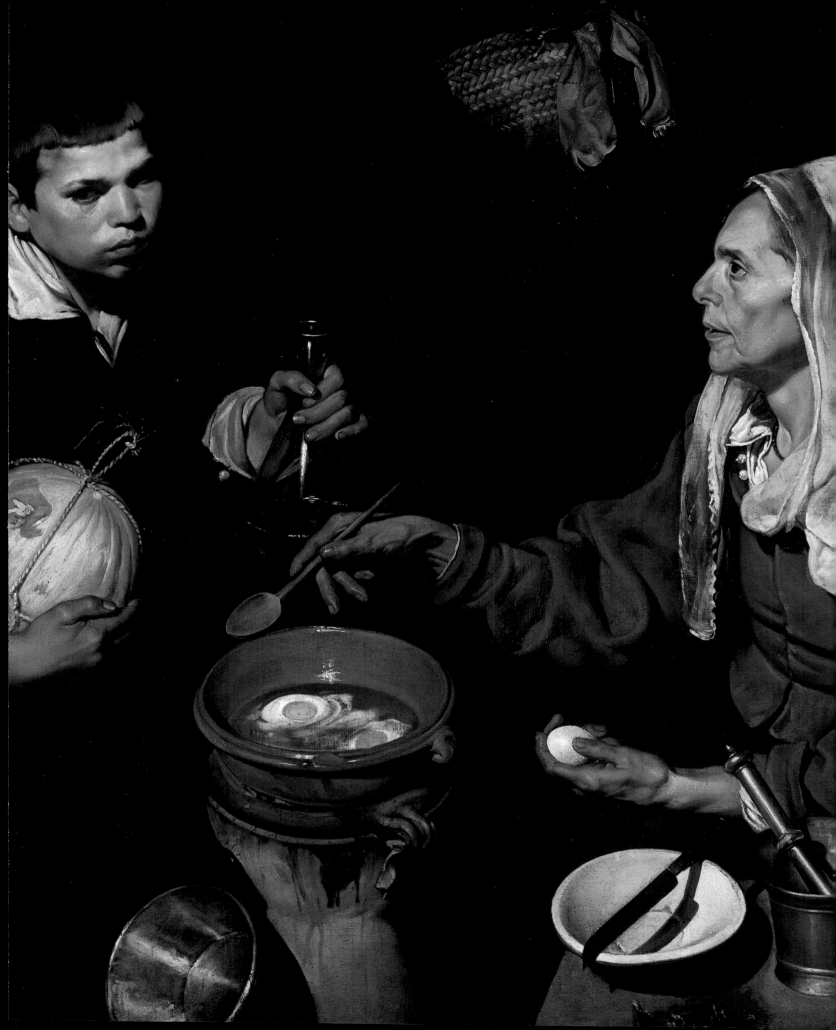

Biographies

Christiana Herringham
(1852–1929) was one of the
four founders of the National
Art Collections Fund. She was
the daughter of Thomas Wilde
Powell, an art collector and
stockbroker, and his wife Mary
Elizabeth. In 1880 she married
the physician Wilmot (later
Sir Wilmot) Herringham, who
shared her enthusiasm for art. An artist and copyist, she
was particularly interested in tempera painting, and in
1899 she translated Cennino Cennini's treatise (c. 1390)
on the painter's craft as *The Book of the Art of Cennino
Cennini*. In 1901 she became a founding member of
the Society of Painters in Tempera. Nine years later
she was involved in the formation of the India Society
with the artist William Rothenstein (see cat. 79, 80), and
subsequently she made several visits to India to copy
the Buddhist wall paintings in the caves at Ajanta.

Herringham received a substantial inheritance from
her father. In 1903 this enabled her to respond to D.S.
MacColl's call for a society dedicated to saving works of
art for the nation by offering to give £200 to cover the
initial expenses of setting it up. She served on the fund's
Executive Committee until 1914, and was instrumental
in initiating the original framework for its policies and
working procedures, believing strongly that membership
should be accessible to as many people as possible. She
also suggested the fund's name.

The fund benefited greatly from her family connec-
tions: Robert Witt, its second Chairman, was a cousin
by marriage, and Christiana's sisters, Agnes Dixon,
Eleanor Powell and Theodora Powell, were all early
members. Theodora contributed to the appeals and left
a large legacy of £1,000 to the fund in 1920. In 1929,
the year of her death, both Christiana's brothers, Herbert
A. Powell and Charles Marten Powell, continued the
family tradition, the first donating his important collection
of 130 British watercolours to the nation through the
Art Fund, and the second leaving a bequest of etchings,
which went to Somerville College, Oxford.

**Dugald Sutherland ('Suthie')
MacColl** (1859–1948) was one
of the four founders of the
National Art Collections Fund,
and was born in Glasgow, son
of the Reverend Dugald and
Janet MacColl. He read classics
at Oxford and initially intended
to enter the Church or academic
life, but then decided to study
art at Westminster School of Art. In 1894 he collaborated
on the book *Greek Vase Paintings* with the renowned
scholar Jane Harrison (who later joined the Art Fund
Council). MacColl joined the New English Art Club
in 1896, remaining a member all his life; fourteen of
his works have been presented through the Art Fund
to galleries in Britain, including the Tate and the Cooper
Art Gallery, Barnsley.

Although he was an accomplished painter, MacColl is
best known as an outspoken critic, controversialist and
indefatigable champion of contemporary British and
foreign art. He was highly critical of the Royal Academy's
administration of the Chantrey Bequest which had been
set up to buy significant contemporary works, but was
acquiring mediocre examples, mainly by members of
the Royal Academy. He was also very concerned about
the exodus of great works of art from Britain, and in
an article in the *Saturday Review* in 1900 called for the
establishment of a society to help secure them for the
nation. It was not until three years later that the vision
became reality when Christiana Herringham offered
to donate £200 towards the formation of the National
Art Collections Fund. MacColl remained on the
Executive and Pictures ('A') Committees of the fund
until 1929, when he became Vice-Chairman. As a result

of his suggestion that the fund buy a sculpture by Rodin, *The Burghers of Calais* (cat. 11) was purchased and presented to the nation in 1914.

MacColl was Keeper of the Tate Gallery (1906–11), Keeper of the Wallace Collection (1911–24), and was on the Committee of the Contemporary Art Society (1910–13), which he co-founded. He was also on the editorial board of *The Burlington Magazine* (1905–36). His many books include *Confessions of a Keeper* (1931).

Roger Fry (1866–1934), who was one of the four founders of the National Art Collections Fund and served on the Committee from 1903 to 1906, came from a notable Quaker family. He read natural sciences at King's College, Cambridge, but by the time he graduated in 1888 he was already turning to art as his main interest. His training as a painter included a brief period at the Académie Julian, Paris, in 1892. He continued to paint throughout his life, and eight of his pictures have entered public collections through the fund. He was a member of the New English Art Club, part of the Bloomsbury Group, and the founder in 1913 of the Omega Workshops, applying Cubist and Fauvist ideas to the decorative arts.

Fry is best remembered for his ideas on aesthetics, and especially for the importance he attached to the 'formal' properties of a work of art. He was initially a Renaissance scholar, publishing a book on Giovanni Bellini in 1899, and he also wrote for *Pilot, Monthly Review* and the *Athenaeum*, for which he was art critic from 1901 to 1906. In 1903 he co-founded *The Burlington Magazine* with C.J. Holmes, Sidney Colvin, Herbert Cook, Campbell Dodgson, Sir Claude Phillips, Bernard Berenson and Herbert Horne, and he was co-editor from 1909 until 1919. In 1906 he became Curator of Paintings at the Metropolitan Museum of Art, New York, buying mainly Italian Renaissance art from Europe and also advising such collectors as J.P. Morgan and John J. Johnson.

On his return to England in 1910 Fry turned his attentions to modern foreign art, organizing two famous exhibitions of the Post-Impressionists (a term he coined) at the Grafton Galleries in London in 1910 and 1912. In 1910 he co-founded the Contemporary Art Society with MacColl, Holmes and Sir Philip and Lady Ottoline Morrell, among others, and remained on its committee until his death. In 1911 he was involved in organizing the first exhibition of Old Masters at the Grafton Galleries in aid of the fund. He became Slade Professor of Fine Art at Cambridge in 1933. His writings include collections of essays entitled *Vision and Design* (1920), and *Transformations* (1926).

Sir Claude Phillips (1847–1924), one of the four founders of the National Art Collections Fund, was educated mainly in France and Germany. He trained as a solicitor and then as a barrister, but his main interest was in art, on which he began writing articles in the 1880s. In 1897 his career took an artistic turn when he became the art critic for his uncle's newspaper, the *Daily Telegraph* (a job he retained until his death), and in the same year he was appointed first Keeper of the Wallace Collection, a post he held until 1911.

It was Phillips who, shortly after the first meeting of the fund in June 1903, invited Lord Balcarres to become its Chairman. He remained on the Executive Committee until 1906 and was nominated the 'buyer' of paintings and works on paper for the Pictures ('A') Committee. In addition to publishing several books, he wrote widely on art matters in the *Manchester Guardian, Gazette des Beaux-Arts, Magazine of Art, Art Journal, Fortnightly Review* and *Nineteenth Century*, and responded enthusiastically to contemporary art of the period as well as to Old Masters. For example, he wrote with insight on the work of Rodin, Cézanne, Van Gogh, Matisse and Sickert. Phillips bequeathed half his fortune and half his paintings to the National Gallery, London, and the residue to other museums in the UK.

David Alexander Lindsay, 27th Earl of Crawford and 10th Earl of Balcarres (1871–1940) was the first Chairman of the National Art Collections Fund. His family had made its fortune in the coal and steel industry (he was Chairman of its firm Wigan Coal & Iron Co until it was rationalized in the 1930s). Over several generations the Lindsays had amassed a magnificent collection of books and art; the Duccio *Crucifixion* now in Manchester (cat. 146) came from the family collection. In 1895 Lindsay became a Conservative MP for the Chorley Division of Lancashire, and in 1903 he became Junior Lord of the Treasury. In the same year he published a book on Donatello and was invited to become Chairman of the fund. In this role he lobbied the government to exempt bequests to the Art Fund from death duties.

Lindsay was particularly interested in the display of works of art and was influential in modernizing the South Kensington Museum, which became the Victoria and Albert Museum, and later in the reorganization of rooms at the British Museum.

After serving as First Commissioner of Works (H.M. Office of Works) for the government (1921–22), Lindsay left active politics. He became a trustee of the National Portrait Gallery, National Gallery, British Museum and Royal Fine Art Commission; President of the Society of Antiquities; Chairman of the Council for the Preservation of Rural England and of the Royal Commission on Historical Manuscripts; and Chancellor of Manchester University.

Sir Isidore Spielmann (1854–1925) was the son of a Polish immigrant. His brother Marion was the editor of the *Magazine of Art*. Spielmann worked as a civil engineer and then as a stockbroker, but retired early to devote more time to art, British art in particular. He was Director for Art, Board of Trade (Exhibitions Branch), and a Commissioner for several of the International Exhibitions that flourished at this time: Brussels 1897 and 1910; Paris 1900; Glasgow 1901; St Louis 1904; and Turin and Rome 1911. He was also a member of the Advisory Council for the Victoria and Albert Museum, and was knighted in 1905.

When Spielmann learnt about the formation of the National Art Collections Fund, he offered his services immediately, becoming the joint Honorary Secretary with Robert Witt in the fund's founding year. The fund used his offices at 47 Victoria Street, London, until its move to Hertford House (home of the Wallace Collection) in 1919, and he played a vital role in the recruitment of members and in helping to raise money for the fund's two major early public appeals – to save Velázquez's *'Rokeby Venus'* (cat. 4) and Holbein's *Christina of Denmark* (fig. 23). He remained on the Executive Committee and the Other Works of Art ('B') Committee until his death.

Sir Robert Witt (1872–1952) read history at New College, Oxford, and had a lifelong interest in the Italian Renaissance. He qualified as a solicitor in 1897 and married Mary Marten, Christiana Herringham's cousin, in 1899. As students at Oxford they had each separately collected photographs and reproductions of works of art, and after their marriage their joint collection grew into the vast Witt Library, the world's largest archive of illustrations of paintings and drawings. This was bequeathed to the Courtauld Institute of Art, which Witt co-founded with Samuel Courtauld and Lord Lee of Fareham in 1931.

In 1903 Witt became Joint Honorary Secretary of the National Art Collections Fund with Isidore Spielmann, and remained an active force in the fund for the rest of his life. He became its second Chairman in 1921, and steered it through the difficult years of the Second World War until 1945, when he became the first President of the Art Fund's Council. That same year the Robert Witt Fund was set up to purchase and donate works in his honour.

Witt was a trustee of the National Gallery (1916–23, 1924–31 and 1933–40) and became its Chairman in 1930. He gave several works of art through the fund to public collections, including Augustus John's *Robin* and William Orpen's *Model in the Studio* to the Tate Gallery, and Hoogstraten's *Peepshow* to the National Gallery. He was an advocate of greater state funding for art and, although he devoted a large part of his life to two metropolitan institutions, he believed strongly that great art should be accessible to the public outside the capital and other large cities.

Witt made no claims as a writer, but his book *How to Look at Pictures* (1903) was well received and was reprinted several times.

Sir Charles Holmes (1868–1936), artist and writer, studied at Oxford before entering the family printing firm of Rivingtons. He then worked at the Vale Press, one of the outstanding private presses of the day, through which he came into contact with several artists, notably Charles Ricketts, Charles Shannon, William Strang and D.Y. Cameron. In 1903 he co-founded *The Burlington Magazine*, of which he was joint editor with Robert Dell until 1909, and in 1910 he joined forces with Roger Fry to establish the Contemporary Art Society. He joined the Executive Committee of the National Art Collections Fund in 1906.

Holmes was Slade Professor of Fine Art at Oxford from 1904 to 1910. He became Director of the National Portrait Gallery in 1909 and then was Director of the National Gallery from 1916 to 1928, where he promoted the purchase of Dutch and French nineteenth-century paintings. He was a prolific writer on art, publishing monographs and art manuals as well as catalogues for the National Gallery and an amusing anecdotal auto-biography, *Self and Partners (Mostly Self): The Reminiscences of C.J. Holmes* (1936).

Throughout his career Holmes painted, concentrating mainly on landscapes. Examples of his work were given

to public collections by Sir Michael Sadler through the fund in 1931 and 1933.

Sir Sidney Colvin (1845–1927), artist, writer and connoisseur, wrote for the *Pall Mall Gazette*, *The Fortnightly Review*, *Portfolio*, *Cornhill Magazine* and *Nineteenth Century* before becoming Slade Professor of Fine Art at Cambridge in 1873. He held this post concurrently with that of Director of the Fitzwilliam Museum (1876–84), then was Keeper of Prints and Drawings at the British Museum from 1884 to 1912.

Colvin joined the Executive Committee of the National Art Collections Fund at its inception, playing an active administrative role, supporting major appeals and lobbying the Treasury. He was given the responsibility of buying works on paper for the Pictures ('A') Committee, which first met at the British Museum on 15 December 1903. He was also part of a sub-committee of the fund set up in 1906 at the suggestion of Mrs Arthur Strong (*née* Eugenie Sellars, an Executive Committee member) to look into the registration of works of art, and was the first witness before the Curzon Committee's 1911–15 enquiry into the retention of important pictures in this country.

Kenneth Clark, Baron Clark of Saltwood (1903–83) was part of the National Art Collections Fund's Pictures ('A') Committee from 1931 to 1938, and was on the Executive Committee from 1946 until 1972. In a glittering career he was Keeper of Fine Art at the Ashmolean Museum, Oxford (1931–33), Director of the National Gallery, London (1934–45), Surveyor of the King's Pictures (1934–44), Chairman of the Arts Council (1953–60), and the first Chairman of the Independent Television Authority

(1954–57). His many books include *Leonardo da Vinci* (1939), *Landscape into Art* (1949), *Piero della Francesca* (1951), *The Nude* (1956) and *Looking at Pictures* (1960), and he became a worldwide celebrity with his television series *Civilisation* (1969).

Although he wrote mainly on the Old Masters, Clark was an important patron of contemporary art (using his inherited wealth) and he also collected Chinese and African antiquities. It was while he was Keeper at the Ashmolean Museum that he acquired Piero di Cosimo's *Forest Fire* (cat. 45), which he initially bought himself to save it from being taken abroad by the dealer Duveen. While he was Director of the National Gallery he acquired seven pictures by Sassetta from Duveen, bringing them back from America with the aid of a grant from the fund.

Anthony Blunt (1907–83) served on the National Art Collections Fund's Pictures ('A') Committee from 1944 until it was abolished in 1955, and on the Executive Committee from 1944 to 1979. He spent his childhood in France (his father was chaplain at the British Embassy in Paris), but was educated in England and became a fellow of Trinity College, Cambridge, in 1932. In the 1930s he wrote a good deal of journalism on modern art (mainly for the *Spectator*), but after the Second World War he concentrated on Renaissance and Baroque art and architecture. In 1945 he succeeded Kenneth Clark as Surveyor of the King's Pictures, a post he retained until 1972, despite confessing to the authorities in 1964 that he had spied for the Soviet Union.

From 1947 to 1974 Blunt was Director of the Courtauld Institute of Art. A distinguished scholar, he was noted especially for his work on seventeenth-century French art, his books including *Art and Architecture in France: 1500–1700* (1953), and a magisterial three-volume monograph on Poussin (1966–67). During his time on the Committee a greater emphasis was given to supporting seventeenth-century paintings; in 1945, for example, the National Gallery acquired Poussin's *Adoration of the Golden Calf* (on which Blunt published a short book in 1951). In 1948 Blunt joined the Fine Art Committee of the British Council, and in the same year he became the first picture adviser to the National Trust. He resigned from the Art Fund Executive Committee in 1979 following his sensational exposure as a Soviet agent.

David Robert Alexander Lindsay, 28th Earl of Crawford and 11th Earl of Balcarres (1900–75) followed in his father's footsteps as Chairman of the National Art Collections Fund, a post he held from 1945 to 1970 (he had served on the Executive Committee as Lord Balniel since 1931, before inheriting his father's title in 1940). He played a prominent role in the successful nationwide appeal organized by the fund in the spring and summer of 1962 to save the Leonardo Cartoon *The Virgin and Child with Saint Anne and Saint John the Baptist* (fig. 31), which was being sold by the Royal Academy for £800,000.

He was Conservative MP for Lancashire from 1924 to 1940 before moving to the House of Lords. He was a keen supporter of public patronage of art institutions, and was a trustee of the Tate Gallery (1932–41), the National Gallery (intermittently 1935–60), the British Museum (1940–73), and the National Galleries of Scotland (1947–74), Chairman 1952–72; he was also Chairman of the National Library of Scotland (1944–74), the Pilgrim Trust (1949–75) and the National Trust (1945–65).

Crawford was on the Waverley Committee on the Export of Works of Art, which in 1952 produced a report that laid down the criteria for new export regulations and which has existed largely unchanged ever since. He was also involved with the Finance Act of 1956, which established the principle of acceptance of works of art in lieu of death duties. The *Fluorspar Drinking Cup* (cat. 115) was presented to the British Museum in 1971 in commemoration of his twenty-five years of service as Chairman of the fund, and in 1976, the year after his death, the *'Chellini Madonna'* by Donatello (cat. 125) was presented to the Victoria and Albert Museum in his memory.

Ernest Edward Cook
(1865–1955), who is remembered for his generous bequest, was the grandson of Thomas Cook, who founded the travel agency in 1841. Ernest developed the banking side of the agency and consolidated his fortune when the company was sold in 1928, after which he retired to the country.

Cook set up many charitable trusts and was a great benefactor to the National Trust, contributing £100,000 to their funds; in 1931 he presented Montacute House and the Bath Assembly Rooms to the Trust. Between 1929 and 1939 he built up a large collection of paintings, acquired almost exclusively from the dealers Gooden & Fox, for his mansion at 1 Sion Hill Place, Bath. He bequeathed the entire contents of his home to the National Art Collections Fund, specifying that the works of art were to be distributed throughout England to provincial museums and galleries. Over 150 pictures, as well as Beauvais and Mortlake tapestries, Chippendale and other English furniture, porcelain and silver, were distributed by the fund to nearly one hundred locations across the UK (see cat. 84–89).

Francis Denis ('Peter') Lycett Green (1893–1959) was the grandson of a Yorkshireman who had made his money in engineering. He inherited two paintings from his father and, despite his limited means, began to acquire more during the Second World War, some of which he gave to the National Gallery.

In 1937 Lycett Green suggested donating his collection through the National Art Collections Fund to Wakefield, York or another suitable provincial or Commonwealth gallery. However, he had a change of heart and in 1947 emigrated to Cape Town, taking his collection with him. In South Africa he lent the majority of his paintings to the National Gallery, Cape Town, but he was upset to find that most of them were kept in storage, and in 1954 he decided to revert to his original plan and moved his pictures back to England. On 8 March 1955 he presented 120 Old Master paintings, ranging as he said 'from Giotto to Watteau', to York Art Gallery, adding seven more later that year and another six in 1957 (see cat. 90–92). The collection includes works of the main schools and periods of European painting from the fourteenth to the early nineteenth century, and is notable for featuring examples by many interesting but little-known artists who are otherwise poorly represented in British galleries.

© Derry Moore 2003

Sir Brinsley Ford (1908–99), the heir to a fine collection of art, began his own collecting while at Oxford. He first bought modern sculpture by Eric Gill, Henri Gaudier-Brzeska and Frank Dobson, but his taste expanded to include the Baroque, and eighteenth-century British art. In 1937 he was a founding member of the Georgian Group, and in 1952 he joined the Society of Dilettanti, becoming its joint secretary in 1972 and sole secretary from 1978 to 1988. He was a director of *The Burlington Magazine* from 1964 to 1972.

Sir Brinsley, who became a member of the National Art Collections Fund in 1927, was invited to join the Executive Committee in 1960; he became the Vice-Chairman in 1973, and Chairman in 1975, holding the post until 1980. He was bitterly opposed to the break-up of old collections, and it was under his chairmanship that the Art Fund's charter was amended to empower it to make grants to the National Trust and the National Trust for Scotland in order to ensure that works of art in their properties, but still in the ownership of the original family, could be bought where necessary and thus remain *in situ*.

In 1987 Sir Brinsley became Chairman of the National Trust Foundation for Art. He was also the Chairman of the Watts Gallery at Compton, Surrey, a post previously held by Robert Witt, and he left a bequest of seventy-five drawings by Watts to the gallery through the fund.

In 1998 a substantial grant was given towards the acquisition of Hugh Douglas Hamilton's pastel *Antonio Canova in his Studio with Henry Tresham* (cat. 202) by the Victoria and Albert Museum on the occasion of Sir Brinsley's 90th birthday, and in 2002 the fund presented *The Calling of St Matthew* by Giandomenico Tiepolo to the British Museum in his memory.

Francis Haskell (1928–2000) joined the National Art Collections Fund Committee in 1976, and was a lively and outspoken contributor to its discussions, vigorously defending his view that the fund should concentrate its resources on objects of the highest quality. Most notably he supported the Fitzwilliam Museum's application to the fund for a grant for Poussin's *Rebecca and Eliezar* after the government had refused to accept the work in lieu of tax because it had been owned by the disgraced Anthony Blunt, arguing that it was a fine painting and entirely suitable for the Fitzwilliam. A member of the Export Reviewing Committee, he was strongly committed to keeping the best works of art in Britain.

Haskell read history at King's College, Cambridge, becoming a Fellow there in 1954. He was subsequently Professor of Art History at Oxford from 1967 until his retirement in 1995. His publications, with their emphasis on the social context of art, proved groundbreaking and inspirational. His first book, *Patrons and Painters* (1963), studied the relationship between art and society in Baroque Italy. Other highly acclaimed works include *Rediscoveries in Art: Some Aspects of Taste, Fashion and Collecting in England and France* (1976), *Taste and the Antique: The Lure of Classical Sculpture, 1500–1900* (1981) (written with Nicholas Penny), *History and its Images: Art and the Interpretation of the Past* (1993) and *The Ephemeral Museum* (2000). Haskell was a Visitor (trustee) of the Ashmolean Museum, Oxford, from 1967 to 1995, a trustee of the Wallace Collection from 1976 to 1997, and a director of *The Burlington Magazine*, from 1972 to 2000.

Sir Nicholas Goodison (b. 1934) was elected to the National Art Collections Fund Committee in 1976 (the same year that he became Chairman of the London Stock Exchange), and became Chairman of the fund in 1986. He brought to the fund both his business acumen and an extensive knowledge of English fine and decorative art. His publications include two books, *English Barometers 1680–1860* (1968, revised 1977) and *Matthew Boulton: Ormolu* (1974, revised 2002). Sir Nicholas has been a keen supporter of Soho House, the museum housed in Boulton's former home.

During his Chairmanship the fund's membership grew strongly and the amount of money given to museums and galleries multiplied. He played an important role in the purchase of Millais House in 1992, which provided the fund with its own headquarters for the first time. He also presided over a more active political programme. This included the Art Fund's lead role in the campaign to free museums from the burden of VAT, which cleared the way for the restoration of free admission at all national museums in 2001.

Sir Nicholas has been Chairman of the TSB Group, Deputy Chairman of Lloyds TSB and British Steel, Chairman of the Courtauld Institute of Art, Deputy Chairman of the English National Opera, Chairman of *The Burlington Magazine* and the Crafts Council, and President of the Furniture History Society. He and his wife Judith share an enthusiasm for contemporary craft and have made a series of gifts of ceramics, glass and furniture through the fund to the Fitzwilliam Museum (see cat. 198), where he is Honorary Keeper of Furniture.

cat. 111
Rembrandt van Rijn, *Belshazzar's Feast, c.* 1636 (detail)

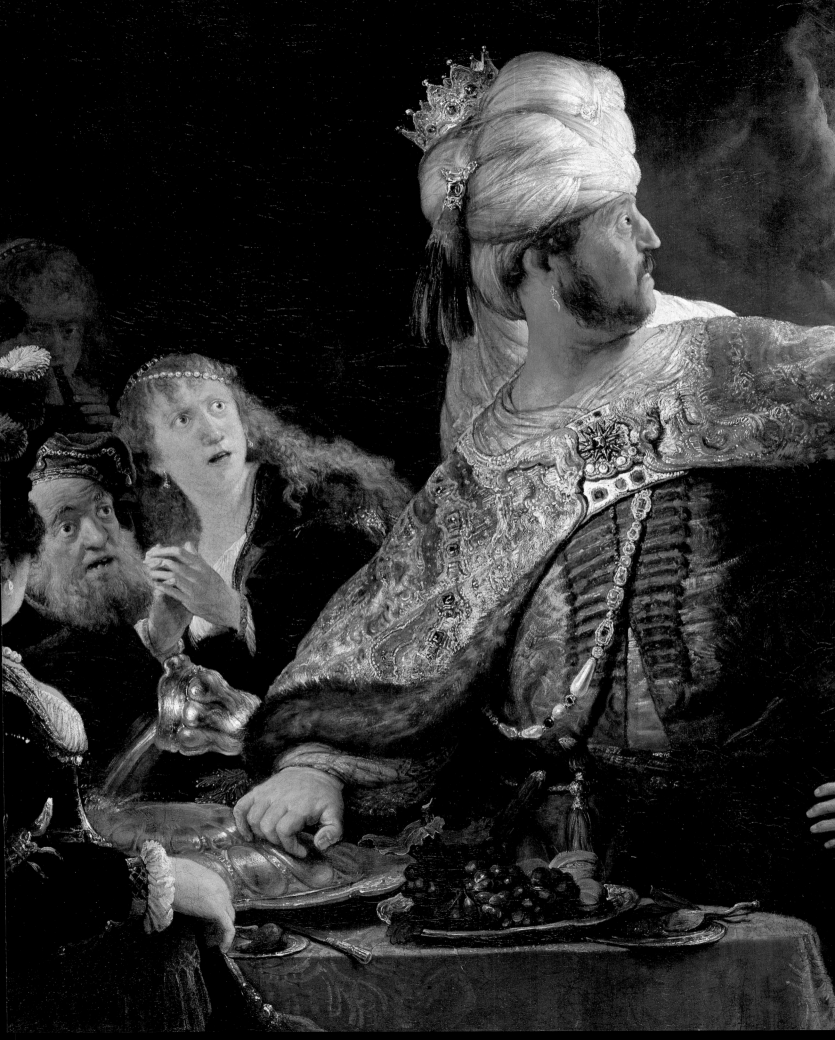

Chronology

1903

- National Art Collections Fund (Art Fund) founded by Christiana Herringham, D.S. MacColl, Roger Fry and Claude Phillips. First General Meeting, 11 November 1903; 308 members and £700 accrued. Earl of Balcarres (later 27th Lord Crawford) elected Chairman
- *The Burlington Magazine* founded

1904

- First acquisition made through the Art Fund: Max Rosenheim gives eighteenth-century watch by Daniel Quare (cat. 1) to the British Museum
- Art Fund gives first grant towards a *Fête Champêtre*, attributed at the time to Watteau (now to Pierre Antoine Quillard), for the National Gallery of Ireland, Dublin

1905

- Art Fund membership is 551
- Whistler's *Nocturne: Blue and Gold – Old Battersea Bridge* (cat. 3) presented by the Art Fund to the National Gallery of British Art (now Tate)

1906

- Velázquez's *'Rokeby Venus'* (cat. 4) bought by the Art Fund after a public appeal and presented to the National Gallery
- Edward VII becomes Patron of the Art Fund
- Boudin's *Entrance to Trouville Harbour* presented to the Art Fund for the National Gallery by Frank Rutter on behalf of the French Impressionist Fund (now on long loan to York Art Gallery)

1909

- 'People's Budget' raises death duties, increases income tax, introduces supertax and taxes land values, which adversely affects landed gentry and aristocracy, traditionally the owners of works of art

- Holbein's *Christina of Denmark* (fig. 23) bought by the Art Fund after a public appeal and presented to the National Gallery
- Henry van den Bergh presents 250 pieces of ancient Peruvian pottery (see cat. 6) to the British Museum through the Art Fund

1910

- Contemporary Art Society founded
- Roger Fry organizes *Manet and the Post-Impressionists* at the Grafton Galleries, London
- Finance Act exempts bequests to national collections and to the Art Fund from death duties, partly as a result of lobbying by Lord Crawford
- Art Fund membership is 1,178. Members privilege of special private views of exhibitions and collections initiated
- 147 Chinese paintings collected by Olga-Julia Wegener acquired by the British Museum with Art Fund assistance

1911

- Treasury refuses to give a grant to the National Gallery for the purchase of *The Mill* by Rembrandt (fig. 8), which goes instead to an American collector for £100,000 (now in the National Gallery of Art, Washington)
- Roger Fry helps organize the first exhibition in aid of the Art Fund held at the Grafton Galleries
- Gossaert's *Adoration of the Kings* purchased for the National Gallery with a contribution from the Art Fund
- Bronze *Head of Augustus, Emperor of Rome* (*'The Meroë Head'*) (cat. 7), excavated at Meroë, in Sudan, presented by the Art Fund to the British Museum

1912

- Roger Fry organizes the second Post-Impressionist exhibition, *The French Post-Impressionists*, at the Grafton Galleries

1913
- Auguste Rodin visits London to establish a location for *The Burghers of Calais* (cat. 11), which has been bought by the Art Fund; he attends the Art Fund's AGM on its tenth anniversary
- *Seated Luohan* (*Disciple of Buddha*) (cat. 9) presented to the British Museum by the Art Fund

1914
- *'The Rokeby Venus'* slashed by suffragist Mary Richardson in protest at the arrest of Emmeline Pankhurst
- Art Fund membership is 1,651, with three times as many members as the National Trust

1915
- Curzon Committee (set up in 1911) reports on its enquiries into matters relating to the nation's art collections. It recommends that the Tate Gallery becomes the National Gallery of British Art and that it should also house a collection of modern foreign art

1916
- Masaccio's *Virgin and Child* (fig. 11) acquired by the National Gallery with the help of the Art Fund

1918
- Last letter of Mary Queen of Scots (cat. 14) presented to the National Library of Scotland through the Art Fund
- Art Fund buys Degas' *Princess Pauline de Metternich* at the first Degas studio sale and presents it to the Tate Gallery (now in the National Gallery)

1919
- Members of the Art Fund admitted free to the National Gallery, Tate Gallery, National Portrait Gallery and Wallace Collection on paying days
- William Blake's 102 watercolour illustrations to Dante's *Divine Comedy* acquired by a group of public galleries and museums with the assistance of the Art Fund

1920
- Transfer of a number of British pictures from the National Gallery to the Tate Gallery
- Art Fund membership is 2,237

1921
- Finance Act enacts that sales to the National Gallery, British Museum and other similar institutions, including the Art Fund, should be exempt from all death duties
- Gainsborough's *Jonathan Buttall: The Blue Boy* (fig. 7) sold to the American collector Henry Edwards Huntington for £182,200. It was exhibited at the National Gallery before its export and seen by 90,000 visitors in three weeks
- Lord Crawford retires as Chairman; he is succeeded by Sir Robert Witt
- Bruegel's *Adoration of the Magi* (cat. 20) secured for the National Gallery with a contribution from the Art Fund
- John Everett Millais's *Christ in the House of His Parents* (*'The Carpenter's Shop'*) (cat. 19) bought by the Tate Gallery with the assistance of the Art Fund

1922
- Art Fund membership is 3,028, almost twice that of 1914
- Members granted free admission to the Ashmolean Museum, Oxford

1923
- Samuel van Hoogstraten's peepshow cabinet presented to the National Gallery by Sir Robert and Lady Witt through the Art Fund

1924
- Art Fund celebrates its twenty-first birthday; Ramsay MacDonald, Prime Minister, speaks at AGM
- Tintoretto's *Portrait of Vincenzo Morosini* presented to the National Gallery by the Art Fund in celebration of the gallery's centenary and the Art Fund's twenty-first birthday

1925

- Sir Joseph Duveen presents Sargent's *Study of Madame Gautreau* (cat. 29) and Augustus John's *Madame Suggia* to the Tate Gallery through the Art Fund (the latter is now on long loan to the National Museum of Wales, Cardiff)

1926

- Paintings by Courbet, Monet and Corot presented to the Tate Gallery by the Art Fund to celebrate the opening of the Modern Foreign Gallery

1927

- Sir Robert Witt gives a radio talk on the work of the Art Fund
- Art Fund membership increases by 2,000 in the year, bringing total to 6,674

1928

- Art Fund celebrates its twenty-fifth anniversary; receives Royal Charter of Incorporation

1929

- Christiana Herringham, a founder of the Art Fund, dies
- *The Luttrell Psalter* (cat. 38) bought by the British Museum (now in the British Library) with the assistance of the Art Fund
- Wilton Diptych and Titian's *Vendramin Family* bought by the National Gallery with the assistance of the Art Fund. Pesellino's *Trinity with Saints* presented to the National Gallery through the Art Fund by Sir Joseph Duveen

1930

- Pilgrim Trust founded in the US 'to promote the UK's wellbeing', which includes the promotion of scholarship within museums, galleries, libraries and archives by means of grants made through charitable or public organizations
- Art Fund's official seal (two men carrying a bunch of grapes) designed by Eric Gill. First Art Fund advertisements appear in the London Underground with the slogan 'All Art Lovers Should Join'

- Art Fund membership peaks at 12,500 – a figure not regained until the 1980s
- Antonio Canova's *Sleeping Nymph* presented by the Art Fund to the Victoria and Albert Museum
- Dürer's *Portrait of a Peasant Woman* (cat. 39) acquired by the British Museum with the assistance of the Art Fund

1931

- *The Great Bed of Ware* acquired by the Victoria and Albert Museum through an appeal and with the help of the Art Fund
- Sir Michael Sadler presents a large collection of paintings and watercolours for distribution to museums and galleries through the Art Fund

1932

- Art Fund presents *Holy Family with the Infant St John*, attributed at the time to Fra Bartolomeo (now to Pierino del Vaga), to the recently founded Courtauld Institute as an inauguration present
- Collection of Jewish antiquities and ritual art (see cat. 43) presented by the Art Fund to the newly founded Jewish Museum in London

1933

- Edward, Prince of Wales, a member of the Art Fund, speaks at the AGM
- Piero de Cosimo's *Forest Fire* (cat. 45) acquired by the Ashmolean Museum, Oxford, with the assistance of the Art Fund

1935

- Overseas Loan Bill permits the loan of British works from the National Gallery and Tate Gallery to exhibitions overseas
- George Eumorfopoulos's collection of oriental art acquired jointly by the British Museum and Victoria and Albert Museum with the assistance of the Art Fund (see cat. 50)
- *The Heneage 'Armada' Jewel* (cat. 49) presented as a gift to the Victoria and Albert Museum by the Art Fund

cat. 136
Joos van Cleve, *Virgin and Child with Angels, c.*1520–25 (detail)

1938

- Rembrandt's *Saskia van Uylenburgh in Arcadian Costume* acquired by the National Gallery with the assistance of the Art Fund

1942

- *The Drake Cup* (cat. 61) purchased by the Art Fund and presented to the City of Plymouth in recognition of the fortitude of its citizens during enemy air-raids

1945

- Sir Robert Witt retires as Chairman of the Art Fund and becomes first President. The Robert Witt Fund, established in his honour, acquires Reynolds's *The Thames from Richmond Hill* for the National Gallery (now at Tate). The 28th Earl of Crawford becomes Chairman, following in the footsteps of his father, the Art Fund's first Chairman
- Dante Gabriel Rossetti's *Venus Verticordia* acquired by Russell-Cotes Art Gallery, Bournemouth, with a contribution from the Art Fund
- Nicolas Poussin's *Adoration of the Golden Calf* purchased by the National Gallery with a contribution from the Art Fund

1946

- Arts Council of Great Britain founded

1952

- Publication of Waverley Committee Report laying down the criteria by which any application to export a work of art is to be judged. Lord Crawford serves on the first Committee

1953

- Art Fund's fiftieth anniversary: Queen Elizabeth, the Queen Mother, attends AGM; publication of *Art Treasures for the Nation: 50 Years of the National Art-Collections Fund*
- Rodin's *Kiss* (fig. 27) acquired by the Tate Gallery with the assistance of the Art Fund

1954

- Matisse's *Portrait of André Derain* (fig. 13) bought by the Tate Gallery with the help of the Art Fund, causing consternation among the members

1955

- E.E. Cook Collection (the entire contents of his house) (see cat. 84–89) bequeathed to the Art Fund to be distributed to art galleries and museums throughout Britain – the Art Fund's most important bequest; F.D. Lycett Green gift (see cat. 90–92) presented to York Art Gallery through the Art Fund

1956

- Finance Act establishes the principle of government acceptance of works deemed to be of aesthetic value in lieu of death duties

1959

- Gallery purchase grants substantially increased: the National Gallery from £12,500 to £100,000; Tate Gallery from £7,500 to £40,000; the British Museum gains £100,000; and the Victoria and Albert Museum, £40,000. The sum for provincial galleries rises from £2,000 to £15,000

1960

- Rubens' *Virgin and Child with St Elizabeth and the Infant Baptist* (cat. 103) bought by the Walker Art Gallery, Liverpool, with the assistance of the Art Fund – the first municipal museum or art gallery to receive a government special purchase grant

1962

- Leonardo's *Virgin and Child with Saint Anne and Saint John the Baptist* (fig. 31) acquired by the National Gallery after a public appeal launched by the Art Fund and with a contribution of over £71,000 from the Art Fund

1964

- First Minister for the Arts appointed (Jennie Lee)

1970

- Lord Crawford retires after twenty-five years as Chairman and becomes President of the Art Fund. Anthony Hornby becomes Chairman

1972

- Finance Act exempts gifts made to the Art Fund from Estate Duty and Capital Gains Tax up to any amount
- Girona Treasure (items recovered from the Spanish galleass *Girona* wrecked in 1588) (cat. 117) bought by the Ulster Museum with the assistance of the Art Fund
- Titian's *Death of Actaeon* (fig. 12) bought by the National Gallery with a contribution of £100,000 from the Art Fund, its largest grant to date

1974

- Van Gogh's *Portrait of Alexander Reid* bought by Glasgow Art Gallery and Museum with the assistance of the Art Fund

1975

- Anthony Hornby retires as Chairman of the Art Fund; Brinsley Ford succeeds him
- Verrocchio's *Madonna and Child ('The Ruskin Madonna')* acquired by the National Gallery of Scotland with the help of the Art Fund
- Art Fund amends its Charter so as to permit it to give grants or outright gifts to the National Trust to acquire works of art for its properties

1977

- Art Fund's Scottish Fund launched with an initial £50,000 transfer, the money to be spent only on works of art for Scottish galleries and museums
- Giovanni Bellini's *Madonna and Child Enthroned with Saints Peter, Mark and a Donor* acquired by the Birmingham Museum and Art Gallery with the assistance of the Art Fund in memory of Lord Crawford's service to museums

1980

- National Heritage Memorial Fund established as a government fund of last resort for the purchase of items of outstanding importance to the national heritage which are deemed at risk
- Brinsley Ford retires as Chairman and the Marquis of Normanby succeeds him
- Altdorfer's *Christ Taking Leave of His Mother* (cat. 133) bought by the National Gallery with a contribution from the Art Fund

1981

- Sir Peter Wakefield becomes first Director (Chief Executive) of the Art Fund

1983

- Art Fund *Report* changes to *Review*

1985

- *The Crucifixion*, attributed to Duccio (cat. 146), acquired by the Manchester Art Gallery after a public appeal launched by the Art Fund and with a grant of £500,000 (in celebration of the Art Fund's 80th birthday), the largest sum given to date

1986

- Marquis of Normanby retires and Sir Nicholas Goodison becomes Chairman
- Art Fund receives thirty-three legacies, a record number for a single year

1989

- Art Fund launches its Modern Art Fund with the exhibition *Monet to Freud* at Sotheby's, London
- Family membership introduced
- Charles Kearley bequeaths his collection of modern art through the Art Fund to Pallant House, Chichester. It includes Severini's *Danseuse No. 5*, then one of only two works by an Italian Futurist in a UK public collection

1990

- Art Fund membership reaches 30,000

1991
- *Middleham Jewel* acquired by Yorkshire Museum for £2,500,000

1992
- Sir Peter Wakefield retires as Director of the Art Fund; Wakefield Fund for the purchase of contemporary craft set up in his honour. David Barrie becomes Director
- Holbein's *Portrait of a Lady with a Squirrel and a Starling* bought by the National Gallery with the assistance of the Art Fund

1993
- Heritage Lottery Fund established; first grant requests accepted in 1995

1994
- Art Fund moves into Millais House, South Kensington, its new freehold headquarters
- Hoxne Hoard of Roman jewellery acquired by the British Museum with assistance from the Art Fund
- Canova's *Three Graces* (cat. 176) bought jointly by the Victoria and Albert Museum and the National Gallery of Scotland with a contribution of £500,000 from the Art Fund (only the second time that it had awarded such a large sum)
- Bill Viola's *Nantes Triptych* (fig. 14) bought by the Tate Gallery with a contribution from the Art Fund; the first acquisition of a video work to have Art Fund support
- Sir Denis Mahon announces his proposed bequest to the nation through the Art Fund of Italian Baroque paintings

1996
- Treasure Act replaces old common law of Treasure Trove and introduces new and wider criteria by which found items are deemed treasure and must be reported
- Exhibition *Treasures for Everyone*, celebrating the work of the Art Fund over the previous fifteen years, at Christie's, London

1997
- Art Fund launches campaign to maintain free admission at all non-charging national museums and galleries

1999
- Botticelli's *Virgin Adoring the Sleeping Christ Child* (cat. 209) bought by the National Gallery of Scotland with a grant of £550,000 from the Art Fund – the largest grant to date

2000
- Mrs Brenda Knapp, a member since 1986, bequeathes a portfolio of shares and property worth over £5 million to the Art Fund
- Charles Saatchi gives thirty-nine works by contemporary artists to be distributed by the Art Fund throughout the country
- Resource, the Council for Museums, Archives and Libaries established

2001
- Art Fund's VAT campaign successful – all national museums and galleries now able to grant free admission
- Cecil Collins' bequest of over 300 paintings, drawings and prints left through the Art Fund for distribution throughout Britain

2002
- Sir Nicholas Goodison retires as Chairman of the Art Fund

2003
- Professor Brian Allen becomes Chairman of the Art Fund
- Titian's *Venus Anadyomene* (*Venus Rising From the Sea*) (cat. 230) acquired by the National Gallery of Scotland with a grant of £500,000 from the Art Fund
- The Art Fund celebrates its centenary year with the exhibition *Saved! 100 years of the National Art Collections Fund* at the Hayward Gallery, London (23 October – 18 January 2004)

cat. 172
Jan van de Cappelle, *A Calm*, 1654 (detail)

Catalogue

Richard Verdi

The catalogue entries are ordered by year of acquisition. Some works have been grouped together and are represented by one entry only. These are ordered by the year of the first acquisition in the group. Dimensions are height x width x depth, unless otherwise stated. Museum accession numbers are given for all entries. 'AF Review no.' refers to the number each work is allocated in the Art Fund annual *Review*.

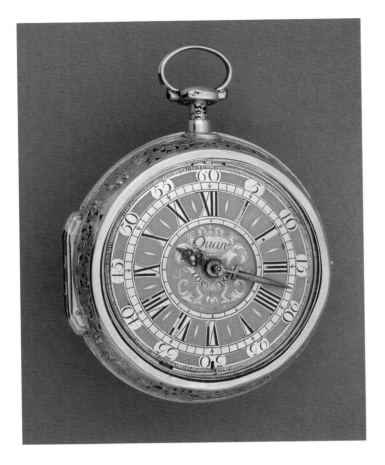

Daniel Quare (1647–1724), *Repeating Watch*, c. 1710
gold case and dial, brass, steel and silver movement; 5.5 cm diameter,
3 cm thick
P&E 1905, 0418.2 / AF Review no. 0001
Trustees of the British Museum
Presented in 1904 as a gift by Max Rosenheim through the Art Fund

The first work ever to enter the nation's collections through
the National Art Collections Fund (Art Fund), this watch
enjoys something of a talismanic status in its history. It was
donated to the British Museum by Max Rosenheim, who
was a trustee of that institution and a founding committee
member of the Art Fund. He also founded the Friends of the
British Museum, which merged with the Art Fund upon its
formation, and he was among the most generous benefactors
to museums in the fund's first decade.

Daniel Quare was a celebrated maker of clocks, watches and
barometers. He began making quarter-repeating watches
around 1680 and was one of the first clockmakers to make
the hour and minute hands work as one. In 1671, he joined
the Clockmakers' Company and, during the second part of
his career, took Stephen Horseman as his partner. Among his
most distinguished patrons were James II and William III.

Reference: 'Old English Repeating Watch, by Daniel Quare', *National
Art-Collections Fund, First Annual Report, 1903-4*, 1905, p. 9.

2 (right)
Turkish, *Iznikware Pot*, c. 1570–80
tin-glazed earthenware with silver-gilt mounts; 26 x 14 cm
1561.1904 / AF Review no. 0010
Victoria and Albert Museum
Acquired in 1905 for £450 from Durlacher and Co. with a contribution
of £100 from the Art Fund

One of the earliest works acquired through the Art Fund, this
earthenware pot from Iznik in Turkey had a silver-gilt lid,
neck and foot mounts added to it in the late-sixteenth century,
most probably in England. Iznikware was uncommon and
considered exotic in Elizabethan England, which may explain
why the mounts are so finely worked. The lid consists of three
masks – two variant lions and a female mask – in burnished
cartouches between fruit on ribbon pendants. The neck mount,
which is cemented to the elegantly painted pot, is elaborately
engraved with scrolling foliage, and the clasping foot mount
is also intricately decorated.

Ceramic-ware flourished in the town of Iznik in the six-
teenth and seventeenth centuries, much influenced by the
blue-and-white porcelain of Ming-dynasty China and by
Persian ceramics. It reached its high-point by the sixteenth
century – when this pot was made – and subsequently
declined, as Kütahya supplanted Iznik as the principal centre
of ceramic production.

Reference: Philippa Glanville, *Silver in Tudor and Early Stuart England*,
Victoria and Albert Museum, London, 1990, p. 430, no. 49.

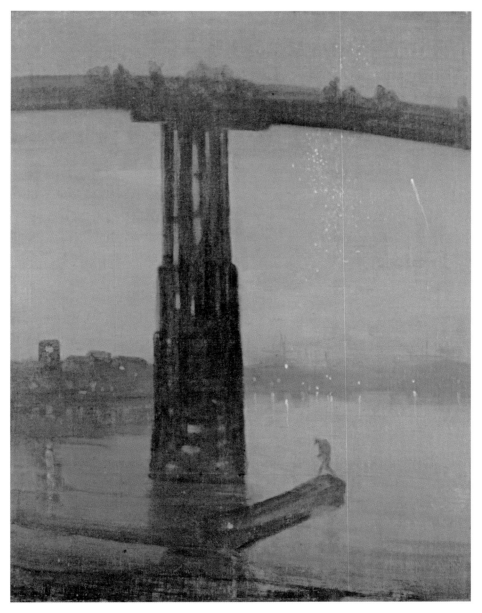

3

James Abbott McNeill Whistler (1834–1903), *Nocturne: Blue and Gold – Old Battersea Bridge, c.* 1872–75

oil on canvas; 68.3 x 51.2 cm
N01959 / AF Review no. 0008
Tate
Presented in 1905 as a gift by the Art Fund; acquired for £2,000 from R.H.C. Harrison

Cited as evidence in the libel action Whistler brought against Ruskin in 1878, hissed at in 1886 – and deemed worthy by Oscar Wilde of attention for no more than 'a quarter of a minute' – this canvas was the Art Fund's first major acquisition and marks England's official acceptance of Whistler two years after his death and fourteen years after Paris and Glasgow had respectively acquired the landmark portraits of the artist's mother and Thomas Carlyle.

The picture depicts the River Thames and Battersea Bridge by moonlight. In the background is the Albert Bridge, still under construction. The composition – with its unconventional angle of vision and bold cropping – owes much to Hiroshige. But the fluid and painterly handling derive instead from Velázquez, whose art was already linked with Whistler's in the artist's lifetime. The title 'Nocturne' – indelibly associated with Chopin – was used by the artist to describe many of his poetical moonlight scenes.

The first painting by Whistler to enter an English collection, it is ironic that this work should have received such enthusiastic support from the Art Fund, given the artist's own stipulation in his will that none of the pictures remaining in his studio 'should ever find a place in an English Gallery'.

References: Andrew McLaren Young et al., *The Paintings of James McNeill Whistler*, New Haven and London, 2 vols., 1980, I, pp. 85-87, no. 140; Richard Dorment, 'Decorative Perfection', in *Art Quarterly*, Spring 2003, I, pp. 35-37.

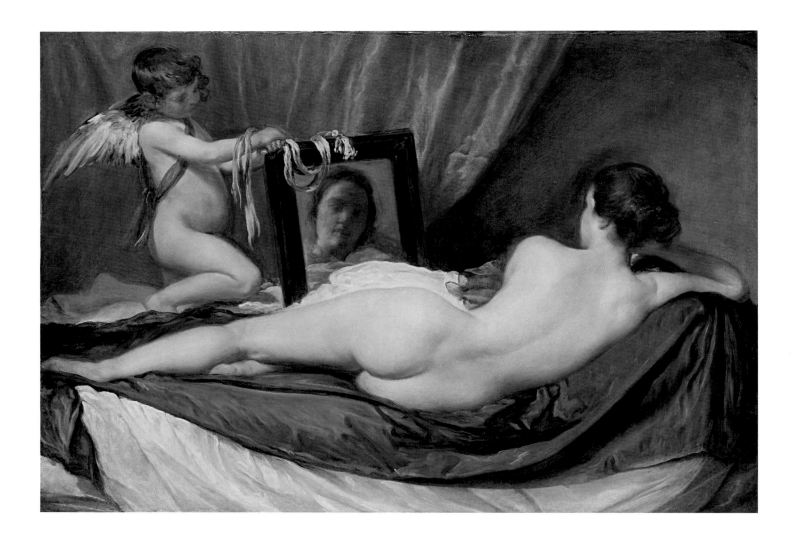

4
Diego Velázquez (1599–1660)
The Toilet of Venus ('The Rokeby Venus'), 1648–51

oil on canvas; 124.5 x 179.8 cm
NG2057 / AF Review no. 0022
National Gallery, London
Presented in 1906 as a gift by the Art Fund; acquired for £45,000 from Agnew's

This sublime picture was the subject of the Art Fund's first great campaigning triumph (see Nead, pp. 74 – 79) and is probably forever destined to remain its signature image. First documented in the collection of Don Gaspar Méndez de Haro, Marquéz de Heliche, in 1651, it is Velázquez's only surviving depiction of a female nude and one of only two such works in all of Spanish seventeenth-century art, the other being the figure of Eve in Alonso Cano's *Christ's Descent into Limbo* (1645 – 52; Los Angeles County Museum of Art).

The painting is remarkable for portraying a back view of the female form and in its near denial of its mythological subject, the wings of Cupid alone indicating the theme. But its reticence in this is as nothing compared with its miraculous economy, which empties the scene of all attributes and accoutrements and concentrates upon essentials. Focusing upon Venus' left buttock, which is defined more precisely than anything else in the picture, the artist treats her extremities in a more cursory and unfocused manner, replicating pin-point vision as no other painter had before. Scarcely less economical is the colour scheme, virtually the entire picture being created out of red, white and grey, including the skin tones of Venus herself. Like a handful of only the very greatest masters, Velázquez knew how much he could omit from a picture.

Reference: Andreas Prater, *Venus at her Mirror*, Munich, 2002.

5

Hans Reinhart the Elder (*c.*1500 – 81), *The Trinity Medal*, 1544
cast, chased and soldered silver; diameter 10.2 cm
CM 1908 3-6-1 / AF Review no. 0054
Trustees of the British Museum
Presented in 1908 as a gift by the Art Fund; acquired for £175 from
Adolf Cahn

One of the greatest of all Renaissance medals, this is the master-
piece of Reinhart, the most important Saxon medallist of the
second quarter of the sixteenth century. It was made for Duke
Moritz of Saxony, who had converted to Protestantism but was
eager not to alienate himself from the Catholic Holy Roman
Emperor Charles V, in whose gift was the Electorship of
Saxony. Since both religions derived their concept of the
Holy Trinity from the Athanasian Creed, its first few lines
form part of the long inscription on the tablet on the reverse
of the medal (above right), emphasizing the unity between
them. A shorter inscription, which runs around the edge, may
be translated as: 'In the reign of Maurice, by the Grace of
God Duke of Saxony etc, Hans Reinhart cast this medal in
Leipzig in the month of January, 1544.'

The obverse (above left) portrays the Trinity itself, with God
the Father enthroned, holding a sceptre and orb, above the
Holy Dove and the crucified Christ. Flanking them are angels
and, at the base of the cross, the medallist's initials. Around the
edge of the medal is the inscription 'PROPTER . SCELVS .
POPULI . MEI . PERCVSSI . EVM . ESAIAE . LIII' ('Stricken
to the death for my people's transgression' – Isaiah 53: 8).

Hans Reinhart, who trained as a cabinet-maker, produced
fewer than fifty medals, mainly between 1535 and 1545. A
later version of this medal, with minor alterations, is in the
Victoria and Albert Museum. Like so many of the Art Fund's
early purchases, this was bought outright by the fund and
given to the museum.

References: M. Trusted, *German Renaissance Medals: A Catalogue of the Collection in the Victoria and Albert Museum,* London, 1990, pp. 98-99, no. 149; J. Chipps Smith, *German Sculpture of the Later Renaissance, c.1520-1580: Art in an Age of Uncertainty,* Princeton, 1994, pp. 68-71, nos. 390-91; Stephen K. Scher (ed.) *The Currency of Fame, Portrait Medals of the Renaissance,* Frick Collection, New York, 1994, pp. 287-89.

Diego Velázquez
The Toilet of Venus ('The Rokeby Venus')

Lynda Nead

The purchase of *'The Rokeby Venus'* (cat. 4) by the National Art Collections Fund (Art Fund) in January 1906 was a pivotal moment in its history and the outcome of its first important campaign. Formed in 1903, the fund had made a number of smaller purchases and, more notably, had bought Whistler's *Nocturne: Blue and Gold – Old Battersea Bridge* (cat. 3) in 1905, but the heated public debate surrounding its campaign to save Velázquez's painting established the fund within the constellation of cultural forces of modern Britain.

The Art Fund came into being in a period of historical transformation and national and international crisis.[1] In this context, many looked to culture and the arts to provide the national prestige and identity that seemed to be lacking in other areas of public life. The fascinating story of the Velázquez campaign not only reveals the energy and commitment of the fund's founding members, but also demonstrates the interconnections between art and the dominant social and political debates of the period.

The Toilet of Venus, more familiarly known as *'The Rokeby Venus'*, was painted by Diego Velázquez *c.* 1648–51. It was brought to England in 1813 by the businessman and art importer William Buchanan and, on the recommendation of the painter Sir Thomas Lawrence, was bought by J.B.S. Morritt of Rokeby Hall, Yorkshire. In spite of occasional offers to purchase the picture, it remained in the Morritt family collection throughout the nineteenth century, making only rare appearances at major art exhibitions. By the end of the century the pressure to sell the picture became more intense. Prices on the art market had rocketed, as fortunes made in America and on the Continent were spent on the creation and consolidation of private and public art collections. The situation in Britain, however, was different. Unlike some of its European competitors, notably France and Germany, Britain had never committed itself to a wholesale programme of state patronage

and financial support of the arts. It was a source of constant frustration for Britain that Germany, its major colonial competitor and military opponent at the time, had such powerful cultural institutions as the Kaiser-Friedrich-Museum in Berlin, ready to snap up any artistic gem that came onto the international market.

For some time there had been rumours that *'The Rokeby Venus'* was about to come onto the market and in 1905 it was sold for £30,500 and subsequently passed into the hands of the dealer Thomas Agnew & Sons for £39,500. The international art market was set alight; an American collector was believed to have offered £55,000, but Agnew's agreed to accept only £45,000 if the Art Fund could raise the money to purchase the painting for the nation.

The sale came at a difficult moment for the Art Fund, which was only just finding its stride. Its membership still numbered only a few hundred and it had not yet been able to establish financial reserves from subscriptions, donations or bequests. In December 1904 an article in the *Daily Mail* expressed disappointment in the recently established organization that 'was started with so much beating of drums ... but so far we have not heard that anything has been done'. If successful, the acquisition of *'The Rokeby Venus'* would be a huge triumph; if unsuccessful, the campaign could spell the fund's collapse.

The Executive Committee met in November 1905 to consider the matter. The price was incredibly high (comparable to the highest prices realized by works of art today) and the Committee was forced to consider its principal aims and objectives. Was it better to try to save one outstanding work, such as *'The Rokeby Venus'*, or a greater number of objects of lesser value? How could the money be raised? Would the National Gallery and the Treasury make a contribution? It was a tricky time to launch a public appeal. With unemployment and urban poverty a visible and pressing problem, wealthy

cat. 4
Diego Velázquez, *The Toilet of Venus* ('*The Rokeby Venus*'), 1648–51 (detail)

fig. 20 Henry Tonks, drawing of the inspection of *'The Rokeby Venus'* by the Art Fund, from a letter to D.S. MacColl

benefactors might prefer to support social charities rather than contribute to the purchase of a painting.[2]

In spite of this uncertainty, however, the Committee agreed that a campaign should be launched for the purchase of the painting and its presentation to the National Gallery in London. Approaches were made to the Treasury and to the National Gallery but, once again, historical factors seemed to conspire against the Committee. Following the resignation of Sir Edward Poynter, the gallery was without a Director and, following the collapse of Arthur Balfour's Conservative government at the beginning of December 1905, Henry Campbell-Bannerman's new Liberal administration had barely established itself. The Art Fund thus found itself with few in authority with whom it could negotiate.

On 22 November 1905, the Chairman of the Art Fund, Lord Balcarres, and the Honorary Secretaries, Sir Robert Witt and Sir Isidore Spielmann, wrote to *The Times* inviting contributions to a campaign to save *'The Rokeby Venus'* for the nation. The announcement opened the floodgates of gossip and opinion in the national and regional press. The following day Lord Ronald Sutherland Gower, a trustee of the National Gallery who was to prove one of the most outspoken opponents of the purchase, expressed his hope that 'the nation will not be hoodwinked by a small artistic clique into the folly of subscribing such a stupendous sum … in order to buy a painting suited for the sanctum of some multi-millionaire, but not for an English public art-gallery'.[3] The suggestion that the morality of this famous nude was questionable and that the picture was therefore not suitable for display in the National Gallery was made repeatedly during the following weeks. Classics scholar Jane Harrison, a member of the Art Fund, took issue with these accusations in a letter to *The Times*, in which she protested against 'the mischievous prurience which condemns the nude human form as something inherently impure'.[4]

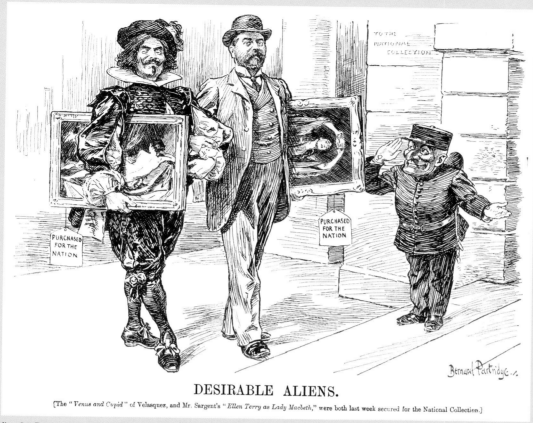

DESIRABLE ALIENS.

[The "*Venus and Cupid*" of Velasquez, and Mr. Sargent's "*Ellen Terry as Lady Macbeth*," were both last week secured for the National Collection.]

fig. 21 Bernard Partridge, *Desirable Aliens*, from *Punch, or The London Carnival*, 31 January 1906

The purchase was also opposed in terms of the condition of the painting. It was suggested that it had been badly damaged in a fire and was not worth Agnew's asking price. Not surprisingly, Agnew's immediately denied these claims and endorsed the quality of the work. In spite of powerful voices of dissent, the Committee continued to pursue its objective and on 7 December 1905 announced that £15,000 had been raised, which included an anonymous donation of £10,000 from 'An Englishman'.[5] The pressure over the following days was intense; the Treasury refused assistance and the campaign looked as if it would collapse. Agnew's extended its deadline and at the end of December the picture was removed from public display. Although this must have driven home to the Committee the urgency of the situation, it did allow a small group from the Art Fund to remove the glass and to inspect the canvas at close hand. A small sketch by the artist Henry Tonks in a letter to one of the founding members of the Art Fund,

D.S. MacColl, lends a touch of humour to what must otherwise have been a grim situation (fig. 20). The inspectors are shown poring over Venus's body with magnifying glasses and suggesting, in the tone of a doctor to a patient, 'Lie down, my dear, it will soon be over.' The conclusions of the inspection were unambiguous: the painting was in excellent condition and was an outstanding example of the work of Velázquez.

There was one more cloud hanging over the campaign. From the outset, it was suggested that the purchase might involve some shady dealings and that individuals associated with the Art Fund stood to make personal profit from the sale. Doubts had initially been raised by the fact that the current owner of the picture had not been identified and that the price was now considerably higher than when it had been sold by the Morritt family. Critics suggested that a syndicate, associated with the Art Fund, now owned the painting and that those who praised it did so to justify its price. The rumour

fig. 22 Mary Richardson, Holloway, London, *c.*1912

The surfacing of this smear at this particular historical moment is not surprising. In the first years of the twentieth century Jews seemed to have unprecedented visibility at all levels of British society. In 1905 the Aliens Act was passed in order to reduce the levels of Jewish immigration into the poorest areas of London, and at the highest levels of society prominent Jews were actively involved in the court of Edward VII. Anti-Semitism fed into widespread concerns in this period regarding unemployment and urban unrest and national and imperial decline. The campaign to save *'The Rokeby Venus'* was drawn into this larger and unresolved landscape of Edwardian social relations.

Despite the constant barrage of opposition, the Art Fund's Executive Committee steadfastly continued its campaign. Towards the end of December, it received a significant boost when it was reported that the King had been to see the painting and supported its campaign; but still it was hard to see how the funds could be raised in time, and at the beginning of January 1906 the Committee announced in the press that the campaign had failed. Whether or not this move was their final strategy, it was at this last possible opportunity that more donors came forward. Evidence suggests that £8,000 was provided on behalf of the King, who also offered to lend the balance of £5,000. This, together with other smaller donations, at last secured *'The Rokeby Venus'*.

On 24 January the Art Fund publicly announced that the purchase was assured and that names of contributors and amounts subscribed would be published in its annual report. The report made evident the scale of effort involved in the campaign and quelled rumours of a financial conspiracy. Donations ranged from large to small and donors included individuals such as the artist Sigismund Goetze, who had cashed in his savings to make his contribution, saying: 'having waited in vain for the Tritons of art to lead the way, perhaps you will allow one of the smallest of minnows to rise to the surface and make his Lilliputian ripple.'[7]

It was a hard-won and important triumph for the Art Fund; as *The Times* stated, 'The Fund has justified its existence.'[8] *Punch* celebrated by publishing a full-page cartoon depicting Velázquez walking into an art gallery with *'The Rokeby Venus'* tucked under his arm

took a specifically anti-Semitic turn when Lord Sutherland Gower wrote to Lord Balcarres suggesting that it was a conspiracy involving Spielmann and corrupt Jewish art dealers. He wrote: 'I think you might try [to] discover the amount of the Commission that the Jew Spielmann [and] Witt would make if the forty thousand was collected. I thought your Art Collections Fund was intended to save works of historical art and interest [from] leaving the country but not to benefit rascally Jew dealers and picture brokers.'[6]

accompanied by Sargent carrying his portrait of Ellen Terry (fig. 21). But even this apparently straightforward image had its political message. Titled *Desirable Aliens*, it inevitably recalled those undesirable and dangerous aliens who were believed to have such a degenerative influence on British society.

On 14 March 1906 the Art Fund presented *'The Rokeby Venus'* to the National Gallery, but controversy was never far from this incredible canvas. Doubts continued to surface concerning the picture's attribution and value; for instance it was suggested that the work was not by Velázquez at all, but by his son-in-law, Juan Bautista Martínez del Mazo. And, on 10 March 1914, almost eight years to the day since its original presentation to the nation, an event occurred that sealed its iconic importance. Mary Richardson (fig. 22), a militant suffragist involved with the Women's Social and Political Union, went to the National Gallery and attacked the painting with a small axe. The special significance of the picture and its purchase was understood by all parties. This was not just a valuable work of art; it was, as the

Daily Express put it: 'the Nation's Venus'.[9] Christabel Pankhurst put it differently: *'The Rokeby Venus* has because of Miss Richardson's act acquired a new human and historic interest. Forever more, this picture will be a sign and a memorial of women's determination to be free.'[10]

It is relatively easy to describe a picture as a masterpiece without really understanding where its power and greatness lie. A picture's importance is not only a question of what it depicts or how well it is made; it is something more than that. Great paintings gather history into themselves; as they age they grow in importance and articulate in the most subtle ways possible the debates and values of generations. This is what we experience when we look at *'The Rokeby Venus'*. Not only is it a rare and valuable work, but it is also a reliquary of history. The story of its purchase by the fledgling Art Fund is part of its historical beauty.

Lynda Nead is Professor of History of Art, School of History of Art, Film and Visual Media, Birkbeck College, University of London.

Notes

1
See Juliet Gardiner, 'Rebels and Connoisseurs', pp. 19-25.

2
See Isidore Spielmann quote in Juliet Gardiner, 'Rebels and Connoisseurs', p. 23.

3
The Times, 23 November 1905, p. 6.

4
Quoted in Mary Lago, *Christiana Herringham and the Edwardian Art Scene*, London, 1996, p. 134.

5
This anonymous 'Englishman' is now known to have been Herbert Cook, of Doughty House, Richmond, one of the founding members of *The Burlington Magazine* and a member of the Art Fund's Executive Committee from 1903-29.

6
Letter from Sutherland Gower to Balcarres, National Library of Scotland, Acc 9769 (the Crawford muniments), Personal Papers 97/22, item 849. My thanks to Kenneth Dunn of the National Library of Scotland for assistance with this material and to the Earl of Crawford for his permission to refer to the Papers. Reference to the anti-Semitic opposition to the campaign is made in Mary Lago, pp. 129 and 134.

7
Quoted in Mary Lago, p. 135.

8
The Times, 25 January 1906, p. 9.

9
Daily Express, 11 March 1914, p. 1.

10
Suffragette, 20 March 1914.

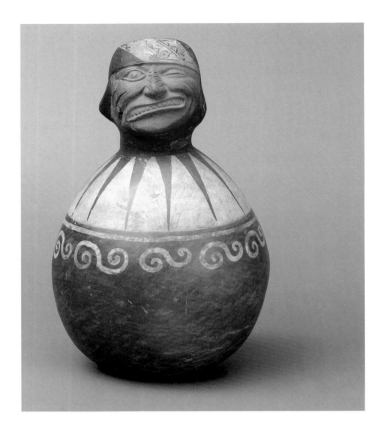

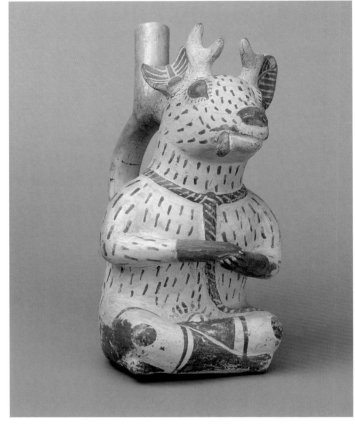

6

Moche culture (Peru), Collection of Vessels, 2nd–8th century

Man grimacing and winking (illustrated above left)

Pot with two birds

Seated deer (illustrated above right)

ceramic, paint; 29 x 17 cm, 23 x 27 x 8.5 cm, 24 x 12.5 x 22 cm
Ethno 1909, 12-18.35, 74 and 59/AF Review no. 0066
Trustees of the British Museum
Collection (250 vases) presented in 1909 as a gift by Henry van den
Bergh through the Art Fund

One of the greatest early twentieth-century benefactors of the
nation's museums was Henry van den Bergh (1853–1937),
a Dutchman who was based in London as director of a large
company that would eventually become Unilever. A member
of the Executive Committee of the Art Fund, in the 1910s and
1920s, he donated numerous coins and medals to the British
Museum (see cat. 16–18, 26), and a large collection of Dutch
tiles to the Victoria and Albert Museum – all via the fund.

Even earlier than this, in 1909, he presented 250 Peruvian pots
to the British Museum, from which this small selection has
been drawn. All of these had been discovered in the Chicama

Valley on the northwest coast of Peru and were the product
of a civilization that flourished there and in the nearby Moche
valley between *c.*100 BC and *c.*700 AD, one thousand years
before the Inca Empire. Henry van den Bergh bought them
from Thomas Hewitt Myng, who had excavated them by
accident (probably before 1903) while digging for Inca gold.

The pots are mostly made in reddish clay, though a few are
dark grey. Many of them depict figures and animals, often
treated in a highly characterful manner; and all are elaborately
painted and decorated, providing valuable evidence of the
customs of the Moche people. Used in life and also serving
a funerary function, the majority of them are equipped with
a stirrup-spout and were intended to hold liquid.

References: 'A wonderful civilisation of 7000 years ago', in *The Illustrated
London News*, 4 December 1909, pp. 803-06; C.H. Read, 'Ancient
Peruvian Pottery', in *The Burlington Magazine*, XVII, 1910, pp. 22-26;
George Bankes, *Moche Pottery from Peru*, British Museum, London, 1980,
pp. 7-13; Christopher B. Donnan, *Ceramics of Ancient Peru*, Berkeley
and Los Angeles, 1992, pp. 56-69; Christopher B. Donnan and Donna
McClelland, *Moche Fineline Painting, its Evolution and its Artists*,
Los Angeles, 1999.

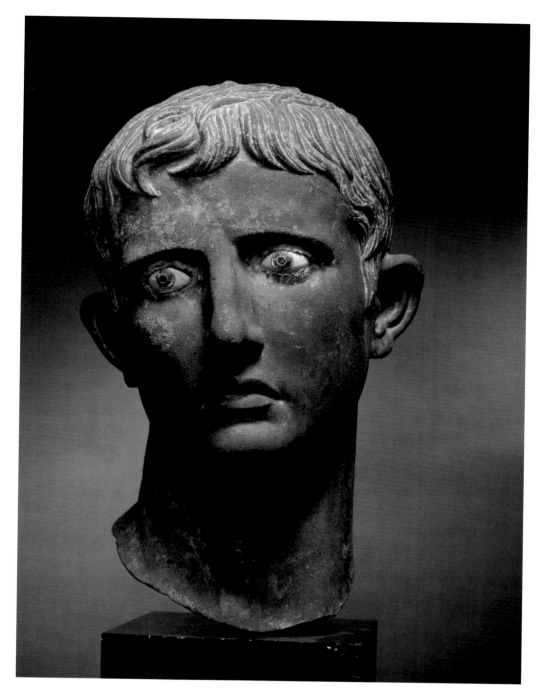

7

Roman, *Head of Augustus, Emperor of Rome ('The Meroë Head')*, 27–25 BC

bronze, with alabaster, glass and coral inlay; height 47.7 cm
GR 1911.9-1.1 / AF Review no. 0097
Trustees of the British Museum
Presented in 1911 as a gift by the Art Fund; acquired from the Sudan Excavations Committee of the Archaeological Institute of the University of Liverpool in exchange for £1,000 towards further excavations

This mesmerizing head depicts the Emperor Augustus (63 BC – 14 AD), who ruled Rome from 31 BC to his death in 14 AD. It was excavated in 1910 on the palace site at Meroë, near Kabushia in the Anglo-Egyptian Sudan. Astonishingly well-preserved – even down to the coloured eyes – it originally formed part of an over-life-sized statue which was probably made in Egypt and decapitated by raiding Meroitic tribesmen. It was then buried beneath the temple, where it remained under the feet of its captors.

Augustus was a short man of unprepossessing appearance who did, however, show great concern for his image. More than 250 statues of him survive, possessing perfect proportions, in accordance with classical Greek norms of ideal form.

References: S. Walker, *Greek and Roman Portraits*, British Museum, London, 1995, pp. 62-63; Nigel Spivey, 'Augustus Survives Decapitation', in *Art Quarterly*, Autumn 1998, pp. 48-49; L. Burn, *The British Museum Book of Greek and Roman Art*, London, revised edition, 1999, pp. 182-83; Susan Walker and Peter Higgs, *Cleopatra of Egypt: from History to Myth*, British Museum, London, 2001, p. 272, no. 323.

8
Attributed to Mir Sayyid Ali (c.1510 – after 1573)
The Princes of the House of Timur, c.1550–55

gouache and gold on cotton; 108.3 x 106.9 cm
Asia 1913.2-8.01 / AF Review no. 0122
Trustees of the British Museum
Presented anonymously in 1912 through the Art Fund

This is the earliest known example of Mughal painting, which has been described by J.M. Rogers as 'a variety of Islamic painting practised in India principally in the sixteenth and seventeenth centuries'. Though substantially cut down, it depicts a ruler seated in a garden pavilion and wearing Central Asian dress. He is flanked by two servants and faces a visitor. To either side of him are courtiers and nobles and, in the background, servants. The missing foreground probably depicted dancers and musicians performing a courtly entertainment.

The central figure is believed to be Humayun (1508–56), the second Mughal Emperor. About fifty years later, his grandson, Emperor Jahangir (reigned 1605–27) had the painting reworked, transforming it from a garden entertainment. With many of the heads repainted to depict later Mughal rulers, it became instead a genealogical scene.

References: J.M. Rogers, *Mughal Miniatures,* British Museum, London, 1993, pp. 35-36; S. Canby (ed.), *Junayun's Garden Party: 'Princes of the House of Timur', and Early Mughal Painting,* Bombay, 1994.

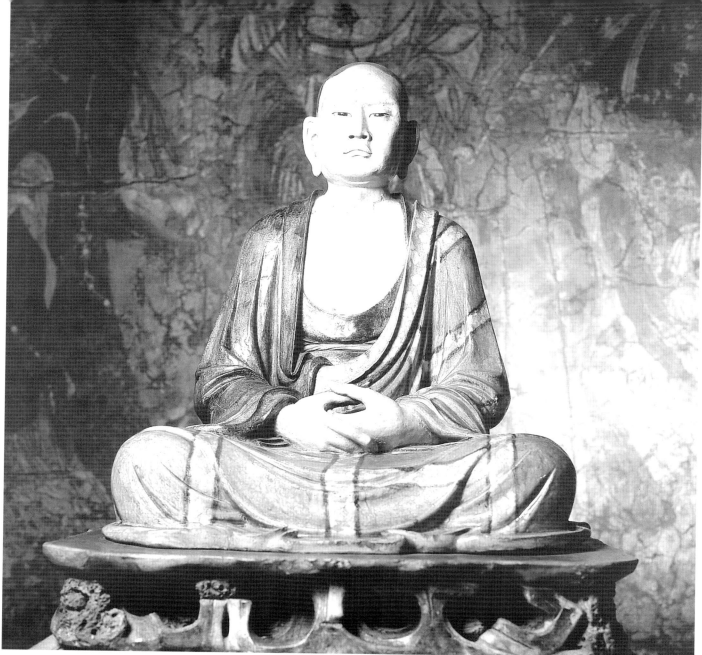

9
Chinese, Liao Dynasty
Seated Luohan (Disciple of Buddha), 907–1125
Sancai (three-coloured) glazed earthenware; 109 x 82 cm
Asia 1913.11-21.1 / AF Review no. 0137
Trustees of the British Museum
Acquired in 1913 for £1,480 from an anonymous vendor with a
contribution of £1,000 from the Art Fund and additional support from
5 private benefactors through the Art Fund

Justifiably regarded as one of the British Museum's most
compelling Chinese sculptures, this *Luohan* was found in a cave
in Yi-xian in Hebei province, northern China, together with
seven others, which are all in North American collections.

Luohans were followers of the Buddha gifted with supernatural
powers. They achieved eternal life, assuring that they would
preserve and perpetuate the Buddha's teachings. By the Tang
Dynasty (618–906 AD) *Luohans* were often depicted in groups
of eighteen, on either side of the main Buddha in a temple hall.

The *Luohans* that survive from this set are so strikingly indi-
vidualized that they have been considered to be portraits of
specific monks, but this is unlikely to be the case. This one
wears an orange-brown robe with banding representing the
patchwork garment traditionally donned by monks as a sign of
humility. His elongated ears are an indication of his wisdom.

This spectacular acquisition was the subject of an appeal
kick-started by the Art Fund, and topped-up by five private
donors. It moved the first Chairman of the fund, Lord
Crawford, to claim in 1914: 'I look back myself with satisfaction
upon many gifts we have been able to make to the Nation,
but I confess, to my own mind, few impress me so much as
this great Chinese figure.'

References: S.J. Vainker, *Chinese Pottery and Porcelain, from Prehistory
to the Present,* British Museum, London, 1991, pp. 166-68; J. Rawson
(ed.), *The British Museum Book of Chinese Art,* London, 1992, pp. 158-60.

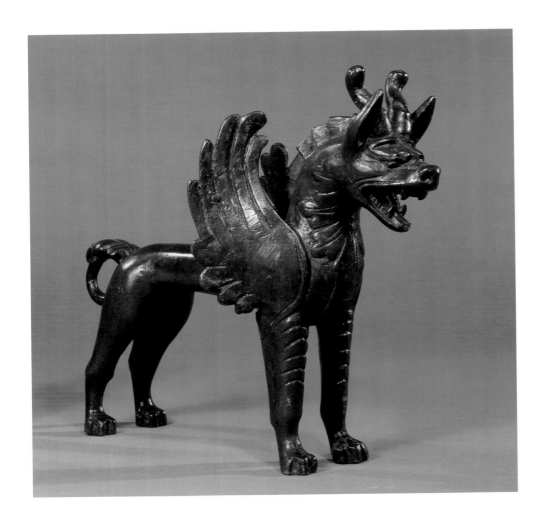

10
Parthian, *Winged Beast*, possibly 1st–3rd century
bronze; 24.9 x 32 cm
ANE 123267 / AF Review no. 0149
Trustees of the British Museum
Presented in 1913 as a gift by the Art Fund; acquired for £200 with
another object from an anonymous vendor

Said to have been found near the banks of the River Helmand
in Afghanistan, this fabulous creature is of uncertain date and
has one wing that has been crudely restored, possibly when
an inscription was added in the fourteenth century, or more
recently.

The date of this splendid winged beast has attracted consider-
able discussion. It has been variously identified as Achaemenid,
Scythian, Indo-Greek, Parthian, Sasanian or even Early Islamic,
on the basis of comparison with representations of other mythical
beasts of these periods. Its function is likewise uncertain, and
it has been suggested that it was part of a piece of elaborate

furniture. If it is Sasanian, it may represent Ahriman, the Evil
Spirit of Zoroastrian belief. The problems of identification
largely reflect the fact that it was found in a region where there
has not been sufficient archaeological investigation. However,
a Parthian date, between the first and third centuries AD, now
seems the most likely.

The Parthians captured Iran and Mesopotamia from the
Seleucids in the third and second centuries BC and gradually
extended their empire west, where they came into contact with
that of Rome, and east, gaining control of the Silk Route,
which brought them into contact with the Han Dynasty
(206 BC – 220 AD) in China. They were captured early in the
third century by the Sasanians, who took over their kingdom.

References: S.R. Canby, 'Dragons' in *Mythical Beasts*, J. Cherry (ed.),
British Museum, London, 1995, pp. 14-43; J. Curtis, *Ancient Persia*,
British Museum, London, 2000, p. 83, fig. 99.

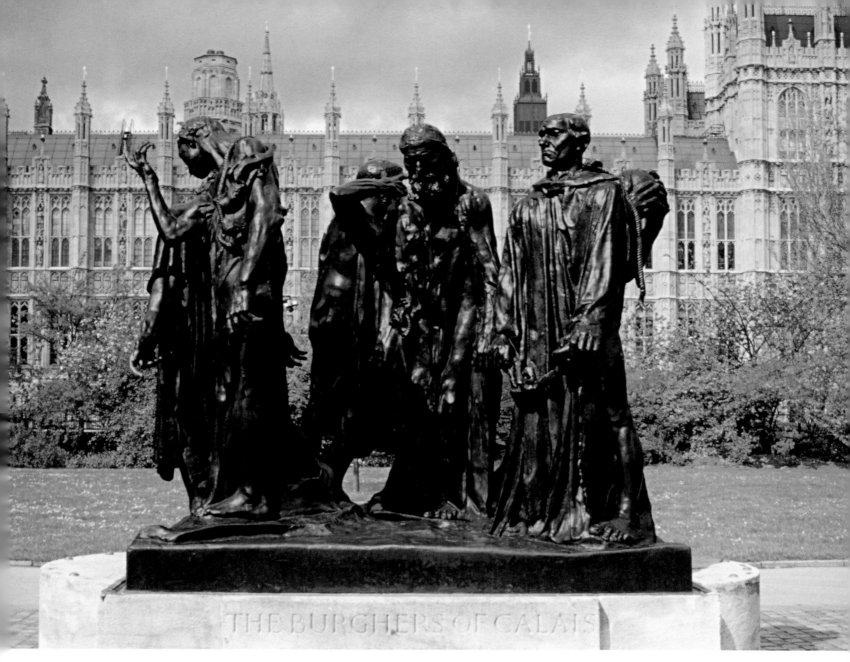

11

Auguste Rodin (1840–1917)
The Burghers of Calais, 1884–95, cast 1907–08
bronze; 210 x 232 x 178 cm
AF Review no. 0136
Victoria Tower Gardens, The Royal Parks
Presented in 1914 as a gift to the nation by the Art Fund; acquired for
£2,400 from Mr Rothschild, Sackville Gallery

Rodin himself was present at the tenth anniversary meeting of the Art Fund in 1914 at which this momentous acquisition was announced and its eventual destination – Victoria Tower Gardens, near the Houses of Parliament – was decided in close consultation with the sculptor. In gratitude for this patronage, Rodin donated eighteen examples of his work to the Victoria and Albert Museum. Since this acquisition the Art Fund has consistently supported works by the sculptor – including the notorious *Kiss* (fig. 27, acquired by Tate in 1952) – the only late nineteenth-century French artist to be so honoured, probably because he was seen as a latter-day Michelangelo.

The original bronze was commissioned by the Mayor of Calais to commemorate the six citizens who, in 1347, agreed to be hanged by Edward III after handing him the keys to the city. This was the result of a macabre deal struck with the King, in which he agreed to lift his siege from the city in return for these citizens' lives. Rodin depicts them as figures of unbearable pathos, wearing ropes around their necks as they prepare to meet their death, though they were spared this fate at the last minute through entreaties by Queen Philippa.

The completed bronze was installed in Calais in 1895. This version was the fourth and final cast made in Rodin's lifetime, under his supervision, and dates from 1907–08. Eight more were subsequently made after the sculptor's death, the most recent in 1995.

References: *Auguste Rodin, Le monument des Bourgeois de Calais (1884-1895)*, Musée Rodin, Paris, 1977; Susan Beattie, *The Burghers of Calais in London*, London, 1986.

12

Japanese, *Court Sword*, 1682

lacquer and mother-of-pearl scabbard, steel blade, with gilt bronze
mounts and inlaid enamel; length 96 cm
M.144-1915 / AF Review no. 0172
Victoria and Albert Museum
Presented in 1915 as a gift by Sir H.H. Howarth, and an anonymous
subscriber through the Art Fund

Bearing an inscription stating that it was made in 1682 for Lord
Nobumitsu (or Tsunemitsu) – who is otherwise unknown –
this magnificent sword would have been used by courtiers and
senior officials, purely on ceremonial occasions. As the blade
in such swords was not for military purposes, it was often
quite poor in quality and construction, as is the case here.

The mounting of the sword is of the type known as the
Kazaridachi, which was the standard form of court sword used
in Japan from the Heian period (794–1185) to the nineteenth
century. It is luxuriously inlaid with pairs of mythical Hō-ō
birds in mother of pearl and turquoise enamels inlaid into
metal fittings of gilt filigree. The decoration also includes the
triple hollyhock crest of the Tokugawa family and a design of
kiri (Pauwlonia) leaves.

Sir Henry Howarth, who presented this sword to the nation,
was Vice-President of the Society of Antiquaries when he
became a member of the Art Fund in 1903. He died twenty
years later.

References: Basil Robinson, *The Arts of the Japanese Sword*, London,
1961, pp. 72-74; Greg Irvine, *The Japanese Sword: The Soul of the
Samurai*, Victoria and Albert Museum, London, 2000, pp. 26-28.

13
Paestan (Italy), attributed to the painter Python
Orestes and the Furies, c. 340–330 BC

ceramic, red-figured bell-krater (wine-bowl); 57 x 51 cm
GR 1917.12-10.1 / AF Review no. 0226
Trustees of the British Museum
Presented in 1917 as a gift by the Art Fund; acquired for £450 from the
sale of the Deepdene Collection

Acquired during the directorship of Frederick Kenyon, himself a noted scholar of Classical art, this magnificent vase was purchased from the Deepdene Collection in Dorking.

A red-figured bell-krater – or wine bowl – the vase is decorated with figures from the *Oresteia* of Aeschylus (525–456 BC). Orestes sought sanctuary at Delphi after killing his mother, Clytemnestra, and her adulterer, Aegisthus, on orders from Apollo. Rather than depict a specific scene from this drama,

the vase merely portrays the principal characters in the manner of a curtain call at the close of the play. Orestes is addressed by Athena – an allusion to his forthcoming trial in Athens – while Apollo (right) turns to a Fury holding a large serpent. Above, a second Fury wields live snakes. The busts at the upper left and right probably represent Clytemnestra and Pylades, friend of Orestes, and the tripod-cauldron is a reference to Delphi, where a golden tripod stood before the temple.

The vase was made in one of the Greek colonies of southern Italy, possibly Paestum, where scenes depicting Orestes were especially popular throughout the fourth century BC.

References: A.J.N.W. Prag, *The Oresteia: Iconographic and Narrative Tradition*, Warminster, 1985, p. 49; H.A. Shapiro, *Myth into Art: Poet and Painter in Classical Greece*, London and New York, 1994, pp. 147-48.

14
Mary Queen of Scots (1542–87)
Last Letter, 8 February 1587
pen and ink on paper; 2 sheets, 31 x 20 cm each
Adv.MS.54.1.1 / AF Review no. 0230
Trustees of the National Library of Scotland
Presented in 1918 as a gift by Rt Hon F. Leverton Harris through the Art Fund

One of the relatively few works of purely historical interest to be acquired for the nation's collections through the Art Fund, this letter aroused considerable debate because of this, with the Chairman of the fund, the Earl of Crawford and Balcarres, eventually conceding that the fund was right to support the acquisition because it had 'a calligraphic interest'.

The letter was written by Mary Queen of Scots two hours after midnight on the day of her execution, 8 February 1587. It is addressed from Fotheringay Castle, Northamptonshire, to her brother-in-law, Henry III, King of France. Mary had been imprisoned in the Castle since September 1586 because of her involvement in a plot to murder the Protestant Queen, Elizabeth I, which would have brought about a Catholic uprising that was certain to place the Catholic Mary on the throne.

Written in French and of extremely elegant calligraphy, it announces Mary's sentence of death and declares that 'the Catholic religion and the maintenance of the right that God has given me to this crown are the two points of my condemnation', making it clear that she saw herself dying as a religious martyr. She also observes that she is to be denied the last rites of the Catholic Church and entreats the King to recompense her servants and to pray for one who dies 'stripped of all her goods'. It concludes by recommending her son, James VI, to Henry and requesting that the latter have a requiem mass said for her 'and give the alms required'.

This is one of three works associated with Mary Queen of Scots that the Art Fund has supported, the others being the grille for her tomb, purchased outright by the fund for £400 in 1920 and returned to Westminster Abbey, and her cameo jewel (cat. 99).

Reference: *The Last Letter of Mary Queen of Scots*, National Library of Scotland, Edinburgh, 1971.

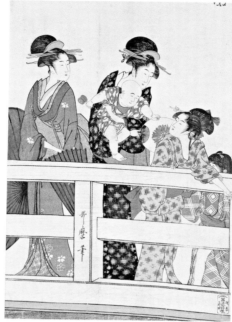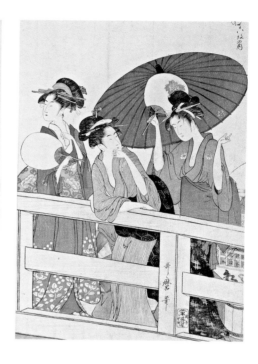

15

Kitagawa Utamaro (1753–1806)
Women on the Ryōgoku Bridge, 1795–96
colour woodcut on three sheets; 36.8 x 25.3 cm (R); 36.8 x 25.4 cm (C);
36.7 x 25.3 cm (L)
Asia 1918,0705.13 / AF Review no. 0245
Trustees of the British Museum
Presented in 1918 as a gift by Oscar Raphael through the Art Fund

In the 1880s and 1890s many Japanese colour prints were exported to the West, where they were sold to eager collectors in Europe and America and also exerted a profound influence upon artists, including Degas, Van Gogh, Gauguin and Whistler, one of the first modern artists championed by the Art Fund. The fund established its own credentials with these works in 1910, when it purchased outright Utamaro's *Awabi Fishers*, which it presented to the British Museum. Eight years later, it was entrusted with the bequest of the present work to the same institution; and it has maintained an enduring commitment to Japanese art of all kinds ever since.

Women on the Ryōgoku Bridge is one of two triptychs by Utamaro designed to be displayed one above the other – an unusual, but not unprecedented, arrangement. It depicts a procession of elegantly dressed women, one holding a child, watching the boats traversing the Sumida river below. Its companion portrays a view of the river, with fashionably attired girls travelling along it. Linking the two compositions is the balustrade of the bridge, its defiant geometry contrasting with the sinuous curves of the promenaders. The result is a masterpiece of *ukiyoe* ('pictures of the floating world'), a school of popular art that explored the life and customs of Japan's urban population from the seventeenth to the nineteenth centuries.

References: J. Hillier, *Utamaro, Colour Prints and Paintings*, London, 1961, p. 105; S. Asano and T. Clark, *The Passionate Art of Kitagawa Utamaro*, London, 1995, I, pp. 178-79, no. 254.

16

Bertoldo di Giovanni (*c.* 1420–91), *Portrait medal of Mehmed II, Sultan of Turkey, c.* 1480–81

bronze; diameter 9.3 cm
CM 1919-10-1-1 / AF Review no. 285
Trustees of the British Museum
Collection of medals presented in 1919 as a gift by Henry van den Bergh through the Art Fund

Ten years after the Dutch industrialist Henry van den Bergh (1853–1937) bequeathed 250 Moche pots to the British Museum (cat. 6), he donated a fine group of three medals, including this one. Its obverse depicts a bust-length profile of Mehmed II, Sultan of Turkey (1432–81; above left) that is closely based on the only known medal by Gentile Bellini (*c.* 1430–1507), which was executed in Constantinople in *c.* 1479–80. A painted portrait of the Sultan attributed to Gentile is in the National Gallery, London.

The reverse of the medal commemorates the Sultan's conquests in Greece, Trebizond and Asia, which are personified by three bound women riding in a chariot led by the Sultan himself (above right). He holds a small figure, probably symbolizing Victory, and the chariot itself is drawn by two horses led by the figure of Mars, god of war. The reclining male figure below holding a trident represents the sea, and the woman with a cornucopia, the earth.

Bertoldo di Giovanni is best known as the pupil of Donatello and master of Michelangelo, whom he reputedly taught *c.* 1490.

References: G.F. Hill, *A Corpus of Italian Medals of the Renaissance Before Cellini*, Florence, 1930, I, p. 239, no. 911; Stephen K. Scher (ed.), *The Currency of Fame, Portrait Medals of the Renaissance*, Frick Collection, New York, 1994, pp. 127-28, no. 39.

17

Attributed to Giovanni Candida (before 1450 – after 1504)
Portrait medal of Cardinals Giuliano della Rovere and Clemente della Rovere, 1493–97

bronze; diameter 6.2 cm
CM 1919-10-1-2 / AF Review no. 0285
Trustees of the British Museum
Collection of medals presented in 1919 as a gift by Henry van den Bergh through the Art Fund

In the early 1490s Giuliano della Rovere – later Pope Julius II (1503–13) – quarrelled with the existing Pope, Alexander VI, and fled to France, where this medal was probably made (above). It is attributed to Candida, a Neapolitan who settled at the French court in 1480, working for Charles VIII.

18

Pastorino of Siena (1508–92)
Portrait medal of Cornelia Siciliana, before 1548
bronze; diameter 3.5 cm
CM 1919-10-1-3 / AF Review no. 0285
Trustees of the British Museum
Collection of medals presented in 1919 as a gift by Henry van den Bergh
through the Art Fund

This is the third of the Italian Renaissance medals bequeathed to the nation by Henry van den Bergh in 1919. It depicts an unidentified sitter known only as Cornelia of Sicily (above left). She is portrayed on the obverse, bust length and facing to the right. The reverse of the medal (above right) shows the female figure of Truth lifting her veil and is inscribed 'INTER O(N)NES VERITAS' ('Truth among all').

Philip Attwood has plausibly suggested that medals featuring women with no direct reference to men, containing just a name and a location, may have been intended to represent local beauties (*belle*) characteristic of different parts of Italy and modelled on either courtesans or professional models.

All three medals came from the collection of S. Pozzi, which was sold in Paris, and formed part of van den Bergh's astoundingly generous gifts to the nation through the Art Fund. Between 1909 and 1927, these numbered no fewer than thirty-six separate bequests, including Persian pottery, Dutch tiles, rare etchings by Rembrandt and drawings by Romney and Corot.

References: Giuseppe Toderi and Fiorenza Vannel, *Le Medaglie italiane del xvi secolo*, Florence, 2000, II, p. 589, no. 1752; Philip Attwood, *Italian Medals c.1530-1600 in British Public Collections*, London, 2003, I, pp. 25 and 250, no. 478.

The reverse of the medal depicts a bust of Clemente della Rovere (above), who became Bishop of Mende in 1483. Reputedly Giuliano's brother, he may have been a nephew or other close relative. Clemente is presumably included here for safeguarding Giuliano's affairs in Avignon while he was away in 1494–95 – as one writer has observed 'the only time that Clemente had done something worthy of praise in the form of a medal.'

References: G.F. Hill, *A Corpus of Italian Medals of the Renaissance Before Cellini*, Florence, 1930, I, p. 218-19, no. 843; Stephen K. Scher (ed.), *The Currency of Fame, Portrait Medals of the Renaissance*, Frick Collection, New York, 1994, pp. 125-26, no. 38.

Hans Holbein
Christina of Denmark, Duchess of Milan
Flaminia Gennari Santori

In May 1909 the National Art Collections Fund (Art Fund) launched the most difficult appeal of its early history. It needed to raise £72,000 in less than a month to save Hans Holbein's portrait *Christina of Denmark, Duchess of Milan* (fig. 23) for Britain. The painting had been commissioned by Henry VIII in 1538, who considered making the 16-year-old Duchess of Milan his fourth wife. Henry is said to have given the portrait to Henry Fitzalan, Earl of Arundel, and it passed through the hands of various descendants to the 15th Duke of Norfolk,[1] who placed it on loan at the National Gallery in London, in 1880.

In 1909, by which time the Holbein had hung there for nearly thirty years, the National Gallery found itself in financial difficulty. Although it had acquired a group portrait by Frans Hals the previous year, this had been thanks to a special grant from the Treasury and required the gallery to mortgage future income. Its Director, Charles Holroyd, feared for the loss of *Christina of Denmark*, and cautiously sounded out the Duke of Norfolk as to whether he would ever sell the Holbein. The Duke candidly replied that if, 'as … sometimes happens that a price was offered for a picture far in excess of its real value', he could be tempted to sell. Norfolk believed that the painting could fetch £60,000; he said that if he did sell, he would not want a public subscription organized.[2]

Holroyd quickly set to work on controlling the possible price of the painting should the Duke decide to sell. This he did by dissuading two of the most 'dangerous' competitors – Wilhelm von Bode, Director of the Kaiser-Friedrich-Museum in Berlin, and J. Pierpont Morgan, the American collector – from trying to buy the work. Bode declared that he would not compete with the National Gallery, 'but that he would rather have [the painting] go to Berlin than to America'.[3] Morgan too promised not to buy the picture, and declared that if a public subscription were to be launched he was willing

to participate.[4] With Bode and Morgan out of the running, Holroyd believed that the Holbein would not fetch more than £40,000, a sum that could be raised by the National Gallery, as it had been two years earlier for Velázquez's *'Rokeby Venus'* (cat. 4). Nevertheless, Holroyd alerted the Art Fund to the possible sale, and the fund resolved to be ready to take action if necessary. The National Gallery Trustees said that they would not take any measure until they knew the Art Fund's position. Although still young, this private organization was already considered a public institution.

Some months later, Norfolk was finally tempted to sell *Christina of Denmark*. Holroyd's forecasts regarding the price, however, proved to be wrong. At the end of April the Duke accepted an offer of £61,000 for the painting from the art dealers Colnaghi. He offered it to the National Gallery for the same amount if they could pay by 1 May. However, this deadline was not met, and on 1 May all the major newspapers published the news that the picture had been sold to Colnaghi. On 5 May, Lloyd George, Chancellor of the Exchequer, promised to grant £10,000 towards the purchase of the painting for the National Gallery if a public subscription were organized. The next day Colnaghi offered the painting to the National Gallery for £72,000, with a payment deadline of 1 June. This new price meant that the art dealers would profit by £11,000: a public scandal was inevitable.

The Art Fund hastened to organize Christina's 'rescue'. On 6 May the newspapers launched the subscription campaign and five days later the Art Fund sent out a public appeal signed by Lord Balcarres (Chairman) and Robert Witt and Isidore Spielmann (Joint Honorary Secretaries). The Art Fund was determined to be as inclusive as possible. Lord Balcarres stated that 'very large donations will be required to raise the necessary sum of money. But small donations will be required too. We will accept from any supporter or member of the Fund a cheque for £20,000 … we will equally

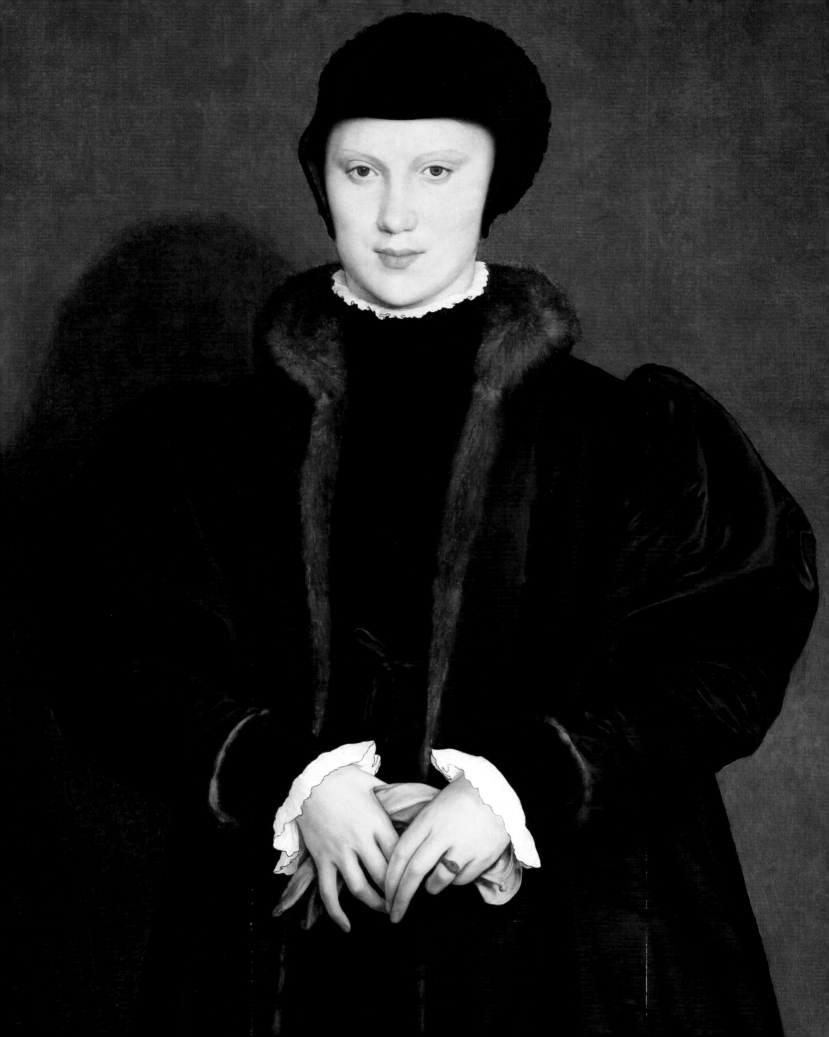

fig. 23 Hans Holbein, *Christina of Denmark, Duchess of Milan, c.* 1538, oil on oak, 179.1 x 82.6 cm, National Gallery, London. Art Fund assisted 1909

accept a cheque for half a guinea.'[5] Notwithstanding the efforts of the organization, the campaign was a failure: by 26 May, only £4,500 had been raised, and the public subscriptions eventually amounted to only £15,000. Colnaghi's itself offered £2,000, but the Duke of Norfolk offered nothing, which greatly disturbed both commentators and subscribers. The matter was further complicated by a jurist who suggested that the painting could not be legally sold in view of a parliamentary act of Charles I that forbade the sale of the works of art listed in the inventory of Arundel Castle, although the inventory had been lost. The Art Fund also tried to raise money through private lobbying, but with little success. However, the painting was saved at the eleventh hour by a private donation of £40,000 through the Art Fund, offered by an anonymous English woman, evidently in a 'German watering place', on condition that her name was never revealed. Her identity, sealed in a letter, still remains a secret and, to this day, is passed from each Art

Fund chairman to his successor. The painting was presented to the National Gallery on 9 November 1909, King Edward VII's birthday.

Just before the picture was secured, and when everything looked hopeless, Spielmann confided to a friend that 'the response would have been more successful if some of the newspapers had thought more of the picture and less of the dealers' profit'.[6] But precisely because the picture was not the only issue at stake, the sale of the Norfolk Holbein was the sensation of the day.

The acquisition of the picture became a political 'hot potato'. Around this time, the House of Lords had embarked on a strenuous opposition to the Budget presented by Lloyd George, which raised death duties and introduced a supertax on incomes in order to finance old age pensions. The so-called 'People's Budget' clearly did not favour the landed aristocracy and it provoked a fierce conflict between the House of Lords and the government that shaped the British political climate for years. The transaction offered an instant example of the consequences of increased taxation on aristocratic collections and the press exploited it as such. They used it both to blame the government for the fallout of increased taxation and as proof of the decadence of the aristocracy and its disloyalty towards the nation. Furthermore, the sale heightened the debate over the management of the National Gallery and the definition of British heritage. Even if *The Times*, *The Daily Telegraph* and the *Morning Post* supported the Art Fund, the rest of the press presented the affair as a well-orchestrated fraud, one in which all the actors – Norfolk, the dealers, the Art Fund, the government and the press – were either the perpetrators or the sufferers, and in which the public were always the victims. The Art Fund never questioned the legitimacy of the sale, nor the Duke's or Colnaghi's profit, but the press coverage was outside its control.

British national newspapers devoted about 330 items to the issue, including articles, letters and comments. In the United States *The New York Times* published sixteen features on the story, including articles and editorials. For *The Times* in London, the government's deficit and the new Budget hindered the acquisition of the portrait through public funding.[7] A reader of the *Morning Post* accused the government of 'exterminating our nobility',[8]

while the *Saturday Review* condemned the new Budget, suggesting, however, that the call to save the painting was for the citizens, not for the government.[9] On 3 May, the liberal *Westminster Gazette* invented Norfolk's marketing slogan: 'Buy my picture at any price I like to ask for it, or rest forever damned as traitors to your country.'[10] As with other newspapers, the *Gazette*'s analysis of the sale's dynamics was contradictory: it acknowledged that the price of the painting was inflated thanks to the manipulation of collective anxieties, while it claimed that the transaction was perfectly correct. It criticized the Duke while it invited its readers to subscribe.[11] Others, like the liberal *Daily Chronicle*, published editorials and letters that harshly criticized Norfolk and Colnaghi's, who, through 'modern … business methods', exploited 'public sentimentality'.[12]

If death duties were seen as a national threat to aristocratic collections, American buyers were the international one, as shown in cartoons, satires and apprehensive commentaries (see fig. 24). A large section of the English press assumed that the painting would end up in the United States and a few newspapers, such as *The Republican*, rejoiced at the possibility.[13] *The New York Times* closely followed the developments of the campaign, speculating on which American collector – perhaps H. C. Frick (Colnaghi's main client in the United States), or P. A. B. Widener – was going to acquire the Holbein. Furthermore, the story enabled the paper to comment on the general state of Britain, which appeared to be heading towards cultural impoverishment and social levelling.

The theme of the cunning exploitation orchestrated by the seller, the dealers and the critics was a transatlantic one, which, however, was disparaged by the same voices who created it. Those who did not wish to get mired in the arguments over the legitimacy of the transaction invoked the 'need' of the painting for the welfare of the nation. Julia Cartwright, the popular British writer who in 1913 published a biography of Christina of Denmark, declared that the sale of the painting abroad would have been a sacrilege.[14] But even regarding the nation's need there was no agreement. For the conservative *Pall Mall Gazette* the Holbein was not 'vitally necessary'.[15] For *Vanity Fair* there were already too many Holbeins in England and the staggering sum asked for the portrait

fig. 24 Bernard Partridge, *Hans Across the Sea?*, from *Punch, or The London Carnival*, 12 May 1909

could be better employed in the acquisition of modern French paintings.[16]

The Times suggested that the Art Fund should concentrate its efforts on the acquisition of works of historical or specific interest: being a private organization, it could express a more innovative and daring taste, whereas purchases made with public funds had to 'represent the orthodox taste of their time'.[17] The *Daily Chronicle* suggested that the Italian legislation for the protection of antiquities and works of art, established in 1902 and revised in 1909, which foresaw the registration of important works of art in private hands and forbade their sale abroad, could have provided the model for a British protective policy.

The Art Fund was attacked for constructing a public need around a transaction which, in the end, favoured private interests. But the crucial point that the Art Fund tried to make acceptable to public opinion was that certain works of art were essential to the welfare of the

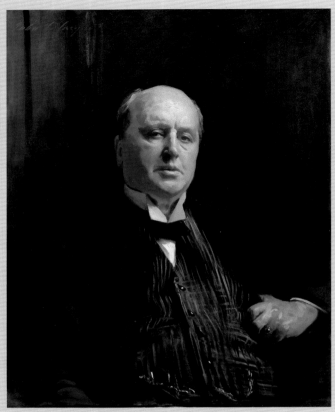

fig. 25 John Singer Sargent, *Portrait of Henry James*, 1913, oil on canvas, 85.1 x 67.3 cm, National Portrait Gallery, London

country; public rhetoric, private lobbying and expertise were the organization's weapons. The Art Fund members who wrote for various newspapers – D.S. MacColl, Claude Phillips and Charles Holmes – and those who worked behind the scenes – Isidore Spielmann and Robert Witt – all blamed the government and the National Gallery trustees for the fiasco, for being unable to act in a 'businesslike way'. Charles Holmes, the then editor of *The Burlington Magazine*, charged the Trustees of the National Gallery with irresponsible policy.[18] MacColl argued in the *Saturday Review* that the nation's need for the painting was unquestionable: the subscription was not only a means to an end, but a way to underline public responsibility.[19] Phillips turned to Wagnerian metaphors to solicit subscriptions in *The Daily Telegraph*.[20] Holmes urged a comprehensive strategy. In the *Morning Post* he argued that there were only about ten paintings still in private hands that should be purchased for the National Gallery. He opposed official registration of works of art still privately owned because it would cause friction with

the owners, as in fact had happened in Italy.[21] After the end of the affair, Holmes suggested in *The Times'* pages that a fund should be created for the National Gallery, made up of the Gallery's invested funds and the capitalization of the annual grants given by the Treasury.[22]

The campaign for the Norfolk Holbein demonstrated that relying on public subscriptions for exceptionally expensive paintings from aristocratic collections was a dangerous strategy. From then on, the Art Fund embraced the policy suggested by Holmes: to pursue the establishment of systematic financial measures and more controllable confidential transactions. Robert Witt, in his influential pamphlet *The Nation and its Treasures*, published in 1911, endorsed these measures, as did the Curzon Committee, appointed in 1912 by the Trustees of the National Gallery, which comprehensively examined the management of national museums and the issues relating to the acquisition of 'important' paintings still in private hands.

In the autumn of 1909, Henry James (see fig. 25) wrote *The Outcry*, a play about the drain of Britain's art treasures to America, which was inspired by the sale of the Norfolk Holbein. Two years later, he transformed it into a novel, probably the most successful of his late years.[23] Although the plot centred on two crucial aspects of the art market that were not at play in the case of the Norfolk Holbein – the assessment of a work's value through the artist's name attached to it and the acquisitiveness of an American collector – James drew upon the Holbein affair for the treatment of the impact of publicity and the sudden and yet profound shift in public notions of the morality of private property. In *The Outcry* this shift is represented through a contrast between a father – the impecunious British aristocrat, Lord Theign, who is tempted to sell his painting to a wealthy American collector – and his daughter, Grace, who is in love with a middle-class expert engaged in 'saving' the painting. The book thus exemplified generational, cultural and class tension. As a comment in *The Illustrated London News* in 1909 shows, this tension was at the heart of the debate:

'They [Old Master paintings] are often art, because great artists have wrought them; they are apparently treasures, since they fetch a great deal of money. The one

thing they never have been is national. There are certain central masterpieces which cannot in their nature be private property, and which are not allowed to be public property. Our wealthy class will be chiefly tested by whether it perceives these things – and gets rid of them. A man might privately own that which is unique and is the object of a private affection. But he must not own that which is unique and the object of a public affection.'[24]

Flaminia Gennari Santori is Research Co-ordinator at the Fondazione Adriano Olivetti in Rome.

This painting is on panel and was too fragile to be included in the exhibition *Saved! 100 years of the National Art Collections Fund* at the Hayward Gallery, London. The work is, however, on permanent display at the National Gallery, London.

Notes
The author would like to thank Mary Yule, Caroline Elam, the National Gallery History Group, the entire staff at the Archive and Library of the National Gallery, Jennifer Booth and the staff at the Tate Archive, Caroline Bugler and Alison Cole at the Art Fund, and, in particular, Tim Warner Johnson at Colnaghi's.

1
M. Levey, *Holbein's Christina of Denmark, Duchess of Milan*, London, National Gallery, 1968, p. 19.

2
Duke of Norfolk to Charles Holroyd, 12 February 1908; National Gallery Archives. The letter was read at a Board Meeting; see, Minutes of Board Meetings, 10 March 1908, National Gallery Archives.

3
Director's Memoranda, 10 March 1908; National Gallery Archives.

4
C.H. Read to J. P. Heseltine, 6 March 1908; National Gallery Archives.

5
National Art Collections Fund, Sixth Annual Report, 1909, p. 23.

6
I. Spielmann to F. Rutter, 27 May 1909. National Art Collections Fund (Art Fund) Papers, Tate Archives.

7
'Holbein's "Duchess of Milan"', in *The Times*, 1 May 1909; see also *The Daily Telegraph*, 1 May 1909.

8
Letter to the Editor, signed G.D. Leslie, in *Morning Post*, 11 May 1909.

9
'The National Art-Collections Fund', in *Saturday Review*, 8 May 1909.

10
Cosmos, 'The Duke of Norfolk's Holbein and the Budget', in *Westminster Gazette*, 3 May 1909.

11
'The £10,000 Profit. The Nation and Proposed Holbein Purchase', in *Westminster Gazette*, 11 May 1909; 'Holbein's Duchess of Milan', in *Westminster Gazette*, 12 May 1909.

12
'Severe Critics. Is the Picture Private Property', in *Daily Chronicle*, 10 May 1909.

13
'The Honest American Raider', in *The Republican*, 1 June 1909.

14
J. Cartwright, 'Holbein's Duchess: Christina of Denmark', in *Westminster Gazette*, 17 May 1909.

15
'Where Will it Stop?', *Pall Mall Gazette*, 5 May 1909.

16
Vanity Fair, 12 May 1909.

17
'The drain of works of art from Great Britain', in *The Times*, 31 May 1909. According to *The Times*, the government should appoint an experts' commission to register the important works of art in private collections, select the works whose exportation had to be forbidden and grant the State the right of pre-emption for all the others. On 15 May, the *Morning Post* published 'The Exodus of Works of Art' by R. Ross, a detailed list of all the Old Masters from aristocratic collections that had been sold abroad. The Art Fund had set up a Registration of Works of Art sub-committee to make a list of works of art that might be saved by prompt intervention if they were threatened with sale. But since it was thought that publishing a list of *desiderata* would be indiscreet and only increase the value of the works when they appeared on the market, it was abandoned.

18
'Unanswered Questions about the Norfolk Holbein', in *The Burlington Magazine*, XV, 1909, no. 75, pp. 135-37.

19
D.S. MacColl, 'The Norfolk Holbein', in *Saturday Review*, 8 May 1909.

20
Claude Phillips, 'Again the "Duchess of Milan"', in *The Daily Telegraph*, 22 May 1909; this article follows the same author's 'Holbein's Duchess of Milan', in *The Daily Telegraph*, 8 May 1909.

21
Charles Holmes, 'The exodus of works of art', in *Morning Post*, 22 May 1909. For a similar view, see 'Topics of the Day. The rescue of the Holbein', in *The Daily Telegraph*, 4 June 1909.

22
Letter to the Editor, *The Times*, 9 June 1909. According to Holmes, the fund could amount to £300,000 and it would have made superfluous new forms of taxation, although Holmes believed that an eventual tax on art sales should be destined to the Art Fund. Holmes advocated the same measure in *The Burlington Magazine*'s July editorial; see, 'A purchase fund for works of art', *The Burlington Magazine*, XV, 1909, no. 76, pp. 201-02. A few years later Robert Witt proposed a similar procedure; see, R. Witt in *The Nation and its Treasures*, London, 1911.

23
Henry James, *The Outcry*, New York, 1911; with an introduction by Toby Litt, London, 2001.

24
G. K. Chesterton, *The Illustrated London News*, 12 June 1909.

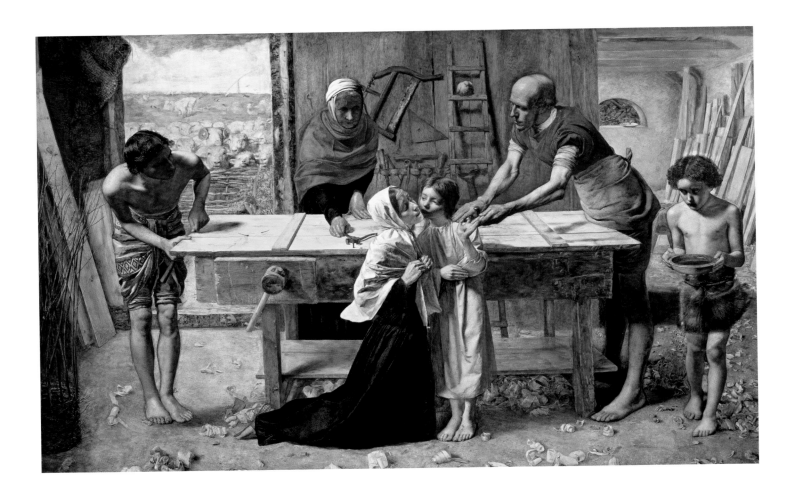

19

John Everett Millais (1829–96), *Christ in the House of His Parents ('The Carpenter's Shop')*, 1849–50

Inscribed: *'J Millais 1850'* (initials in monogram)
oil on canvas; 86.4 x 139.7 cm
N03584 / AF Review no. 0327
Tate
Acquired in 1921 for £10,500 from Mrs Beer with a contribution of £8,750 from the Art Fund and additional support from Arthur Serena

Acquired in the same year as Bruegel's *Adoration of the Magi* (cat. 20), also by means of a direct appeal to members of the Art Fund, this picture was described at the time as providing a British equivalent of the achievements of the early Italian and Flemish schools. Exhibited at the Royal Academy some seventy years earlier, however, it had been vilified by (among many others) Dickens, who described the young Christ as 'a hideous, wry-necked, blubbering red-headed boy in a bed gown'.

The scene shows Christ in the workshop of his father and is steeped in symbolism. Christ has cut his hand on a nail and is succoured by the Virgin and examined by Joseph. At the right the young Baptist holds a bowl of water with which to bathe the wound. At the left are St Anne and a workshop assistant. Behind him a group of sheep symbolize the Christian flock. The white dove on the ladder alludes to the descent of the Holy Spirit from heaven at Christ's baptism; and the triangular set-square to the left of it is a reference to the Trinity. Even the birds drinking from a bowl of water at the background right are representative of human souls seeking spiritual refreshment through Christ.

The Art Fund was especially eager to acquire *Christ in the House of His Parents* because, in 1908–09, it had launched an appeal for Millais' *Portrait of Tennyson*, which had been unsuccessful. In the end, the latter came to the nation by another route. Purchased by the 1st Viscount Leverhulme in 1923, it is now in the Lady Lever Art Gallery, Port Sunlight.

References: Edward Morris, 'The Subject of Millais's "Christ in the House of his Parents"', in *Journal of the Warburg and Courtauld Institutes*, XXXIII, 1970, pp. 343-45; *The Pre-Raphaelites*, Tate Gallery, London, 1984, pp. 77-79, no. 26.

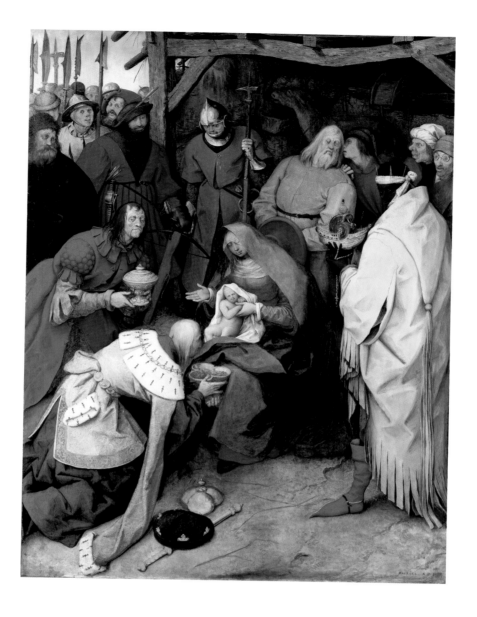

20

Pieter Bruegel the Elder (*c.* 1525/30–69)
The Adoration of the Magi, 1564
Signed and dated lower right: *BRVEGEL MDLXIIII*
oil on wood; 111.5 x 83.5 cm
NG2556 / AF Review no. 0325
National Gallery, London
Acquired in 1921 for £15,000 from G. Roth with a contribution of
£7,500 from the Art Fund and additional support from Arthur Serena

'Bruegel is the single painter who has expressed our modern
sense of life and force of character and humour', wrote
C.J. Holmes, Director of the National Gallery, in the appeal
to acquire this picture. The only work by the artist in the
collection, it forms the perfect complement to the *Adoration
of the Magi* by Gossaert that the Art Fund helped acquire in
1911, the latter so regal and this so plebeian.

As Mary presents the fearful Christ Child to the Magi, the
two older of these kneel in a seemingly obsequious manner.
The third stands at the right holding a precious vessel coveted
by a spectacled man next to him, who gapes at it. Behind
them, a man whispers into Joseph's ear, fuelling the latter's
legendary doubts concerning Mary's purity. Behind the manger,
a motley crowd of onlookers bearing weapons gaze on in
sheepish wonderment.

The picture is one of only two upright works by Bruegel,
and his earliest containing large-scale figures. It was the object
of an appeal to members of the Art Fund in 1920 because it
was recognized that no other painting by Bruegel was ever
likely to become available to the National Gallery. As Claude
Phillips, founding member of the fund, acknowledged at the
time, virtually all of this master's works were to be seen in
the Kunsthistorisches Museum, Vienna, and the *Adoration of
the Magi* was 'the only work that [could] be admitted to equal
rank with them'.

References: Fritz Grossmann, *Bruegel: The Paintings*, London, 2nd., 1966,
p. 196; Wolfgang Stechow, *Bruegel*, New York, 1970, p. 92.

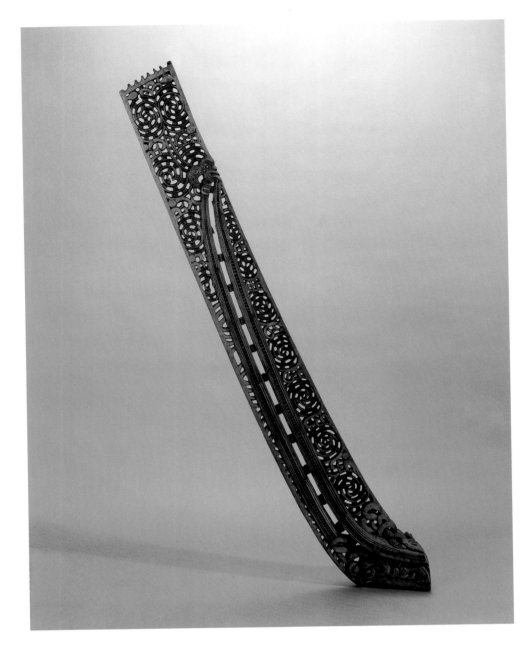

21

Maori (New Zealand)
Taūrapa (war canoe stern-piece), c.1850
wood and haliotis shell; 210 x 30 cm
Ethno 1922.1-10.1 / AF Review no. 0358
Trustees of the British Museum
Presented in 1921 as a gift by the Art Fund; acquired for £35 from
A.D. Passmore

New Zealand Maori constructed large, fine war canoes. Made out of either totara or kauri timber, they were occasionally as long as 100 feet but more usually between 60 and 70 and could carry as many as one hundred warriors to places of battle. Maoris considered canoes to represent the body of an ancestor and to be highly sacred. Contact with a canoe was restricted to men, specifically to carvers and warriors.

This imposing end piece includes the prescribed elements of two ribs, scroll-work and two human figures. One of the figures faces forward, as though to cover the attack, and one faces behind, for defence. This carver took some liberty with the usual mode of depicting the figures protruding from the main form, and has made them elegantly flush with the ribs. The ornamentation of stern-pieces such as this was completed by decorating it with feathers and streamers.

The skills of Maori wood carving survive to this day and experienced a revival when twenty-two war canoes were built to coincide with the 150th anniversary of the Treaty of Waitangi in 1990.

References: Elsdon Best, *The Maori Canoe*, Wellington, 1976, pp. 150-57; D.C. Starzecka (ed.), *Maori: Art and Culture*, British Museum, London, 1996, p. 98, fig. 62.

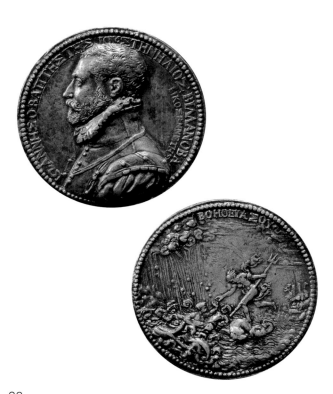

22

Pier Paolo Galeotti (*c.* 1520–84)
Giambattista Giustiniani, c. 1560–65

bronze; diameter 5.1 cm
CM 1921-6-11-10 / AF Review no. 0335
Trustees of the British Museum
Presented in 1921 as a gift by the Art Fund; part of a collection of Italian medals acquired for £130 from Sotheby's

Formerly identified as depicting Giambattista Villanova, who is otherwise unknown, this medal is now thought to portray Giambattista Giustiniani of Villanova who may have belonged to the Genoese family of this name.

Shown in profile facing to the left, the sitter is identified by his name and age (twenty-nine) on the obverse of the medal (above left). The reverse shows Neptune riding out to a shipwrecked man at sea and is inscribed (in Greek) 'your help' (above right). This suggests that Giustiniani must have made a miraculous escape from a raging storm at sea and lends credibility to the idea that he may have been from Genoa, which had a large seagoing merchant community.

This is one of the numerous acquisitions of coins and medals made for the British Museum (see cat. 14–18, 25) during the keepership in that department of Sir George Francis Hill (1867–1948), who joined the museum in 1893, became its director in 1931 and was a leading authority on Greek and Italian coins and medals.

References: Giuseppe Toderi and Fiorenza Vannel, *Le medaglie italiane del XVI secolo*, Florence, 2000, II, p. 515, no. 538; Philip Attwood, *Italian Medals c.1530-1600 in British Public Collections*, London, 2003, I, p. 353, no. 844.

23

Late or post Sasanian (Iran), *Dish, c.* 7th century or later

silver gilt; diameter 19.3 cm
ANE 124095 / AF Review no. 0402
Trustees of the British Museum
Presented in 1922 as a gift by the Art Fund; acquired for £75 from an anonymous vendor

Emblazoned on this dish is a bird-tailed dragon, the *senmurv* (or *simurgh*), a legendary Iranian beast, which combines the forms of a peacock, lion, griffin and dog, and was regarded as a creature of good omen. Intended to startle and perplex, it was occasionally depicted in Late Sasanian art, including embroidered robes, but continued to feature in the early Islamic art of Iran, hence the uncertainty over the exact date of this work.

'Sasanian' is the name given to the Iranian dynasty that was the dominant power in the Near East during the late antique period and extended from Mesopotamia to the Caucasus, Central Asia and Pakistan. It ruled from *c.* 224 to 651 AD, when it fell to the Arabs and the Islamic era began. The silverwork of the Sasanians enjoyed a deservedly high reputation and was copied and imitated long after the fall of the dynasty.

This was the second work of Sasanian-style art to be added to the British Museum's collections with the support of the Art Fund. It was preceded, in 1912, by a silver bowl presented to the museum by Max Bonn through the fund.

References: O.M. Dalton, *The Treasure of the Oxus with Other Examples of Early Oriental Metal-work*, British Museum, London, 1964, p. 66, no. 210; D. Collon, *Ancient Near Eastern Art*, British Museum, London, 1995, pp. 207-08.

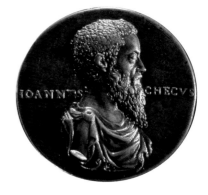

24

English
The Tring Tiles, 1320–30

4 of 8 ceramic tiles; each approximately 32.5 x 16.2 x 3.5 cm
P&E 1922,4-12,5,6,7 and 8 / AF Review no. 0383
Trustees of the British Museum
8 tiles acquired in 1922 for £1,420 with a contribution of £500 from the
Art Fund

Bought at a 'curiosity shop' in Tring, Hertfordshire, in the
mid-nineteenth century by their earliest recorded owner, these
four tiles are among only ten such works to survive intact, eight
of which are in the British Museum and the other two in the
Victoria and Albert Museum. Judging from their remarkable
state of preservation and elaborate design, they were almost
certainly intended to decorate a wall rather than a pavement.

The tiles depict scenes from the childhood miracles of Christ.
These portray: a boy pitch-forking a sheaf of corn that has
been miraculously sown by Jesus into a cart; Jesus and three
men in front of an oven in which the men have imprisoned
their sons so that they cannot play with Jesus; Jesus, the Virgin
and St Joseph looking at three lion cubs; Jesus straightening
the beam of a plough (illustrated); and Jesus turning the water
into wine at Cana or (less probably) blessing a family feast.

Technically the tiles are unusual. After their surfaces were
covered in white slip, the design was cut through this, with
individual details incised through the slip, after which the
latter was scraped away from the entire background.

References: Montague R. James, 'Rare Mediaeval Tiles and their Story',
in *The Burlington Magazine*, XLII, 238, 1923, pp. 32-37; E. Eames,
Catalogue of Medieval Lead-glazed Earthenware Tiles, British Museum,
London, 1980, I, pp. 56-61; J. Alexander and P. Binski, *The Age of
Chivalry: Art in Plantagenet England, 1200-1400*; Royal Academy of Arts,
London, 1987, pp. 283-84, no. 217.

25

Paduan (Italy)
Portrait medal of Sir John Cheke, 1555

bronze; diameter 5.4 cm
CM 1923-5-24-1 / AF Review no. 0439
Trustees of the British Museum
Presented in 1923 as a gift by the Art Fund in memory of Max and
Maurice Rosenheim; acquired for £16 from Sotheby's

Between 1904 and 1917, the brothers Max (d. 1911) and
Maurice Rosenheim gave twenty separate gifts to the nation
through the Art Fund, including the first-ever acquisition made
through the fund (cat. 1). At the death of Maurice, in 1922,
the fund purchased this important medal in their memory –
a fitting tribute as Max, at least, had published on medals in
The Burlington Magazine, in addition to being a member of
the Art Fund Committee and Head of the Friends of the
British Museum, which merged with the Art Fund in 1904.

The medal depicts Sir John Cheke (1514–57), the humanist
and supporter of the Protestant Reformation, who was knighted
by Edward VI in 1552. One year later, upon the accession
of Mary, he lost his position as Regius Professor of Greek
at Cambridge, was imprisoned and, upon release, fled abroad.
Captured in 1556, he was again confined to the Tower of
London and died the following year.

Cheke is here shown bust-length and facing to the right. The
medal's reverse is blank. Though it was acquired in 1923 as
attributed to the Paduan artist, Lodovico Leoni (1542–1612),
it is now ascribed to an unknown Paduan master.

References: Giuseppe Toderi and Fiorenza Vannel, *Le Medaglie italiane
del xvi secolo*, Florence, 2000, I, p. 218, no. 589; Philip Attwood, *Italian
Medals c. 1530-1600 in British Public Collections*, London, 2003, I, p. 234,
no. 426.

26

Pisanello (active by 1395 – died by 1455), *Portrait medal of Filippo Maria Visconti, Duke of Milan*, c. 1435–40
bronze; diameter 10 cm
CM 1923-5-23-1 / AF Review no. 0440
Trustees of the British Museum
Presented in 1923 as a gift by Henry van den Bergh through the Art Fund

Pisanello made his first medals in the 1430s and this is believed to be one of the earliest. It depicts Filippo Maria Visconti, Duke of Milan – an active patron of the arts – and shows a bust-length portrait of him facing to the right on the obverse (above left). On his shoulder are a crown, or ducal coronet, and a wreath containing a dove, traditional symbols of Victory and Peace.

The reverse depicts a mountainous landscape on top of which a large female figure holds a sceptre (above right). In the foreground are three horsemen, including the Duke on the left and a foreshortened page on the right. This scene may stand for the Duke's chivalric ideals.

It is ironic that Visconti, recently described as a 'paradigm of Christian militarism', suffered from severe physical abnormalities and was grossly overweight. Pisanello flatters him unashamedly in this portrait, which became the model for all subsequent depictions of the Duke.

References: G.F. Hill, *A Corpus of Italian Medals of the Renaissance Before Cellini*, Florence, 1930, p. 8, no. 21; Luke Syson and Dillian Gordon, *Pisanello, Painter to the Renaissance Court*, National Gallery, London, 2001, pp. 65-66 and 114-16.

27

Greek, *Statuette of Socrates*, c. 200 BC – 100 AD
marble; height 27.5 cm
GR 1925.11-18.1 / AF Review no. 0491
Trustees of the British Museum
Acquired in 1925 for £1,225 with a contribution of £400 from the Art Fund

Born in 469 BC, Socrates was put to death by drinking hemlock in 399 BC on charges of introducing new and strange gods into the state religion and of corrupting youth. Yet his method of asking penetrating questions in order to pursue the underlying truths of knowledge formed the basis for all rational thought. Though he left behind no writings, his conversations are recorded in the works of his pupils, Plato and Xenophon.

They also describe Socrates as portly, pug-nosed and fleshy-lipped, and somewhat resembling a satyr. Though all of the portraits of him that survive must have been produced after his death, some of them follow this description with clinical accuracy, belying the great philosopher's inner spirit.

The present statuette dates from at least two centuries after Socrates' death and presents a more idealized figure of benevolence, equanimity and deep thought. It is the only full-length statue of Socrates known. A head of the philosopher, similar to that in this work, is in the Louvre, Paris, mounted on a herm-type bust.

References: G.M.A. Richter, *The Portraits of the Greeks*, London, 1965, p. 116; Paul Zanker, *The Mask of Socrates*, Berkeley and Los Angeles, 1995, pp. 57-62.

28

Albrecht Altdorfer (*c*.1480–1538), *St Christopher Carrying
the Christ Child on his Shoulders*, 1512

Inscribed upper right with the artist's monogram and the date 1512
pen and black ink, on dark brown prepared paper and heightened with
white; 27.2 x 15.5 cm
PD 1925-5-9-1 / AF Review no. 0522
Trustees of the British Museum
Presented in 1925 as a gift by Granville Tyser through the Art Fund

Donated to the Department of Prints and Drawings at the
British Museum under the keepership of Campbell Dodgson,
a passionate champion of German Renaissance art (see cat. 34,
39), this is among Altdorfer's finest drawings and depicts one
of his favourite themes. St Christopher is the subject of two
engravings, two woodcuts and four other drawings by the
artist. Unusually, this sheet depicts the Saint from the rear,
steering his way across the river as he bears the burden of the

Christ Child. A much more orthodox treatment of the theme
is the painting by Jordaens included here (cat. 112).

The drawing is notable for its fluency and elegance, especially
in the white highlights that delineate the Saint's staff and the
billowing folds of his drapery. These reveal a remarkable
development from a much more laboured drawing of the same
subject of only two years earlier (Kunsthalle, Hamburg).

The leading figure of the Danube school of artists, which
flourished in southern Germany in the early sixteenth century,
Altdorfer is best known for his pioneering achievements in
landscape.

References: Campbell Dodgson, 'Two Drawings by Altdorfer', in *The
Burlington Magazine*, XLVIII, 276, 1926, pp. 140-43; John Rowlands,
*Drawings by German Artists ... in the Department of Prints and Drawings
in the British Museum: The Fifteenth Century and the Sixteenth Century
by Artists Born Before 1530*, London, 1993, I, p. 26, no. 50.

29

John Singer Sargent (1856–1925)
Study of Madame Gautreau, c. 1884
oil on canvas; 206.4 x 107.9 cm
N04102 / AF Review no. 0488
Tate
Presented in 1925 as a gift by Sir Joseph Duveen through the Art Fund

In 1884, Sargent exhibited a portrait of '*Madame X*' (Metropolitan Museum of Art, New York) at the Paris Salon. Though the sitter was unidentified, the public was in no doubt that it was Madame Gautreau. This created a scandal through its provocative pose and *décolletage,* and through the sitter's reputation for flouting conventional values. Virginie Gautreau was born in Louisiana, the daughter of an Italian father and French mother. When her father died in the American Civil War, her mother returned to France, where Virginie married a wealthy banker. Sargent became obsessed with her and painted her – in a style much indebted to both Velázquez and Manet – without a commission. This unfinished picture is a replica of the original, which the artist began, probably to replace the extensively reworked original, but never completed.

The Art Fund's *Report* for 1926 reveals how this audacious work was acquired:

'*As announced at the Sargent Sale at Christies, July, 1925, in which it was number 79, this picture by special arrangement between the members of Mr Sargent's family was withdrawn from the sale and acquired by the donor [Duveen] in order that it might be preserved for this country instead of passing as it otherwise would have done to the United States.*'

Sir Joseph Duveen (1869–1939) was a dealer who frequently sold to American collections but was also a great supporter of the Art Fund and the museums of London. He paid for a gallery (which bears his name) to house the Parthenon sculptures in the British Museum, and was a Trustee of the National Gallery. The year after he donated *Madame Gautreau* to the nation, he also contributed towards the purchase of Michelangelo's drawing of Adam for the Sistine Ceiling (cat. 35).

Reference: Richard Ormond and Elaine Kilmurray, *John Singer Sargent, the Early Portraits, Complete Paintings,* I, New Haven and London, 1998, pp. 115-17, no. 115.

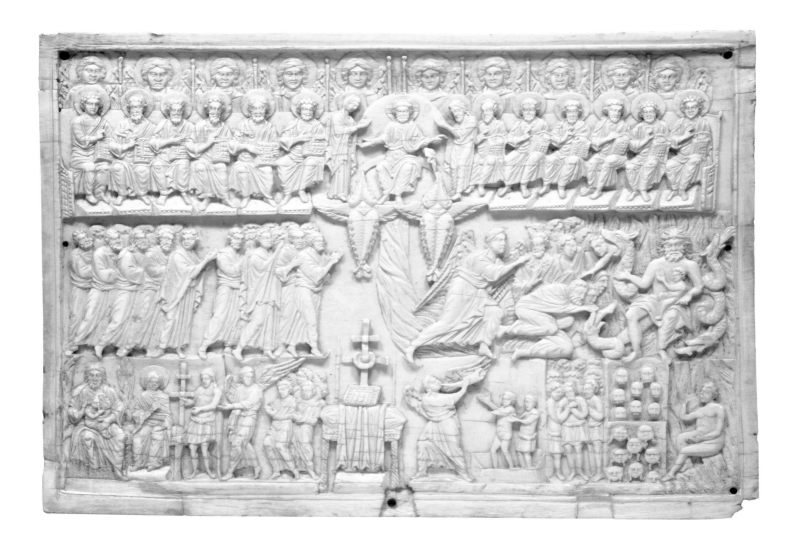

30
Italo-Byzantine, *The Last Judgement*, *c.*1100–1200
ivory; 15.5 x 21.5 cm
A.24-1926 / AF Review no. 0535
Victoria and Albert Museum
Acquired in 1926 for £1,200 from G.R. Harding with a contribution of
£400 from the Art Fund

The year 1926 was a remarkable one for the Art Fund. Not
only did it help with the acquisition of the relief by Agostino
di Duccio (cat. 31) and the drawings by Michelangelo (cat. 35)
and Ambrosius Holbein (cat. 34) included here, but it bought
a group of later nineteenth-century French pictures to mark
the opening of the Modern Foreign Gallery at Millbank
(later the Tate Gallery). It also helped the nation to acquire
this fine ivory of the Last Judgement, which is inspired by the
mosaics in Torcello Cathedral near Venice, of *c.*1100, and was
probably made in or near the city soon after this date.

The relief depicts Christ seated on a globe between the
Virgin and Baptist, intercessors at the Last Judgement. To either
side of them are the twelve Apostles. At the bottom right, an
angel blows a horn to signal the resurrection of the dead. At
the bottom left, two groups of the Blessed are led into Paradise,
which is already occupied by the penitent thief (with his cross),
the Virgin and Abraham, who holds Lazarus. At the lower
right an angel ushers the Damned towards Satan, seated on
his throne of serpents. He holds a small figure who may be
the rich man, the antithesis of Lazarus in Paradise. The empty
throne with the book and instruments of the Passion at the
bottom centre is the Byzantine 'Etimasia', which symbolizes
Our Lord as Judge.

References: M.H. Longhurst, 'A Byzantine Ivory Panel for South
Kensington', in *The Burlington Magazine*, XLIX, 280, 1926, pp. 38-39;
Paul Williamson (ed.), *The Medieval Treasury*, London, new edition,
1998, p. 162.

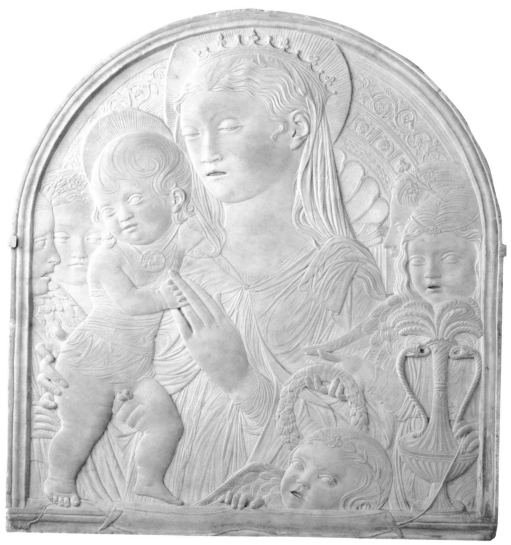

31
Agostino di Duccio (1418–81)
Virgin and Child with Five Angels, c. 1455
marble; 56.6 x 48.5 cm
A.14-1926 / AF Review no. 0526
Victoria and Albert Museum
Acquired in 1926 for £3,000 from Lord St Oswald with a contribution of
£1,000 from the Art Fund and additional support from Sir Joseph Duveen

Purchased from the Trustees of Lord St Oswald at Nostell Priory, this relief was acquired in the same year as Michelangelo's drawing of Adam (cat. 35), making 1926 an early landmark in the Art Fund's support of works by Italian Renaissance masters.

Agostino di Duccio was born in Florence but probably trained in Emilia, and is best known for the reliefs he executed in the Tempio Malatestiano in Rimini between 1449 and 1457. This relief is contemporary with them and depicts the Virgin and Child behind a parapet surrounded by five angels. Two of them frame the central figures, while the fifth peers playfully over the edge of the parapet, as though courting our gaze. His informal pose is mirrored by the lively stance of the Christ Child, who wears a medallion depicting a charioteer driving

four horses. This may be a reference to the victory of Christ, which would also explain the wreath offered to him by an angel on the right, presumably intended as a victor's crown. At the far right is a vase filled with palm leaves. A string attached to it contains a *cartellino* label which dangles in front of the parapet and is precariously held in place at the left by the Christ Child's foot.

Contrasting with the improvisatory nature of these details is the austere linearity of Agostino's style, also apparent in his work at Rimini for the Malatesta family. Many features of this relief suggest that it, too, was commissioned by them — among them the stylized roses worn by the angels, which were an emblem of the family.

References: Eric Maclagan, 'A Relief by Agostino di Duccio', in *The Burlington Magazine*, XLVIII, 277, 1926, pp. 166-67; John Pope-Hennessy, *The Virgin and Child by Agostino di Duccio*, Victoria and Albert Museum, London, 1952; John Pope-Hennessy, *Catalogue of Italian Sculpture in the Victoria and Albert Museum*, London, 1964, I, pp. 122-24.

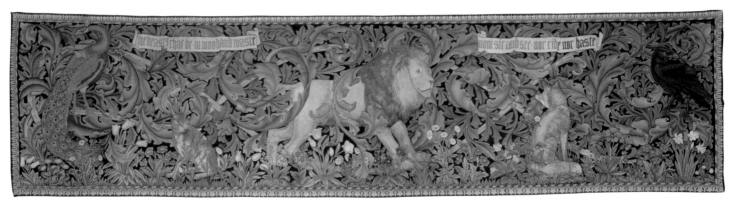

32
William Morris (1834–96), Philip Webb (1831–1915) and
John Henry Dearle (1860–1932), *The Forest Tapestry*, 1887
woven silk and wood on a cotton warp; 122 x 460 cm
T.111-1926 / AF Review no. 0547
Victoria and Albert Museum
Acquired in 1926 for £500 with a contribution of £100 from the Art Fund

Purchased for the nation's premier textile collection at a time
when Morris was deeply unfashionable, this was the first of
many works by him to be supported by the Art Fund. As
recently as 1993, the fund was instrumental in assisting the
Victoria and Albert Museum to reunite his tapestry *Angeli
Ministrantes* of 1894 with its companion, *Angeli Laudantes*,
which the museum had acquired ninety-five years earlier.

The *Forest Tapestry* was woven at Morris' tapestry works,
Merton Abbey, in 1887 and is a collaboration between him,

Philip Webb and Henry Dearle. Webb added the five animal
studies into Morris' background of acanthus leaves and Dearle
supplied the floral details in the foreground. The embroidered
inscription at the top reads: 'the beast that be in woodland
waste, now sit and see nor ride nor haste'. It was later published
under the title 'The Lion' in Morris' *Poems By the Way* of 1891.

With its elaborately filigreed patterning and sumptuous detail,
the tapestry is a superb example of Morris' revival of the
craftsmanly richness and precision of medieval art. It was
acquired from the artist by Aleco Ionides of 1 Holland Park,
from whose heirs the museum purchased it in 1926.

Reference: Linda Parry, *William Morris 1834-1896*, Victoria and Albert
Museum, 1996, p. 288, no. M.120.

33
Vilhelm Hammershøi (1864–1916), *Interior*, 1899
oil on canvas; 64.5 x 58.1 cm
N04106 / AF Review no. 0564
Tate
Presented in 1926 as a gift in memory of Leonard Borwick by his friends
through the Art Fund

Donated to the Modern Foreign Gallery at Millbank (now
the Tate), in the year of its opening, this picture was given by
the artist in 1903 to Leonard Borwick (1868–1925), a concert
pianist whose brother-in-law was Sir Charles Hallé, founder
of the Hallé Orchestra.

Hammershøi was a Danish painter who visited London, where
he was influenced by the subtly atmospheric art of Whistler,
with its refined nuances of colour and tone and tender poetry.
This picture depicts a room in the artist's house at Strandgade
30, Copenhagen, where he lived from 1899 to 1909. Though
its monochromatic colour scheme is manifestly Whistlerian, the
motif of a solitary female in quiet reverie in a simple domestic
interior recalls instead the rarified genre paintings of such
Dutch seventeenth-century masters as Vermeer and de Hooch.

Reference: S. Michaelis and A. Bransen, *Vilhelm Hammershøi*,
Copenhagen, 1918, pp. 55-59 and 97, no. 196.

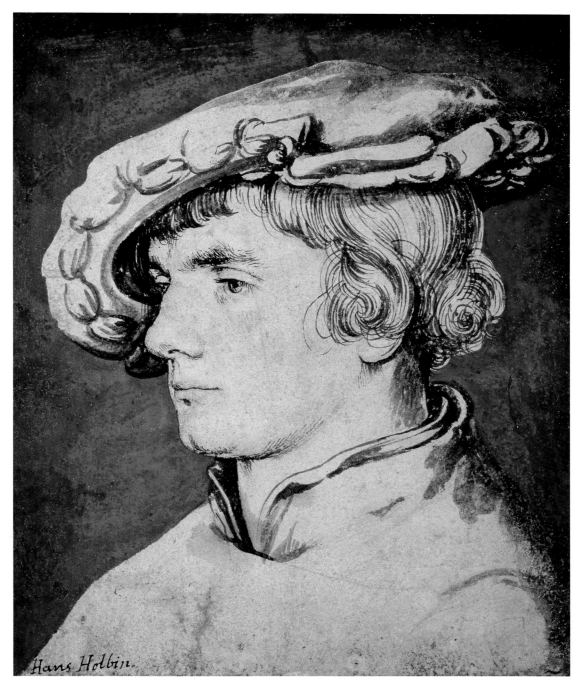

34

Ambrosius Holbein (*c.* 1494 – *c.* 1519)
Portrait of a Young Man, c. 1518

brush drawing in grey and black wash, touched with red chalk, and pen and brown ink; 14.8 x 12.2 cm
PD 1926-4-10-1 / AF Review no. 0532
Trustees of the British Museum
Presented in 1926 as a gift by the Art Fund; acquired for £800 from the Kerrich family

One of many distinguished German Renaissance works on paper acquired by the British Museum during the keepership of Campbell Dodgson (see pp. 35–36), this handsome drawing was originally attributed to Hans Holbein the Younger. Now, however, it is given instead to his tragically short-lived older brother, for it closely resembles certain of the latter's signed and dated works. These reveal Ambrosius to be a portraitist of great sensitivity and refinement – qualities clearly apparent in this exquisite sheet, which was presumably intended as a finished work of art rather than as a study for a painting.

Born in Augsburg, Ambrosius Holbein is first recorded in Basle in 1515 and entered the painters' guild there two years later. He became a citizen of Basle in 1518 and then disappeared from view, presumably dying shortly thereafter.

Reference: John Rowlands, *Drawings by German Artists … in the Department of Prints and Drawings in the British Museum*, London, 1993, pp. 136-37, no. 298.

35

Michelangelo (1475–1564), *Studies of a reclining male nude: Adam in the fresco 'The Creation of Man' on the vault of the Sistine Chapel*, 1508–12

dark red chalk over some stylus underdrawing; 19.3 x 25.9 cm
PD 1926-10-9-1 / AF Review no. 0528
Trustees of the British Museum
Acquired in 1926 for £600 from Locker Lampson with a contribution of
£400 from the Art Fund and additional support from Sir Joseph Duveen
and Henry van den Bergh

Bought for only £600 because its authenticity was then questioned, this superb drawing ranks among Michelangelo's greatest studies for the Sistine Chapel ceiling. It is also the most ambitious of three drawings that survive by him for the reclining figure of Adam, reaching out to God the Father, whose touch will infuse him with life.

The drawing depicts a studio model, whose left leg has been moved at least three times while posing. His right hand is drawn separately at the lower left of the sheet, and his left hand is lightly sketched out at the upper right. The technique is

identical to those of other life studies for the ceiling, featuring dense diagonal hatching in red chalk.

The drawing has an illustrious provenance and was previously in the collections of both Reynolds and Lawrence. When it was being considered for purchase by the Art Fund a supporting statement from the British Museum noted: 'It is an opportunity which ought, undoubtedly, not to be missed, of acquiring a drawing by a great master for one of his greatest works.' Much more recently, two drawings by Michelangelo were lost to the nation; *The Risen Christ* sold in 2000 for £8.3 million, and *The Study of a Mourning Woman* sold one year later for £5.9 million to a London-based dealer who sold it on to an American collector after it had been valued at £7.5 million.

References: Luitpold Dussler, *Die Zeichnungen des Michelangelo*, Berlin, 1959, p. 265, no. 580; Frederick Hartt, *The Drawings of Michelangelo*, London, 1971, pp. 81-82, no. 77; Nicholas Turner, 'The Creation of Adam', in *Art Quarterly*, Summer 1999, pp. 40-43.

36
Georges Seurat (1859–91)
Market Porter (Fort de la halle), c. 1882

black chalk; 31.4 x 23 cm
PD 1927-7-9-150 / AF Review no. 0613
Trustees of the British Museum
Presented in 1927 as a gift by two anonymous donors through the
Art Fund

The 1920s saw the growth of Seurat's reputation in Britain.
In 1924 the Trustees of the Courtauld Fund purchased his
masterpiece, *Bathers at Asnières*, for the National Gallery; and,
three years later, the British Museum acquired this fine drawing
from two anonymous donors via the Art Fund. It was not until
the 1960s, however, that other museums were actually to approach
the Art Fund for assistance in acquiring Seurat's works (see

also cat. 105) – a gap of more than thirty years that also applied
to the art of his contemporary, Cézanne (see cat. 48, 110).

This is one of three drawings of a market porter that Seurat
made around 1882. Wearing a broad-brimmed hat and carrying
a stick, the figure is executed in *conté* crayon on a coarsely
textured rag paper, in which the blacks shimmer against the
indentations that were left white when the artist lightly stroked
the surface. Enhancing the anonymity of the figure is
the absence of any detail and his reduction to a silhouette
(the artist's favourite device), which imbues the work with
a monolithic simplicity.

Reference: C.M. de Hauke, *Seurat et son oeuvre*, Paris, 1961, II, p. 90,
no. 483.

111

37
John Martin (1789–1854)
Adam and Eve Entertaining the Angel Raphael, 1823
oil on canvas; 131 x 198.5 cm
KIRMG 17 / AF Review no. 0599
Fife Council Museums: Kirkcaldy Museum and Art Gallery
Presented in 1927 as a gift by Ewan Fraser through the Art Fund

When the Kirkcaldy Museum and Art Gallery opened in 1925, it possessed no collection and, initially, limited itself to loan exhibitions. This remarkable landscape was one of the first works donated to the museum, in an attempt to kick-start it. To this day it remains the greatest English painting in the collection.

The picture is based on Books V to VIII of Milton's *Paradise Lost*. At the far right Adam and Eve embrace. Addressing them is the angel Raphael, sent by the Lord to caution them against disobeying God's command and to warn them of Satan's plan to bring about the Fall. Sheltering them is a shady bower and, to the angel's left, a selection of the 'savoury fruits' and 'nectarous draughts' that Eve has prepared for them.

The terrain then descends dramatically to reveal a panoramic vista of Paradise, a visionary landscape of luxuriant growth, which leads to a shimmering view of rivers, buildings, mountains and clouds bathed in an unearthly light. This is nature at its very birth, in a primal state of innocence, before its corruption by man. So blissful a scene becomes even more potent – and poignant – when one recalls that it was conceived at the height of the Industrial Revolution.

Reference: William Feaver, *The Art of John Martin*, Oxford, 1975, pp. 62-64.

38

English, *The Luttrell Psalter, c.* 1320–40
(open at 'Sowing' (f170 verso) and 'Harrowing' (f171))
illuminated manuscript; vellum; 36 x 24.5 cm
Add. MS 42130 / AF Review no. 0697
The British Library
Acquired in 1929 for £31,500 from Mrs Alfred Noyes with a contribution
of £7,500 from the Art Fund and additional support from a special grant
from H.M. Treasury, Mr Dyson Perrins and over 1,000 subscribers. This
acquisition was made possible by the generosity of John Pierpont Morgan
who lent the purchase price to the Trustees of the British Museum,
free of interest, for one year.

Few works associated with the Art Fund can have had a more
nail-biting acquisition history than *The Luttrell Psalter*, sold from
Lulworth Castle by Herbert Weld in 1929. The manuscript
had been on loan to the British Museum since 1896 and was
almost certain to go abroad, but, at the last moment, it was
saved by John Pierpont Morgan – an American! – who agreed
to lend whatever purchase money might be required for a year
without interest on the condition that, if the British Museum
failed to repay the loan, the manuscript would become part

of his own collection. One year later, he did the same for
another manuscript from the same collection, the *Bedford
Psalter Hours* (British Library, MS. 42131), also acquired with
Art Fund assistance, a gesture of outstanding generosity since
he was the greatest of all American collectors of manuscripts
and drawings, and founder of the New York museum that
bears his name.

The Luttrell Psalter was written and illuminated in the early
fourteenth century for Sir Geoffrey Luttrell (1276–1345) of
Irnham, Lincolnshire. It contains texts of the Psalms decorated
with scenes illustrating the everyday life of medieval England.
The opening shown here depicts scenes of sowing and
harrowing. In the right hand margin of the right-hand page
are the Luttrell family arms.

References: Janet Backhouse, *The Luttrell Psalter*, British Library, London,
1989; Michael Camille, *Mirror in Parchment: The Luttrell Psalter and the
Making of Medieval England*, London, 1998; Janet Backhouse, *Medieval
Rural Life in the Luttrell Psalter*, British Library, London, 2000.

40
Sumerian (Iraq), *Gudea, King of Lagash*, *c.* 2100 BC
dolerite; height 73.6 cm
ANE 122910 / AF Review no. 0778
Trustees of the British Museum
Acquired in 1931 for £7,500 from Mme Luiz de Sousa Barbosa with a contribution of £5,300 from the Art Fund

39
Albrecht Dürer (1471–1528)
Portrait of a Peasant Woman, 1505
Signed, dated and inscribed by the artist: 'A Windisch peasant woman' (*Una vilana Windisch*)
pen and brown ink and brown wash; 41.6 x 28.1 cm
PD1930-3-24-1 / AF Review no. 0748
Trustees of the British Museum
Acquired in 1930 for £5,000 from Mr Houthaker with a contribution of £2,000 from the Art Fund and additional support from Campbell Dodgson

Dürer visited Italy in 1494 and 1505. On the first journey he travelled to Venice over the Brenner Pass. But, on the second, he evidently went via Klagenfurt in southern Austria, where he made this drawing, the inscription of which refers to Windisch Mark, the archaic name of the area around Gurk in Carinthia, southern Austria.

The drawing portrays a laughing peasant woman from this region. Widely regarded as among the artist's greatest portrait drawings, it was evidently already much admired in the sixteenth century, when at least one copy of it was made. It isn't hard to see why. Given the fleeting nature of the peasant woman's expression and the meticulous execution of the drawing, Dürer must have had to recall her mirthful grin from memory.

In the third millennium BC, the ancient Sumerians lived in southern Mesopotamia, between the Tigris and Euphrates rivers, where their most famous city was Ur, a site of spectacular archaeological importance. Another was Tello, whose ancient name was Girsu, in the city state of Lagash, where the French conducted excavations between 1877 and 1933. This imposing bust of Gudea, ruler of Lagash around 2001 BC, may have been unearthed there in 1924.

A pious man, Gudea commissioned numerous statues of himself standing or seated in prayer. During his reign these adorned the public buildings, palaces and temples of the city. But a period of political unrest soon ensued and Girsu was ravaged and the statues decapitated. Thus, all of the Gudea figures found by the French were discovered without heads.

This statue was discovered as a torso and finished with a head which does not match the surface of the break, but is believed to be the original. One eye and the left side of the skull have also been damaged by severe blows. Traces of gold on the fingernails indicate that they were originally gold-plated. The neck was modelled in plaster by the sculptor Leon Underwood, when it was in the collection of its previous owner, Sydney Burney, but has been restored again since.

References: Campbell Dodgson, 'Una Vilana Windisch', in *The Burlington Magazine*, LVI, 326, 1930, pp. 237-38; John Rowlands, *Drawings by German Artists ... in the Department of Prints and Drawings in the British Museum: The Fifteenth Century and the Sixteenth Century by Artists Born Before 1530*, London, 1993, pp. 78-79, no. 164; Giulia Bartram (ed.), *Albrecht Dürer and his Legacy: the Graphic Work of a Renaissance Artist*, British Museum, London, 2002, pp. 156-57, no. 96.

Reference: Flemming Johansen, 'Statues of Gudea, Ancient and Modern', in *Mesopotamia*, 6, Copenhagen, 1978, pp. 5-7 and 22; J. Reade, 'Early Monuments in Gulf Stone at the British Museum, with observations on some Gudea Statues and the Location of Agade', in *Zeitschrift für Assyriologie*, 92, 2002, pp. 276-84.

41

Jean-Baptiste Camille Corot (1796–1875)
Lake Piediluco, Umbria, 1826
oil on canvas; 22 x 41 cm
WA 1913.2; A403 / AF Review no. 0790
Ashmolean Museum, Oxford
Presented in 1931 as a gift by Sir Michael Sadler in memory of Lady
Sadler through the Art Fund

Corot's first visit to Italy between 1825 and 1828 inspired his
earliest masterpieces, among them this picture, which depicts
Lake Piediluco, near Terni, in Umbria. Nestled amidst the
Sabine Mountains and painted in an early morning light, the
lake acquires a pellucid clarity and transfixing stillness. Adding
to this is the subtlety of tone and colour, the entire scene
rendered in delicate shades of blue. The pearly colouring and
immaculate purity that characterize this landscape call to mind
the sublime harmonies coaxed out of nature by Vermeer.

The picture formed part of a magnificent gift through the
Art Fund by a member of its Executive Committee, Sir Michael
Sadler, in memory of his wife in 1931. This consisted of
paintings, drawings and works of Oriental art – including many
examples by Post-Impressionists and living British artists –
that were distributed to ten museums.

References: Peter Galassi, *Corot in Italy*, New Haven and London, 1991,
pp. 199-200; Gary Tinterow, Michael Pantazzi and Vincent Pomarède,
Corot, Metropolitan Museum of Art, New York, 1996, p. 72, no. 25.

42
William de Brailes (working *c.* 1230–60)
Tree of Jesse, c. 1240 (left)
1 of 6 leaves, illuminated manuscript, vellum; 36.3 x 28.7 cm
MS 330.vi / AF Review no. 0837
Syndics of the Fitzwilliam Museum, Cambridge
Presented in 1932 as a gift by the Art Fund; all 6 leaves acquired for £3,500 from Sir Alfred Chester Beatty

This is one of six leaves from an illuminated manuscript that were rescued by the Art Fund in 1932 from a sale of manuscripts owned by the American Chester Beatty. These had already been in an American private collection early in the twentieth century and were almost certain to return there had they not been secured for the Fitzwilliam Museum. This leaf depicts the Tree of Jesse, showing the sleeping figure of Jesse, from whom sprang the ancestors of Christ (Isaiah, 11, 1–3).

The English illuminator William de Brailes is cited in numerous documents relating to Oxford, where he lived with his wife Celena in Catte Street, an area of the city associated with book production. Another of the leaves that formed part of this manuscript, depicting the Last Judgement, shows the figure of de Brailes being rescued from hell by an avenging angel and bears the artist's signature – one of very few self-portraits to survive by any medieval master.

References: S.C. Cockerell, 'Six Leaves from a XIIIth Century Psalter Illuminated by W. de Brailes', in *National Art Collections Fund, Twenty-Ninth Annual Report, 1932,* 1933, pp. 42-47; F. Wormald and P. Giles, *A Descriptive Catalogue of the Additional Illuminated Manuscripts in the Fitzwilliam Museum,* Cambridge, 1982, pp. 319-20.

43
German, *Pair of Rimmonim,* 1757–59 (right)
silver-gilt; height 45.1 cm, diameter of base 15.2 cm each
JM 123 / AF Review no. 0830
Jewish Museum, London
Presented in 1932 as a gift by the Art Fund; part of a collection of Jewish antiquities acquired for £200 from the Howitt Collection

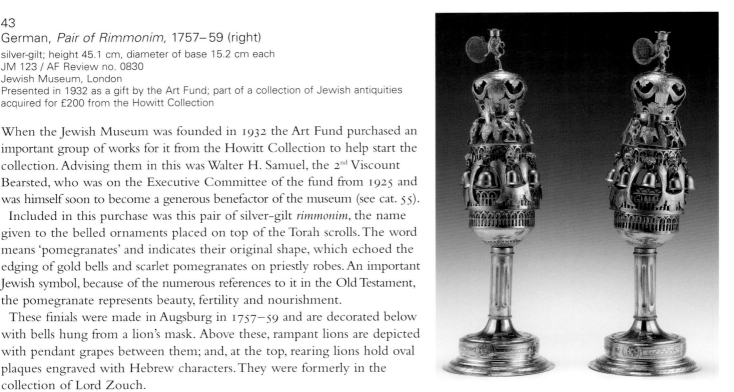

When the Jewish Museum was founded in 1932 the Art Fund purchased an important group of works for it from the Howitt Collection to help start the collection. Advising them in this was Walter H. Samuel, the 2nd Viscount Bearsted, who was on the Executive Committee of the fund from 1925 and was himself soon to become a generous benefactor of the museum (see cat. 55).

Included in this purchase was this pair of silver-gilt *rimmonim,* the name given to the belled ornaments placed on top of the Torah scrolls. The word means 'pomegranates' and indicates their original shape, which echoed the edging of gold bells and scarlet pomegranates on priestly robes. An important Jewish symbol, because of the numerous references to it in the Old Testament, the pomegranate represents beauty, fertility and nourishment.

These finials were made in Augsburg in 1757–59 and are decorated below with bells hung from a lion's mask. Above these, rampant lions are depicted with pendant grapes between them; and, at the top, rearing lions hold oval plaques engraved with Hebrew characters. They were formerly in the collection of Lord Zouch.

Reference: R.D. Barnett (ed.), *Catalogue of the Permanent and Loan Collections of the Jewish Museum, London,* London, 1974, p. 28, no. 123.

44

Ottonian (Germany), *The Basilewsky Situla*, c. 980

ivory; 16 x 13 cm
A.18-1933 / AF Review no. 0852
Victoria and Albert Museum
Acquired in 1933 for £7,900 from Durlacher and Company with a
contribution of £3,950 from the Art Fund and additional support from
the Funds of the Vallentin Bequest

Formerly in the collection of Tsar Alexander III, this *situla* –
or holy water bucket – was also once in the collection of
Alexander Petrovich Basilewsky. It was sold from the Hermitage
in the 1930s, along with many other works in the collection,
as a result of financial hardship in the Soviet Union. It is one
of only four such objects to survive, one of which is in Milan,
another in Aachen; the third was donated to the Metropolitan
Museum of Art, New York, in 1917 by J. Pierpont Morgan.
When the present work came up for sale in 1933, it was deemed
so desirable an addition to the nation's collections that the
Victoria and Albert Museum appealed to the Art Fund for half
of its purchase price – an appeal that was laudably heeded.

The *situla* was made around 980 to mark the visit of Otto II
to Milan. It contains twelve scenes from the Passion on two
superimposed rows: Christ washing the feet of the disciples;

Christ betrayed by Judas; the bargain of Judas and the High
Priest; the Crucifixion; Judas returning the thirty pieces of silver
to the High Priest; Judas hanging himself; the soldiers guarding
Christ's tomb; the Maries at the Sepulchre; the Harrowing
of Hell; Christ's appearance to the two Maries; Christ's
appearance to his disciples; and the Incredulity of St Thomas.

There are also three bands of inscriptions. The two upper
ones contain lines from the fifth-century hexameter version
of the New Testament by Coelius Sedulius. The band at the
base reads: 'May the Father, who added thrice five to the years
of Hezekiah, grant many lustres to the august Otto. Reverently,
Caesar, the anointing-vessel wishes to be remembered for its
art.' In 980 the mention of Hezekiah had special relevance,
since he ascended the throne at the age of twenty-five, which
was Otto's age in that year.

The *situla* would originally have contained a metal bucket
for holy water.

References: John Beckwith, *The Basilewsky Situla*, Victoria and Albert
Museum, London, 1963; Paul Williamson (ed.), *The Medieval Treasury:
the Art of the Middle Ages in the Victoria and Albert Museum*, London,
3rd ed., 1998, pp. 76-77.

45
Piero di Cosimo (1461–1521), *The Forest Fire*, *c.*1505
oil on panel; 71 x 203 cm
WA1933.2; A420 / AF Review no. 0853
Ashmolean Museum, Oxford
Presented in 1933 as a gift by the Art Fund; acquired for £3,000 from
Prince Paul of Yugoslavia

One of the most idiosyncratic – and inspired – outright
purchases ever made by the Art Fund, this picture was probably
a *spalliera* panel, intended to serve as the backboard of a large
chest or bench or (more likely) to be set into the panelling
of a room. Its imagery is fantastic and accords with Piero di
Cosimo's well-documented delight in the imaginary and
bizarre. At the centre left, a forest fire rages, from which animals
and birds flee in terror. Visible among them are a deer and pig
bearing human faces. At the lower left the earth itself appears
red-hot and charred by fire.

These details have been related to two episodes in the life
of primitive man discussed in Lucretius' *De rerum natura* of
*c.*55 BC. The first is the development of communication among
humans and animals through noise and gesture, and the second
is the melting of metals by heat – both of them key stages in
the history of civilization. Neither of these explains the human-
headed animals, however, which Piero added at the last minute,
perhaps to emphasize the uncanny nature of the scene.

According to Vasari, this is one of a series of panels painted for
Francesco del Pugliese, two others being in the Metropolitan
Museum of Art, New York. Another that was probably also part
of the series is in Ringling Museum, Sarasota. It was acquired
for the Ashmolean Museum through the intervention of the
museum's brilliant Keeper in the early 1930s, Kenneth Clark,
who purchased it himself when he realized that the dealer
Joseph Duveen was interested in it and then persuaded the
Art Fund to reimburse him.

References: Christopher Lloyd, *Piero di Cosimo's 'The Forest Fire'*,
Ashmolean Museum, Oxford, 1984; Catherine Whistler and David
Bomford, *'The Forest Fire' by Piero di Cosimo*, Ashmolean Museum,
Oxford, 1999.

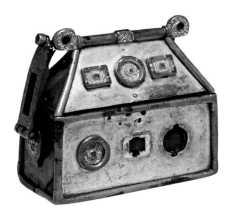

46
Celtic (Scotland), *The Monymusk Reliquary, c.* 8th century
wood, bronze and silver; 11.2 x 8.9 x 5.1 cm
H.KE.14 / AF Review no. 0863
Trustees of the National Museums of Scotland
Acquired in 1933 for £2,500 from Sir Arthur Lindsay Grant with a
contribution of £1,209 from the Art Fund

When *The Monymusk Reliquary* appeared in Christie's auction
rooms in 1933, to be sold from the collection of Sir Arthur
Lindsay Grant, it was the first time in twelve centuries that it
was seen outside Scotland. The exhibition *Saved! 100 years of
the National Art Collections Fund* is the second.

The work is one of nine known early Irish and Scottish
house-shaped reliquaries, made to hold sacred remains and to
be worn around the neck. Comparable examples elsewhere in
Europe contain fragments of bone. In 1211, it is mentioned
together with the name of St Columba (*c.* 521–97), the Irish
missionary who brought Christianity to western Scotland, but
this is the only occasion in which it is associated with this Saint.

The reliquary has enjoyed cult status in Scotland because it
was long identified with the *Breccbennach*, the ancient talisman
carried before the Scottish army in battle when Robert the
Bruce defeated the English at the Battle of Bannockburn in
June 1314, confirming his position as King of Scotland. For
this reason it has even appeared on recent Clydesdale Bank
£20 notes, alongside images of the battle and the King.

Recent research has concluded, however, that the identifica-
tion of *The Monymusk Reliquary* as the *Breccbennach* is unlikely;
for the latter was probably a standard or banner carried in
battle. *The Monymusk Reliquary*, which has no recorded history
before the nineteenth century, was the subject of misplaced
veneration when it caused such a sensation in Scotland at
its sale in 1933 – one which led even the Prime Minister at
that time, Ramsay MacDonald, to pledge his support for its
acquisition for the nation.

References: F.C. Eeles, 'The Monymusk Reliquary or Breccbennach of
St. Columba', in *Proceedings of the Society of Antiquaries of Scotland*,
68, 1933-34, pp. 433-38; David H. Caldwell, 'The Monymusk Reliquary:
the *Breccbennach* of St. Columba?', in *Proceedings of the Society of
Antiquaries of Scotland*, 131, 2001, pp. 267-82.

47
Vittore Carpaccio (1460/66 – 1525/26)
The Vision of St Augustine, 1502–03
pen and brown ink with grey wash; 27.8 x 42.6 cm
PD 1934-12-8-1 / AF Review no. 0911
Trustees of the British Museum
Presented in 1934 as a gift by the Art Fund; acquired for £650 from
Colnaghi

In the early years of the sixteenth century, Carpaccio – one
of the leading masters of Venice – painted a cycle of pictures
for the Scuola di San Giorgio degli Schiavoni. The surviving
series consists of nine works depicting episodes from the lives
of Saints Augustine, George, Jerome and Tryphon.

This is a compositional drawing for the scene depicting
St Augustine in his study. The episode portrayed derives from
an apocryphal account of the life of St Jerome. Augustine
has just sat down at his desk to write Jerome a letter when
'suddenly an indescribable light, not seen in our times …
entered the cell in which I was'. This unearthly glow revealed
to Augustine that Jerome had just died.

The drawing is extremely close to the painting and shows
Augustine, his pen poised, transfixed by the light streaming in
from a window. At the left a small cat (or ermine?) witnesses
this extraordinary vision. It becomes a crouching dog in the
finished picture.

This is one of many Italian Renaissance drawings purchased
outright by the Art Fund and presented to the British Museum
in the first half of the twentieth century (see cat. 51, 62).

Reference: A.E. Popham and Philip Pouncey, *Italian Drawings in the
Department of Prints and Drawings in the British Museum: the Fourteenth
and Fifteenth Centuries*, London, 1950, I, p. 22, no. 35.

48
Paul Cézanne (1839–1906)
Study from a Statuette of Cupid, c. 1890
graphite; 50.5 x 32.2 cm
PD 1935-4-13-2 / AF Review no. 0984
Trustees of the British Museum
Presented in 1935 as a gift by the Art Fund; acquired for £120 from
Alex Reid & Lefevre Ltd

The father of modern art, Cézanne has not figured prominently
in the Art Fund's history. The bequests of the Davies Sisters
of Wales and Samuel Courtauld amongst others have been
more important in gaining him a substantial representation in
the nation's collections. Indeed, when the *Great Bathers* was
acquired for the National Gallery in 1964, certain members of
the Art Fund reputedly threatened to resign if any contribution
was made towards it. In the event, a grant was never requested.

This is one of eleven drawings by the artist of a plaster cast
of Cupid that he owned. The original marble, now lost, was
attributed to the French sculptor Pierre Puget (1620–94)
but is of uncertain authorship. The motif was incorporated
into two of Cézanne's still life paintings (Nationalmuseum,
Stockholm, and Courtauld Gallery, London), attesting to the
revolutionary master's reverence for tradition.

The drawing was acquired for the British Museum a year
after the death of Roger Fry, one of the co-founders of the
Art Fund and the greatest champion of Cézanne in the early
twentieth century.

References: Adrien Chappius, *The Drawings of Paul Cézanne: A Catalogue
Raisonné*, Greenwich, Connecticut, 1973, I, p. 229, no. 988; *Cézanne*,
Tate Gallery, London, 1996, p. 388, no. 163.

49
English, *The Heneage ('Armada') Jewel, c.* 1550–75
gold enamel, rock crystal, diamonds and rubies; 7.1 x 5.2 x 1.1 cm
M.81-1935 / AF Review no. 0958
Victoria and Albert Museum
Presented in 1935 as a gift by Viscount Wakefield through the Art Fund

Known by two names, this jewel was reputedly a gift from
Queen Elizabeth I to Sir Thomas Heneage (died 1595) of
Copt Hall, Essex, in gratitude for his services as Treasurer at
War of the Armies during the time of the threat of the Armada.
However, Roy Strong has argued for a later date, *c.* 1600, on
the basis of the costume worn by Elizabeth in the miniature
by Nicholas Hilliard (?1547–1619) set within it. The front is
adorned with a profile portrait in gold of the Queen under
rock crystal, and the back forms a locket holding the miniature.
The cover of this depicts the Ark of the English church on a
storm-tossed sea and bears a motto which translates as 'Calm
amidst the raging seas'. The inside of the cover bears the device
of a red rose and the complementary inscription: 'Alas, that
virtue inviolate, with so great honour decked, hath not eternal
length of days.'

The jewel was among the greatest treasures of the Pierpont
Morgan Collection in New York. When it was sold at auction
in 1935, the Art Fund stepped in dramatically to reclaim it for
Britain, paying the entire purchase price. When Viscount
Wakefield learned of this he reimbursed the full amount and
presented it to the Victoria and Albert Museum through the fund.

References: *Sale of J.P. Morgan Miniatures*, Christie's, London, 24 June
1935, pp. 41-42, no. 99; R. Strong, *Artists of the Tudor Court: the portrait
miniature rediscovered, 1520-1620*, Victoria and Albert Museum, London,
1983, pp. 129-30, no. 208; Clare Phillips, *Jewels and Jewellery*, Victoria
and Albert Museum, London, 2000, pp. 38-39.

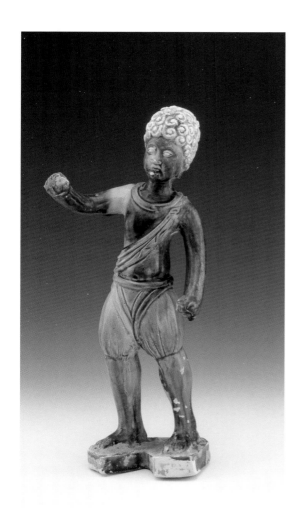

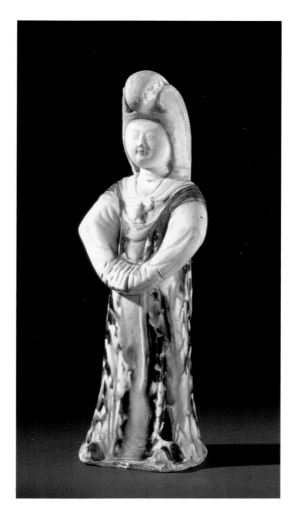

50

Chinese, Tang Dynasty (618–907 AD)

Ewer

Figure of a Foreigner (illustrated above left)

Tomb Figure of a Lady (illustrated above right)

glazed pottery; heights 28, 30 and 33.5 cm
Asia 1936.10-12.1, .288 and .135 / AF Review no. 0957
Trustees of the British Museum
Part of the Eumorfopoulos Collection (including paintings, sculptures,
jades and bronzes as well as pottery and porcelain) acquired in 1935 for
£100,000 from George Eumorfopoulos, with a contribution of £2,500
from the Art Fund and additional support from Sir Percival David and a
loan from the Bank of England for £10,000 guaranteed by Oscar Raphael

The Greek businessman George Eumorfopoulos (1863–1939)
was the first and lifelong president of the Oriental Ceramic
Society from 1921 and an insatiable collector of Chinese,
Korean and Near Eastern art. He displayed his collection in
a two-storey museum at the back of his house at 7 Chelsea
Embankment, which the public could visit. Though he had
always intended to bequeath his collection to the nation, the
Depression of the 1930s forced him instead to sell it to the
nation at a preferential rate. Three-fifths of it was acquired
by the British Museum and the remaining two-fifths by the
Victoria and Albert Museum between 1935 and 1940, with the
help of the Art Fund. According to Sir David Wilson, former

Director of the British Museum, the purchase of the collection
'was more complicated (in fundraising terms) than almost
anything else the museum had acquired'.

Exhibited in *Saved!* are three Tang ceramics from the collec-
tion, an area in which – according to the Art Fund *Report*
of 1935 – it had no 'serious rival'. These formed the contents
of tombs which were excavated and broken up as a result of
the building of the Chinese railway network. In addition to
vessels, dishes and containers, they include a cool ceramic
pillow, used to support a corpse's neck, a pert figure of a
standing and elegantly dressed lady, and a statuette of a black
boy with his right arm upraised, who was probably intended
to depict a young groom, holding the reins of a horse.

Between 1925 and 1932 the entire Eumorfopoulos Collection
was published in eleven volumes by various authors, led by
R.L. Hobson, then Keeper of the Department of Oriental
Antiquities and of Ethnography at the British Museum
(see below).

References: Sir C. Hercules Read and R.L. Hobson, 'The Eumorfopoulos
Collection', in *The Burlington Magazine*, ten articles between January 1919
and June 1920, XXXIV, 190, p. 15; 191, pp. 69-74; 192, pp. 100-06; 195,
pp. 231-37; XXXV, 196, pp.19-26; 197, pp. 67-68; 200, pp. 211-17; XXXVI,
202, pp. 27-30; 205, pp. 183-89; 207, pp. 299-300; Robert Lockhart Hobson
and others, *The George Eumorfopoulos Collection*, London, 1925-32.

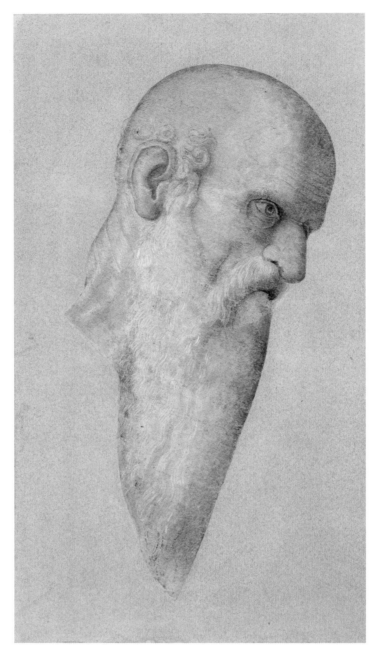

51

Giovanni Battista Cima da Conegliano (*c.* 1459–*c.* 1517)
Head of St Jerome, *c.* 1496–98

brush drawing in brown ink, heightened with white on blue paper;
25.2 x 12 cm
PD1936-10-10-8 / AF Review no. 1001
Trustees of the British Museum
Presented in 1936 as a gift by the Art Fund; acquired for £273 from
Henry Oppenheimer

In *c.* 1496–48, the Venetian master Cima painted a large
altarpiece of the *Virgin and Child with Saints Jerome and Louis of
Toulouse* (Accademia, Venice), popularly known as the *Madonna
of the Orange Tree*, for the church of Santa Chiara on the island
of Murano, outside Venice. This detailed drawing is a study
for the head of St Jerome in this painting. It is exactly the
same size as the finished head, suggesting that it may have

served as a guide during the completion of the picture. Since
it is unmarked by a stylus or by pricking, it cannot have been
used as a cartoon in the usual sense.

The year 1936 was something of an *annus mirabilis* for the Art
Fund. In addition to assisting the National Gallery to acquire
Rubens' *Watering Place*, it purchased outright the Evesham
Psalter and seven drawings at the sale of Henry Oppenheimer's
collection for the British Museum. The majority of these, like
the present work, were of the Italian Renaissance.

References: A.E. Popham and Philip Pouncey, *Italian Drawings in the
Department of Prints and Drawings in the British Museum, the Fourteenth
and Fifteenth Centuries*, London, 1950, I, p. 25, no. 40; Peter Humfrey,
Cima da Conegliano, Cambridge, 1983, pp. 65-6 and 175, no. 194.

52
Iranian, *Basin*, 2600–2400 BC

chlorite; 11.4 x 17.8 cm
ANE 128887 / AF Review no. 1018
Trustees of the British Museum
1 of 6 works acquired in 1936 for £1,000 from Mme Luiz de Sousa
Barbosa with a contribution of £500 from the Art Fund

One of six works found in ancient Mesopotamia and purchased by the British Museum in 1936, this handsome bowl was part of the Art Fund's fourth major acquisition of this type for the museum. Among the earlier ones were a monumental stone trough – purchased outright by the fund in 1928 and presented to the museum – and the seer-like statue of Gudea acquired three years later (cat. 40).

This chlorite basin is decorated with mythological scenes in relief. Prominent among them is the figure of a man taming two spotted snakes. To either side of him sit two animals with their heads turned back and tails erect. To the right, a vulture and lion attack a prostrate bull. On the opposite side is a contrasting scene showing a kneeling figure 'holding' two streams of water. To either side of it are two Brahmani or Indian humped bulls.

The basin was made in south-east Iran where this type of stone is commonly found and where the local inhabitants developed a lively local style of carving known as the 'Inter-cultural Style'. This was exported to southern Mesopotamia, which was ruled by the Sumerians between *c.* 3500 and *c.* 2000 BC. Mesopotamia encompassed modern Iraq, north-east Syria and parts of south-east Turkey, but it had trade connections much further afield.

References: S. Smith, 'Early Sculptures from Iraq', in *British Museum Quarterly*, XI, 1937, pp. 117-19; E. Strommenger, *The Art of Mesopotamia*, London, 1964, p. 388.

53
Achaemenid Persian (Iran)
Relief of a Sphinx, 4th century BC

limestone; 82 x 75 x 7.5 cm
ANE 129381 / AF Review no. 1067
Trustees of the British Museum
Presented in 1937 as a gift by the Art Fund; acquired for £600 from
Alfred Spero

Founded by Cyrus the Great in 550 BC, the Achaemenid Empire dominated the Near East from the sixth to the fourth centuries BC. At its height, under Darius I (522–486 BC), construction began on the great royal centre of Persepolis, a complex of palaces, columned halls and storerooms on a huge terrace cut into natural rock, which was reached by a group of monumental stairways.

This relief was originally part of the façade of one of these palaces, which was constructed by the ruler Artaxerxes III (reigned 358–338 BC), but was eventually transferred to form part of the staircase of another palace. It depicts a male sphinx wearing the elaborate head-dress of a divinity. Intended to protect the building from an enemy, he raises his left forefoot, to ward off intruders. Such fantastic beasts were derived from Assyrian art, where they were colossal figures guarding palaces and gateways.

This relief was discovered at Persepolis in June 1826 during excavations by Lieutenant-Colonel John MacDonald (Kinneir), then heading an official delegation from the East India Company to the Persian Court. It originally formed one of a pair, but its pair no longer survives. Like all of the sculptures at Persepolis, it would originally have been coloured, but no evidence of the exact colour scheme survives.

References: D. Collon, *Ancient Near Eastern Art*, British Museum, London, 1995, pp. 180-81; J. Curtis, *Ancient Persia*, British Museum, London, 2000, p. 53.

54

Joseph Wright of Derby (1734–97), *Miravan Breaking Open the Tomb of his Ancestors*, 1772

oil on canvas; 127 x 101.6 cm
DBYMU 1937-657 / AF Review no. 1060
Derby Museums and Art Gallery
Presented in 1937 as a gift by Mr and Mrs A.L. Nicholson through the Art Fund

Of the myriad British artists associated with the Art Fund, few can have enjoyed greater favour than Wright of Derby, whose reputation has risen steadily since the early twentieth century. More than two dozen works by him have entered the nation's collections via this channel since 1925, one of the greatest being this mesmerizing canvas.

The subject is from John Gilbert Cooper's *Letters Concerning Taste* of 1755. Miravan, an Arab nobleman, has come upon the tomb of one of his ancestors inscribed with the words 'in this tomb is a greater treasure than Croesus ever possessed'.

Inflamed by greed, he orders it to be opened and is struck dumb when he discovers only a heap of dust and bones, his avarice unrewarded.

Wright portrays Miravan recoiling in horror as two workmen violate the tomb, one of them pointing to the inscription, as though bewildered by the disparity between its claims and the tomb's contents. Intensifying the drama and theatricality of the whole are the smashed door and the lurid moonlit sky, which add a sense of menace to the picture.

References: Benedict Nicolson, *Joseph Wright of Derby*, London and New York, 1968, I, pp. 53-54 and 243, no. 222; Judy Egerton, *Wright of Derby*, Tate Gallery, London, 1990, pp. 93-94, no. 42; F.P. Lock, 'Wright of Derby's "Miravan breaking open the tomb of his ancestors"', in *The Burlington Magazine*, CXLI, 1158, 1999, pp. 544-45.

55
Italian, 16th–17th century
Jewish Betrothal Ring (above left)
gold filigree with enamel; diameter 3.5 cm
JM 463 / AF Review no. 1058
Jewish Museum, London
Presented in 1937 as a gift by Viscount Bearsted through the Art Fund

South German, 17th–18th century
Jewish Betrothal Ring (above right)
gold; diameter 3.8 cm
JM 464 / AF Review no. 1093
Jewish Museum, London
Presented in 1938 as a gift by Viscount Bearsted through the Art Fund

Betrothal rings were common within the Jewish community in northern Italy and south Germany from the sixteenth to the eighteenth century. Ceremonial in purpose, they were often given by the fiancé to his bride-to-be one year before the marriage and were normally too big to wear regularly, but scholars remain uncertain as to exactly how they were used.

The Italian ring illustrated here is in gold filigree with large central bosses and small border bosses in blue and white enamel. Its blue enamel roof is hinged to reveal a small locket; and the inside of the ring is engraved with the Hebrew letters for 'Good Luck'. The south German ring is identically inscribed and decorated with a bezel in the form of a Romanesque synagogue.

Both are among the many bequests presented to the Jewish Museum through the Art Fund by Viscount Bearsted and his family, the most spectacular of which is the unrivalled Synagogue Ark, presented by the Viscount's children in 1937, which is so large that it can never be removed from the museum.

References: R.D. Barnett (ed.), *Catalogue of the Permanent and Loan Collections of the Jewish Museum*, London, 1974, p. 85, nos. 463-64; Gertrude Seidmann, 'Marriage Rings in the Jewish Museum, London', in *Annual Report of the Jewish Museum, London*, 1982, pp. 5-7.

56
Roman or Germanic, *Ship's Figurehead*, 4th–6th century
oak; height 149 cm
P&E 1938,2-2,1 / AF Review no. 1096
Trustees of the British Museum
Acquired in 1938 for £750 from Dr Burg with a contribution of £350 from the Art Fund

Dredged from the River Scheldt near Appels in Belgium in 1934, this striking ship's figurehead was initially believed to be of the Viking period and dated to the ninth century. In 1970, however, the British Museum's Research Laboratory undertook carbon-14 analysis of it which proved that it was much earlier in date. It is now thought to be either late Roman or Germanic and to derive from the Migration Period, when the Germanic peoples roamed throughout much of Europe, or the time of consolidation of the Germanic kingdoms around the North Sea basin. The wood has been dated to 350-650 AD but the figurehead was probably carved in the fourth to sixth century.

The menacing appearance of the carving, with its gaping mouth and large eyes and teeth, probably had a protective function at a time when journeys by ship were dangerous and it was seen to be necessary to ward off the evil forces encountered at sea.

Excellently preserved, the figurehead is equipped at the base with a long rectangular tenon containing a hole for a cylindrical attachment, a peg or dowel, which suggests that it was designed to be removable.

References: R.L.S. Bruce-Mitford, *Aspects of Anglo-Saxon Archaeology, Sutton Hoo and Other Discoveries*, London, 1974, pp. 175-87; D.S.W. Kidd, 'Fifty Years On: New Discoveries about an NACF Grant of 1938', in *National Art Collections Fund Magazine*, 38, 1988, pp. 8-10.

57

Attributed to Filippo Negroli (active 1532–51) and brothers of Milan, *Burgonet (Parade Helmet)*, *c*.1540–45

embossed steel with gilt details; 31.4 x 20.2 x 29.3 cm
M.19.1938 / AF Review no. 1095
Syndics of the Fitzwilliam Museum, Cambridge
Acquired in 1938 for £1,750 from John Hunt with a contribution of £1,250 from the Art Fund and additional support from the Friends of the Fitzwilliam

Filippo Negroli was known by his contemporaries for making 'miraculous helmets and bucklers' and this example, which is widely attributed to him and his workshop, is no exception, hammered out of a single piece of metal and elaborately embossed and further decorated by counterfeit-damascening in gold. The visor takes the form of a lion's mask and the skull is embossed with trophies, acanthus leaves and allegorical figures of Fame (right) and Victory (left). The comb includes an inscription in Greek which may be translated as 'by these things to the stars' and is counterfeit-damascened in gold.

The chinpiece is missing. The helmet is likely to have had a distinguished original owner, as Negroli worked for both the Emperor Charles V and his son, the Archduke Ferdinand.

'The finding of the helmet is one of the romances of the art world in recent times', declares the entry on it in the Art Fund *Report* for 1938. 'The story goes that it appeared at a sale of theatrical properties in London where it might have been sold to disappear into the limbo where unwanted theatrical properties eventually go.' Instead, it was sold to a small trader who thought it might have some value. He took it to the Wallace Collection, where its importance was immediately recognized.

References: Charles R. Beard, 'A New-Found Casque by the Negroli', in *The Connoisseur*, CI, June 1938, pp. 293-99; S.W. Pyhrr and J.A. Godoy, *Heroic Armor of the Italian Renaissance, Filippo Negroli and his Contemporaries*, New York, 1998, pp. 209-12; Ian Eaves, *Catalogue of European Armour at the Fitzwilliam Museum*, Woodbridge, 2002, pp. 204-06.

58

Roman, *Cameo Portrait of Claudius*, 41–50 AD

sardonyx; 6.2 x 5.8 cm
GR 1939.6-7.1 / AF Review no. 1165
Trustees of the British Museum
Presented in 1939 as a gift by the Art Fund; acquired for £100 from
Eric Hope Masham

The Roman Emperor Claudius I ruled from 41 to 54 AD,
married two murderous wives, Messalina and Agrippina,
and was eventually poisoned by a toadstool sauce added to
his mushrooms. Pliny tells us that he was fond of wearing
sardonyx cameos.

This example, formerly in the collection of Sir Bernard
Oppenheimer, is a fragment showing only the Emperor's head
crowned with a laurel wreath. Originally it would have been
much larger and probably also included his shoulders.

The sardonyx stone used here is horizontally stratified and
carved so that the flesh is a semi-transparent blue-white, the
hair an opaque pure white and the wreath and background
a tortoiseshell brown. Though clearly idealized, the profile
is characteristic of Claudius' portrait type in the sharp angle
between the flat top of the skull and the forehead, the small,
deep-set eyes and prominent brows and the slanting line
between the chin and neck. It probably dates from relatively
early in the Emperor's reign and has been tentatively attributed
to the famous gem-engraver Herophilos, the son of
Dioskourides.

References: D.E.L. Haynes, 'A Sardonyx Cameo Portrait of Claudius',
in *The British Museum Quarterly*, 13, 1939, pp. 79-81; W.R. Megow,
Kameen von Augustus bis Alexander Severus, Berlin, 1987, pp. 61-62
and 194, no. A75.

59

Ifé, Yoruba People (Nigeria), *Head with a Beaded Crown
and Plume*, 12th–15th century

leaded brass; height 36 cm
Ethno 1939.Af34.1 / AF Review no. 1154
Trustees of the British Museum
Presented in 1939 as a gift by the Art Fund; acquired for £100 from an
anonymous vendor

One of a group of heads excavated in 1938 behind the
palace at Ifé, this remarkably life-like brass head depicts an
unidentified ruler of the Yoruba people of southern Nigeria.
He wears a crown painted red to represent carnelian beads
(traces still remain), and the small holes surrounding the mouth
were probably intended for inserting hair to depict a beard
and moustache.

The head was possibly made for use at funerary ceremonies,
when it may have been attached to a wooden figure. Its date
is unknown, but is most likely to be between the twelfth and
fifteenth centuries and it is characteristic of the art of Ifé in
its realism. This led the German anthropologist Frobenius to
assume that it was the product of Western inspiration, its
naturalism revealing a highly advanced civilization, a status
he denied to Africa. Predating European influence in Africa
in the fifteenth century, this is now regarded as one of the
supreme achievements of West African art.

References: William R. Bascom, 'The Legacy of an Unknown Nigerian
"Donatello"', in *The Illustrated London News*, vol. 194, no. 5216,
8 April 1939, pp. 592-94; H. and V. Meyrowitz, 'Bronzes and Terra-cottas
from Ile-Ifé', in *The Burlington Magazine*, LXXV, 189, 1939, pp. 151-55;
John Mack (ed.), *Africa: Arts and Cultures*, New York and Oxford, 2000,
p. 100, no. 24.

Auguste Rodin, *The Burghers of Calais*

James Hall

The unveiling of a cast of Rodin's *Burghers of Calais* (cat. 11) in London in 1915 could not have been more low-key, yet the acquisition of this piece was a major landmark in the history of collecting in Britain. When negotiations to acquire it began in 1910, it was the first time that the National Art Collections Fund (Art Fund) had proposed buying a major work of sculpture, and the first acquisition intended for an outdoor location. After protracted and often acrimonious arguments over a site and pedestal, the statue was installed on a high pedestal next to the Houses of Parliament in the autumn of 1914, but it was kept under wraps for months. It was finally 'unveiled' surreptitiously on the night of 19 July 1915. This bathetic episode sheds fascinating light on attitudes to public sculpture, and the questions it raised have still not been fully answered today.

The Burghers of Calais, on which Rodin worked from 1884 to 1889, was his first commission for a public commemorative monument.[1] The Calais town councillors envisaged it as a memorial to Calais' most celebrated son, Eustache de Saint-Pierre, who offered himself as hostage to King Edward III of England in 1347. Calais had been besieged for eleven months, and the King offered to spare the town if six of its citizens gave themselves up as hostages. According to the fourteenth-century chronicler Jean Froissart, Edward insisted they come out 'with their heads and their feet bare, halters round their necks and the keys of the town and castle in their hands. With these six I shall do as I please, and the rest I will spare.' Eustache, the richest man in Calais, was the first to volunteer.

Instead of having a single dominant figure, in the conventional manner, Rodin sent a plaster maquette of six figures of almost equal height, bound together and placed on top of a triumphal arch. Rodin's main advocate, the painter Jean-Charles Cazin, said his proposal 'glorified the entire population'. The *mise-en-scène* recalled traditional Breton Calvaries – church monuments in which arched pedestals were surmounted by sculpted figures representing the Crucifixion. The maquette was approved and Rodin started work on a second, larger maquette in which the individuality and suffering of the six figures was intensified. This proved controversial. The local newspaper, *Le Patriote*, complained that it was too depressing: 'We want to say, "If your sadness is so great … why didn't you stay at home?"' The councillors thought it made their ancestors look like criminals rather than martyrs. But Rodin mounted a powerful defence in which he claimed to be expressing 'the Gallic soul of our Gothic epoch'.

Many still had misgivings, but the Mayor, Omer Dewavrin, supported Rodin, who carried on undaunted, making hundreds of studies, working on the bodies, the hands and the heads separately. Wherever possible, he sought models from Calais. The completed plaster, with each figure almost 7 ft-high, was shown at Georges Petit's Paris gallery in 1889, as part of a two-man show with Monet. Because of an economic crisis, further disagreements in the Town Council, and disputes over a site and a pedestal, the casting into bronze was delayed, and the unveiling had to wait until 1895. *The Burghers of Calais* was hailed as a masterpiece by the critics, but the mixed feelings of the locals were reflected in a souvenir postcard whose caption informs us that the general public found it 'a bit too realistic' (fig. 26).[2] Rodin was unhappy

fig. 26 Nineteenth-century postcard showing the cast of *The Burghers of Calais* in the Place de l'Hôtel de Ville, Calais

cat. 11 (right)
Auguste Rodin, *The Burghers of Calais*, 1884–95, cast 1907–08 (detail)

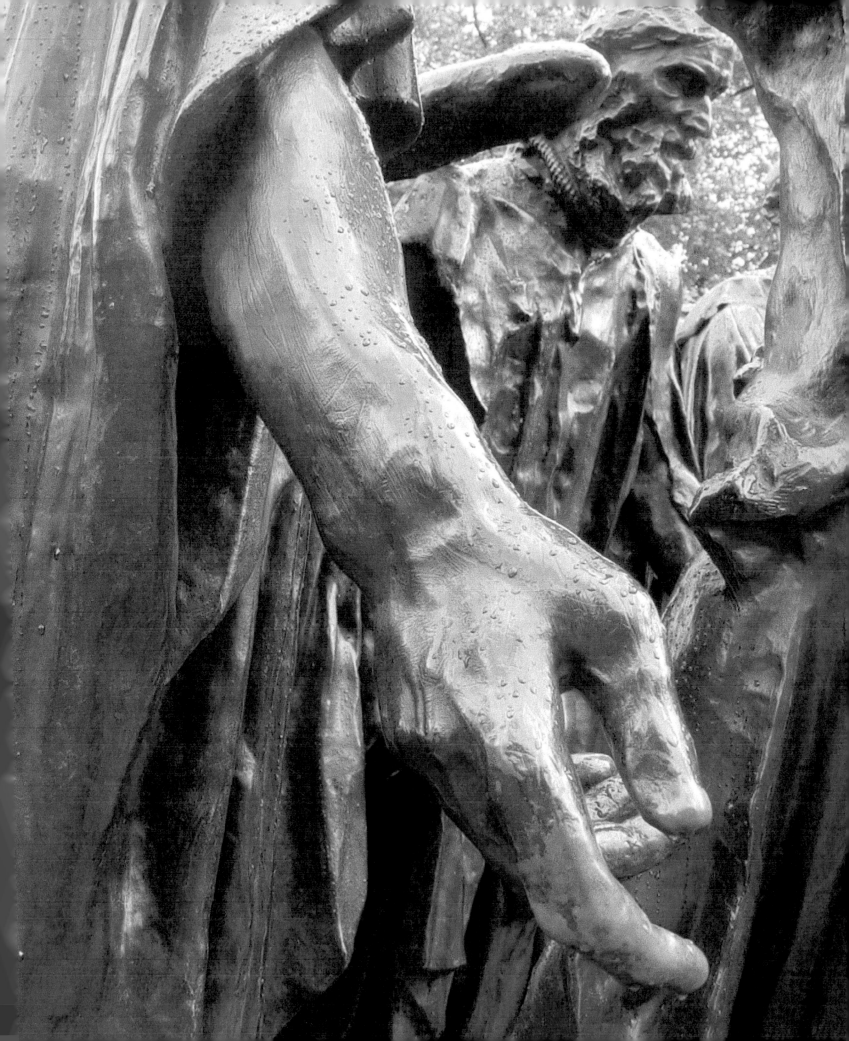

fig. 27 Auguste Rodin, *The Kiss*, 1901–04, marble, 182.2 x 121.9 x 153 cm, Tate. Art Fund assisted 1953

some of the casting seams are still visible, as are pieces of plaster from the casting process.

The asymmetrical disposition of Rodin's figures, and the range of gesture, is extraordinary. There is a subtle but clear development from the figures at the rear, whose muscles are tightly clenched, through to those at the front, whose gestures have an almost balletic grace. It is as though Rodin conceived the group as different sections of a tree, with gnarled roots at one end and swaying branches at the other. The Austrian poet Rainer Maria Rilke, writing in 1903, evoked the 'vague gesture' of the adolescent Pierre de Wissant, who is at the front of the procession of burghers: 'His right arm is raised in an uncertain curve; his hand opens in the air and lets something go, somewhat in the way in which we set free a bird.'[4] He is sleepwalking towards his own fate: he looks back to the dreamy musicians and lovers of Watteau, and forward to the melancholy acrobats of Picasso's Blue and Rose periods.[5] The sculpture as a whole prophesies the non-hierarchical arrangement of parts that occurs in so much modern and contemporary sculpture. It is one of the greatest figure groups in European art.

The English were second only to the Germans in their enthusiasm for Rodin.[6] In the 1880s and 1890s it was young artists who hero-worshipped him. But after Rodin's one-person show at the 1900 *Exposition Universelle* in Paris established him as the world's most celebrated living artist, they were joined in droves by the very rich and the titled. Yet these wealthy patrons were far more inclined to commission portrait busts than to buy his more controversial and often erotic figure sculptures. In the twentieth century, the English commissioned more portrait busts from Rodin than did any other nationality. But exhibitions, as well as acquisitions of major works, were relatively scarce. The first important acquisition was the striding figure of *St John*, given to the Victoria and Albert Museum in 1902, and paid for by a subscription initiated by a group of friends, most of whom were artists. They included the painters William Rothenstein and John Singer Sargent, and the critic and painter D.S. MacColl, who had written a rapturous review of the Paris exhibition. The other major commission came from Rothenstein's friend Edward Perry Warren, a wealthy American who lived in

both with the location and with the 5 ft-high pedestal, and the work has subsequently been redisplayed in front of Calais town hall at ground-level.

Apart from the Breton Calvaries, the most important precedents for this startlingly original figure group are the hooded standing mourners (*pleureurs*) that were often placed on the side of free standing medieval tombs, beneath the recumbent effigy of the deceased.[3] Free-standing figures of scantily clad mourners are subsequently found on Baroque tombs, and they became ubiquitous in the nineteenth century. Mostly, they are individual female figures elegantly swooning by the side of a tomb, but Canova's tomb of Maria Christina of Austria (1798–1805) in the Augustinerkirche, Vienna, has a procession of mourners, including an old man, walking towards a door. Stylistically, Rodin's biggest debt would appear to be to the sculpture of Donatello, with its expressively modelled surfaces and gaunt physiognomies. However, Rodin's sculptures are far more 'unfinished' than any previous completed sculptures. In the *Burghers*

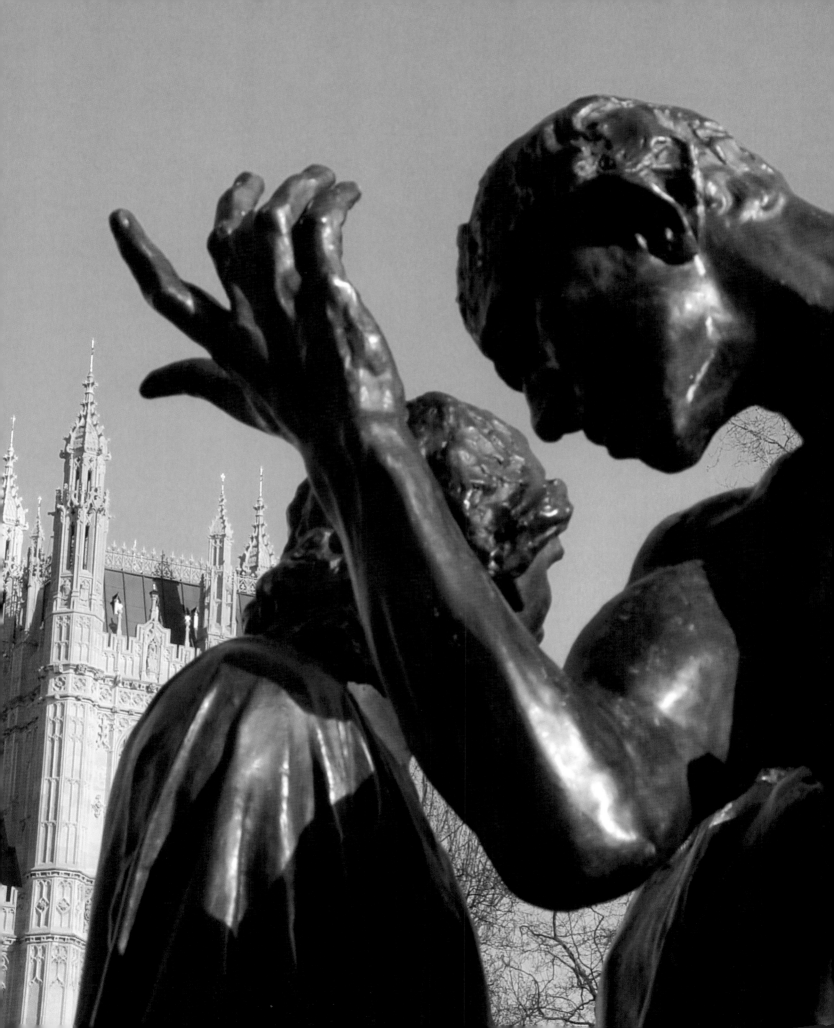

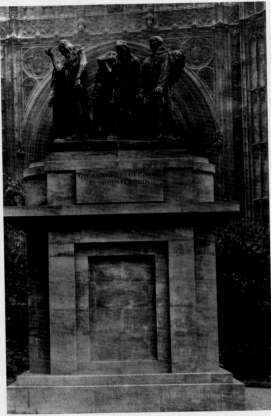

fig. 28 *The Burghers of Calais* on its original pedestal in Victoria Tower Gardens, London. From a photograph in *Country Life,* 31 July 1915

Sussex and collected antiquities, with a strong emphasis on male nudity. In 1900, Warren ordered a marble version of *The Kiss* (fig. 27), stipulating that the 'genital organ of the man is to be presented in its entirety'.

D.S. MacColl, one of the founding members of the Art Fund, believed work by contemporary artists should be collected, as they would be 'the masters of the future'. When in 1910 a cast of *The Burghers of Calais* was offered to the Art Fund for £2,400, it is not surprising that the fund agreed to purchase it.[7] The cast had been ordered from the Paris founders Alexis Rudier by a Belgian collector in 1906 and delivered in September 1908. But the owner died in 1909, and the group was bought by another Belgian collector, Joseph Mommen, who exhibited it at the 1910 *Exposition Universelle* in Brussels. Due to financial problems he in turn sold it to the Art Fund.[8] As a group of walking figures *The Burghers* complemented the Victoria and Albert Museum's *St John*.[9]

The Burghers was purchased by the Art Fund during the heyday of the Entente Cordiale, and Rodin was an important symbol of the close relationship between France and Britain. The first of his many visits to England was in 1881, and in 1903 he had succeeded Whistler as President of the London-based International Society of Sculptors, Painters and Gravers; the francophile King Edward VII visited him at his home at Meudon in 1908. Later that year a French artist included Rodin in an album of portrait drawings of the most important promoters of the Entente Cordiale. Nonetheless, it hardly seems fortuitous that the most prominent French sculpture in England should represent their defeat by the English.

As with the original *Burghers* for Calais, there were protracted wrangles over the choice of site and plinth in London. The Art Fund approached the Office of Works about finding a site, and recommended a new garden, then under construction, which would extend from the Victoria Tower of the Houses of Parliament to Lambeth Bridge (Victoria Tower Gardens). This proposal was initially rejected, but after the Trustees of the Wallace Collection refused to site it in front of Hertford House, the Office of Works reverted to the Gardens. Rodin, however, wanted it to be sited on a high pedestal in Old Palace Yard, in front of the Houses of Parliament, 'near the statue of William the Conqueror' (he meant Marochetti's *Richard the Lion-Heart*, but his mistake seems like wishful thinking). On 28 May 1913 Rodin was driven around London to see some other potential sites, but he eventually agreed to Victoria Tower Gardens.

Negotiations dragged on, however, because of serious disagreements with the Art Fund. They felt that the Neo-Gothic Victoria Tower was an inappropriate backdrop. They instead proposed a site in the middle of the Gardens and a pedestal not more than 9 ft-high on which would be inscribed the name of the artist and the title of the work, together with an English translation of Froissart's text and the names of the donors. At one point the Art Fund threatened to offer the *Burghers* to the Victoria and Albert Museum if their wishes were not met. The Office of Works sided with Rodin, however, and the Art Fund backed down. But a strike in the building industry halted work on the pedestal until the summer of 1914, when Britain declared war on Germany. The fund, evidently still smarting, insisted the unveiling ceremony be delayed, and the sculpture boarded up, because it was

inappropriate to draw attention to a group representing the 'Surrender of Calais' at a time when German troops were trying to reach the town. Questions were soon asked in Parliament, and a letter was even sent to *The Times* from the 'Burghers of Calais' complaining that 'to keep us concealed is hardly polite to Monsieur Rodin'.[10]

After the 'unveiling' on the night of 19 July 1915, the *Burghers'* travails were by no means over. The Art Fund complained that the 16-ft pedestal, which was based on Donatello's *Gattamelata* monument in Padua, made it impossible to see the lower parts of the figures, and that it was too close to the overpowering Victoria Tower (see fig. 28). These objections were widely shared. During the 1930s it was suggested the group be transferred to the Tate Gallery. Nothing happened, however, until the spring of 1956, when the sculpture was moved nearer to the centre of the gardens and placed on a new pedestal, which incorporated the original inscription carved by Eric Gill. At just over 2 ft-high, it fitted the fashion for low pedestals. It is comparable to those used for open-air sculpture exhibitions in London parks after the Second World War.

While allowing closer scrutiny of the figures, the lower pedestal has exposed the sculpture to vandalism. Proposals have since been made to re-erect it on a higher base or even to put it on the fourth plinth in Trafalgar Square. While these proposals would make it more vandal-proof, they would do nothing to protect it from atmospheric pollution, from which it has also suffered. In 1999 it was covered in an inappropriate thick, black wax coating by the Office of Parliamentary Works, which has made it irresistible to graffiti writers.[11]

To coincide with its centenary, the Art Fund has undertaken the restoration and reinstallation of the *Burghers* on a new plinth, generously funded by Sir Nicholas Goodison (Chairman of the Art Fund from 1986 to 2002) and his wife, Judith. The newly restored *Burghers* is displayed in the *Saved!* exhibition for the first time, and at its close the sculpture will return to Victoria Tower Gardens, where it will be installed in the centre of the Gardens on a plinth more in keeping with the original design. The Art Fund has liaised closely with the Royal Parks to devise an appropriate annual maintenance programme that will safeguard the sculpture for the foreseeable future. It is hoped that this conservation programme will become a model on which the maintenance of all public sculptures in Britain will be based.

James Hall is an art critic, historian and lecturer. He is the author of *The World as Sculpture: the Changing Status of Sculpture from the Renaissance to the Present Day* (1999).

Notes

1
All quotes relating to the *Burghers* are taken from the following sources: Claudie Judrin, Monique Laurent and Dominique Viéville, *Auguste Rodin: Le Monument des Bourgeois de Calais*, Musée Rodin, Paris, 1977; Mary Jo McNamara and Albert Elsen, *Rodin's Burghers of Calais*, Beverley Hills, 1977; Ruth Butler, *Rodin: The Shape of Genius*, New Haven and London, 1993, chap 16.

2
I am grateful to Philip Ward-Jackson for bringing this postcard to my attention.

3
Erwin Panofsky, *Tomb Sculpture*, London, 1964, pp. 61–62; cf also the tomb of Philippe Pot in the Louvre.

4
Rainer Maria Rilke, *Rodin and Other Prose Pieces*, G. Craig (trans.), Houston and London, 1986, p. 37.

5
For Rodin, Watteau and the *Burghers* see Auguste Rodin, *Art: Conversations with Paul Gsell*, Jacques de Caso and Patricia B. Sanders (trans.), Berkeley, 1984, pp. 34ff (originally published in French in 1911). The figure of Jean d'Aire resembles a tense version of Watteau's *Pierrot* (Louvre, Paris).

6
For Rodin and the British see Butler, *Rodin: The Shape of Genius*, chap 29, and David Fraser Jenkins, 'How the British Came to Like Rodin', in *Rodin in Lewes*, Lewes Town Hall, 1999, pp. 17–25.

7
For the early years of the Art Fund see Robert C. Witt, 'The National Art Collections Fund and its Achievements', in *Connoisseur Christmas Annual 1914*, pp. 29–33. The Art Fund was more interested in modern foreign painting than sculpture: Witt urges the creation of a gallery of modern foreign painting.

8
Vers L'Age d'Airain: Rodin en Belgique, Musée Rodin, Paris, 1997, pp. 437 and 447–70.

9
Three casts were made of the *Burghers* during Rodin's lifetime in addition to the one at Calais. Twelve additional casts were made after Rodin's death, as well as many bronzes of individual figures.

10
The Times, 4 March 1915. I am grateful to Tania Adams for this reference.

11
See Sir Nicholas Goodison 'Rodin at Risk', in *Art Quarterly*, Summer 2000, p. 7, and Andrew Naylor, 'Conservation or Preservation', in *Art Quarterly*, Winter 2000, pp. 15–17.

60
Pre-Columbian, Quimbaya period (600–1600)
Neck of a lime flask, c. 600 AD
gold and copper alloy; height 16.2 cm
Ethno 1940 Am11.2 / AF Review no. 1194
Trustees of the British Museum
1 of 2 works presented in 1940 as a gift by the Art Fund; acquired for
£150 from Lady Davis

61
Abraham Gessner (1552–1613), *The Drake Cup, c.* 1571
silver gilt; height 52 cm
1942.65 / AF Review no. 1259
Plymouth City Museum and Art Gallery (on long term loan to Buckland
Abbey)
Presented in 1942 as a gift by the Art Fund; acquired for £2,100
from Christie's

When it was purchased for the museum in 1940, this consisted
of two distinct objects. A female figure seated on a stool sat
on top of this trumpet-shaped neck of a lime flask. They had
been soldered together in such a way as to make the latter serve
as a pedestal for the figure, but their relationship was not orig-
inal and must have been contrived in post-Columbian times.

Both objects are made of gold-copper alloy and owe their
surface brilliance to a process which retains the gold on the
exterior. The Spaniards referred to such alloys as *tumbaga*, a
Malay word meaning copper.

This portion of the flask is adorned with six human heads of
formidable austerity. Around the bottom edge are four holes
for the attachment of the rest of the flask. The work originated
in the Cauca Valley and is ascribed to the ancient Quimbaya
people who lived between 1000 and 1500 AD, contemporary
with the Incas in Peru. The greatest collection of their work
in the world is the so-called 'Treasure of the Quimbayas', which
was discovered in 1891 and is now in the Museo Arqueológico,
Madrid. The acquisition of this work strengthened significantly
the holdings of Pre-Columbian gold which are also among
the pre-eminent collections of the British Museum.

References: 'Gold Filigree from Ancient Columbia', in *National Art-
Collections Fund, Thirty-seventh Annual Report*, 1940, p. 7; *The Gold
of El Dorado*, Royal Academy of Arts, London, 1978, p. 191, no. 374; Colin
McEwan (ed.), *Precolumbian Gold: Technology, Style and Iconography*,
London, 2000, pp. 94-109.

This magnificent cup would have been an inspired purchase
by the Art Fund at any time, but was especially so during the
Second World War, when it was presented to the city of
Plymouth 'in recognition of the courage and fortitude shown
by the citizens during enemy action by air-raids, and in view
of Sir Francis Drake's close association with the City'. By
tradition, it was said to have been given to Drake by Queen
Elizabeth I in 1579 upon his return from circumnavigating
the globe in the *Golden Hind*. But there is another tradition
that claims that Drake actually gave it to the Queen in 1582.
Since it remained in the collection of Drake's heirs until
1919, the former is more likely to be true.

It was made by Abraham Gessner, the celebrated gold- and
silversmith of Zürich, and depicts the terrestrial globe. The
names of the continents, islands and seas are engraved in Latin;
and sailing vessels, dolphins and whales are depicted on the
seas. The stem is shaped like an oviform vase and decorated
with marine deities. The cover is surmounted by a vase and
armillary sphere, a skeleton celestial globe in which the great
circles of the heavens (e.g. the equator, polar circles, etc.) are
represented by rings or hoops, which revolve on an axis within
a low horizon.

Reference: 'The Drake Cup', in *National Art-Collections Fund, Thirty-ninth
Annual Report*, 1942, p. 7.

62
Attributed to Francesco da Sangallo (1494–1576)
Portrait of Leonardo Buonafede, c. 1545

red chalk; 26.1 x 32 cm
PD 1946-7-13-5 / AF Review no. 1437
Trustees of the British Museum
Part of the Phillipps Fenwick Collection (23 drawings) presented in 1946
as a gift by the Art Fund; acquired for £3,000 (including support from
Count Seilern) from an anonymous vendor

This is one of twenty-three drawings purchased for the British
Museum by the Art Fund for £3,000 in 1946, including
a contribution of £500 from Count Seilern, the expatriate
Austrian collector who, in the 1970s, was to bequeath his
outstanding collection to the Courtauld Gallery. The majority
of the drawings were of the fifteenth- and sixteenth-century
Italian school, including sheets by Mantegna and Michelangelo,
and the rest Dutch, Flemish and French. Such generosity
was characteristic of the Art Fund during and immediately
after the Second World War, when museums had seriously
depleted funds.

This drawing was attributed to Domenico Ghirlandaio
(*c.* 1449–94) when it was acquired, but it is now thought
to be much later and is ascribed to the Florentine sculptor
Francesco da Sangallo. It depicts Leonardo Buonafede on his
deathbed and was subsequently used by Sangallo as a basis for
Buonafede's tomb for the Certosa del Galluzzo, near Florence,
which he completed in 1550. According to one early source
Buonafede lived to be nearly one hundred years old. A
Carthusian monk, he served as Bishop of Cortona from 1529
to 1538, and died in 1545.

Reference: Nicholas Turner, *Florentine Drawings of the Sixteenth Century*,
British Museum, London, 1986, p. 160, no. 117.

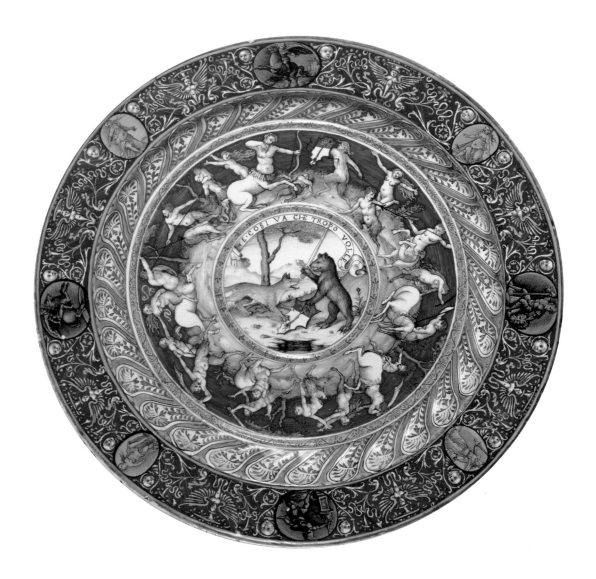

63
Cafaggiolo, Tuscany (Italy), attributed to 'The Vulcan Painter',
Basin for a Ewer, *c.* 1520–30

tin-glazed earthenware (maiolica), painted in polychrome; height 5.5 cm,
diameter 46.3 cm
EC.19-1946 / AF Review no. 1427
Syndics of the Fitzwilliam Museum, Cambridge
Acquired in 1946 for £2,000 from Mrs Leopold de Rothschild with a
contribution of £1,000 from the Art Fund and additional support from
the F. Leverton Harris Fund

Formerly in the collection of Baron Lionel de Rothschild,
this magnificent dish was ranked 'among the 100 or perhaps
50 finest maiolicas in the world' by Bernard Rackham, the
leading British authority on maiolica, when it was acquired
by the Fitzwilliam Museum in 1946.

An outstanding example of the classical influence on maiolica,
it is almost certainly from Cafaggiolo, near Florence, though
it does not bear the SP monogram mark, which appears on
many other works of this origin that date from *c.* 1520–30.

The subject of the design is far from clear. At its centre is a
landscape in which a fox attempts to capture a shield from

the possession of a bear. Above them is inscribed, 'E COSI VA
CHE TROPO VOLLE' ('this is what happens to him who
wants too much'). The arms have been identified as those of
the Dini family of Florence, but no conclusive explanation
has been put forward for the feud between the animals.

Surrounding the central medallion is a depiction of what
appears to be the Battle between the Lapiths and Centaurs
(Ovid, *Metamorphoses*, 12: 210-535). The rim is decorated with
grotesques and eight oval medallions showing scenes from
the Bible and Roman history: Marcus Curtius leaping into
a chasm; Dido falling on her sword; David with the head of
Goliath; Judith with the head of Holofernes; Mucius Scaevola
thrusting his hand into a fire; a woman with a shield; Horatius
defending the bridge; and (probably) the suicide of Lucretia.
All of these scenes depict acts of heroism or self-sacrifice.

References: Galeozzo Cora and Angiolo Fanfani, *La maiolica di Cafaggiolo*,
Florence, 1982, p. 83, pl. 67; Julia E. Poole, *Italian Maiolica and Incised
Slipware in the Fitzwilliam Museum, Cambridge*, Cambridge, 1995,
pp. 133-35, no. 191.

64

Jean-Auguste-Dominique Ingres (1780–1867)
Portrait of Mr and Mrs Joseph Woodhead and Mr Henry Comber in Rome, 1816

Inscribed lower right: *Ingres a rome 1816*
pencil on paper; 30.4 x 22.4 cm
PD.52.1947 / AF Review no. 1459
Syndics of the Fitzwilliam Museum, Cambridge
Presented in 1947 as a gift by the Art Fund; acquired for £1,200 from Brigadier General H.A. Walker

Ingres' portrait drawings are among the finest of the nineteenth century, despite the fact that the artist only undertook them reluctantly. Deprived of patrons after the fall of Napoleon and his family in Europe in 1815, he no longer attracted sufficient commissions for history paintings and had to resort to making works like this, which served as mementos for important foreign sitters of a visit to Rome.

Harriet Comber (1793–1872) married Joseph Woodhead (1774–1866), a naval agent, in 1815. She is here shown seated with her right arm intertwined with that of her husband, who leans towards her, in a pose of romantic affection. Standing beside them is her brother Henry George Wadesford Comber (1798–1883), aged eighteen, who is posed as a dandy. He married and was ordained in 1822 and spent the rest of his life in Yorkshire and Somerset. The drawing is among the most ambitious of all such works by Ingres portraying English sitters.

One of the seven drawings by Ingres to be supported by the Art Fund since 1936, this work testifies to its penchant for favouring artists who followed in the tradition of earlier masters, others being Canova, Blake and Rodin (see cat. 176; 74, 108; 11).

References: Hans Naef, *Die Bildnisszeichnungen von J.A.D. Ingres*, Bern, 1977, II, pp. 104-07, IV, no. 180; *Art Treasures of England, the Regional Collections*, Royal Academy of Arts, London, 1998, pp. 178-79, no. 106.

65
Rembrandt van Rijn (1606—69)
A Young Woman Seated in an Arm Chair, c. 1654—60
brush drawing in brown wash, over monotype; 16.3 x 14.3 cm
PD 1948-7-10-7, H98 (a) / AF Review no. 1503
Trustees of the British Museum
Acquired in 1948 for £3,000 from Sotheby's with a contribution of £1,500
from the Art Fund and additional support from an anonymous donor

This drawing depicts a seated young woman in a pensive and introspective mood characteristic of many of Rembrandt's finest works of the 1650s, such as the *Woman Bathing in a Stream* (National Gallery, London) or *Bathsheba* (Louvre, Paris), both of 1654. She holds what appears to be a scroll in her left hand. Together with the Renaissance costume, this suggests that the work may have been intended as a study for a biblical subject, such as Esther meditating on the decree to slay the Jews. The model has been identified as Hendrickje Stoffels, Rembrandt's mistress in his later years, but this is far from certain.

The drawing is executed with a reed pen, whose broad nib is here used to audacious effect. Bold, angular strokes delineate the figure and chair in a painterly manner much favoured by the artist in the 1650s and 1660s. This is one of only three drawings by Rembrandt acquired with the assistance of the Art Fund, for the simple reason that the vast majority of such works to be found in the nation's collections were already there by 1903.

References: Otto Benesch, *The Drawings of Rembrandt,* London, 2nd ed., 1973, V, p. 314, no. 1174; Martin Royalton-Kisch, *Drawings by Rembrandt and his Circle in the British Museum,* London, 1992, pp. 135-36, no. 59.

66

Jean-Antoine Houdon (1741–1828)
Bust of François-Marie Arouet de Voltaire, 1781
Inscribed on the back: *Houdon F. 1781 au Marquis de Villette*
marble; 49.5 x 25 x 21 cm
A.24-1948 / AF Review no. 1502
Victoria and Albert Museum
Acquired in 1948 for £4,000 from Sir Francis Oppenheimer with a
contribution of £2,000 from the Art Fund

The wide-ranging genius of Voltaire (1694–1778) epitomizes the spirit of the French Enlightenment and this bust captures perfectly his penetrating wit and intellect. It was executed three years after the sitter's death and is closely based on the most famous of all sculptures of him – Houdon's seated, full length statue, also of 1781, in the Comédie Française, Paris.

Given Voltaire's enormous popularity, it is not surprising that Houdon and his studio produced more sculptures of him than of any other individual. This one bears the masks of Comedy and Tragedy at its base and is dedicated to the Marquis de

Villette. Voltaire had died on a visit to the second Marquis in 1778; and this bust was presumably intended as a lasting memorial to their friendship.

When this work was acquired, in 1948, it was the first sculpture by Houdon to enter the Victoria and Albert Museum and one of the relatively few examples of French eighteenth-century art to have been supported by the Art Fund. This reflects no necessary prejudice on the part of the fund, but rather, the relative disinclination of many museums in Britain to increase their holdings in this field given the superb representation of it in the Wallace Collection, which owns two female busts by Houdon.

References: Terence Hodgkinson, 'French Eighteenth-Century Portrait Sculptures in the Victoria and Albert Museum', in *Victoria and Albert Museum Yearbook*, no. 3, 1972, pp. 108-09; H.H. Arnason, *The Sculptures of Houdon*, London, 1975, p. 53.

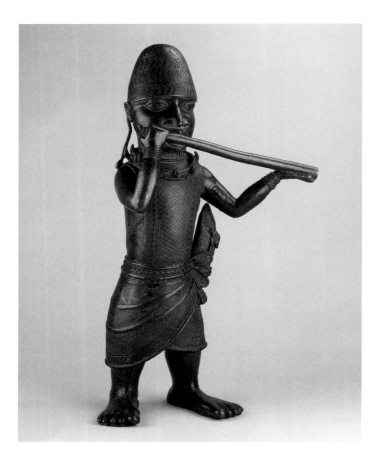

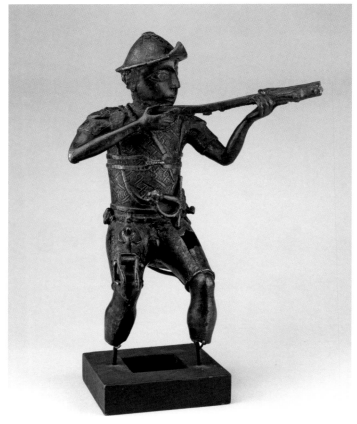

67
Benin (Nigeria)
Portuguese crossbowman, c. 1550 (above right)
Horn blower, c. 1600 (above left)
cast bronze; heights 35 cm and 62.2 cm
Ethno Af 1949, 45.158 and Ethno Af 1949, 46. 156 / AF Review no. 154
Trustees of the British Museum
Part of the Oldman Ethnographic Collection (30 works) presented in 1949
as a gift by the Art Fund; acquired for £3,000 from Mrs W.O. Oldman

These two works were part of a large and varied collection of ethnographic art formed by W.O. Oldman, which the Art Fund presented to the nation on account of its 'exceptional merit' (see also cat. 68–72). Both figures were made in Benin, Nigeria, in West Africa. This area of Africa was visited by Portuguese explorers in search of a route to India in the fifteenth century, and the Portuguese remained significant to its civilization throughout the fifteenth and sixteenth centuries.

The *Horn blower* wears a helmet, leopard's tooth necklace and kilt with a side bustle to the left. He stands in the foursquare position characteristic of most Benin sculptures. More dynamic – and European-inspired – is the swivelling pose of the *Crossbowman*, who probably represents a Portuguese soldier. His knees bent, he aims his weapon, wearing a sword at the left and a dagger at the right. Below this is a goat's foot lever for drawing the crossbow. This sculpture was formerly in the collection of Admiral Rawson, Commander of the Benin Expedition in 1897.

References: 'The Oldman Collection', in National Art-Collections Fund, *Forty-sixth Annual Report, 1949*, p. 31. William Fagg, *Nigerian Images*, London, 1963, pls. 27 and 42; William Fagg, *Divine Kingship in Africa*, British Museum, London, 1970, p. 33; Nigel Barley, 'Beyond the Pale', in *Art Quarterly*, Autumn 1995, p. 41-45.

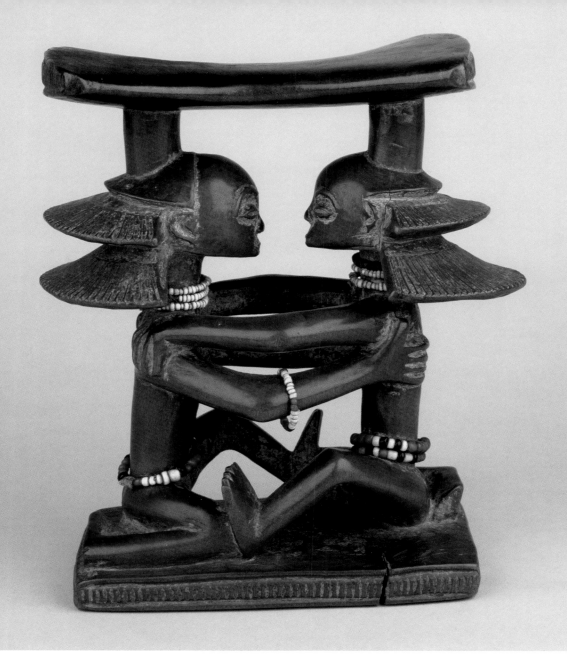

68

Luba people (Democratic Republic of Congo)
Headrest, early 20th century

wood, red, blue and white glass beads, fibre; height 16.8 cm
Ethno Af 1949, 46.481 / AF Review no. 1545
Trustees of the British Museum
Part of the Oldman Ethnographic Collection (30 works) presented in 1949
as a gift by the Art Fund; acquired for £3,000 from Mrs W.O. Oldman

The seated and embracing women at the base of this carving
relate to its use. Made by the Luba people of the Congo,
headrests such as this were used as pillows, helping to preserve
their complex hair–styles and to keep the back of the neck
cool during sleep.

Headrests were a cherished possession of the Luba people.
Passed on from generation to generation, they were a sign
of social status and may also have had additional significance.
The two women depicted here appear identical, and twin
births were highly symbolic in Luba worship. Twins were
known as 'children of the moon' and, along with the moon,
signified hope, rejuvenation and benevolence. The Luba also
treated the mothers of twins with reverence and wonderment
for their remarkable fertility.

This is one of six Congolese works acquired by the Art
Fund from the Oldman Collection in 1949 and donated to
the British Museum.

Reference: John Mack (ed.), *Africa: Arts and Cultures*, New York and
Oxford, 2000, pp. 127-28 and 140, fig. 56.

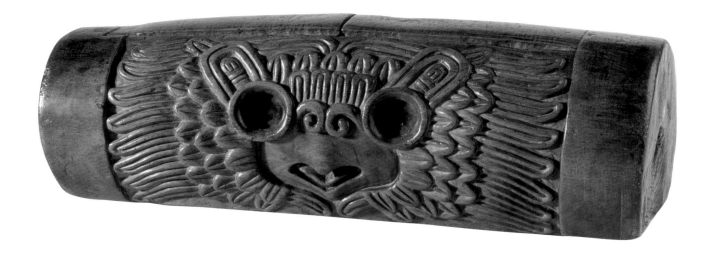

69
Aztec (Mexico), *Drum with Owl Face, c.* 1500
wood; 16.5 x 50 cm
Ethno 1949 Am22.218 / AF Review no. 1545
Trustees of the British Museum
Part of the Oldman Ethnographic Collection (30 works) presented in 1949
as a gift by the Art Fund; acquired for £3,000 from Mrs W.O. Oldman

Carved from a hard, heavy wood, this drum was designed to be placed on a stand and beaten with a pair of sticks padded with raw rubber. It is typical of a kind of drum used throughout Mexico and Central America in dances and religious festivals from the fourteenth to the sixteenth centuries. Only about twenty of these survive, all of them carved with different designs. This one bears the head of a horned owl, whose feathers fan out to decorate the entire surface. Because of its

nocturnal habits, the owl was known in Mexican mythology as a messenger from the underworld.

This horizontal drum, known as a *teponaztli* in the Aztec language, was the only work of Mexican art purchased by the Art Fund from the Oldman Collection. 'Aztec' is the term used since colonial times to refer to the native people who settled around Lake Texcoco in the Valley of Mexico from the fourteenth century AD to 1521, when they were invaded by the Spaniards. All the surviving drums of this type are either Aztec or Mixtec, the latter being the name of the indigenous people of Central America.

References: Esther Pastory, *Aztec Art*, New York, 1983, p. 270; Colin McEwan, *Ancient Mexico in the British Museum*, London, 1994, p. 7.

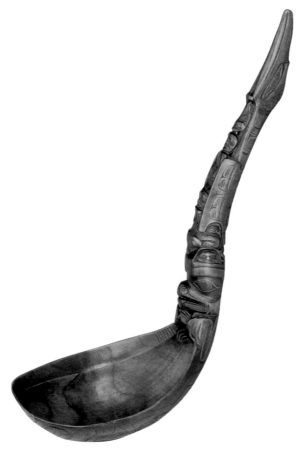

70

Haida (British Columbia, Canada), *Feast Ladle*, 19th century

Big-horned Sheep horn; length 55.9 cm
Ethno 1949 Am22.82 / AF Review no. 1545
Trustees of the British Museum
Part of the Oldman Ethnographic Collection (30 works) presented in 1949
as a gift by the Art Fund; acquired for £3,000 from Mrs W.O. Oldman

This elaborately carved ladle is one of eight works by or
attributed to the Haida, one of the indigenous people of British
Columbia, that the Art Fund acquired for the nation from the
Oldman Collection. It came from Haida Gwaii or the Queen
Charlotte Islands, off the coast of Western Canada, and is
decorated with a group of crests around the bowl that include
a bear. It would have been used to serve candle fish or seal
oil by a chief of high rank at *potlatches* – feasts celebrating the
events of the life cycle. The ladle is made from the horn of
a big-horned sheep (*Ovis canadensis*), which was softened by
boiling until it opened up and could be carved.

 The story of how the Haida acquired the bear crest centres
upon a young woman picking berries. Inadvertently stepping
into bear droppings, she swears at the bear, whereupon she is
seduced into marriage with a handsome young stranger, who
is actually a bear in human form. Her bear–human descendants,
through the female line only, then became eligible to use the
bear crest.

Reference: 'The Oldman Collection', in *National Art-Collections Fund,
Forty-sixth Annual Report, 1949*, p. 30, no. 18.

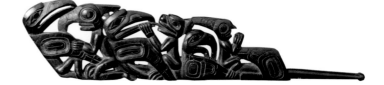

71

Haida (British Columbia, Canada)
Smoking Pipe, 19th century

argillite and wood; length 42 cm
Ethno 1949 Am, 22.78 / AF Review no. 1545
Trustees of the British Museum
Part of the Oldman Ethnographic Collection (30 works) presented in 1949
as a gift by the Art Fund; acquired for £3,000 from Mrs W.O. Oldman

Like the *Feast Ladle* (cat. 70), this pipe originates with the Haida,
who, in prehistoric times, as well as inhabiting Haida Gwaii,
also lived on the southern Prince of Wales Island, Alaska.
Around 1820 the Haida began to carve objects from argillite,
a black carbonaceous shale found in the Skidegate Inlet area,
which they sold to traders and travelling seamen. These were
among the earliest works of art made by the Northwest
Coast Indians for the open market.

 This pipe, which was probably not intended for smoking, is
elaborately carved with a wealth of crest figures. It is elongated
and heavily pierced, features that became more exaggerated as
the art of the Haida evolved.

References: 'The Oldman Collection', in *National Art-Collections Fund,
Forty-sixth Annual Report, 1949*, p. 31, no. 25; Bill Holm, *The Box of
Daylight: Northwest Coast Indian Art*, Seattle Art Museum, Seattle, and
London, 1983, pp. 104 - 06.

72

Inupiak (Alaska), *Two Drill Bows*, 19th century

walrus ivory; length 44 cm each
1949 Am 22.25 and 26 / AF Review no. 1545
Trustees of the British Museum
Part of the Oldman Ethnographic Collection (30 works) presented in 1949
as a gift by the Art Fund; acquired for £3,000 from Mrs W.O. Oldman

These drill bows were made by the Inupiak people of northern Alaska and were among four works of 'Eskimo' art acquired by the Art Fund from the Oldman Collection. They were primarily used to drill holes by a technique that is still in use today. A wooden shaft would be attached to a bit-like mouthpiece held between the user's teeth, freeing both hands. Attached horizontally to the top of the shaft would be the drill bow, a thong extending from the bow to the shaft. As the drill bow is moved from side to side, the thong tightens around the shaft, which rotates, driving it into the surface to be drilled.

Alaskan drill bows are often decorated with scenes from the hunt or other aspects of daily life. Both of these represent the hunting of land and sea creatures. One also shows geese flying and being netted and the other fantastic scenes of dancing caribou and monstrous beings performing around people's houses.

These two drill bows were in the Hurst and Collier Collection before being acquired by W.O. Oldman. Much of Oldman's collection was sold to the New Zealand government in 1948, but 800 works from it were also acquired by the British Museum, including two of the Benin bronzes exhibited here (cat. 67).

References: 'The Oldman Collection', in *National Art-Collections Fund, Forty-sixth Annual Report, 1949*, p. 31, nos. 27 and 28; William Fitzhugh and Susan Kaplan, *Inua: Spirit World of the Bering Sea Eskimos*, Washington DC, 1982, pp. 255-67.

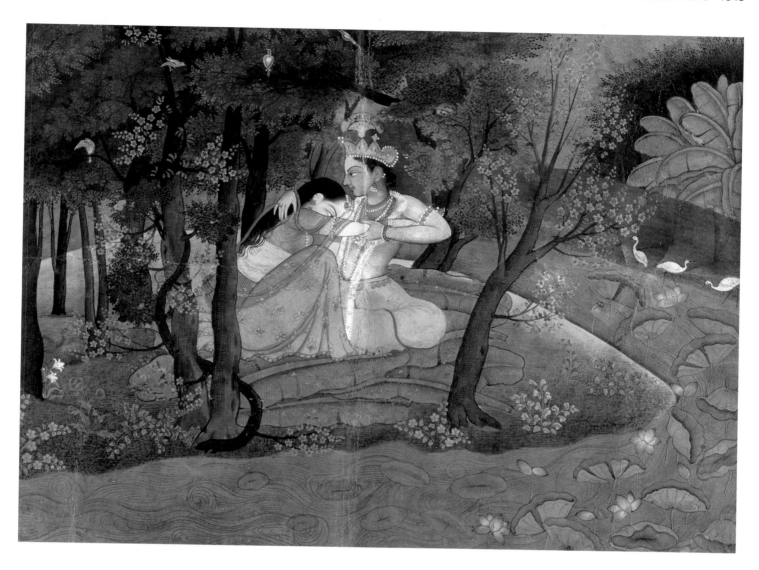

73

Kangra (India), *Radha and Krishna in the Grove, c.*1780
opaque watercolour on paper; 13 x 17.5 cm
IS.15-1949 / AF Review no. 1546
Victoria and Albert Museum
Part of the Manuk and Coles Collection of Indian art bequeathed in
1949 through the Art Fund

Percival Carter Manuk began collecting Indian and Persian
paintings early in the twentieth century, and by his death in
1946 his collection numbered around 1,400 works. These were
eventually bequeathed through the Art Fund to Bristol Art
Gallery, the British Museum, Fitzwilliam Museum, Cambridge,
and the Victoria and Albert Museum. The bequest also bore the
name of Miss G.M. Coles, who had assisted him in collecting
in his later years. Stipulated in the bequest was the condition
that, after those museums had made their selection, the residue
be sold. This was done in 1948 and 1949, realizing a total of
£5,326 1s 13d (approximately £ 5,326.10), with the Art Fund
benefiting from the sale.

Among the finest Indian miniatures in the collection was this
one of Radha and Krishna embracing in an idyllic landscape.
It was executed around 1780 in Kangra in the Pahari hills of
Punjab, northern India during the reign of Raja Sansar Chand
(1775–1823). Krishna was the eighth and most popular incar-
nation of the Hindu god, Vishnu. In his early years he lived
among the cowherds of Vrindavan and was beloved by Radha.
The graceful, intertwining poses of the couple in this elegant
miniature meet with an ecstatic response from the natural
world, where egrets graze, lotuses flower and the trees suddenly
spring into bloom around them.

References: W.G. Archer, *Kangra Painting*, London, 1952, pp. 6-7;
W.G. Archer, *Indian Paintings from the Punjab Hills*, London, 1973, I,
p. 293, no. 35; Balraj Khanna, *Krishna: The Divine Lover*, Hayward Gallery,
London, 1997; Harsha Dehejia, *The Flute and the Lotus: Romantic
Moments in Indian Poetry and Painting*, Ahmedabad, 2002, p. 18.

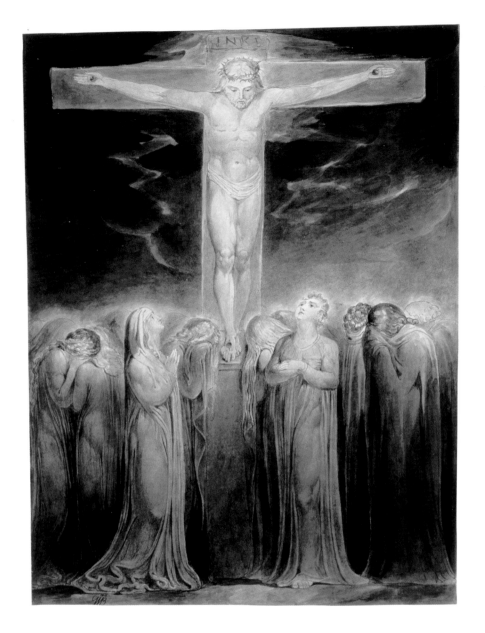

74

William Blake (1757–1827)
*The Crucifixion: 'Behold Thy Mother', c.*1805

Inscribed bottom left: *WB inv*
pen and ink and watercolour on paper; 41.3 x 30 cm
N05895 / AF Review no. 1538
Tate
Presented in 1949 as a gift by the executors of W. Graham Robertson
through the Art Fund

Blake is an artist who has consistently won the support of the Art Fund. In 1919 it acted as 'honest broker' in the acquisition of 102 watercolours by the artist for Dante's *Divine Comedy*, which were purchased by the British Museum, the National Gallery of British Art (now Tate Britain), Ashmolean Museum, Birmingham Museum and Art Gallery and the National Gallery of Victoria, Melbourne. (At this time, the Art Fund also supported acquisitions for museums in the Commonwealth.)

This watercolour formed part of the second great Blake gift to come through the fund's hands from the painter, author and theatrical designer Graham Robertson, an avid collector of the artist's work. In 1939 Robertson donated nine colour prints by Blake to the Tate Gallery; and, at his death in 1948, he bequeathed four more. In the following year, the executors of his estate purchased twenty additional watercolours from the auction of his collection and distributed these via the Art Fund to six museums throughout the country, from Edinburgh to Brighton and Southampton.

This *Crucifixion* forms part of a distinct group of works by Blake, identical in size and format, and all concerned with the Crucifixion and Resurrection. All are also near-symmetrical in composition and largely monochromatic. They were painted for Thomas Butts (1757–1845), a minor civil servant, who was one of Blake's most loyal patrons.

Reference: Martin Butlin, *The Paintings and Drawings of William Blake*, New Haven and London, 1981, I, p. 361, no. 498.

75
Abraham Bloemaert (1564–1651)
*The Prodigal Son, c.*1615

Inscribed lower right: *A. Bloemaert fe*
oil on canvas; 105.8 x 164.2 cm
344.1950 / AF Review no. 1555
Art Gallery and Museum, Royal Pump Rooms, Leamington Spa
(Warwick Districk Council)
Presented in 1949 as a gift by the Art Fund; acquired for £650 from
the Cook Collection. This painting has been conserved through the
Woodmansterne Art Conservation Awards programme, sponsored by
Woodmansterne Publications Ltd, the fine-art greeting card company

Unquestionably the greatest work by the artist in the UK, this enchanting farmyard landscape had been on loan to the Leamington Museum for many years when it was sold from the collection of Francis Cook and purchased outright by the Art Fund so it could be retained by the museum.

The parable of the Prodigal Son (Luke 15, 11-32), who is shown feeding among the swine at the right, here serves as a pretext to explore a theme of Netherlandish daily life in the midst of a bucolic landscape. A woman feeds chickens, a man binds faggots, another climbs a tree – probably gathering more faggots – and, at the far left, a pair of chickens survey this idyllic scene.

Bloemaert was the founding father of the Utrecht School of painters and counted among his pupils most of the younger generation of artists in the city – among them Gerrit van Honthorst (1592–1656) – who became collectively known as the Utrecht Caravaggisti. A prolific master of religious paintings, genre pictures and landscapes, his works often betray a very refined sensibility, evident here in the delicate gradations of colour and light and in such lovingly described details as the man pointing out the Prodigal Son to a child who strains to see from behind the fence, and the roof tiles of the central cottage. Different in type and arrangement, these tiles have evidently been laid on separate occasions and have also weathered differently.

Reference: Marcel G. Roethlisberger, *Abraham Bloemaert and his Sons: Paintings and Prints*, Ghent, 1993, I, p. 193, no. 224.

76
Chinese, (mainly) 18th century
The Burrows Abbey Collection of Chinese Glass

Bottle, early 18th century
colourless glass with roughened white surface; 22 x 12 cm; N4720

Flask, early 18th century
dichroic glass (brown by reflected light, clear blue by transmitted light);
14.2 x 12 cm; N4730

Bottle, 1723–35
transparent blue glass, ribbed body; 31 x 16 cm; N4573

Bottle, mid 18th century
opaque orange glass; 14.5 x 8.8 cm; N4528

Bottle, mid 18th century
crimson glass; 14.5 x 8.8 cm; N4531

Bottle, mid 18th century
celadon glass; 13.8 x 8.8 cm; N4529

Bottle with incised dragon, mid 18th century
turquoise glass; 14.3 x 8.8 cm; N4527

Vase carved with phoenix in tree peony, 1750–75
opaque yellow glass; 17 x 9.8 cm; N4772

Water-pourer (Yi), 1750–75
yellow glass; 8 x 11 x 14 cm; N4750

Huqqah-base, 1768–69
red and white glass; 15 x 15 cm; N4788

Bottle with dragon in the waves, 1775–80
red on white glass; 16 x 8 cm; N4662

Bottle with lotus design, 1780–1800
red glass on snowstorm glass; 38 x 16 cm; N4649

Bottle with bats, flowers and butterflies, 1850–1900
turquoise glass with polychrome overlay; 22 x 12.5 cm; N4748

Tripod vessel (ding) and two candlesticks, 1850–1900 (illustrated)
red and white glass; respectively 24 x 20 x 15 cm and 25 x 12.5 cm each;
N4675, N4676, N4677

Vase with fish among water plants, 1850–1900
white glass with polychrome overlay; 16 x 11 cm; N4718

AF Review no. 1613
Bristol Museums and Art Gallery
Part of a collection (290 pieces) bequeathed in 1950 by H.R. Burrows
Abbey through the Art Fund

The city of Bristol boasts the largest collection of Chinese glass tableware outside China. This is principally due to the generosity of H.R. Burrows Abbey, former director of Kemp Town Brewery, Brighton, who donated 290 pieces of Chinese glass to the museum in his will. Although some of the collection had been on loan to Brighton Museum, which expressed a clear interest in acquiring it, the Art Fund opted for Bristol instead because of the city's involvement with glass-making since the Middle Ages. The Burrows Abbey Bequest included a number of pieces from the collections of A.H. Bahr, E.B. Ellice Clark, S.D. Winkworth and Captain A.T. Warre, all of whom had lent to the great Chinese exhibition at the Royal Academy in 1936.

The collection consists of a number of early works from the second or third century AD, but the majority date from the Qianlong period (1736–95) and are brightly coloured to resemble other materials, such as celadon-glazed ceramics and jade. As Lord Crawford, Chairman of the Art Fund, noted when the bequest was made in 1950: 'most of the beauty lies in the colour'.

To enhance the Burrows Abbey Collection, the Art Fund also supported the acquisition by Bristol Museums and Art Gallery, in 1994, of a gouache depicting a Chinese glass-blowing workshop, datable to the late eighteenth or early nineteenth centuries.

Reference: W.B. Honey, 'Early Chinese Glass', in *The Burlington Magazine*, LXXI, 416, 1937, pp. 211-22.

77
British, *The Great Torc from Snettisham*, *c.* 75 BC
gold mixed with silver; diameter 20 cm
P&E 1951 4-2.2 / AF Review no. 1625
Trustees of the British Museum
Presented in 1951 as a gift by the Art Fund; part of the Snettisham
hoard acquired for £1,850 from the finder of the Treasure Trove

Since 1948 at least twelve hoards of torcs, ingots and coins have
been unearthed at Ken Hill, Snettisham, Norfolk, the most
recent in 1990. This great torc is the most magnificent of all
of these objects and one of Britain's greatest antiquities. It was
discovered in 1950, when the land was owned by Sir Stephen
Lycett Green, nephew of the man who – five years later –
would bequeath his important collection of Old Master paint-
ings to York Art Gallery via the Art Fund (see cat. 90–92).

This Celtic torc is made of over a kilogram of gold mixed
with silver and consists of sixty-four threads twisted eight at
a time to make eight separate ropes of metal. These were
then all twisted around one another to make the final torc.
An object of great complexity, the torc is as sophisticated as
anything known to have been made by Greek, Roman or
Chinese gold workers living 2,000 years ago. Unusually, this
torc can be closely dated because a small coin was found
caught up within its strands.

References: I.M. Stead, *Celtic Art in Britain before the Roman Conquest*,
British Museum, London, revised edition, 1996, pp. 49-50; S. James
and V. Rigby, *Britain and the Celtic Iron Age*, British Museum, London,
1997, p. 26; R. Rainbird Clarke, 'The Early Iron Age Treasure from
Snettisham, Norfolk', in *Proceedings of the Prehistoric Society*, 20,
London, 1954, pp. 27-86.

78
Guro (Ivory Coast), *Dance Mask*, 19th century
hard wood; height 27.3 cm
Ethno Af 1951.34.1 / AF Review no. 1626
Trustees of the British Museum
Presented in 1951 as a gift by the Art Fund; one of two masks acquired
for £75 from the Hon. Andrew Shirley

Of all the world's artistic traditions, African art was the last to
win the support of the Art Fund. In 1933, it accepted a dona-
tion of South African native beadwork from Frank Cornner
and six years later the fund purchased outright the Nigerian
brass head (cat. 59) – probably the greatest work of Nigerian
art with which it has been associated.

In 1949 it purchased part of the Oldman Collection (cat. 67–
72) and three years after this, it bought two wooden dance
masks made by the Guro people of the Ivory Coast, French
West Africa, of which this is the more striking. Carved from
hardwood, and with a fine black patina, it depicts a small-
featured face with a high forehead marked by a prominent
median ridge and unusually elaborate hairstyle.

Guro masks belong to two distinct categories. The first
represents beasts that inhabit the forests and mountains and are
brought into the village by a hunter to receive regular offerings.
These are cult objects and belong to families. The second –
of which this is an example – are worn by talented dancers and
enjoyed by the whole village. They usually belong to individuals,
who commission them from a sculptor, and are intended to
be startling and original, reflecting the latest trends in fashion.

Reference: Eberhard Fischer and Lorenz Homberger, *Masks in Guro
Culture, Ivory Coast*, New York and Zürich, 1986, pp. 16-31.

79
Punjab (India), *Maharaja Gulab Singh of Jammu and Kashmir, c.* 1846

opaque watercolour on paper; 27 x 20.9 cm
IS.194-1951 / AF Review no. 1639
Victoria and Albert Museum
Part of the Rothenstein Collection of Indian Paintings and Drawings (111 works) acquired in 1951 for £2,500 with a contribution of £500 from the Art Fund and additional support from Lady Rothenstein

Three years after receiving the Manuk and Coles Bequest of Indian and Persian paintings (see cat. 73), the Victoria and Albert Museum acquired 111 Indian paintings and drawings from the collection of Sir William Rothenstein (1872–1945), the painter and teacher. Passionate about Indian art, Rothenstein built up a great collection of it between 1912 and 1925. A friend of both Roger Fry and Christiana Herringham, founders of the Art Fund, Rothenstein travelled to India to meet Christiana in 1911 with her brother, Herbert Powell. He also helped to organize exhibitions of Indian art and loaned his own collection to the Indian Pavilion of the British Empire Exhibition at Wembley in 1924.

One of the masterpieces of the Rothenstein Collection is this awe-inspiring miniature, described in the Art Fund *Report* of 1952 as 'the greatest Sikh picture ever to have been painted'. It depicts Gulab Singh (1792–1857), Maharaja of Jammu and Kashmir, the Sikh territory ceded by the British at the Treaty of Lahore in 1846. Seated and resplendently clad in a multi-coloured turban, imposing white robe and orange-red trousers, he holds the hilt of his sword in one hand and a sprig of flowers in the other. Behind him rests his shield. Calculated to intimidate, the miniature achieves this in the powerful head – the largest in Sikh miniature painting – with its wily eyes and resolute grin leaving the viewer in no doubt that the sitter is both powerful and menacing.

References: W.G. Archer, *Paintings of the Sikhs*, London, 1966, pp. 54 and 146-48, no. 25; Susan Stronge (ed.), *The Arts of the Sikh Kingdoms*, Victoria and Albert Museum, London, 1999, pp. 106-09 and 231, no. 158.

पुंषउपतीनटक

80
Basohli (India)
The Lonely Krishna Explains his Plight, c.1660–70
opaque watercolour on paper; 17.8 x 25.9 cm (with border 23.3 x 32.1 cm)
IS.120-1951 / AF Review no. 1639
Victoria and Albert Museum
Part of the Rothenstein Collection of Indian Paintings and Drawings
(111 works) acquired in 1951 for £2,500 with a contribution of £500
from the Art Fund and additional support from Lady Rothenstein

Along with *Maharaja Gulab Singh of Jammu and Kashmir*
(cat. 79), this is from the collection of the painter Sir William
Rothenstein, a pioneering champion of such works in England.
 It is part of a series of sixteen illustrations of the *Rasamanjari*
('Posy of delights') of Bhanu Datta, a Sanskrit poem of the
fourteenth century which describes the traditional conduct

of lovers and their mistresses. These were executed in Basohli
in the Punjab in *c.* 1660–70.
 In this work Krishna is dressed in yellow, leaning on an
empty bed and explaining to a companion dressed in striped
green trousers the tribulations of being without his mistress.
The inscription at the top reads 'he whose *pati* is away', *pati*
literally meaning 'husband' but here, by implication, mistress.
On the reverse of the miniature is an elaborate Sanskrit verse
extolling the virtues of Krishna's absent mistress, Radha, and
ending with the lament: 'Alas! there is still no abatement of
the fever in my heart.'

Reference: W.G. Archer, *Indian Painting from the Punjab Hills*, London,
1973, I, p. 37, no. 4 (XI).

81

The Kelekian Collection of Islamic Pottery, late 11th–15th century

Mesopotamian (Iraq), *Small bowl with spoked circles on a dot and dash ground*, mid 9th century
earthenware painted in brown, yellow and pale green lustre; diameter 14.3 cm; C.46-1952

Fatimid (Egypt), *Jar with a band of fish and palmette*, late 11th or early 12th century
fritware painted in yellowish lustre; height 33 cm; C.48-1952

Fatimid (Egypt), *Bowl with the figure of a Coptic Christian priest*, first half of the 12th century (illustrated)
fritware painted in gold lustre on a white glaze; diameter 23.5 cm; C.49-1952

Persian (Kashan, Iran), *Dish with a polo player on a piebald horse*, 1207
fritware painted in gold lustre; diameter 35 cm; C.51-1952

Persian (Iran), *Bottle with a gazelle in a fantastic landscape*, 17th century
fritware painted in gold lustre; height 26.7 cm; C.59-1952

AF Review no. 1688
Victoria and Albert Museum
Part of a collection of 15 pieces acquired in 1952 for £5,000 from the Executors of D.G. Kelekian with a contribution of £2,000 from the Art Fund and additional support from the Bryan Bequest

In 1910, Dikran Garabed Kelekian (1868–1951) placed his collection of 182 works of Near Eastern or Islamic pottery on loan at the Victoria and Albert Museum. An Armenian who was originally from Turkey, Kelekian was an antiques dealer, who moved to Paris in 1891 and to New York two years later, and first acquainted America with Persian pottery at the Chicago World Fair of 1893. He was also a close friend of the American Impressionist painter, Mary Cassatt (1844–1926), and an avid collector of early modern art.

When Kelekian died in 1951, from a fall from the twenty-third floor of a New York hotel, the Victoria and Albert Museum purchased fifteen of the finest works from his collection with the help of the Art Fund.

Among the most celebrated is the Egyptian bowl of the Fatimid dynasty (969–1171), reputedly found at Luxor, which is the only complete work of its type with a Christian subject. It depicts a Coptic monk holding a large lamp. To the right of him is an *ankh*, the ancient Egyptian hieroglyphic sign for life, a symbol appropriated by the Copts. Decorating the exterior of the bowl is the Arabic word *sa'd*, which is probably the mark of the workshop in which it was made. Meaning 'good luck' or 'good fortune' in Arabic, this occurs on many examples of Fatimid lustre pottery.

Another major work in the collection is the early thirteenth-century *Dish with a polo player on a piebald horse*, which is dated 1207 and is decorated with verses of love poetry in Persian that bear no relation to the subject of the painting. Executed in the Kashan area of Persia, renowned for its elaborately patterned tiles, this dish epitomizes the high quality of Kelekian's collection and explains why he was known throughout the world as the 'dean of antiquities'.

References: Arthur Lane, *Early Islamic Pottery: Mesopotamia, Egypt and Persia*, London, 1947, pp. 22 and 40; (Fatimid Bowl only) *Africa: the Art of a Continent*, Royal Academy of Arts, London, 1995, p. 584, no. 7.53; *The Glory of Byzantium: Art and Culture of the Middle Byzantine Era, AD 843-1261*, Metropolitan Museum of Art, New York, 1997, p. 417, no. 273; Anna Contadini, *Fatimid Art at the Victoria and Albert Museum*, London, 1998, p. 86, pls. 34a & b; (Persian Dish only) Oliver Watson, *Persian Lustre Ware*, London, 1985, pp. 90 and 198, no. 15.

82
Claude Monet (1840–1926)
Springtime (*Le Printemps*), 1886
Signed and dated lower left: *Claude Monet 86*
oil on canvas; 64.8 x 80.6 cm
PD.2-1953 / AF Review no. 1695
Syndics of the Fitzwilliam Museum, Cambridge
Acquired in 1953 for £4,000 with a contribution of £1,000 from the Art Fund

Purchased from Monet by the singer Jean-Baptiste Fauré in 1887, this picture was acquired for Cambridge at a bargain price, even for the 1950s.

Springtime is one of two paintings of Monet's orchard at Giverny and depicts his favourite model, Suzanne Hoschedé with his elder son, Jean. They are seated in an exhilarating landscape, bathed in dappled light. Created almost entirely out of a variegated range of pinks, greens and blues, the picture exudes a sense of joyous celebration at the coming of spring. As Virginia Spate has observed: 'This is not description, but a recreation of the sensation of being submerged in blossom and new leaves, in the scent and warmth of a spring day in which everything is vibrantly alive.'

Monet may have had more personal reasons for the enchanting mood which emanates from this scene. Since the death of his first wife, Camille, in 1879 he had grown increasingly attached to Suzanne's mother, Alice Hoschedé, who was helping him to raise his own children, and whom he would marry in 1890.

References: Virginia Spate, *The Colour of Time: Claude Monet*, London, 1992, p. 172; Daniel Wildenstein, *Claude Monet: Catalogue Raisonné*, Cologne, 1997, vol. III, p. 403, no. 1066.

83
Samuel Palmer (1805–81)
The Sleeping Shepherd, 1831–32
pen and sepia wash; 15.7 x 18.8 cm
D.1954.2 / AF Review no. 1746
Whitworth Art Gallery, University of Manchester
Acquired in 1954 for £310 from Sotheby's with a contribution of £155 from the Art Fund

A product of the artist's so-called 'visionary' years (*c.* 1825 to *c.* 1832), this has rightly been described as 'among Palmer's most poetic works'. Though sleeping shepherds appear earlier in his art, they were employed merely as staffage. This haunting drawing is the first occasion that Palmer treats this motif as the central theme of a composition.

The shepherd had dual connotations in art. In Virgil, he came to symbolize the pastoral and rural life, one lived in idyllic harmony with nature. Later, he came to bear specifically Christian connotations. Palmer here employs the motif in both of these senses. A deeply religious man, he had been steeped in the Bible by his father, as well as immersed in Virgil, Milton and Bunyan. Fascinated by the Miltonian belief that the natural world might be a reflection of the divine, he here gives it visual expression as the lace-like fronds of the trees encircle the heavenly moon.

References: Raymond Lister, *Catalogue Raisonné of the Works of Samuel Palmer*, Cambridge, 1988, p. 85, no. 142; *From View to Vision*, Whitworth Art Gallery, University of Manchester, 1993, p. 135, no. 77.

84

French, *Statutes of the Order of St Michael*, 1551

illuminated manuscript, 36 folios on vellum, leather binding
(not contemporary); 24 x 17 cm
MS 141 / AF Review no. 1784
John Rylands University Library of Manchester
Bequeathed in 1955 by Ernest E. Cook through the Art Fund

The only illuminated manuscript included in the Cook
Bequest, this magnificent volume contains two miniatures.
One precedes the table of chapters and depicts the triumph
of the Archangel Michael over the Devil. The other heads the
text of the Statutes of the Order of St Michael, founded by
Louis XI at Amboise on 1 August 1469. It portrays a meeting
of the Knights of the Order under the presidency of a king,
who appears to be Henry II (illustrated; unfoliated, verso).

The beardless figure to the King's left has been identified by
one scholar as Edward VI of England, who became a member
of the Order in July 1551. This may be the manuscript that
Henry II had executed for him to mark that occasion.

The manuscript has a very distinguished provenance. It was
in the collections of a succession of well-known French bib-
liophiles in Paris in the eighteenth and nineteenth centuries.
In 1908, it was exhibited at the Burlington Fine Arts Club in
London. It was subsequently owned by Sir Alfred Chester
Beatty, from whom Ernest Cook purchased it in 1933.

Reference: 'Notes and News', in *Bulletin of the John Rylands Library,
Manchester*, vol. 38, no. 2, March 1956, pp. 271-72.

85
Jacob van Ruisdael (1628/29–82)
Landscape Near Muiderberg, c.1653
oil on canvas; 66 x 75 cm
WA 1955.67; A876 / AF Review no. 1784
Ashmolean Museum, Oxford
Bequeathed in 1955 by Ernest E. Cook through the Art Fund

The ruins of the church at Muiderberg, about six miles east of Amsterdam, were depicted by other artists, including Rembrandt, but no one imbued them with greater resonance than Ruisdael, the supreme Dutch landscape painter. Combining the isolated church in the background with the grove of gnarled trees before it, the artist evokes the unceasing struggle for survival in nature, in the face of indomitable forces. This idea is reinforced by the dramatic *chiaroscuro*, which reminds one of the ever-changing face of nature and, thereby, of the passage of time; and it is given its most overt expression by the rushing stream in the foreground, with its prominent dead tree trunk. This conjures up thoughts of the eternal cycle of life and death, a recurring theme in Ruisdael's career.

Rarely content to paint identifiable sites, the artist here portrays an existing building in an imaginary setting and invests it with a deeper, symbolic significance. A preliminary drawing for the picture is in the Albertina, Vienna.

References: Seymour Slive, 'Additions to Jacob van Ruisdael', in *The Burlington Magazine*, CXXXIII, 1062, 1991, pp. 602-04; Seymour Slive, *Jacob van Ruisdael: A Complete Catalogue of his Paintings, Drawings and Etchings*, New Haven and London, 2001, pp. 102-03, no. 77.

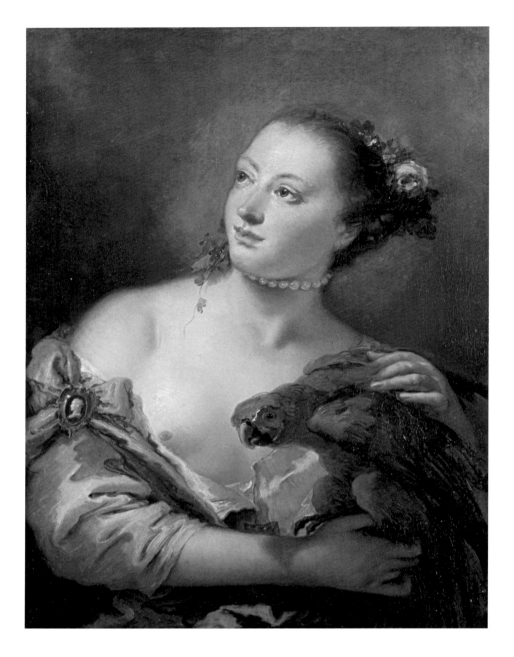

86
Giambattista Tiepolo (1696–1770)
A Young Woman with a Macaw, c. 1760
oil on canvas; 70 x 52 cm
WA 1955.67; A876 / AF Review no. 1784
Ashmolean Museum, Oxford
Bequeathed in 1955 by Ernest E. Cook through the Art Fund

Among the greatest Old Master paintings to come to the nation with the Ernest E. Cook Bequest was this elegant fancy picture by the supreme genius of eighteenth-century Italian art. It was probably painted for the Empress Elizabeth Petrovna of Russia, for whom Tiepolo is recorded as making 'di donne a capriccio' (women of caprice) in December 1760. It has been suggested that the model was one of the artist's daughters.

The theme of a woman with a parrot was a popular one in the eighteenth and nineteenth centuries, usually symbolizing luxury, exoticism and moral laxity – or a combination of any of these. In Tiepolo's case the brilliant red macaw serves as a colourful foil for the pale, smooth skin tones of the young woman, who wears flowers in her hair and a cameo on her sleeve as she casually fondles the bird.

The picture originally had a pendant, now lost, of a woman with a fur. Both were clearly intended as images of luxury. Pastels of the two by Tiepolo's son, Lorenzo, are in the National Gallery of Art, Washington.

References: Giuseppe Fiocco, 'Zwei Pastelle von Giambattista Tiepolo', in *Pantheon*, IV, 3, March 1931, pp. 101-04; Massimo Gemin and Filippo Pedrocco, *Giambattista Tiepolo, I dipinti, Opera completa*, Venice, 1993, p. 478, no. 502.

87
Francesco Guardi (1712–93), *Venice: S. Giorgio Maggiore with the Giudecca and the Zitelle, c.* 1775

oil on canvas; 47.6 x 87.6 cm
16.1/55 / AF Review no. 1784
Leeds Museums and Galleries (Temple Newsam)
Bequeathed in 1955 by Ernest E. Cook through the Art Fund

This sparkling view of Venice is among the most attractive of the many important paintings from the Ernest E. Cook Bequest.

The picture depicts the church and monastery of San Giorgio Maggiore (left). On the right is the island of the Giudecca with the Campanile of San Giovanni Battista and the dome of the church of the Zitelle (Santa Maria della Presentazione).

Along with Canaletto, Guardi was the most accomplished *vedute* painter of eighteenth-century Venice and differed from the former in his more spontaneous technique, which employs flickering brushstrokes and an enchantingly vivacious light to evoke the magical atmosphere of the city. This is one of seven known canvases of this scene executed by him and is rightly described by the greatest expert on the artist, Antonio Morassi, as an *'opera bellissima'*.

Reference: Antonio Morassi, *Antonio e Francesco Guardi*, 1973, Venice, I, p. 395, no. 450.

88
John Sell Cotman (1782–1842)
*Gateway of Kirkham Priory, c.*1805
pencil and watercolour on paper; 27.9 x 42.7 cm
YORAG R1702 / AF Review no. 1784
York Museums Trust (York Art Gallery)
Bequeathed in 1955 by Ernest E. Cook through the Art Fund

This is one of only two watercolours by Cotman that formed part of the Cook Bequest. Since they both depict Yorkshire subjects, the other was appropriately allocated to the Leeds Art Gallery.

Born in Norwich, Cotman went to London in 1798, when he was sixteen, returning to his native city in 1806. Between 1803 and 1805 he spent three very happy summers in Yorkshire, where he was befriended by the Cholmeley family of Brandsby.

From there he went on regular sketching expeditions to York, Rievaulx Abbey, Duncombe Park and elsewhere.

This delicate watercolour depicts the fourteenth-century gateway to Kirkham Priory. Cotman first visited the site in 1803 and painted a fine watercolour of the refectory doorway the following year (Courtauld Gallery, London). The present work probably dates from 1805 and combines the most sensitive pencil drawing, which carefully delineates the weathered and crumbling façade of the abbey, with bold passages of wash that distil the motif into a pattern of abstract shapes and colours.

Reference: *John Sell Cotman, 1782-1842*, Victoria and Albert Museum, and Arts Council of Great Britain, London, 1982, p. 68, no. 38.

89
John Constable (1776–1837)

Golding Constable's Flower Garden, 1815 (above left)
oil on canvas; 33.1 x 50.7 cm

Golding Constable's Kitchen Garden, c. 1815 (above right)
oil on canvas; 33.4 x 51.1 cm

1955-96.1 and 2 / AF Review no. 1784
Ipswich Borough Council Museums and Galleries
Bequeathed in 1955 by Ernest E. Cook through the Art Fund

These sparkling landscapes depict the view from the back of Constable's parental house in East Bergholt, Suffolk, and were painted from an upper window or the roof. They show his father's flower and kitchen gardens and (beyond) the family farm, and are conceived as a panorama, moving from the village at the left of the flower garden to the rectory and houses at the right of the kitchen garden. In the distance, workers harvest and thresh wheat, and cattle graze.

Every detail of these 'mundane' scenes has been lovingly

painted by the artist, revealing his close identification with the landscape of his birth. Particularly remarkable are the pinpoint strokes of colour that describe the flowers and foliage in the foreground, the luminosity of the fields and sky, and the unusual angle of vision, which immediately reveals that this is an eye-witness account of the scene.

One of more than 400 works bequeathed to the nation as part of the Ernest E. Cook Collection (see p. 37 and cat. 84–88), these two landscapes enjoy particular prominence in Constable's career. Not only do they depict his parents' house, but they are also associated with his lengthy courtship of his future wife, Maria Bicknell.

References: Leslie Parris and Ian Fleming-Williams, *Constable,* Tate Gallery, London, 1991, pp. 90-92, nos. 25 and 26; Graham Reynolds, *The Early Paintings and Drawings of John Constable,* New Haven and London, I, 1996, pp. 208-09, nos. 15.22 and 15.23.

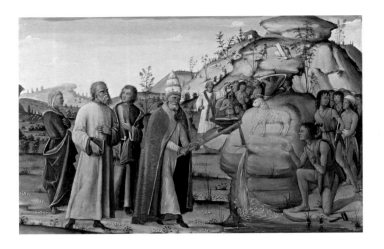

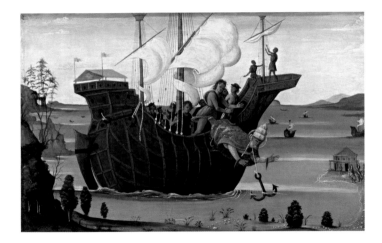

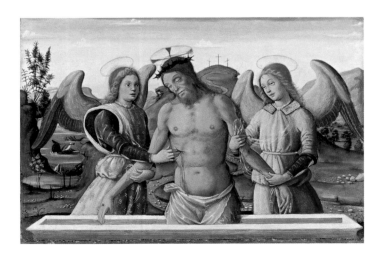

90
Bernardino Fungai (1460–1516)
St Clement Striking the Rock, *c.* 1500 (top)
oil and tempera with gilt on poplar; 43.1 x 65 cm
YORAG 1804 / AF Review no. 1785
York Museums Trust (York Art Gallery)
Presented by F.D. Lycett Green in 1955 through the Art Fund

The Martyrdom of St Clement, *c.* 1500 (middle)
oil and tempera with gilt on poplar; 42 x 62 cm
YORAG 1355 / AF Review no. 2742
York Museums Trust (York Art Gallery)
Acquired in 1978 for £30,000 from the Executors of Sir Thomas Merton
with a contribution of £2,500 from the Art Fund (Miss St Leger Good
Bequest) and additional support from the MGC/V&A Purchase Grant
Fund, the Pilgrim Trust, the York Civic Trust, a local benefactor and a
public appeal

Christ Supported by Two Angels, *c.* 1500 (bottom)
oil and tempera with gilt on poplar; 43.5 x 65 cm
YORAG 1455 / AF Review no. 3714
York Museums Trust (York Art Gallery)
Acquired in 1992 for £48,500 from Whitfield Fine Art Ltd with a
contribution of £12,125 from the Art Fund (including £2,900 from the
London Projects Committee) and additional support from the MGC/V&A
Purchase Grant Fund, the York Civic Trust and the Friends of York Art Gallery

These three predella panels demonstrate brilliantly how a
bequest to a museum can pave the way for future acquisitions.
Only *St Clement Striking the Rock* was given to York Art Gallery.
The other two were 'stalked' until they could join it in the
collection, *Christ Supported by Two Angels* being sold from the
collection of Imelda Marcos in 1992.

Together with two other predella panels in Strasbourg, these
originally may have adorned Fungai's altarpiece *The Coronation
of the Virgin,* on the high altar of Santa Maria dei Servi in Siena,
completed in 1501. Four of these depict episodes from the life
of St Clement, to whom the church was originally dedicated.

Clement was chosen to be Peter's successor as Bishop of
Rome, and reigned as Pope from *c.* 91 to *c.* 101 AD. Exiled
by the Emperor Trajan to the island of Chersonesus, he was
sentenced to work in the marble quarries with two hundred
fellow Christians. Forced to walk six miles a day to find drink-
ing water, Clement prayed that he might be shown a well
or spring nearby, whereupon a lamb appeared above a rock.
Realizing that this was the answer to his prayer, Clement struck
the rock and water gushed forth. Three months after this
miracle, Trajan appointed a new governor of Chersonesus, who
ordered Clement's death. He was taken to the governor's ship
and thrown overboard with an anchor tied around his neck.

Christ Supported by Two Angels was the central panel of the
predella and relates to the background of both of the other
two, showing water to the left of Christ and a rocky terrain
strewn with pebbles on the opposite side. All three are among
the finest achievements of Fungai, a Sienese master much
influenced by artists of the Umbrian School.

References: F.M. Perkins, 'Two Panel Pictures by Bernardino Fungai', in
Apollo, XV, 1932, pp. 143-46; *Painting in Renaissance Siena 1420–1500*,
Metropolitan Museum of Art, New York, 1988, pp. 353-58.

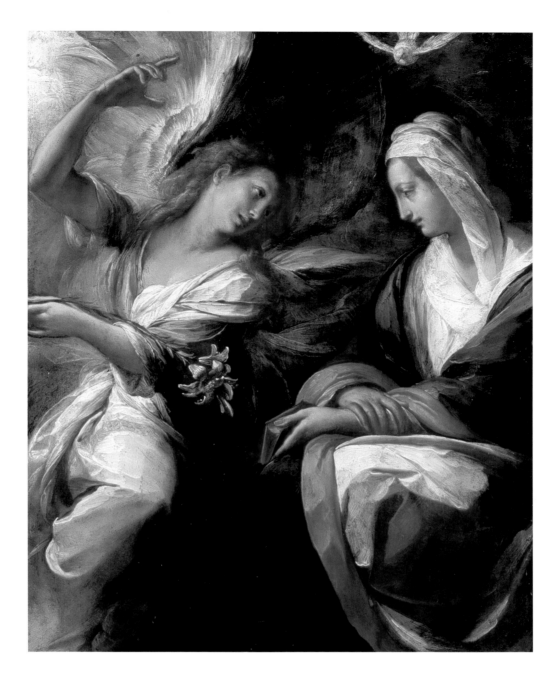

91
Giulio Cesare Procaccini (1574–1625)
*The Annunciation, c.*1610

oil on wood; 60.3 x 47 cm
YORAF 793 / AF Review no. 1785
York Museums Trust (York Art Gallery)
Presented in 1955 by F.D. Lycett Green through the Art Fund

Unusually for a seventeenth-century artist, Procaccini worked as both a painter and sculptor. Born in Bologna, he moved to Milan in the mid-1580s, where he trained in sculpture. By 1600, however, he had turned to painting. This lustrous little panel is among the earliest of his works and reveals the characteristics of his style: a refined elegance in the treatment of figures, coupled with an emotional intensity in their poses and expressions, evident here in the vehement attitude of the angel.

If the former recalls his Mannerist origins, the latter reveals his interest in the more dramatic currents of the Baroque.

The engineer and industrialist, F.D. Lycett Green (1893–1959), who bequeathed this work, was a collector of relatively modest means, unable to afford works by the very greatest names. Making a virtue of necessity, he specialized in collecting excellent examples by lesser masters and, in 1955, bequeathed 137 paintings to York through the Art Fund, in recognition of the remarkable efforts made after the Second World War by its curator Hans Hess, to transform it into a gallery of international importance.

Reference: Hugh Brigstocke, 'Giulio Cesare Procaccini Reconsidered', in *Jahrbuch der Berliner Museen*, XVIII, 1976, pp. 112-14.

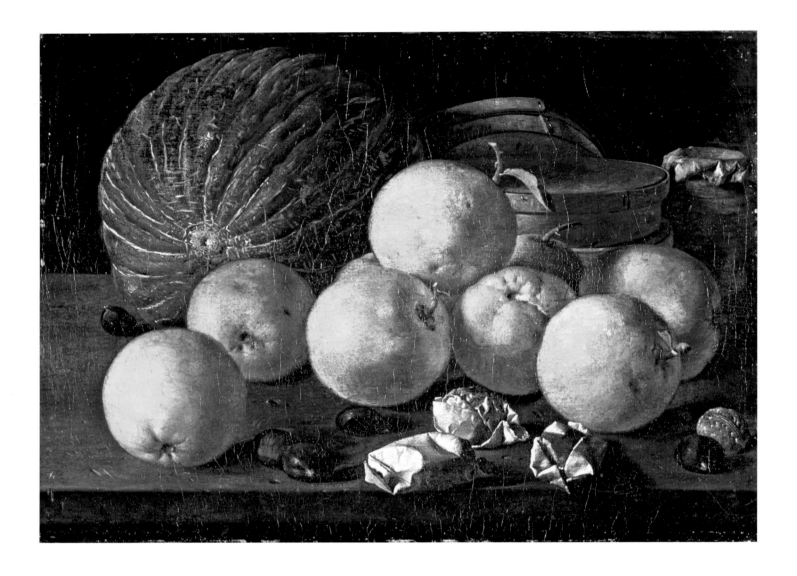

92
Luis Meléndez (1716–80)
*Still Life with Citrus Fruit and Nuts, c.*1770
Signed lower right: *L.M.*
oil on canvas; 37.1 x 50.1 cm
YORAG 774 / AF Review no. 1785
York Museums Trust (York Art Gallery)
Presented by F.D. Lycett Green in 1955 through the Art Fund

One of the handful of still lifes ever to be associated with the Art Fund, this was among three such works bequeathed to York as part of the Lycett Green Collection.

Meléndez was the greatest Spanish still-life painter of the eighteenth century, a status which the National Gallery, London acknowledged when they acquired a magisterial work by him in 1986. Born in Naples, he trained in Spain but visited Italy in the late 1740s. He returned to Madrid in 1753 and, by the late 1750s, had embarked on a career as a painter of still-lifes, inheriting the tradition of the seventeenth-century *bodegón* (see cat. 93), with its trenchant realism and dramatic lighting.

In this picture he portrays fruits, nuts, wrapped sweets and their boxes, together with a jar. All are distributed informally on a ledge, as though in a kitchen or larder. Meticulously scrutinized, with their surfaces and textures subtly differentiated, these mundane objects are illuminated so intensely that they acquire a revelatory quality. As in so much Spanish art – from Zurbarán to Dalí – the visible world here becomes a means of exploring the super-sensory.

Reference: Eleanor Tufts, *Luis Meléndez*, Columbia, Missouri, 1985, pp. 109-10, no. 93.

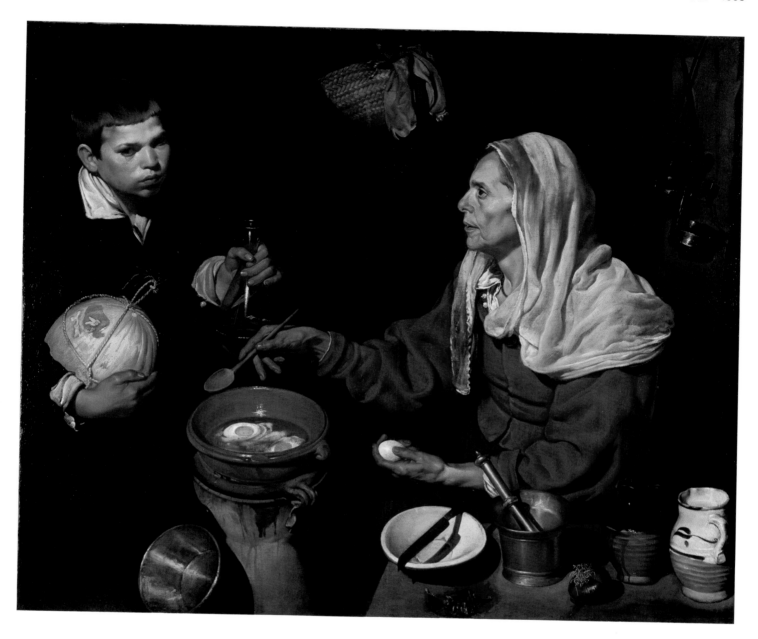

93
Diego Velázquez (1599–1660)
An Old Woman Cooking Eggs, 1618
oil on canvas; 100.5 x 119.5 cm
NG 2180 / AF Review no. 1772
National Gallery of Scotland, Edinburgh
Acquired in 1955 for £57,000 from Sir Francis Cook and the Trustees of
the Cook Collection with a contribution of £5,000 from the Art Fund and
additional support from a special grant from H.M. Treasury

Among Velázquez's earliest works is a group of genre scenes
in which figures and still life feature equally. The majority of
these are kitchen scenes (*bodegones*) painted from life models,
and were executed in *c*.1618–20, when the artist was in his
late teens and early twenties. Little short of miraculous in their
intense scrutiny of the visual world, these works may be seen
as 'portraits' of stilled life, for the figures in them appear every
bit as motionless as the objects.

This picture depicts an old woman cooking eggs and a youth
bearing a flask of wine and a melon. Their actions frozen, the
two do not communicate, their gazes never meeting. Instead,
the momentous encounters in this picture all occur in the
realm of illusionism – in the light reflected from a pestle and
mortar, the stains on an earthenware jug, the uniqueness of
an onion or chili, or the old woman's left ear, conjured forth
from under the folds of her headscarf.

References: Antonio Dominguez Ortiz, Alfonso E. Pérez Sánchez and
Julián Gállego, *Velázquez*, Metropolitan Museum of Art, New York,
1989, pp. 58-61, no. 1; Hugh Brigstocke, *Italian and Spanish Paintings
in the National Gallery of Scotland*, National Gallery of Scotland, Edinburgh,
2nd ed., 1993, pp. 191-93; *Velázquez in Seville*, National Gallery of
Scotland, Edinburgh, 1996, p. 128, no. 16.

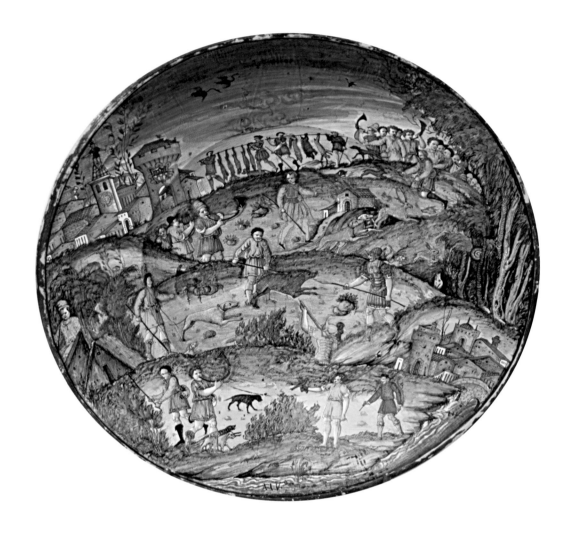

94
Federigo of Modena (active 1590s), *Maiolica Dish*, 1593–94

ceramic; diameter 73.3 cm, depth 16 cm
HASMG 956.40 / AF Review no. 1845
Hastings Museum and Art Gallery
Acquired in 1956 for £650 from H.E. Backer with a contribution of £325
from the Art Fund (Cochrane Trust) and additional support from the
Turner Fund and Vicat Cole Fund

The largest *maiolica* dish known to exist, this bears on the reverse the dated signatures of both the painter – Alessandro di Giorgio of Faenza, 1593 – and the potter – Federigo of Modena, 1594. Neither of these individuals is otherwise recorded; and the gap between the painting and firing processes has plausibly been explained by the need of the potter to find a solution to performing his task on so large an object.

The dish depicts three separate hunting scenes, with figures pursuing a wild boar, stag and hare. In the foreground stands a man with a falcon on his wrist; and above him another man aims a musket at birds in the sky. Though its origin is uncertain, it is now thought to have been made in Montelupo, west of Florence.

Scarcely less remarkable than the dish itself is its history. In 1862, it was owned by Alexander Barker, the 'most opulent collector of *maiolica* of his time'. It subsequently belonged to Sir Francis Cook, Lord Lee of Fareham – generous benefactor of the Courtauld Gallery and a trustee of the Art Fund – and King Baudouin of Belgium. And how did it end up in Hastings? Simple. George Savage, a great ceramics expert, lived nearby in the 1940s and 1950s and was honorary advisor to the museum. He spotted it in a sale catalogue and encouraged the museum to try to acquire it. The museum itself had a purchasing grant in the 1950s thanks to a Miss Turner – distant relative of the artist – who had left it a collection of ceramics with permission to sell some of these to raise funds for acquisitions.

References: Arthur Lane, 'A Dish of 1593-4, perhaps made at Modena', in *FAENZA: Bulletino del Museo Internazionale delle Ceramiche*, no. 3, 1955, pp. 53-54; George Savage, 'On the Front Cover', in *The Antique Dealer and Collector's Guide*, April 1968, p. 60.

95
Celtic (Isle of Man)
The Calf of Man Crucifixion, 8th – early 9th century
slate; 65.3 x 24.8 x 3.5 cm
IOMMM 1956-0011 / AF Review no. 1839
Manx National Heritage
Presented in 1956 as a gift by the Art Fund; acquired for £750
from Mrs Pharo-Tomlin

Off the southwest tip of the Isle of Man is the little island of
the Calf of Man, where this relief was unearthed in 1773 in
the remains of a ruined chapel. Purchased outright by the Art
Fund nearly two centuries later, it was presented to the Manx
Museum, which had never before received the fund's support.

The relief is of a type first known in eastern Mediterranean
and Byzantine art of the late sixth century. Christ is depicted
alive on the cross, with a soldier piercing his side. On his
other side, another soldier originally appeared holding the
sponge soaked with vinegar and, above Christ, were two
angels. Though all of these are missing from the present
relief, the foot of one of the angels can just be seen above
Christ's right shoulder.

The immediate inspiration for *The Calf of Man Crucifixion*
was probably a Celtic bronze plaque of Irish origin dating from
the late seventh or early eighth centuries – a time when
northern Britain and Ireland were one cultural entity.

References: P.M.C. Kermode, *Manx Crosses*, London, 1907, pp. 125-27;
B.R.S. Megaw, 'The Calf of Man Crucifixion', in *The Museums Journal*,
vol. LVI, no. 1, April 1956, p. 14.

96
Syrian, *Goblet* ('*The Luck of Edenhall*'), *c.*1355
glass painted in enamel colours and gilt; 15.8 x 11.1 cm
tooled leather case (probably French, possibly Narbonne, mid-14th century);
height 18.1 cm, diameter 12.7 cm
C.1-b-1959 / AF Review no. 1934
Victoria and Albert Museum
Acquired in 1958 for £5,500 from Sir Nigel Courtney Musgrave with a
contribution of £1,500 from the Art Fund and additional support from
the Pilgrim Trust, Goldsmiths' Company, Slaters' Company, Drapers'
Company and Merchant Taylors' Company

Few objects associated with the Art Fund can have had a more
romantic – if partly mythical – history than the so-called 'Luck
of Edenhall'. It is first mentioned in 1729 in a ballad referring
to a drinking match organized at Eden Hall, near Penrith, in
1721, by Philip, Duke of Wharton. But the earliest account
of its supposed origins occurs in the *Gentleman's Magazine*
of August 1791 by a writer signing himself 'W.M.' (almost
certainly Sir William Musgrave, a member of the Musgrave
family of Edenhall) who writes:

*'Tradition, our only guide here, says that a party of Fairies were
drinking and making merry round a well near the Hall, called
St Cuthbert's well; but, being interrupted by the intrusion of some
curious people, they were frightened, and made a hasty retreat, and
left the cup in question: one of the last screaming out:*

If this cup should break or fall,
Farewell the Luck of Edenhall.'

It was also later celebrated in a ballad by Johan Ludwig
Uhland, translated by Henry Wadsworth Longfellow.

Probably made at Aleppo, in Syria, in the mid-fourteenth
century, and possibly brought back from the Crusades, the
'Luck' is a beaker of yellowish glass enamelled in red, blue,
green and gilt. A superb example of luxury Syrian medieval
glass-making, its excellent condition may in part be explained
by its leather case, which also dates from the fourteenth
century. A sacred monogram on the case suggests that the
glass may once have served as a chalice.

There is evidence that the 'Luck' was in the possession of the
Musgrave family at a very early date, and it unquestionably
possesses one of the longest pedigrees of any glass object in
an English collection.

From 1926 to its acquisition in 1958, it was on loan to
the Victoria and Albert Museum from Sir Nigel Courtenay
Musgrave.

Reference: R.J. Charleston, 'The Luck of Edenhall', in *The Connoisseur*,
CXLIII, January 1959, pp. 34-35.

97
Roman, *The Lycurgus Cup*, 4th century
dichroic glass with gilded metal mount; 16.5 x 13.2 cm
P&E 1958, 1202.1 / AF Review no. 1935
Trustees of the British Museum
Acquired in 1958 for £20,000 from Lord Rothschild with a contribution of £2,000 from the Art Fund and additional support from a special grant from H.M. Treasury

98
Lorenzo Monaco (active 1399 – died *c.* 1423/24), *St John the Baptist Entering the Wilderness*, early 15th century
tempera on wood panel; 23 x 34 cm
L.F33.1959 / AF Review no. 1960
Leicester City Museums Service
Acquired in 1959 for £1,500 from Colnaghi with a contribution of £250 from the Art Fund and additional support from the Victoria and Albert Museum Purchase Grant Fund

This remarkable cup, which was probably originally used as a lamp, changes colour when light passes through it. In reflected light it appears opaque and pea-green, but, when held up to the light, it becomes a deep wine red. Tiny amounts of colloidal gold and silver in the glass give it these unusual properties; and it is the only complete surviving example of this type of glass, which is technically known as dichroic.

The scene depicted on it is an episode from the legend of Lycurgus, King of the Thracians. After angering the god Dionysus by driving him to the depths of the sea, Lycurgus attacked his *maenads*, one of whom – Ambrosia – was saved by Mother Earth, who transformed her into a vine. She then coiled herself around Lycurgus and trapped him. The scene shows him struggling to escape from her clinging tendrils. While Dionysus, Pan and a satyr threaten the King, Ambrosia reclines on the ground. The classical source for this myth is Nonnus, *Dionysiaca*, books 20 and 21.

Attributed to Andrea di Bartolo (b. between 1358/64 – d. 1428) when it was acquired, this little panel is now ascribed to Lorenzo Monaco, who was probably born in Siena but settled in Florence, where he was the presiding artist during the first two decades of the fifteenth century.

The picture is one of five predella panels that formed part of an altarpiece of *Saint Jerome, Saint John the Baptist, Saint Peter and Saint Paul* (Accademia, Florence). These are now widely dispersed and differ markedly in quality, with experts unable to agree on the extent (if any) of Lorenzo Monaco's participation in this scheme. But the tentative upgrading of this engaging panel – which depicts the Baptist taking leave of the city and setting out for the wilderness – is an example of the upturn in fortune that a museum may enjoy when it is willing to take a risk in buying an uncertainly attributed work.

References: D. Harden (ed.), *Glass of the Caesars*, Milan, 1987, pp. 245-49, no. 139; H. Tait (ed.), *Five Thousand Years of Glass*, British Museum, London, 1991, pp. 92-93, no. 116.

References: Federico Zeri, 'Investigations into the Early Period of Lorenzo Monaco – II', in *The Burlington Magazine*, CVII, 742, 1965, pp. 3-11; Marvin Eisenberg, *Lorenzo Monaco*, Princeton, 1989, pp. 186, 188, 190 and 196.

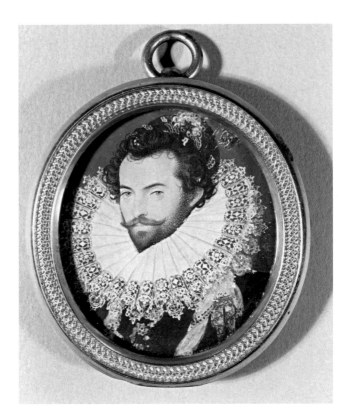

99
French and Scottish
Mary Queen of Scots Cameo, late 16th century
gold, onyx, enamel, diamonds, ruby; width of locket 5.1 cm, length of cameo 2.2 cm
H.NF.33 / AF Review no. 1963
Trustees of the National Museums of Scotland
Acquired in 1959 for £3,571 from Phillips with a contribution of £300 from the Art Fund (Cochrane Trust)

In the years between the two world wars, the Art Fund supported four works apparently linked to Mary Queen of Scots: her last letter (cat. 14); the wrought-iron railing which guarded her tomb in Westminster Abbey (1920); a bed curtain and valances (1921); and the so-called Mary Queen of Scots pendant (1939). The last of these has subsequently been proved to be a nineteenth-century fake, and the bed curtain and valances – though of exceptional quality and beauty – to have nothing to do with her. Instead they are merely of a type she is known to have brought back with her from France in 1561.

In 1959 the Art Fund added to these this splendid jewel, which contains a profile bust of Mary in the form of an onyx cameo. The cameo is of French or Italian origin, while its backplate of *émail en résille sur verre* is comparable to that on a sixteenth-century French pomander in the Thyssen-Bornemisza Collection. The outer case of the heart-shaped pendant in which it is set appears to have been made in Scotland. Made of gold with *cloisonné* enamel, it is elaborately ornamented with flowers and leaves in delicate greens, blue and white and set with diamonds and a native-cut ruby. Though the history of the jewel is unknown, evidence exists that sixteenth-century monarchs often presented mounted cameos of themselves as rewards or marks of favour. Given its elaborate nature, the unknown recipient of this cameo jewel must have performed a deed of considerable importance.

References: Stuart Maxwell, 'The Queen Mary Cameo Jewel Purchased for the Museum', in *Proceedings of the Society of Antiquaries of Scotland*, no. 93, 1959-60, pp. 244-45; Joan Evans, *A History of Jewellery, 1100-1870*, London, 2nd ed., 1970, p. 119; Yvonne Hackenbroch, *Renaissance Jewellery*, Oxford, 1979, p. 286; Rosalind Marshall and George Dalgleish (eds.), *The Art of Jewellery in Scotland*, Edinburgh, 1991, p. 14.

100
Nicholas Hilliard (1547–1619)
Miniature Portrait of Sir Walter Raleigh, c.1581–84
watercolour on vellum; 4.8 x 4.1 cm
NPG 4106 / AF Review no. 1962
National Portrait Gallery, London
Acquired in 1959 for £5,000 from Sotheby's with a contribution of £2,000 from the Art Fund and additional support from the Pilgrim Trust

Of the three miniatures by or attributed to Hilliard that have been supported by the Art Fund, this is undoubtedly the finest. It also boasts a distinguished provenance. Formerly in the collection of the Earls of Carlisle, it passed to Viscount Morpeth, son and heir of the 11th Earl, having lost its identity when it was reframed in the nineteenth century with an inscription identifying it as the Earl of Northampton. The correct identification was made by comparison with an inferior version, now in the Kunsthistorisches Museum, Vienna.

The military and naval commander Sir Walter Raleigh (1552?–1618) was a favourite of Elizabeth I. He was knighted in 1584, which may have occasioned the commissioning of this portrait miniature – apparently the earliest likeness of him to survive. He is depicted wearing a small, decorated black cap and large circular ruff. This costume is French in style. In its elegance and delicacy, the miniature ranks among Hilliard's most outstanding works and testifies to the claim he made in his treatise on art, the *Arte of Limning* (c. 1600), that the perfection of painting 'is to imitate the face of mankind'.

References: Erna Auerbach, *Nicholas Hilliard*, London, 1961, pp. 95-96 and 298; Roy Strong, *Artists of the Tudor Court, the Portrait Miniature Rediscovered 1520-1620*, Victoria and Albert Museum, London, 1983, p. 74, no. 81.

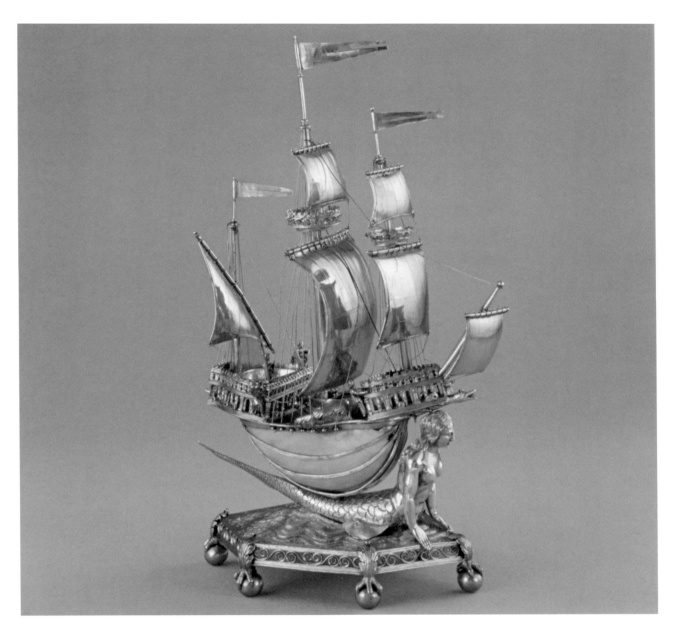

101
Paris (France), *The Burghley Nef*, probably 1527–28
nautilus shell mounted in silver (parcel-gilt); 34.3 x 20.2 cm
M.60-1959 / AF Review no. 1986
Victoria and Albert Museum
Acquired in 1959 for £10,000 from Christie's with a contribution of
£2,000 from the Art Fund (Cochrane Trust) and additional support from
the Worshipful Company of Goldsmiths

In medieval Europe the term 'nef' described a vessel in the
shape of a boat or ship. This superb example served as a salt
cellar. Its hull is made of a nautilus shell, which rests on a
mermaid reclining on a hexagonal base embossed with waves
and supported by six claw-and-ball feet. The forecastle and
stern of the ship are enclosed with battlemented arcading,
and the stern contains a detachable salt cellar with two sailors
holding spears and round bucklers. Two other figures stand on
cannons, a third clings to the forecastle and another climbs
a ladder to the top of the main mast. At the foot of the mast,

seated on a settle, are Tristram and Iseult on their fateful journey
from Ireland to Cornwall, playing chess.

Formerly in the collection of the Marquess of Exeter at
Burghley House (from whence it derives its name), the nef
is of exquisite craftsmanship, but its date and origin remain
a cause for dispute. Some scholars have connected it with the
(possibly Flemish) goldsmith Pierre le Flamand and dated it
1482, but others believe it to be as late as *c.* 1527–28, because
of its stylistic similarities to French Renaissance silver of the
1530s. Upon its acquisition in 1959 advice was sought from
the National Maritime Museum to make its rigging more
accurate, and the ropes are all modern.

References: J.F. Hayward, *Virtuoso Goldsmiths and the Triumph of
Mannerism, 1540-1620*, London, 1976, pp. 86 and 361, pl. 252; Carl
Hernmarck, *The Art of the European Silversmith, 1430-1830*, London
and New York, 1977, p. 171; R.W. Lightbown, *French Silver*, London,
1978, pp. 28-34, no. 19.

102

Pieter Bruegel the Elder (*c.*1525/30–69)
Calumny of Apelles, 1565

Inscribed lower right: *M.D. LXV/P BRUEG.*
pen and brown ink with brown wash, on brown prepared paper;
20.2 x 30.6 cm
PD 1959-2-14-1 / AF Review no. 1961
Trustees of the British Museum
Acquired in 1959 for £1,925 from Colnaghi with a contribution of £963
from the Art Fund (including £400 from the Campbell Dodgson
Bequest)

Bruegel's sole surviving work on a classical theme, this drawing
is inspired by a legendary lost picture by the Greek painter
Apelles (late fourth–early third century BC) described by
Lucian, the Roman writer of the second century AD. Seated
on the right is Prince Ptolomeus, with greatly enlarged ears,
surrounded by his two female advisers, Ignorantia and Suspicio
(Ignorance and Suspicion). Standing before him, with one
foot on the platform of the throne is Lyvor (Envy), who points

towards the prince and gestures for silence. Behind is Calumnia
(Calumny) bearing a torch with one hand and pulling a child
with the other. She is followed by Insidia (Guile), counting false
arguments, and Fallacia (Deceit), waving her arms in the air.
At the extreme left, Penitencia (Repentance) gazes back shed-
ding tears of shame towards Veritas (Truth). The moral of the
work is the power of ignorance and deceit to mask the truth.

According to Karel van Mander, writing in his *Schilder-boeck*
of 1604, Bruegel also executed a painting of 'Truth Will Out',
for which this drawing may have been a preliminary study
and which, according to the artist himself, 'was the best he
ever made'.

References: Christopher White, 'Pieter Bruegel the Elder: Two new
drawings', in *The Burlington Magazine,* CI, 678/79, pp. 336-41; Nadine
M. Orenstein (ed.), *Pieter Bruegel the Elder: Drawings and Prints,*
Metropolitan Museum of Art, New York, 2001, pp. 234-36, no. 104.

103

Peter Paul Rubens (1577–1640), *The Virgin and Child with St Elizabeth and the Infant Baptist, c.* 1635

oil on canvas; 180 x 139.5 cm
WAG 4097 / AF Review no. 2007
National Museums Liverpool
Acquired in 1960 for £50,000 from Agnew's with a contribution of £1,000 from the Art Fund and additional support from a special grant from H.M. Treasury and contributions from various trusts, firms and private individuals

Rubens' imaginative powers were so prodigious that he can only have found the theme of the Holy Family somewhat 'restricted'. Nevertheless, in the last decade of his career – remarried after the death of his first wife and raising four young children – he turned to it on several occasions to portray the warmth and tenderness of human love.

This picture also explores love's interdependence. As the Virgin turns to converse with Elizabeth, Christ suckles her breast while the Baptist caresses his feet. At the left, the Baptist's mother supports him with her right hand. A seamless chain of actions is thereby established linking the entire group, from which Joseph has been omitted – or, more accurately, removed. He was originally included behind the pillar at the upper right and subsequently painted over, probably for compositional reasons.

Formerly in the collection of the Duke of Devonshire, this picture was export-stopped and became the first ever acquisition by a municipal museum to receive a special government purchase grant.

References: John Jacob, 'The Liverpool Rubens and Other Related Pictures', in *Liverpool Bulletin,* Walker Art Gallery, Liverpool, 1960-61, vol. 9, pp. 4-25; *Foreign Schools Catalogue,* Walker Art Gallery, Liverpool, 1963, pp. 173-74.

104
Mūsa (active 1480/81), *Spherical Astrolabe*, 1480–81

brass and silver; diameter 9 cm
MHS 49687 / AF Review no. 2101
Museum of the History of Science, University of Oxford
Acquired in 1962 for £3,780 from Sotheby's with a contribution of £344
from the Art Fund and additional support from the Goldsmiths' Company,
Lord Leigh's Fund, the Hulme Surplus Reserve Fund and the Higher
Studies Fund

105
Georges Seurat (1859–91), *White Houses, Ville d'Avray
(Maisons Blanches, Ville d'Avray)*, 1882–83

oil on canvas; 33 x 46 cm
WAG 6112 / AF Review no. 2083
National Museums Liverpool
Acquired in 1962 for £13,500 from Sir Alfred Chester Beatty with a
contribution of £2,500 from the Art Fund and additional support from
the Victoria and Albert Museum Purchase Grant Fund

Auctioned at a sale of miscellaneous scientific instruments at Sotheby's in 1962, and of uncertain provenance, this spherical astrolabe is the only complete example to survive. It was used for making astronomical calculations and is of Eastern Islamic origin. All of the inscriptions on it are of Eastern Kufic Arabic script, and it is signed 'Work of Mūsa. Year 885 [1480/1 AD]'. Mūsa is an otherwise unknown instrument maker.

The astrolabe is made of brass, with the inscriptions, hour-lines, meridians and almucantars (circles of altitude) damascened in silver. The concentric *'ankabût* or *rete* – a rotating star-map – is also of brass, laminated with silver on the ecliptic and equatorial circles, the vertical quadrant, and near the suspension piece, which is silver. The globe is made in two hemispheres joined by means of single coarse screw-thread.

Though written accounts of spherical astrolabes survive from the ninth to the thirteenth century, the instrument was never as popular as its flat counterpart, the planispheric astrolabe, and it is likely that only very few of them were ever made.

Reference: Francis Maddison, 'A 15th-century Islamic Spherical Astrolabe', in *Physis: Rivista di Storia della Scienza*, IV, 2, 1962, pp. 101-09.

Seurat's instinctual classicism is immediately apparent in this pellucid little landscape. Focusing upon a group of three houses behind a wall, he frames them to either side with foliage and divides the foreground into two rectangular bands, one yellow and the other green, coaxing a hidden geometry out of the entire scene. Further adding to the stark simplicity of the design are the façades of the buildings, which have been flattened, making them appear more cubic, and the blue band of the sky at the top of the picture. The latter echoes the rhythms of the foreground and wall, enhancing the harmony of the composition.

The landscape, which was clearly done from nature, does not relate to any of the studies for Seurat's principal pictures. But its complex intermingling of colour – especially in the blues, greens and oranges of the foliage at the right – prefigures the artist's approach to the depiction of landscape in *Bathers at Asnières* (National Gallery, London) of 1883–84.

References: Henri Dorra and John Rewald, *Seurat*, Paris, 1959, p. 33, no. 34; C.M. de Hauke, *Seurat et son oeuvre*, Paris, 1961, I, p. 12, no. 20; *Georges Seurat 1859-1891*, Metropolitan Museum of Art, New York, 1991, pp. 124-25, no. 87.

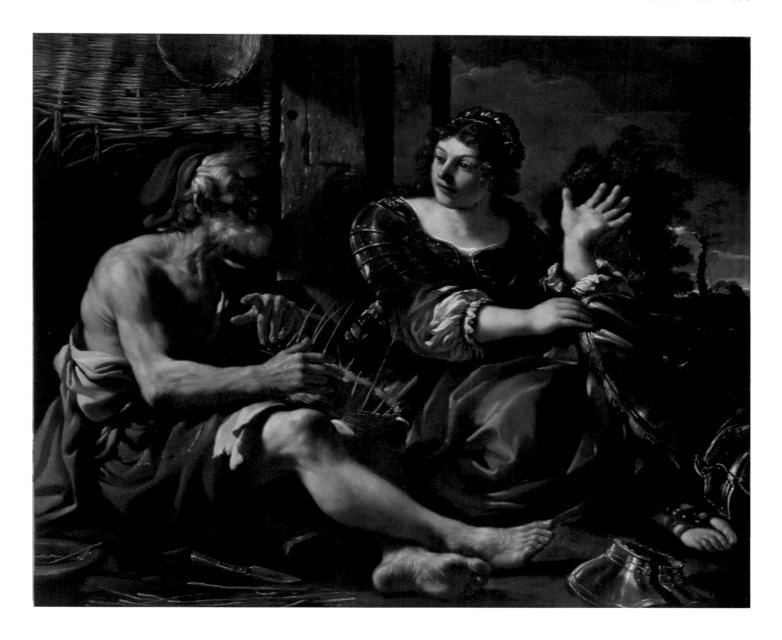

106
Giovanni Francesco Barbieri (known as Il Guercino)
(1591–1666)
Erminia and the Shepherd, c. 1619–20
oil on canvas; 149 x 178 cm
1962P17 / AF Review no. 2089
Birmingham Museums and Art Gallery
Acquired in 1962 for £7,000 from Colnaghi with a contribution of £2,000
from the Art Fund and additional support from the Victoria and Albert
Purchase Grant Fund

Tasso's epic poem on the First Crusade, *Gerusalemme Liberata* (*Jerusalem Delivered*), published in 1581, was among the most fertile sources of imagery for seventeenth-century painters. This magnificent picture illustrates an episode from Canto VII (8-13) of this poem. The Saracen princess Erminia has fled from the crusaders' camp in search of the wounded Tancred, with whom she is unrequitedly in love. Pursued by

a patrol of the Christian army, she seeks shelter in the remote countryside with a shepherd and his family. In conversation with him, she is persuaded to discard her armour and follow a bucolic existence, tending the flocks in the fields until such time as fortune may deem her fit to return to battle.

The picture was commissioned in 1619 by Ferdinando Gonzaga, Duke of Mantua, who knighted Guercino upon receiving it. Arguably the greatest work by the Bolognese master in the United Kingdom, it was a pioneering acquisition, even as late as 1962, by a museum that now boasts the finest collection of Italian Baroque art in England outside London.

References: Luigi Salerno, *I dipinti del Guercino*, Rome, 1988, pp. 140-41, no. 61; *Guercino in Britain: Paintings from British Collections*, National Gallery, London, 1991, pp. 20-21, no. 6.

107
Giovanni Pisano (*c.* 1250 – after 1314)
The Prophet Haggai, 1285–97

marble; 63.8 x 47.9 x 41.3 cm
A.13-1963 / AF Review no. 2110
Victoria and Albert Museum
Acquired in 1963 for an undisclosed sum from Colnaghi with a contribution
of £5,000 from the Art Fund and additional support from a special grant
from H.M. Treasury

This awe-inspiring bust formed the top half of one of fourteen
life-size sculptures made by Pisano and his workshop, which
originally adorned the west façade of Siena Cathedral. Twelve
of these are now in the Museo dell'Opera del Duomo in
Siena, having been replaced by copies on the façade itself.
But they were only removed comparatively recently, and are
much less well-preserved than the present bust, which was
probably removed in the middle of the nineteenth century,
when it must have split from its base.

The sculpture depicts the Old Testament prophet Haggai
holding a scroll and turning to his left. Originally he faced
the figure of Isaiah high up on the north face of the façade,
which may explain why both works are more boldly carved
than those designed to be seen at eye level. But this 'rough-
ness' of carving lends to the work a demonic intensity akin
to that of one possessed. Small wonder that the bust was
acclaimed in the 1963 Art Fund *Review* as 'by far the finest
Italian Gothic sculpture … outside Italy'.

References: John Pope-Hennessy, 'New Works by Giovanni Pisano – I',
in *Essays on Italian Sculpture*, London and New York, 1968, pp. 1-5;
Paul Williamson, *Gothic Sculpture 1140-1300*, New Haven and London,
1995, pp. 259-60.

108
William Blake (1757–1827), *The Raising of Lazarus*, *c.*1805
Inscribed lower left: *WB inv*
pen, ink and watercolour; 40.7 x 29.6 cm
ABDAG 2369 / AF Review no. 2114
Aberdeen Art Gallery & Museums Collections
Acquired in 1963 for £4,500 from Agnew's with a contribution of £1,000
from the Art Fund (Ramsay-Dyce Bequest) and additional support from
the National Fund for Acquisitions, Jaffrey Bequest and Royal Scottish
Museum

Along with *The Crucifixion* (cat. 74), this is one of about fifty
biblical works that Blake executed for his patron, Thomas
Butts. Both works may have formed part of a sub-group within
these, concerned with the Passion of Christ. The Raising of
Lazarus (John 11, 1-44) is often seen as a prefiguration of the
Resurrection; and the symmetrical design and muted colouring
of this work further link it with that group. Blake had earlier
treated the theme as part of his illustrations to Edward Young's
Night Thoughts in *c.* 1795–97.

The watercolour is remarkable for its excellent state of
preservation and for the figure of Lazarus, gliding effortlessly
out of the tomb. It was formerly in the collection of the
Marchioness of Crewe and is one of only two works by
Blake acquired for Scottish collections through the Art Fund.

Reference: Martin Butlin, *The Paintings and Drawings of William Blake*,
New Haven and London, 1981, I, p. 357, no. 487.

109
Frans Hals (1581/85–1666)
Portrait of a Young Woman, c. 1655–60
oil on canvas; 60 x 55.5 cm
526 / AF Review no. 2121
Ferens Art Gallery: Hull City Museums and Art Gallery
Acquired in 1963 for £35,000 from George Wyndham with a contribution
of £5,000 from the Art Fund and additional support from the Gulbenkian
Foundation, Pilgrim Trust, Victoria and Albert Museum Purchase Grant
Fund and a local appeal

Hals is one of the few seventeenth-century portraitists whose
depictions of women are as penetrating and sympathetic as his
portrayals of male sitters, and this tender and wistful portrait
is no exception. Dating from the end of his career, when he
reveals his most profound insights into the human condition,
it depicts a young woman, posed frontally, with her head gently
tilted and her lips just parting to reveal a smile. Adding to the
intimacy of the portrait are the delicate play of light over her
features and the restrained brushwork – unusual in late Hals,
but here enhancing the candour of the characterization.

The picture is among the prize possessions of the Ferens Art
Gallery in Hull, which, given the city's trading links with the
Netherlands, has actively pursued a policy of acquiring major
works of Dutch art.

References: Seymour Slive, *Frans Hals,* London, 1970-74, I, p. 194, III,
p. 102, no. 196; Seymour Slive et al., *Frans Hals,* Royal Academy of
Arts, London, 1989, p. 336, no. 74.

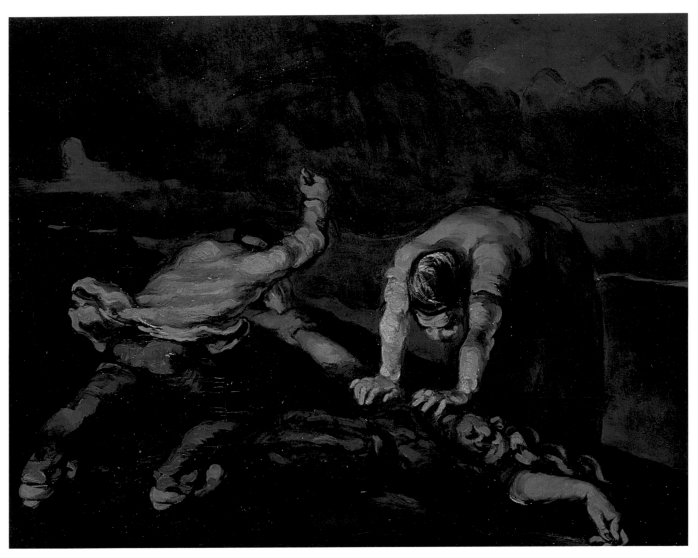

110

Paul Cézanne (1839–1906), *The Murder*, 1867–70

oil on canvas; 64 x 81 cm
WAG 6242 / AF Review no. 2160
National Museums Liverpool
Acquired in 1964 from Wildenstein for £32,400 with a contribution of
£5,000 from the Art Fund

When this harrowing picture was acquired for the Walker Art
Gallery, its director, Hugh Scrutton, observed: 'It seems fitting
that Liverpool – a great nineteenth-century city in whose past
grim and terrible incidents lie buried – should now own this
slate-blue painting which is so powerfully evocative of the
depths of human nature.' What he did not add was that the
picture was an unprecedented acquisition for a British gallery;
and, to this day, it remains the only one of Cézanne's early
subject pictures in a public collection in the United Kingdom.

The painting belongs to a group of works of the 1860s in
which Cézanne appears to be exorcizing the demons of his
tormented relationship with his family – especially his father –
and indulging his early fascination with romantic literature,
which was fuelled by his childhood friendship with the future

novelist Emile Zola (1840–1902). Some of these are based on
identifiable sources, but the majority – including the present
picture – are not; and most are concerned with violent and
disturbing themes such as this, in which two figures have
thrown a woman to the ground and prepare to murder her
and dump her body into the storm-tossed sea. Intensifying
the explosive force of the figures' actions is the brutality of
the handling, with its turbulent swathes of paint and sombre
colouring.

Purchased in the same year as Rembrandt's equally dramatic
Belshazzar's Feast (cat. 111), this picture marked a coming-of-
age for the Art Fund, which had hitherto not embraced such
dark and threatening works. Surprisingly, it is the only painting
by the father of modern art ever supported by the fund,
despite the fact that Cézanne's greatest champion of the
early-twentieth century, Roger Fry, was one of its founders.

References: *Cézanne, the Early Years 1859-1872*, Royal Academy of
Arts, London, 1988, p. 138, no. 34; John Rewald, *The Paintings of
Paul Cézanne, A Catalogue Raisonné*, London, 1996, I, p. 134, no. 165;
Cézanne, Tate Gallery, London, 1996, pp. 108-10, no. 16.

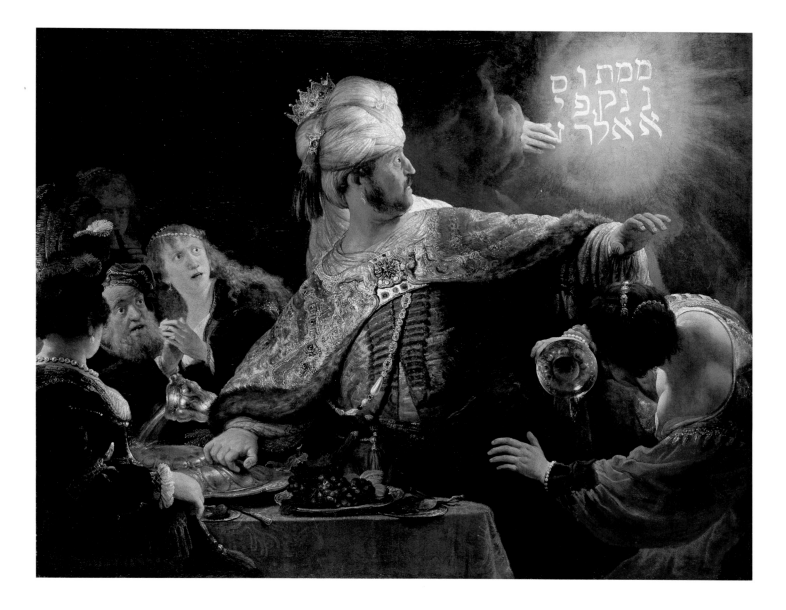

111

Rembrandt van Rijn (1606–69), *Belshazzar's Feast, c.*1636
Inscribed upper right: *Rembrandt.F 163*[?]
oil on wood; 167.7 x 209.2 cm
NG6350 / AF Review no. 2149
National Gallery, London
Acquired in 1964 for £170,000 from the Earl of Derby with a contribution
of £10,000 from the Art Fund

The first startlingly dramatic Baroque painting supported by
the Art Fund, this constitutes a turning-point in its history,
especially when one notes that the fund helped acquire an
even more emotionally extremist work – Cézanne's *Murder*
(cat. 110) – in the same year.

The subject is from Daniel 5: 1-9. Belshazzar is holding a
banquet using gold and silver vessels looted by his father,
Nebuchadnezzar, from the Temple of Jerusalem. During this
feast, the 'fingers of a man's hand' come forth and write upon
the wall, startling the King and defying the interpretation of
his court. Only Daniel is able to decipher the inscription,

which foretells the King's death that night and the subsequent
division of his kingdom.

The picture is a *tour de force* not only of gesture and expression
but also of painterly skill, evident in the bold foreshortening
of the woman at the right, the gleaming gold vessels, and the
dazzling virtuosity of Belshazzar's turban and brocaded cloak.

The most important history painting by Rembrandt in a
British collection, this is one of five works by the artist sup-
ported by the Art Fund, all of which are in the National
Gallery. The other four are *Saskia van Uylenburgh in Arcadian
Costume* (acquired in 1938), the *Portrait of Margaretha de Geer*
(1941), *Frederick Rihel on Horseback* (1960) and the *Portrait of
Hendrickje Stoffels* (1976).

References: J. Bruyn et al., *A Corpus of Rembrandt Paintings*, Dordrecht,
Boston and London, III, 1989, pp. 124-33, A110; Neil MacLaren, *The
Dutch School 1600-1900*, revised and expanded by Christopher Brown,
National Gallery, London, 2 vols., 1991, pp. 362-64.

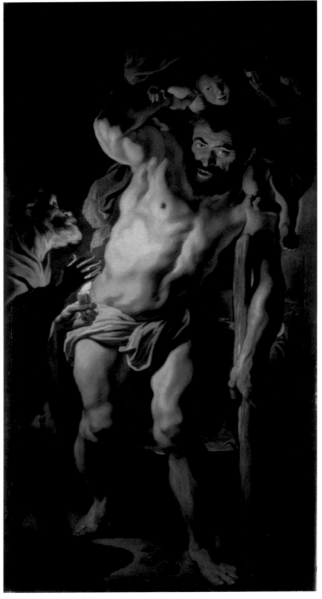

112
Jacob Jordaens (1593–1678)
St Christopher carrying the Christ Child, c.1620–25

oil on canvas; 315 x 160 cm
4133 / AF Review no. 2258
Ulster Museum
Acquired in 1966 for £9,000 from Colnaghi with a contribution of £2,000
from the Art Fund

In 1611–14, Rubens executed a major altarpiece for the altar of the Arquebusiers Guild in Antwerp Cathedral. The patron saint of the guild was St Christopher, who bore the Christ Child across a river, aided by a hermit. Rubens depicted this scene on the outer wings of the altarpiece, providing the direct inspiration for this masterpiece by Jordaens, who was the greatest Flemish history painter of the generation after Rubens. At the left, a hermit holding a lighted candle gazes up at the heroic figure of the Saint, straining under the weight of the Christ Child, who is seated on his shoulder.

Born in Antwerp, and active there throughout his entire career, Jordaens never visited Italy. But he was indirectly exposed to the dramatic lighting effects of Caravaggio and his school through certain early works by Rubens, who had spent eight years in Italy. This is apparent in the striking illumination of the figures in the present picture, which was presumably executed for a church. From the perspective and proportions of the saint, it was clearly intended to hang high.

This would have been an inspired acquisition by any British gallery in the 1960s but was especially so for Belfast, which was then building an extension to its museum in which it wished to display the Jordaens and pleaded more than once with the Art Fund for a more generous contribution than £2,000.

References: Michael Jaffé, *Jacob Jordaens 1593-1678*, National Gallery of Canada, Ottawa, 1968, pp. 87-88, no. 30; R.A. d'Hulst, *Jacob Jordaens*, London, 1982, pp. 138-40.

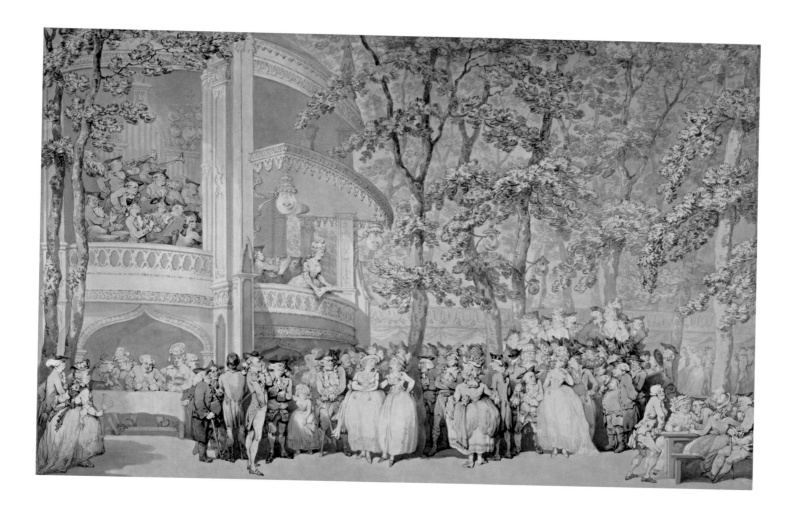

113
Thomas Rowlandson (1756–1827), *Vauxhall Gardens, c.*1784
pen and watercolour over pencil; 48.2 x 74.8 cm
P.13-1967 / AF Review no. 2262
Victoria and Albert Museum
Acquired in 1967 for £5,000 from the Executors of A.E. Pearson with
a contribution of £1,000 from the Art Fund

This watercolour depicts one of the most fashionable of
London's pleasure gardens, and when it was first exhibited at
the Royal Academy in 1784 must surely have set tongues
wagging, for it contains portraits of many of the leading society
figures of the day. At the right is the Prince of Wales (the
future George IV) whispering to his lover, the actress 'Perdita'
Robinson. Under the central tree, Captain Topham, owner
and editor of the *World*, quizzes the Duchess of Devonshire and
Lady Bessborough. On the Duchess's right is the wooden-
legged Admiral Paisley; and behind the tree are Sir Henry Bate-
Dudley, editor of the *Morning Herald* and James Perry, editor
of the *Morning Chronicle*, who is in Highland dress.

It used to be thought that the group dining in the box at the
left depicted Dr Johnson and his party, but this is no longer
sustainable. However, the singer above them entertaining the
crowd is identifiable as Mrs Weichsel, who was best known as
the mother of Elizabeth Billington (1765–1818), also a singer
and reputedly 'the most celebrated vocal performer that
England ever produced'.

References: Bernard Falk, *Thomas Rowlandson: His Life and Art, a
Documentary Record,* London, 1949, pp. 75-84; *100 Great Paintings in
the Victoria and Albert Museum*, introduction by Michael Kauffmann,
London, 1985, p. 84.

The Girona Treasure

Robert Sténuit

In 1588 King Philip II of Spain tried to alter the course of European history by invading England and instituting a change of regime. His invasion was long in preparation and conceived on an unprecedented scale, but it failed utterly, with the loss of roughly half the ships and half the men of his 'Felicissima Armada'. Among the most poignant relics of the disastrous offensive is a group of artefacts from the galleass[1] Girona (cat. 117), which my diving companions and I recovered from the icy waters off Lacada Point, Northern Ireland, almost four centuries after the ill-fated ship sank there.

Philip believed that it was imperative to knock down England's Anglican Queen to remove the threat to Spain posed by this 'heretical' country. In the harbour at Lisbon he gathered a formidable armada (the word is Spanish for fleet of war), made up of some 130 ships carrying more than 30,700 seamen and soldiers. The plan was that they would sail to Flanders, where a large and battle-hardened Spanish army was supposed to be waiting, to be escorted across the Channel on a fleet of barges. After landing in England, the Spaniards would march on London, depose Elizabeth I and replace her with Philip's own daughter, Princess Isabella Clara Eugenia.

This invasion plan was deeply flawed and had little realistic chance of succeeding. Firstly, it depended on a precise rendezvous between two forces that, once the Armada had set sail, had no way of communicating with each other. Secondly, it required absolutely calm waters and a light, favourable wind for the flat-bottom barges to be able to cross the English Channel. Thirdly, the Armada had to contend with an English fleet that was more than a match for it; although the Spanish ships had the advantage in size and in weight of armament, the English navy – under resourceful and experienced commanders – was far superior in seamanship and gunnery.

Before the Armada left Lisbon, one of the most senior Spanish captains, Juan Martínez de Recalde, said to a papal envoy with desperate cynicism: 'It is well known we fight in God's cause … so we are sailing against England in the confident hope of a miracle.' There was no miracle, the rendezvous was missed, God looked and breathed the wrong way and the Armada retreated for home around Scotland and Ireland, often facing severe storms and losing ship after ship on cliffs, reefs and rocks, in shallow bays and in the open sea. In England, Philip's self-inflicted defeat was hailed as a great victory for Elizabeth's seadogs, morale was boosted immensely and national pride bloomed.

As a by-product of the attempted invasion, the Armada abandoned on the bottom of the sea a number of 'time capsules' to await discovery by later generations.[2] The first such time capsule to be recovered in the twentieth century was that of the wreck of the galleass Girona of the Naples squadron (named after the powerful Girón family who had financed the building of the ship). It produced a uniquely rich assembly of treasures since it contained the collections of five ships, put together and lost together.

Part of the Girona treasure had been brought aboard the ship when she was fitted out for the invasion in Naples. Some of it came from palaces in Naples and Genoa and was brought onto the ship in the chest of the captain, the young Don Fabrizio Spinola (a member of a great Genoese family), including his personalized cross of a Knight of Malta. His officers (there were twenty-two of them) also brought their precious possessions, as did two infantry captains who sailed with their companies of harquebusiers and pike men, and the padre brought his liturgical silver. Every man on board – gunners, helmsmen, able seamen, sailors, ship's boys and rowers (whether convicts, slaves or benevoglies) – also received one or several sacred medals before leaving Coruña, where the fleet had briefly anchored for repairs and supplies, together with Communion and Confession.

The Armada had sailed from Lisbon in late May 1588. In October, during the long and tortuous retreat, Fabrizio Spinola came to anchor for food and water in Killybegs, a port in Donegal Bay, on the northwest coast

fig. 29 Detail of an engraving by Claes Jansz. Visscher (1587–1652) showing the burning
of the *Salvador*, with shipwrecked Spanish sailors and monks

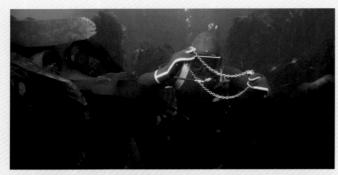

fig. 30 Divers and their finds during the original *Girona* excavation, 1967– 69; top: one of eight recovered chains; bottom: gold *escudos* and a large gold chain

of Ireland. There he took aboard the *Girona* another 750 men (the ship already held 550) led by the much-respected Don Alonzo Martínez de Leiva, the second in command of the Armada. The 750 newcomers were the survivors from four Armada shipwrecks: two small vessels of unknown name, the hulk *Duquesa Santa Ana*, and the great carrack *Rata Sancta Maria Encoronada*. The *Rata* was de Leiva's original ship, and after it was wrecked he transferred to the *Duquesa*, which was soon also lost. Besides Don Alonzo, the commanders, officers, captains and gentlemen-adventurers all re-embarked on the *Girona*, with their caskets of jewels and their chests of gold. When de Leiva climbed on board the *Girona*, his servants were carrying his cash, his gold chains and his badge of a Knight of Santiago. He was followed by young members of some of the leading families of Spain, who had eagerly volunteered to serve under him and who also carried large quantities of gold and jewels, and little else.

Now, however, came their third and last shipwreck, and this time there were few survivors – five out of 1,300, none of whom were of high rank. This time too there was be no further transhipment or salvage of their

treasures, with the exception, that is, of the artillery, gold and jewellery that Sorley Boy McDonnell, the laird of Dunluce, recovered on the rocks in the morning after the *Girona* broke her back in heavy seas near the Giant's Causeway, County Antrim, not far from his cliff-top castle. What McDonnell could not reach was eventually located, studied, mapped and recovered 380 years later (1967–69) by my diving companions and me.[3]

I found the *Girona* after many hundreds of hours of research in libraries and record offices and twenty minutes diving off Lacada Point. Four centuries of gales on that shallow, exposed site had left no remains of the hull. Only two brass guns, an anchor and a number of boat-shaped pieces of lead were immediately visible. The rest was deeply buried under pebbles, stones and boulders. It took us ten months of hard labour in the icy water to turn over every stone, destroying what appeared to be the sea bottom to get to the widely scattered arte-facts, most of which were lying on the real sea bottom – the bedrock. We used light, inflatable boats and lifting bags filled with air to displace boulders weighing up to four tons. Otherwise, we relied on our hands – the best tools yet invented for underwater excavation.

Among the thousands of artefacts we unearthed were 1,300 gold, silver and copper coins struck in six countries at fourteen different mints, during eight reigns and of sixty denominations; sixty Renaissance jewels, many of which I was able to precisely identify (with, in some cases, the name, family history and age of the drowned owner); navigation instruments and numerous guns. There were also simple artefacts for everyday use (from silver forks to a toothpick and ear cleaner), and these are surely the most moving items, as they tell the human side of the Armada story.

Two of the jewels discovered were a gold brooch encrusted with rubies in the form of a winged salamander (believed to protect against fire) and a gold book-shaped hinged box, the lid depicting St John the Baptist. The box contained a number of *agnus dei* reliquaries – small, prophylactic discs or pastilles made from the wax of blessed Paschal candles burnt in Rome – which were said to bring to the bearer divine protection against most kinds of mishaps, including shipwreck. The preciousness of the materials used in many of these

artefacts highlights the extreme wealth of the Spanish Empire in the sixteenth century, when gold arrived in great quantities from the colonies in the Americas.

There were more salvage operations to perform on the artefacts once they were recovered from the sea – first, salvage from self-destruction and then from auction, dispersal and potential oblivion. All artefacts (gold ones excepted) that have spent centuries in seawater generally need immediate and often complicated conservation treatment or they will crumble away as they dry. The Keeper of Antiquities at the Ulster Museum, the late Laurence Flanagan, came to us on his own initiative and offered to treat all of the recovered material in the Museum's laboratory. The Director of the Ulster Museum, Alan Warhurst, fully supported him.

The salvage of the *Girona* artefacts required imaginative help from many sides and was finally successful thanks to numerous factors – from the generosity of the excavation's patron to the dedication and energy of the Ulster Museum's Director and Keeper of Antiquities, and to the creative initiatives and active good will of all civil servants concerned – from Ministers in London and Belfast to everyone in the Department of Trade and Industry, including the local Receiver of Wreck. Most important for the final salvage, sources of funding were found or created. The Northern Ireland government gave a substantial special grant. Part of the balance was raised in six months by public subscription, and the rest of the amount of the agreed valuation was provided by the National Art Collections Fund (Art Fund), which, with untiring enthusiasm, continued to purchase and to present to the Ulster Museum such artefacts as the ever-shifting seabed revealed year after year, thereby securing the collection in one institution. In 1988, Don Alonzo Martínez de Leiva's red and gold enamel cross of a Knight of Santiago was discovered by divers and presented through the Art Fund to the Museum. The most recent treasure from the *Girona* to have entered the Ulster collection is a cameo, found in excellent condition in 1999 (eleven cameos of a set of twelve had been discovered in the first expedition, and – amazingly – this one completed the set).

The *Girona* rooms at the Ulster Museum, which permanently house all the material recovered from the galleass, were opened to the public in 1972, sixteen years after I first saw the word *Girona* printed in a history book, five years after I discovered her first brass gun under the icy waters of Lacada Point, and two years after we had brought up the last of our finds. The date was important to me for obvious personal reasons, but it was more important still for a very new branch of what was, at the time, a very new science – post-medieval underwater archaeology. One consequence of the happy end of the *Girona* story was the long-lasting boost that it gave to the Group for Underwater Post-Mediaeval Archaeological Research or GRASP (Groupe de Recherche Archéologique Sous-Marine Post-Médiévale). I formed this group during the *Girona* salvage operation and ever since it has been steadily pursuing its purpose of materially documenting the history of the European expansion overseas by means of the remains of the hulls and the armament of lost vessels, of the miscellaneous instruments and artefacts, of the goods transported and of the personal belongings aboard these ships. GRASP, to this day, has found and excavated sixteen wrecks. In each case, by recovering artefacts and squeezing them for hard facts, its excavations have helped us to complement a history that was previously known only through fragmentary and often deliberately misleading or biased written documents.

Robert Sténuit is *Directeur-Fondateur* of the Group for Underwater Post-Mediaeval Archaeological Research (GRASP) and led the original diving team that excavated the *Girona*. The full story of the *Girona*, its recovery and the post-excavation study of her thousands of artefacts is told in: Robert Sténuit, *Treasures of the Armada*, Newton Abbot, 1972, and London, 1974.

Notes

1
A galleass is a large, heavily-armed warship with oars and sails.
2
The wrecks of the *Girona*, *Gran Grifón*, *Trinidad Valencera*, *Santa Maria de la Rosa* and *San Juan de Sicilia* have all yielded remains. The much scattered remains of three more wrecks, the *Santa Maria de Visón*, the *Juliana* and the *Lavia*, have also been located in Eire off Streedagh Strand. The material recovered from the *Girona*, *Trinidad Valencera* and *Santa Maria de la Rosa* is now on permanent show (when not on a travelling exhibition) in the Ulster Museum in Belfast.
3
The excavations were made possible thanks to the generous patronage of Henry Delauze, President of the COMEX company (Compagnie Maritime d'Expertises) in Marseilles, the leading underwater engineering and diving services company.

114
George Stubbs (1724–1806)
Cheetah and Stag with Two Indians, 1764–65

oil on canvas; 183 x 275 cm
1970.34 / AF Review no. 2402
Manchester City Galleries
Acquired in 1970 for £220,000 from Agnew's with a contribution of
£10,000 from the Art Fund (Eugene Cremetti Fund) and additional support
from the Victoria and Albert Museum Purchase Grant Fund

Of the very many works by Stubbs that have been supported
by the Art Fund, this is undoubtedly the most spectacular –
and bizarre – and its acquisition caused a sensation when
it was purchased for such a high price in 1970, and by a
museum outside London.

The picture was commissioned by Sir George Pigot,
Governor-General of Madras, who donated a cheetah to
George III in 1764. Apparently wishing to re-enact the rituals
of a Mogul hunt, the Duke of Cumberland, who had acquired
this beast for his menagerie at Windsor Great Park, erected an
enclosed area around it and set it upon its intended target, a
wary stag, on 30 June 1764. The stag repulsed two attempts
and then took to the offensive, chasing off the cheetah. Stubbs
portrays the beast about to be released by one of its Indian
handlers, while another points him in the direction of the
stag. The air of suspended animation, the tense and anxious
poses, and the exotic cast of figures and animals all conspire
to make this one of Stubbs' most arresting works.

References: B. Taylor, *Stubbs*, London, 1971, p. 208, no. 43; *George
Stubbs*, Tate Gallery, London, 1984, pp. 114-15, no. 79.

115
Roman, *Fluorspar Drinking Cup*, 1st century
fluorite; 9.7 x 10.7 cm
GR 1971.4-19.1 / AF Review no. 2407
Trustees of the British Museum
Presented in 1971 as a gift by the Art Fund to commemorate the Earl
of Crawford and Balcarres' 25 years as Chairman of the Art Fund
(1945–70); acquired for £2,300 from A.I. Loewental

Discovered in a Roman tomb on the Turco-Syrian frontier
by a Croatian soldier during the First World War, this cup
is made of an exceedingly rare and valuable material found
only in Parthia (Iran). Prized by the Romans for its delicately
banded appearance, this was known by them as *murra* – or
fluorspar – and used for making small luxury vessels, especially
drinking cups.

According to Pliny, fluorspar vessels originated in Parthia and
were first brought to Rome by Pompey the Great in 62–61 BC
after his victories in the East.

This one is horizontally banded in shades of purple and white
and appears at its most exquisite when light passes through it.
Since finding pieces of *murra* large enough to carve was very
difficult, it was extremely expensive and Nero is reputed to
have paid 1,000,000 *sesterces* for a single example.

Though few such cups survive from antiquity, fluorspar has
been employed in more recent times for ornamental purposes
using Derbyshire fluorspar, which is known as blue john.
This was used in the original version of *The King's Clock*
by Matthew Boulton and William Chambers included here
(cat. 159).

References: A.I. Loewental and D.B. Harden, 'Vasa Murrina', in *Journal
of Roman Studies*, XXXIX, 1949, pp. 31-37; S. Walker, *Roman Art*,
London, 1991, pp. 67-68.

116
Isaac Oliver (*c.* 1558/68–1617)
Portrait of an Unknown Lady, 1596–1600
Signed bottom left: *IO* in monogram
oil on vellum; 21 x 19.7 cm
P.12-1971 / AF Review no. 2411
Victoria and Albert Museum
Acquired in 1971 for £65,100 from Christie's with a contribution of
£5,000 from the Art Fund and additional support from the Pilgrim Trust

This outstanding miniature has a distinguished history. It was
once owned by Horace Walpole and, when sold in the
Strawberry Hill sale of 1842, was acquired by the 13th Earl of
Derby, whose descendants sold it in 1971, eleven years before
they disposed of Poussin's great *Ashes of Phocion Collected by his
Widow* (cat. 142), also supported by the Art Fund. Along with
Holbein's portrait of Mrs Pemberton (also in the Victoria and
Albert Museum), which could not be loaned to the exhibition
Saved!, it is one of the finest miniatures ever to be associated
with the fund.

At the close of the eighteenth century, the sitter in this
work was believed to be Frances Howard, Countess of Essex
and later Countess of Somerset (1593–1632), a legendary
beauty 'famed' for poisoning Sir Thomas Overbury. This
identification has now been rejected on grounds of costume,
as the woman depicted here is not wearing Jacobean dress
but that of the 1590s. Though the sitter was obviously of high
rank, she remains unidentified. What can be stated with some
certainty, however, is that the miniature was probably intended
as a love-token, since the sitter places her hand on her heart,
as in Hilliard's celebrated *Young Man among Roses* (Victoria and
Albert Museum).

One of the few large-scale miniatures by Oliver, this is
regarded as among his masterpieces.

References: Graham Reynolds, 'A Masterpiece by Isaac Oliver', in
Victoria and Albert Museum Yearbook, IV, 1974, pp. 7-10; Roy Strong,
Artists of the Tudor Court, the Portrait Miniature Rediscovered, 1520-1620,
Victoria and Albert Museum, 1983, p. 163, no. 271.

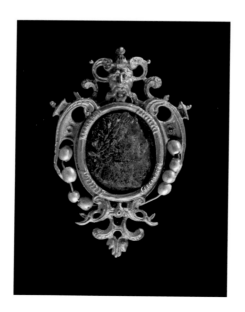

117
Spanish, *The Girona Treasure*, late 16th century

From the initial acquisition:
Agnus Dei Reliquary
containing pellets of wax from a Paschal candle, mixed with holy oil, as a luck charm; 3.9 x 3 x 2 cm; BGR4
Cameo Jewel
1 of 11 cameos found; gold, pearls, lapis lazuli; 4.1 x 2.7 cm; BGR5
Gold Chain
gold; length 230 cm; BGR23
Ring with Two Diamonds
gold and diamond; diameter 2.5 cm; BGR12
Salamander pendant (illustrated top)
gold and rubies; length 4.2 cm; BGR1
10 Coins Minted in Seville: Philip II, 4 Escudo
gold; diameters 2.3-3 cm; BGR556-558/576-580/582/589
10 Coins Minted in Granada, Mexico, Seville, Toledo, Valladolid: Philip II, 8 Real
silver; diameters 3.1-3.9 cm; BGR600/601/604-11
AF Review no. 2453
Ulster Museum, Belfast
Initial and main acquisition (1,560 objects) made in 1972 for £132,000 from Robert Sténuit with a contribution of £5,000 from the Art Fund and additional support from the Northern Ireland government and public subscription

Further acquisitions:
Cross of a Knight of Santiago (illustrated middle)
gold with remains of red enamel; length 4.4 cm; BGR431 / AF Review no. 3380; Ulster Museum, Belfast
Acquired in 1988 for £4,000 from the Portrush Sub-Aqua Club with a contribution of £1,500 from the Art Fund (Cochrane Bequest)
Cameo Jewel (illustrated bottom)
missing 12th cameo of the set acquired in 1972; gold, pearls, lapis lazuli; 4.2 cm; BGR11 / AF Review no. 4757; Ulster Museum, Belfast
Presented in 1999 as a gift by the Art Fund; acquired for £35,000 from the Receiver of Wreck

On 26 October 1588, following the defeat of the Spanish Armada, the galleass *Girona* was wrecked off the north Antrim coast. Commanded by Don Fabrizio Spinola, it contained 1,300 men, of whom only five survived. They carried with them countless treasures, including jewellery, coins and medals from places as far apart as Mexico, Peru, Italy and Spain.

Between 1967 and 1969, the wreck was explored by the Belgian underwater archaeologist Robert Sténuit (see pp. 180–183). Further explorations, by other divers, yielded additional treasure. In 1988, the Portrush Sub-Aqua Club uncovered the gold cross of a Knight of Santiago, which must have belonged to Don Alonzo Martínez de Leiva, designated commander of the Armada, who had boarded the *Girona* at Killybegs. Ten years later, in 1998 a twelfth lapis lazuli cameo was found by Frank Madden, a diver licensed to survey the designated wreck site – the first in Northern Ireland. (The other eleven cameos had already been recovered by Sténuit.) This was purchased outright from the Receiver of Wreck by the Art Fund and presented to the Ulster Museum to 'complete' its collection. This marks the first time that an entire assemblage from an underwater excavation has become the property of a single institution.

Reference: Robert Sténuit, *Treasures of the Armada*, London, 1972.

118
Northern Northwest Coast (Alaska, USA, or British
Columbia, Canada), *Chief's Raven Rattle*, 19th century
alder wood; length 34 cm
Ethno 1972Am 13.10 / AF Review no. 2475
Trustees of the British Museum
Part of Captain A.W.F. Fuller's Collection of ethnographic art
(approximately 30 works including carvings, jewellery and paintings)
bequeathed in 1972 by E.W. Fuller through the Art Fund

A voracious collector of ethnographic art, Captain A.W.F.
Fuller (1882–1961) was made an honorary curator at the
British Museum in 1918. Though he eventually sold and gave
much of his collection to the Field Museum, Chicago, his
widow donated many exceptional works of art to the British
Museum in 1972 through the Art Fund.

This bird rattle formed part of the Fuller Collection and is
among countless examples of its type to survive from the
northwest coast of America. The majority of these are carved
in the form of a raven and used by chiefs at feasts. The raven
enjoys mythic status in this part of the world as a trickster and
glutton. However, it is also known as an important creature
that descended to the bottom of the sea where it stole fire from
an underwater people. The bird then transported this fire to
the sky, where it became the sun – represented by a block in
its beak. The raven's belly is decorated with a carving of a hawk.

Raven rattles are used on ceremonial occasions, their presence
always implying contact with the powers of the ancestral and
supernatural. The most mysterious feature of them is (as here)
the figure of a reclining man resting his head on the raven's
ears, the meaning of which has never been explained.

Reference: Bill Holm, *The Box of Daylight: Northwest Coast Indian Art*,
Seattle Art Museum, and London, 1983, pp. 25-28.

119
Aubrey Beardsley (1872–98), *How King Arthur Saw the
Questing Beast and Thereof had Great Marvel*, 1893
pen, ink and wash; 37.8 x 27 cm
E.289-1972 / AF Review no. 2449
Victoria and Albert Museum
Part of a collection of 44 drawings acquired in 1972 for £12,700 from
Michael Harari with a contribution of £2,700 from the Art Fund

One of the forty-four drawings by Beardsley, the leading
illustrator of the Art Nouveau period, acquired for the nation
in the centenary of his birth, this manic image was executed as
a frontispiece to Volume I of Malory's *Morte d'Arthur* (1893–94).
It is methodically signed and dated 8 March 1893 on the trees
but otherwise looks as though it was conceived in a near-
automatic style, with the artist allowing his pen to meander
of its own free will, in the manner of the Surrealists.

The episode portrayed occurs early in the story of Arthur.
Finding himself alone in a forest after chasing a stag, the King
sits down by a fountain to contemplate when he suddenly
hears the sound of a pack of hounds. 'And with that the King
saw coming toward him the strangest beast that ever he saw
or heard of; so the beast went to the well and drank, and the
noise was in the beast's belly like the questing of thirty couple
hounds; but all the while the beast drank there was no noise
in the beast's belly; and therewith the beast departed with
a great noise whereof the King had great marvel' (Book I,
Chapter 19). Beardsley's rendering of the scene – with its
wealth of phantasmagoric detail – emphasizes its fantastic nature,
while his 'hairline' drawing style ensnares the King, as though
in a spider's web, mirroring his transfixed state.

Reference: Brian Reade, *Beardsley*, London, 1967, pp. 315-16, no. 56;
Simon Wilson, *Beardsley*, Oxford, 1983, pp. 36-37, no. 3.

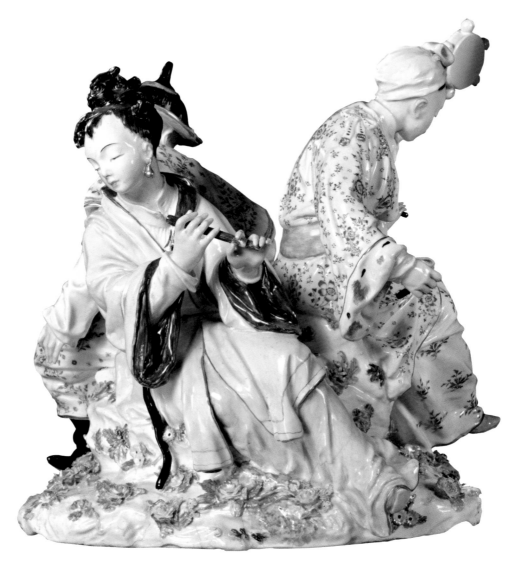

120
English (Chelsea)
Chinese Musicians, c. 1755

soft-paste porcelain, painted in enamels and gilt; height 35.7 cm
C.40-1974 / AF Review no. 2530
Victoria and Albert Museum
Acquired in 1974 for £12,481 from the Trustees of R.C.H. Sloane-Stanley
with a contribution of £1,000 from the Art Fund and additional support
from Mr A.W. Tuke

Presumably designed as a centrepiece which reveals pleasing
views from any angle, this enchanting work contains a central
opening, probably to take some form of lighting device. It
was made at the Chelsea factory in London in *c.* 1755 and
was almost certainly the invention of the Flemish sculptor
Joseph Willems (1716–66), who did much of the modelling
at Chelsea between 1750 and 1765.

Capitalizing on the eighteenth-century vogue for *chinoiserie*,
Willems depicts a seated Chinese youth and two Chinese
women making music while a standing boy dances. Playing
a flute, tambourine and bells, the figures appear transported
by their music-making. Adding to the beauty and delicacy
of the work are the flowers and leaves that adorn the ground
at their feet.

Only one other example of this group survives. It was
auctioned in London in 1930 and is now in America. The
present work was owned by the Sloane-Stanley family,
descendants of Sir Hans Sloane (1660–1753), whose collections
formed the basis of the British Museum.

Reference: (for the other version) Irwin Untermeyer and Yvonne
Hackenbroch, *Chelsea and Other English Porcelain in the Untermeyer
Collection*, Cambridge, Massachusetts, 1957, pp. 53-55.

121
Flemish (?), *The Lomellini Silver*, 17th century

Basin, 1621 (above left)
silver; diameter 64 cm

Ewer, 1622 (above right)
silver; 53.5 x 64 cm

M.11A-1974 and M.11-1974 / AF Review no. 2528
Victoria and Albert Museum
Acquired in 1974 for £75,000 from Christie's with a contribution of
£10,000 from the Art Fund

Purchased in Naples in the 1780s by the 5th Earl of Shaftesbury, this large ewer and basin form part of a set of three sold by the Earl's descendants in 1973. A smaller ewer and dish were acquired by the Ashmolean Museum, also with the assistance of the Art Fund. Birmingham Museum and Art Gallery acquired the other smaller set, using a funding formula that, on this occasion, did not involve the fund.

The present pieces were made in 1621–22 and belonged (as did the other two ewers and basins) to the Lomellini family of Genoa, one of the wealthiest and most powerful of the city's merchant aristocracy. The Lomellini arms are on the front of this ewer and the centre of the basin, and it had previously been thought that they were commissioned by a member of that family. Somewhat confusingly, however, the ewer also bears the arms of the Grimaldi family; and the event commemorated on both the ewer and basin is thought to be the Battle of the Po, waged between the Genoese and Venetians on 23 May 1431. On that occasion Giovanni Grimaldi, Prince of Monaco, joined the Visconti of Genoa in their struggle against the Venetians. Four episodes from this battle are depicted on the rim of the basin and the story is then continued on the body of the ewer and the well of the basin.

It has been suggested that the goldsmith may have used drawings by Lavazzo Tavarone (1556–1641), who worked on frescoes in the Palazzo Grimaldi. The possibility should not be discounted that this ewer and basin were commissioned by the Grimaldi family and entered the collection of the Lomellini family at a later date.

Both pieces bear the mark for Genoa but were probably the work of a Flemish goldsmith, Giovanni Aelbosca Belga. It was not unusual for Flemish goldsmiths to be working in Genoa at this time. A large colony of Flemish artists also resided there in the early seventeenth century, including one certainly known to both the Lomellini and Grimaldi families – whom he painted – namely, van Dyck.

References: Hugh MacAndrew, 'Genoese Silver on loan to the Ashmolean Museum', in *The Burlington Magazine*, CXIV, 834, 1972, pp. 611-20; Mary Newcome, 'Drawings for Genoese Silver', in *Antichita Viva*, I, 1992, pp. 29-36; *Kunst in der Republik Genua 1529-1815*, Schirn Kunsthalle, Frankfurt, 1992, pp. 282-84, no. 151.

122
Julia Margaret Cameron (1815–79)
The Herschel Album, 1864 to 1867
carved oak photograph album; 35.5 x 32.5 x 8.5 cm
Works on display from the album:
My Favourite Picture of All My Works,
My Niece Julia, 1867
albumen print; 22.7 x 28 cm

Portrait of Sir John Herschel, 1867 (illustrated)
albumen print; 28 x 33.4 cm

AF Review no. 2562
National Museum of Photography, Film and Television, Bradford
Acquired in 1975 for £52,000 from Sam Wagstaff with a contribution of
£5,000 from the Art Fund and additional support from public contributions

One of the first two major photographic acquisitions to be
supported by a grant from the Art Fund (see also cat. 124),
this 'pantheon' of eminent Victorians was the subject of an
appeal when its export licence was refused in May 1975. It was
sold the previous year to an American by the descendants of
the man to whom it was presented in 1864, John Frederick
William Herschel (1782–1871) – mathematician, astronomer,
scientist and pioneer of photography in his own right.

Born in Calcutta, Julia Margaret Cameron came to England
in 1848, settling on the Isle of Wight, where she befriended
Alfred Lord Tennyson. Presented with a camera by her daughter
and son-in-law in 1863, she rapidly became England's greatest
amateur photographer, concentrating on portraits of famous
contemporaries seen at close range and in soft focus – a
technique that earned her the reputation of 'a Whistler of
photography'. Her mentor in this was Herschel, whom she
had met on the Cape of Good Hope in 1836 and after whom
this album, which is her best work, is named. In 1875 she
and her husband moved to Sri Lanka, where she effectively
abandoned photography. Her photographs are now regarded
as one of the supreme visual chronicles of the Victorian era.

References: Colin Ford, *The Herschel Album*, National Portrait Gallery,
London, 1975; Colin Ford, 'The Cameron Collection: the final chapter',
in *Amateur Photographer*, 26 November 1975, pp. 94-95.

123
Peter Monlong (d.1699)
*Pair of Flintlock Holster Pistols, c.*1695

walnut, silver, steel, iron; length 52.5 cm each
XII.3829/3830 / AF Review no. 2563
Board of Trustees of the Royal Armouries
Acquired in 1975 for £90,000 from Sotheby's with a contribution of
£5,000 from the Art Fund and additional support from the Pilgrim Trust,
Worshipful Company of Goldsmiths and a public appeal

Formerly in the collection of the Duke of Westminster, these
are arguably the most elaborately decorated firearms ever
made in England. Their maker was Peter Monlong, a French
Huguenot gunmaker who fled from Paris to London in 1684
with his wife and children. Five years later, he was appointed
Gentleman-Armourer-in-Ordinary to William III, and the
portrait bust on the cock screw of these pistols may be based
on a medallion of the King.

Despite the fact that the locks are engraved MONLONG
LONDINI, the works are entirely French in style and elabo-
rately inlaid with scrolls, birds, animals and figures, including
Diana and her hounds on the butt, Apollo driving the chariot
of the sun on the trigger guard, and Fortitude near the fore-end.
The decorative motifs are derived from pattern books published
by Claude and Jacques Simonin in Paris in 1685 and 1693.

These pistols are far from being the only such works supported
by the Art Fund. Other firearms in the Royal Armouries, and
the museums of Glasgow, Warwick and elsewhere have also been
acquired with its assistance. But none are finer than these.

Reference: A.V.B. Norman and G.M. Wilson, *Treasures from the Tower
of London: Arms and Armour*, London, 1982, pp. 84-85, no. 71.

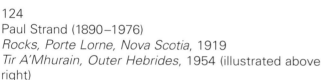

124
Paul Strand (1890–1976)
Rocks, Porte Lorne, Nova Scotia, 1919
Tir A'Mhurain, Outer Hebrides, 1954 (illustrated above right)
gelatin-silver prints; 24.4 x 19.5 cm; 26.3 x 33.4 cm
Circ. 442-1975 and Circ. 445-1975 / AF Review no. not allocated
Victoria and Albert Museum
Presented in 1975 by the Gordon Fraser Trust through the Art Fund

The White Picket Fence, 1916 (illustrated above left)
photogravure; 17 x 22 cm
AF Review no. not yet allocated
Collection of the Royal Photographic Society (RPS) at the National Museum of Photography, Film and Televion, Bradford
Acquired in 2003 (collection of over 270,000 photographs) for £4.5 million with a contribution of £342,000 from the Art Fund and additional support from the National Lottery through the Heritage Lottery Fund and generous public contributions

In 1975, the Gordon Fraser Charitable Trust donated $7,560 (£3,750) towards the purchase of four photographs by Paul Strand and thirteen by Edward Weston through the Art Fund. These were destined for the Victoria and Albert Museum and marked one of the first two major acquisitions of photographs through the fund (see also cat. 122), which has since supported further purchases in this field, including a group of photographs by Lewis Carroll (cat. 222) and – most importantly of all – the entire collection and archive of the Royal Photographic Society, which was acquired for the nation in 2003 (cat. 231–242, 244).

The White Picket Fence of 1916, the earliest of the three photographs exhibited here, formed part of the last acquisition and marked a landmark in Strand's career. In this year Alfred Stieglitz (see cat. 234) held an exhibition of Strand's work at his gallery 291 in New York, which celebrated him as a major new photographer who was (as he said one year later) 'devoid of trickery and any "ism"' and 'brutally direct'. Focusing on the banal motif of a garden fence in Port Kent, New York – not quite rhythmic and, in places, somewhat battered – he encourages the viewer to scrutinize it as an object of consequence, and to attempt to gauge the spatial interval between it and the background buildings.

Around 1920, Strand began to photograph elements of the natural world, seen at close range, where they likewise become objects of wonderment. *Rocks, Porte Lorne, Nova Scotia* is characteristic of these and invites one to concentrate on the otherwise 'inconsequential'. The result has obvious parallels with Cubism in painting, in its concentration upon the abstract qualities of the rock – its surface, texture and physical complexity.

Strand moved to Europe in the early 1950s, living in France but working in Italy, Egypt, Ghana and the Outer Hebrides, which he visited in 1954. *Tir A'Mhurain* depicts a coastal scene on the island of South Uist in the Outer Hebrides. Its title means 'land of marram grass'; and the photograph figured in a volume of works by Strand produced with Basil Davidson in 1962. Awed by Strand's startling objectivity, the latter noted: 'the photographs seem to have come into existence without the camera; for the great gift and genius of this artist … is to be able to place reality before you without demanding that you see the cameraman as well.'

References: Paul Strand and Basil Davidson, *Tir a'Mhurain, Outer Hebrides*, Dresden, 1962; Calvin Tompkins, *Paul Strand: Sixty Years of Photographs*, London, 1976, p. 167; Sarah Greenough, *Paul Strand: An American Vision*, National Gallery of Art, Washington, 1990, pp. 36-37 and 48-49.

125
Donatello (1386–1466)
Madonna and Child with Four Angels ('The Chellini Madonna'), 1455–56
bronze with gilt decoration; diameter 28.2 cm
A.1-1976 / AF Review no. 2602
Victoria and Albert Museum
Acquired in 1976 for £175,000 from Eugene Thau with a contribution of £6,000 from the Art Fund and additional support from public subscription and the Pilgrim Trust, in memory of David, Earl of Crawford and Balcarres

This magnificent relief was first identified and published by John Pope-Hennessy, one of the greatest historians of Renaissance art of the twentieth century.

The sculpture is extraordinarily well-documented. It was given by Donatello to Giovanni Chellini Samminiati, a distinguished Florentine physician, on 27 August 1456. Chellini had recently treated the sculptor for an illness and this work was evidently intended as an expression of gratitude.

The relief depicts the Virgin embracing the Christ Child tended by four angels, one of whom reaches out to him while another offers a dish of fruit or sweetmeats to the Virgin. This reflects contemporary practice of presenting gifts of food to the new mother. It also possesses one feature otherwise unknown in Renaissance sculpture of this kind. The back of the relief is a negative impression of its front. According to Chellini himself this was 'so that melted glass could be cast onto it … and make the same figures as those on the other side.' Modern glass reliefs made from casts of the reverse of the roundel have been made to test this claim and resulted in works of 'extraordinary beauty'.

References: John Pope-Hennessy, 'The Madonna Reliefs of Donatello', in *Apollo*, CIII, 167, March 1976, pp. 172-91; Anthony Radcliffe and Charles Avery, 'The "Chellini Madonna" by Donatello', in *The Burlington Magazine*, CXVIII, 879, 1976, pp. 377-87.

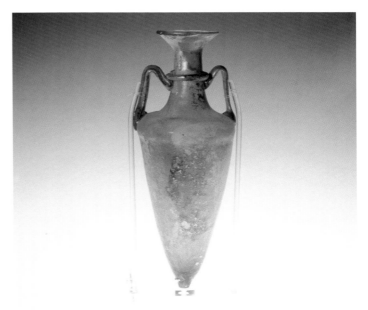

126
The Bomford Collection of Ancient Glass
15th century BC – 5th century AD
glass (cast, mould-blown or free blown), dimensions variable

Origin unknown, *Bowl*, 2nd–1st century BC (no32)

Alexandrian, *Footed Flask Imitating Agate*, 1st century BC – 1st century AD (no37)

Eastern Mediterranean, perhaps Sidon, *Two-handled Toilet Bottle*, 1st century (no41)

Origin unknown, *Beaker*, 1st century (no62)

Italy or Syria, *Beaker with Embossed Pomegranates and Leaves on Vine Scrolls*, mid-late 1st century (no39)

Western Europe, *Two-handled Cinerary Urn*, 1st–2nd century (no70) (illustrated above left)

Northern Italian or Western Empire, *Large Jar*, 1st–2nd century AD (no71)

Syrian, *Janus-headed Sprinkler*, 2nd century (no50)

Eastern Mediterranean, *Deep Bowl*, 2nd century (no97)

Origin unknown, *One-handled Bottle Jug*, 2nd century – early 3rd century (no106)

Eastern Mediterranean, *Two-handled Flask*, 2nd–3rd century (no72) (illustrated above right)

Syria, *Sprinkler*, 2nd–3rd century (no95)

Origin unknown, *Flask*, 2nd century (no108)

Eastern Mediterranean, *Sprinkler*, 3rd century (no96)

Eastern Mediterranean, *Sprinkler*, 3rd century (no103)

Workshop of Frontinus (France), *Two-handled Bottle Jug*, 3rd century (no105)

Eastern Mediterranean, *Flask*, 3rd–4th century (no115)

Eastern Mediterranean, *Jar*, 3rd–4th century (no120)

Eastern Mediterranean, *One-handled Jug*, 3rd–4th century (no135)

Eastern Mediterranean or North African, *Snail Sprinkler*, 4th century (no174)

Origin unknown, *Bowl with Wheel-engraved Bird*, 4th century (no145)

Origin unknown, *Shallow Bowl with Wheel Engraving*, 4th century (no144)

Eastern Mediterranean, *Flask*, 4th century (no151)

Eastern Mediterranean, *Conical Lamp*, 4th century (no152)

Eastern Mediterranean, *One-handled Flask*, 4th century (no165)

Eastern Mediterranean, *Flask*, 4th–5th century (no146)

Origin unknown, *Flask with Internal Threads*, 4th–5th century (no159)

Rhineland, *Fish from a Fish Beaker*, 4th century (no173)

Origin unknown, *Two-handled Flask*, 4th–5th century (no93)

AF Review no. 2658
Bristol Museums and Art Gallery
Part of a collection acquired in 1977 and 1978 for £64,800 from James Bomford with a contribution of £2,698 and £2,500 from the Art Fund and additional support from the Victoria and Albert Museum Purchase Grant Fund, individual and company sponsorship, and a fund-raising campaign by A.C.V. Telling, which attracted many donations. Individual pieces selected for this exhibition also received support from the Dickinson Robinson Group, Friends of Bristol Art Gallery, Fry's Ltd, the HAT Group, S. Lyne, R. Lyons, Mardon Son & Hall, Marks & Spencer, Picton Print, Mr & Mrs Turner, Society of Merchant Venturers and Stewart Wrightson

In 1960 James Bomford began to collect ancient glass, fascinated 'by its delicacy and fairy-like quality'. 'How could anything so fragile', he wondered, 'still be in existence after being buried under the earth for such a long time?'

By 1978 he had collected some 215 works and, four years before this, he placed his collection on loan to the Bristol Museum, which had long acknowledged the importance of glass-making in the city and included a fine array of English glass and the Burrows Abbey Collection of Chinese Glass (cat. 76), but virtually nothing antique.

In 1977 the museum was given the opportunity to acquire the entire Bomford Collection, which it eventually did over a period of two years, assisted not only by the Art Fund but by a series of national and local initiatives that testify to the resourcefulness and determination of regional museums in the second half of the twentieth century.

In addition to offering the collection at a very favourable price, James Bomford also established a trust in his name to enable the museum to make further purchases in this field.

Reference: *Ancient Glass – the Bomford Collection of Pre-Roman and Roman Glass on Loan to the City of Bristol Museum and Art Gallery*, Bristol, 1976.

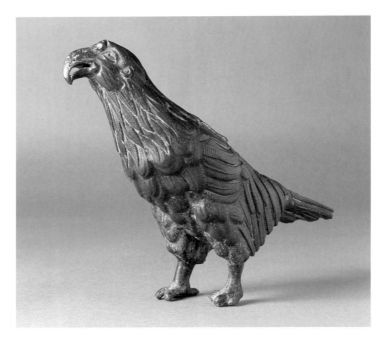

127
Roman (British and European), *The Silchester Collection of Antiquities*, 1st century BC – 5th century AD

From Calleva Attrebatum, Silchester:

Part of a Box Flue Tile, date unknown; inscribed; *FECIT TUBUL CLEMENTINUS* (Clementinus made this tubulus); ceramic; 18.9 x 39.5 x 20 cm; 1995.1.27

Floor Tile Inscribed for Use as a Games Board, date unknown; ceramic; 20 x 20 x 3 cm; 1995.1.186

Ten Counters, Inscribed with Names, Letters and Numbers, date unknown; bone; diameter 1.7-2.2 cm; 1995.1.106/107/110/112/115/122/135/136/137/139

Three Dice Used When Playing Games, date unknown; bone; 1.9 x 1.9 x 3.6 cm; 1.5 x 1.3 x 0.9 cm; 1.3 x 1.3 x 1.2 cm; 1995.86.1/2/3

Stylised Figure of a Prancing Horse, 1st century and probably pre-Roman; copper alloy; 11 x 6.2 cm; 1995.4.2

Jug with a Handle with a Comic Mask, 1st century; copper alloy; height 26.5 cm; 1995.84.31

Arm-purse, 2nd century; copper alloy; 13 x 12 cm; 1995.2.382

Figure of an Eagle, 2nd century (illustrated); copper alloy; height 15 cm, 23 cm (beak-tail); 1995.4.1

One Silver and Four Bronze Coins, 2nd century; copper alloy and silver; diameters 1.6–3 cm; 1995.1.224.142, 1995.1.714/717/737/786

Figure of Euterpe, 2nd–3rd century; copper alloy; height 12.2 cm; 1995.4.3

Steelyard Weight in the Form of the Bust of a Bacchic Figure, 4th century; copper alloy; height 8.2 cm; 1995.4.21

Dorset Black Burnished Ware Jar, 4th century; ceramic; 16.6 x 14.2 cm; 1992.1.1489

Made in France:

Decorated Samian Carinated Bowl, 50–65 AD, stamped by the potter Niger (at La Graufesenque); ceramic; 8.5 x 21.5 cm; 1995.80.667

Motto Beaker, 2nd–3rd century; inscribed: *VITAM TIBI* (Good health to you); ceramic; 14.7 cm high; 1995.1.160

Made in Italy:

Pillar Moulded Ribbed Bowl, 1st century, polychrome glass; diameter at rim 10.7 cm ; 1995.5.4

Made in Rhineland:

Colour-Coated Beaker, 3rd century; ceramic; 16.1 cm high; 1992.1.122

AF Review no. 2739 and 2881
Reading Museum Service (Reading Borough Council)
Collection acquired in 1978 and 1980 for £81,784 from the Executors of the 7th Duke of Wellington with a contribution of £5,000 from the Art Fund

The site of the Roman town of Calleva Atrebatum lies near Silchester, 10 miles southwest of Reading. There is considerable evidence of pre-Roman occupation there and it was an important centre in the late Iron Age, possessing a mint and importing luxury goods. After the Roman invasion local leaders became officials in the Roman administrative system and Calleva became a Civitas, or regional capital.

The Reverend J.G. Joyce conducted excavations on this site between 1864 and 1878, and it was during his work that the Silchester eagle was found, in October 1866. The whole area within the town walls was uncovered by the Society of Antiquaries between 1890 and 1909 under the auspices of the 3rd Duke of Wellington, who owned the land. The extensive collection of artefacts from the site, which had been on loan to the Reading Museum from the Dukes of Wellington since 1891, was subsequently purchased from the executors of the 7th Duke.

The collection includes mosaics, bronzes, stone carvings, jewellery, glass, coins, carpenters' tools, wine barrels, kitchen utensils and even surgical instruments. Pride of place among all of these goes to the bronze eagle which, despite the loss of its wings, has been described as 'the most superbly naturalistic rendering of any bird or beast as yet yielded by Roman Britain'.

References: George Counsell Boon, *Silchester: The Roman Town of Calleva*, Reading, 1974; Colin Sizer, 'The purchase of the Silchester Collection', in *Museums Journal*, vol. 79, no. 2, September 1979, pp. 58-60; Julian Richards, 'The Silchester Chronicles', in *BBC History*, March 2003, pp. 28-32.

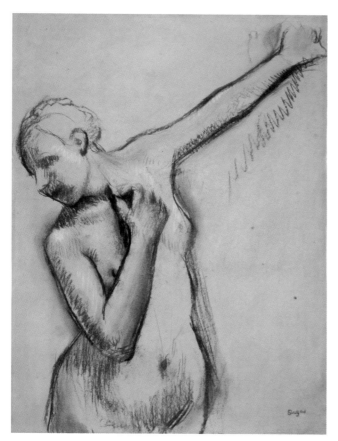

128
Benin (Nigeria), *A Horseman*, 1525–75 (right)
bronze; 46.5 x 28 x 15 cm
1978.226.1 / AF Review no. 2731
National Museums Liverpool
Acquired in 1978 for £60,000 from an anonymous vendor with a
contribution of £5,000 from the Art Fund

This Benin bronze has had a chequered history. It was given to
John H. Swainson (1857–97), an agent for James Pinnock, a
Liverpool merchant in Benin in 1892. Asked to act as 'honest
broker' in negotiations for a treaty with the ruling leader, Oba
Ovonramwen and Captain H.L. Gallwey, who was on a trade
delegation, Swainson was presented with this formidable
horseman, presumably after the successful signing of the treaty.
Thus it was one of the few Benin bronzes to leave the country
before 1897, when the rule of the Obas came to a sudden end.
By the time it became the property of Swainson's great-great-
nephew, it was being used as a doorstop in a suburban terraced
house in the Northwest – a fall from grace unwarranted by
its quality and vigour.

 Three groups of horsemen, totalling around a dozen pieces,
are known in Benin art. This sculpture belongs to the earliest,
which contains about six examples, all by the same hand. They
were probably made to stand on the ancestral altars of one or
more of the ruling Obas of the Middle Period (*c.* 1525–75),
and are the smallest and finest of all such works to survive.

References: *Christie's Sale*, 13 June 1978, pp. 42-44, no. 267; Paula
Ben-Amos, *The Art of Benin*, New York, 1980, p. 37, fig. 37.

129
Edgar Degas (1834–1917)
Nude with Raised Arm (*Nu au bras levé*), *c.* 1898 (left)
charcoal heightened with white on tracing paper; 53.9 x 38.8 cm
PD.35.1978 / AF Review no. 2743
Syndics of the Fitzwilliam Museum, Cambridge
Bequeathed in 1978 by Andrew S.F. Gow through the Art Fund

The pose in this impassioned drawing has a complex genealogy
in Degas' art. First used for a female nude in his *Medieval War
Scene* of 1865 (Musée d'Orsay, Paris), it resurfaces in a pastel
of *c.* 1897 (Pushkin Museum, Moscow), and also appears in a
photograph of *c.* 1895 or earlier that Degas certainly owned
and may have taken himself.

 The drawing was one of over seventy works bequeathed to
the Fitzwilliam Museum by the classical scholar, Andrew Gow,
Fellow of Trinity College, Cambridge. A member of the
Executive Committee of the Art Fund from 1949, he also
edited its *Annual Report* for many years. As the Report noted in
1978, the gift of his collection of (mainly) French nineteenth-
century works to the nation 'was his last and greatest service
to the fund'.

References: *Selected Works from the Andrew Gow Bequest*, Hazlitt,
Gooden & Fox, London, 1978, no. 30; Richard Thomson, *The Private
Degas*, Whitworth Art Gallery, Manchester, and Fitzwilliam Museum,
Cambridge, and Arts Council of Great Britain, 1987, pp. 115-20 and p. 142,
no. 94.

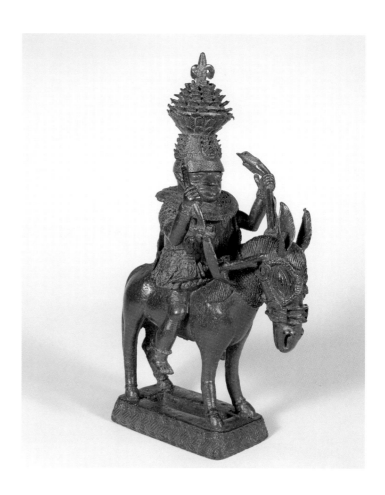

130

Canaletto (1697–1768)
Warwick Castle, the East Front from the Outer Court, 1752
oil on canvas; 73 x 122 cm
1978P173 / AF Review no. 2708
Birmingham Museums and Art Gallery
Acquired in 1978 for £275,000 from Marlborough Fine Art with a contribution of £17,500 from the Art Fund and additional support from the Victoria and Albert Museum Purchase Grant Fund, a public subscription, grants from local government bodies and other charitable trusts

Canaletto painted five views of Warwick Castle during his two visits to England in 1746–50 and 1751–55. Four of these remained there until 1977, when they were all sold abroad. This picture and its companion piece, *Warwick Castle, the East Front from the Inner Court*, were acquired by the American collector Paul Mellon. When their export licence was withheld, Birmingham Museum and Art Gallery launched a national campaign to raise the funding to purchase them. This was nothing short of heroic coming only one year after it had

done the same to save Bellini's *Madonna and Child with Saints Peter and Paul and a Donor*. The latter was bought for £400,000 and the Canaletto and its pendant for £550,000, both with the generous support of the Art Fund. Though the fund only contributed towards the one Canaletto, it passed on donations totalling £31,240 towards its companion.

This scintillating view of the castle is notable for its animated and elegantly dressed figures and for the intense blue of the sky. Painted in 1752, after the artist had just returned from Venice, the picture's Italianate light adds an unexpectedly mediterranean touch to a traditional English scene.

References: David Buttery, 'Canaletto at Warwick', in *The Burlington Magazine*, CXXIX, 102, 1987, pp. 437-45; W.G. Constable, *Canaletto*, revised by J.G. Links, Oxford, II, 2nd ed., 1989, p. 430, no. 446; Michael Liversidge and Jane Farrington, *Canaletto and England*, Birmingham Museums and Art Gallery, 1993, p. 84, no. 23.

131
Thomas Girtin (1775–1802)
*Morpeth Bridge, Northumberland, c.*1802
ink (brown), pencil, watercolour on paper; 32.1 x 52.9 cm
TWM D4812 / AF Review no. 2790
Laing Art Gallery, Newcastle upon Tyne (Tyne and Wear Museums)
Acquired in 1979 for £70,000 from Christie's with a contribution of
£10,000 from the Art Fund

Traditionally regarded as one of the very last works of Girtin's
tragically short career, this is also one of the best preserved
and most emotionally intense. Focusing upon Morpeth Bridge,
silhouetted against a starkly lit building, the artist creates
an air of tragedy through the deep shadows that engulf the
surrounding buildings and by the oppressive sky. Neither the
figures and animals on the banks nor the man watering his
horses in the River Wansbeck alleviate the ominous mood,
which owes much to Rembrandt – the artist Girtin especially
admired late in his life.

Morpeth was not a picturesque town and was known in
Girtin's day only for its castle and a few ruins on a nearby
hill. Through the brooding hues and dramatic contrasts of
light and shade in this highly charged work, however, Girtin
makes it a subject of the profoundest feeling.

References: Thomas Girtin and David Loshak, *The Art of Thomas Girtin*,
London, 1954, pp. 85-89; Greg Smith, *Thomas Girtin: The Art of
Watercolour*, Tate, London, 2002, p. 233, no. 181.

132
Attributed to André-Charles Boulle (1642–1732)
*Still-life marquetry panel, c.*1680, incorporated into
'The Warwick Cabinet'
Mozambique ebony and various woods; panel 87 x 133 cm
1979.63.FW / AF review no. 2766
Bowes Museum
Acquired in 1979 for £63,350 with a contribution of £5,700 from the Art
Fund and additional support from the Victoria and Albert Museum
Purchase Grant Fund, Friends of the Bowes Museum, the Pilgrim Trust,
and Imperial Chemical Industries

Justly described in the Art Fund's *Annual Report* for 1979 as of
'unrivalled quality', this marquetry panel possibly once served
as a table top, and is the finest known work attributed to the
distinguished French cabinetmaker, André-Charles Boulle.

Around 1770 it was incorporated into a cabinet, possibly by
the firm of William Ince and John Mayhew, which may have
been made specifically to display this panel. The cabinet is
first recorded at Warwick Castle in 1810–11 and was sold
from there in the 1960s. In 1979 it was due to be exported
to the Getty Museum when its export licence was deferred,
allowing a museum in Britain to raise the funding. Its combi-
nation of French and British workmanship made it a natural
choice of acquisition for the Bowes Museum in County
Durham, created by the Francophile John Bowes (1811–85)
and his French wife, Joséphine (1825–74), and designed to
resemble a French château.

The Art Fund has supported acquisitions of furniture since
1908, when it donated a Gothic oak cabinet to the Victoria
and Albert Museum. Among its most spectacular acquisitions
have been the *Great Bed of Ware*, purchased in 1931 for the
same museum, the magnificent *Synagogue Ark*, acquired for the
Jewish Museum six years later, and the *Chippendale Writing Table*
and *Channon Cabinet*, bought by Temple Newsam House,
Leeds, in 1965 and 1985.

Reference: Clive and Jane Wainwright, 'A Remarkable Marquetry Cabinet',
in *Antiques*, CXVII, 1980, pp. 1064-68.

Xie Chufang, *Fascination of Nature*

Roderick Whitfield

This fine painting on silk (cat. 206), which would not have been secured without the help of the National Art Collections Fund (Art Fund), is a rare survival, unusual in many respects, and of great historical interest.[1] Indeed, it may well be the first Chinese painting of consequence ever to reach British shores: the first English owner, William Butler, inscribed it just inside the wrapper with his name and the date, 1797. No clue exists as to how the painting came to be in London or whether it had any connection with Lord Macartney's Embassy to China of just a few years earlier, in 1792–94.

William Butler, a native of Bristol who taught young ladies in London, died in 1822, and the scroll was acquired by a noted bibliophile, Sir Thomas Phillipps, from whose vast collection it was eventually acquired by Philip Robinson, a connoisseur of incunabula and other fine books. A printed sale label, perhaps from the sale of William Butler's effects, shows that it was then valued at two guineas, far below the prices that were paid at Christie's in February 1799 for sets of album leaves commissioned in Canton by Andreas Everardus van Braam Houckgeest, Dutch ambassador to the court of Qianlong in 1794.

The painting is a handscroll – designed to be viewed while comfortably seated at a table, rather than displayed at full length. However, this is no ordinary scroll. It is a stunning example of the *gongbi* 'finely-worked' style, and it delighted and astonished the members of the Art Fund Committee when it was presented to them on 11 May 1998. Most unusually for a painting in this decorative style, it is signed and dated and furnished with a fine title in large seal characters at the beginning, and has poems written in beautiful calligraphy by distinguished contemporaries of the artist at the end. As such, it is a bridge between the very different worlds of the amateur literati painter and his professional colleagues. Xie Chufang, the artist who signed his name at the end of the painting, dating it to the year 1321, was previously unknown as a painter, but he was a close relative (an elder brother or cousin) of Xie Yingfang (1296–1392), a noted litterateur who was a native of the very area of Piling in Jiangsu province that was known for specializing in paintings of this style and subject matter. A poem addressed to Chufang by Yingfang is published in the latter's collected works.[2]

The kind of paintings for which the Piling artists were known were usually pairs of hanging scrolls, with clumps of flowering plants, medicinal herbs, butterflies and other creatures, intended for seasonal decoration in the homes of local families. They also inspired the artists who decorated the first generation of blue-and-white porcelain in the mid-fourteenth century.[3] Hardly any of them survive in collections in China, but a considerable number were acquired by Japanese visitors of the time, usually monks who had come to study Buddhism. Embarking at Ningbo in Zhejiang province to return to Japan, they bought paintings of Buddhist themes or, failing those, of flowers and insects. These paintings owe their survival to the care they were afforded by the home monasteries of the returning monks. Some indeed are still exhibited at the annual autumn airing and public exhibition of monastic effects; others have been taken

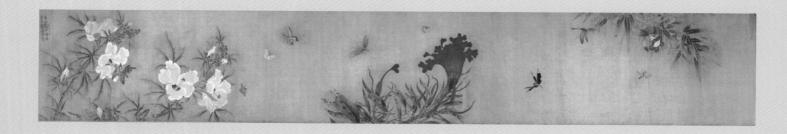

pp. 198–202, cat. 206
Xie Chufang, *Fascination of Nature*, 1321
(details)

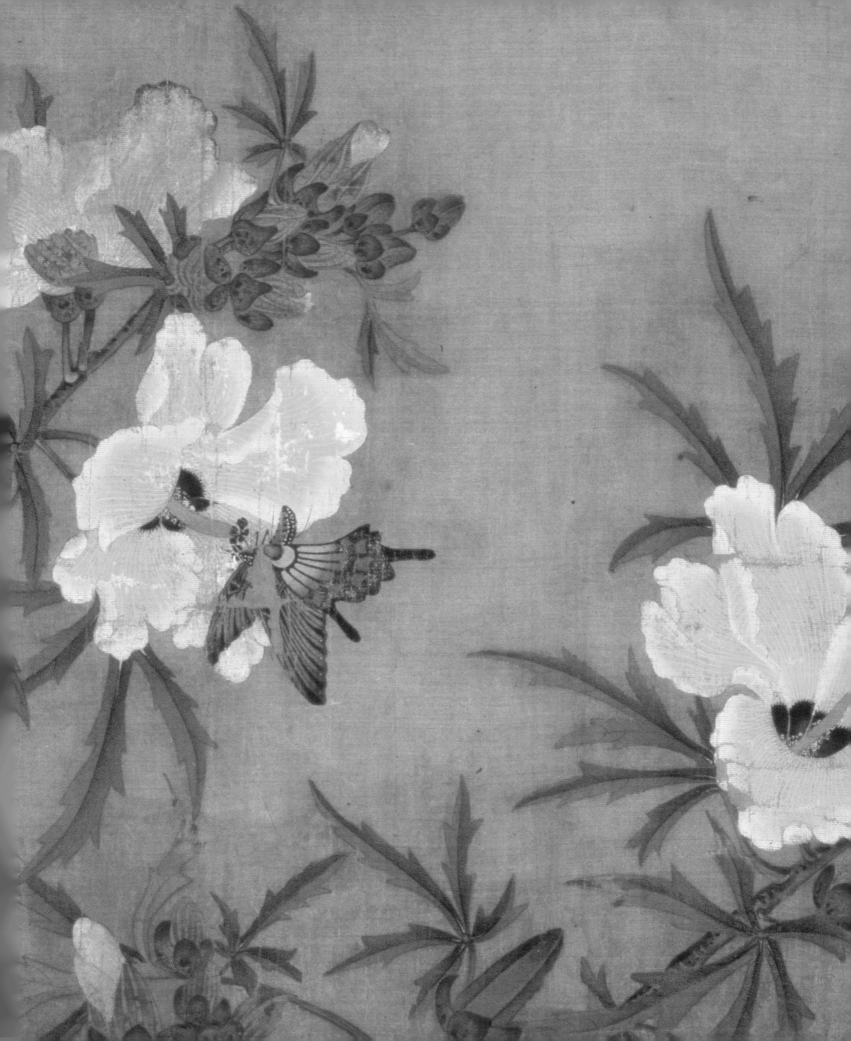

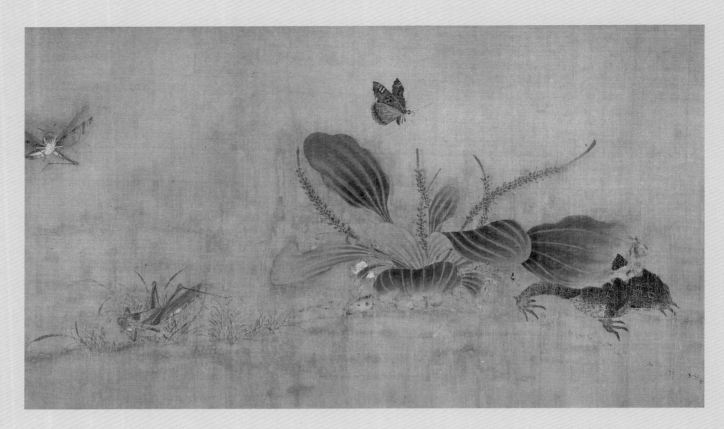

for safekeeping into the major Japanese museums.

The present scroll, however, is not a seasonal painting. The painter has depicted the vicissitudes of daily life from the viewpoint of the insects and other creatures themselves. A toad hides beneath a plantain leaf, picking off ants from a procession that passes by, dragging the remains of a butterfly and swarming up the seed head of the plant. A dragonfly preys on a small fly and a tree frog watches intently as a preying mantis dislodges a cicada from a willow branch and pursues it to the ground. A few wasps build a nest and tend the sealed cells. These themes of foraging and conflict are taken up in the poems written by contemporaries of the artist. When they were written, China was suffering under Mongol rule, which suggests that the artist may have intended a political protest under the cover of the apparently innocuous subject matter. The calligraphic interest of these poems was an important factor in the preservation of the work, as was the fact that the painting was never hung on the wall, but like other handscrolls was unrolled from time to time and then put away again. In the fifteenth century it reached Peking: Cheng Luo, who between 1465 and 1485 served as an official calligrapher at the Ming imperial court, used the ancient seal script to inscribe the title in four large characters, *Qian Kun Shen Yi*, literally 'male-female life-interest' or 'heaven-earth life-interest', here rendered as 'Fascination of Nature', relating the liveliness of its content to the larger interactions of the entire universe. The scroll was still in Peking in the early eighteenth century, when a Manchu collector wrote the label on the outer cover and affixed his seal at the beginning of the painting.

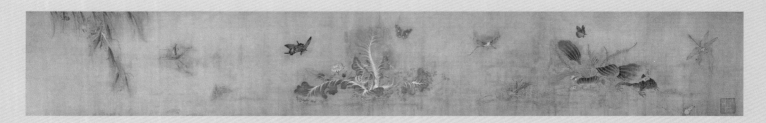

By 1797 it had reached London; and, thanks to the Art Fund, it is now in the public domain in this city – its permanent home.

The British Museum's collection of Chinese pictorial art may be said to date back to the foundation of the museum in 1753, as Sir Hans Sloane's collection contained a number of fine multi-colour woodblock prints acquired by the Dutch physician Engelbert Kaempfer, who visited Japan in 1699. In the course of the nineteenth century, the museum acquired large numbers of album paintings from the East India trade, but it was not until 1881 that Dr William Anderson, Professor of Anatomy and Surgery at the Imperial Naval College in Tokyo, offered – along with his large collection of Japanese paintings – a smaller number of Chinese paintings as a 'first contribution' to the future exploration of the riches of Chinese painting. In 1910, the British Museum acquired 147 Chinese paintings – the Wegener Collection – with Art Fund help following a special appeal. The Liao dynasty over-life-size ceramic *Luohan* acquired by the Museum in 1913 (cat. 9) is another spectacular example of the Art Fund's support for East Asian art.

Because *Fascination of Nature* is such a rare and beautiful work of art, the Art Fund Committee members felt that it was vital to keep it in the country. In 1998 they gave £198,000 towards the British Museum's purchase, having doubled the original offer of £95,000 after the Heritage Lottery Fund had turned down the museum's application. While this is a considerable sum, East Asian works of art, and especially paintings and calligraphy, are still relatively reasonably priced in comparison with European works. Ironically, Chinese porcelains, especially blue-and-white porcelains of the Yuan period, the very ones influenced in style and subject matter by paintings such as these, are liable to be sold for greater sums.

Roderick Whitfield is Percival David Professor of Chinese and East Asian Art, Emeritus, School of Oriental and African Studies, University of London. He is the author of *Fascination of Nature: Plants and Insects in Chinese Painting and Ceramics of the Yuan Dynasty (1279–1368)*.

Notes

1
See Roderick Whitfield, *Fascination of Nature: Plants and Insects in Chinese Painting and Ceramics of the Yuan Dynasty (1279-1368)*, Seoul, 1993.
2
I am grateful to Maggie Bickford for her review of my book *Fascination of Nature* (in *Artibus Asiae*, LVIII (3/4), pp. 343-52), in which she draws attention to this relationship, which came to light after the book had gone to press, and makes other valuable additions to the scholarship of the scroll.

3
Compare for instance the splendid vases of this date in the Topkapi Saray Collection, Istanbul. Similar plants and insects, and the mantis's attack on the hapless cicada, were depicted on these and other porcelains decorated in the new underglaze cobalt blue technique. See Regina Krahl, *Chinese Ceramics in the Topkapi Saray Museum, Istanbul: A Complete Catalogue.* John Ayers (ed.), London, 1986, vol. 2.

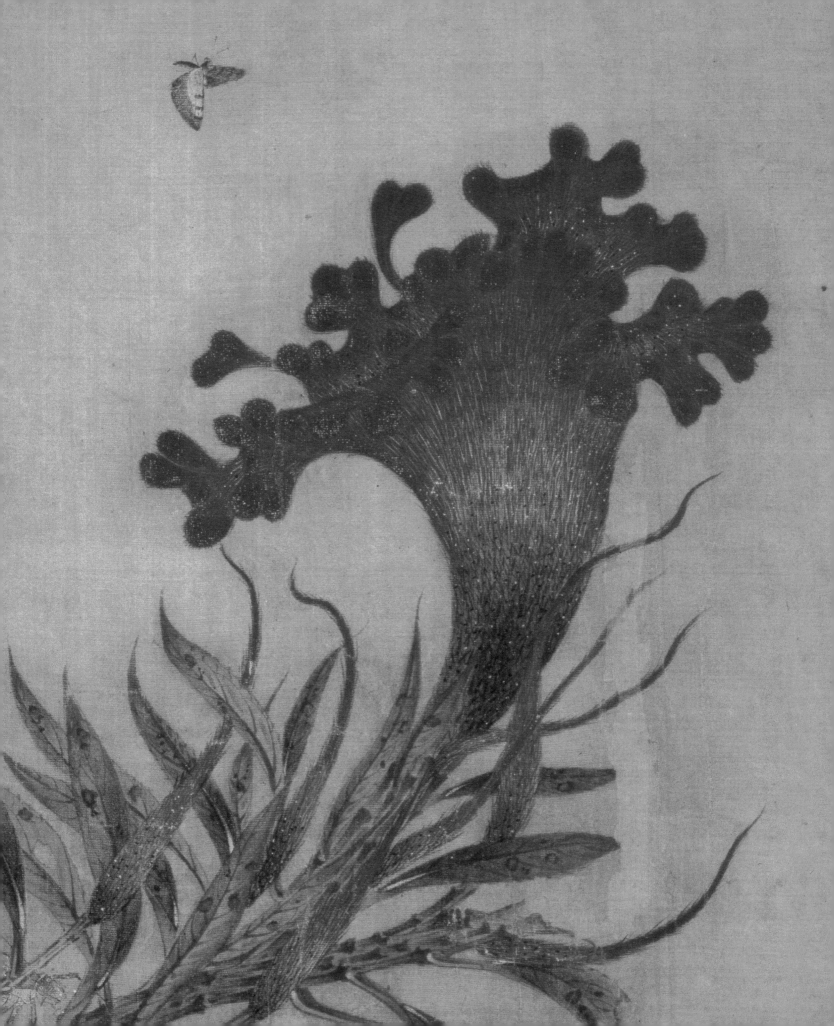

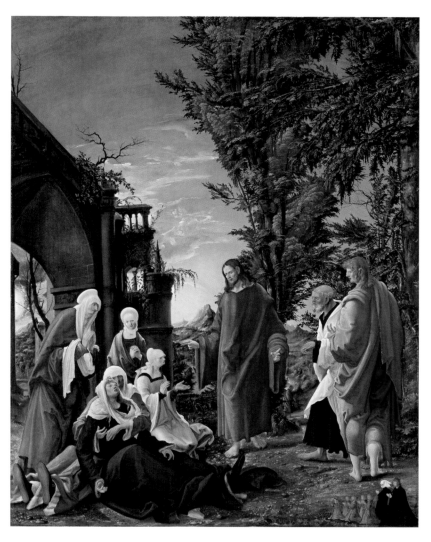

133
Albrecht Altdorfer (*c.* 1480–1538)
Christ Taking Leave of His Mother, *c.* 1520
oil on wood; 139.2 x 108.7 cm
NG6463 / AF Review no. 2810
National Gallery, London
Acquired in 1980 for an undisclosed sum from the Werner Trustees with a contribution of £75,000 from the Art Fund (Eugene Cremetti Fund) and additional support from the Pilgrim Trust and the National Heritage Memorial Fund

Altdorfer was one of the leading German masters of the Renaissance, but his prints and drawings found favour in the UK much earlier than his paintings. In the 1920s, works on paper by him were donated to the nation through the Art Fund (see cat. 28); yet, in 1961, when it was asked to support the acquisition of his *Landscape with a Footbridge* for the National Gallery, it refused. Fortunately, the picture – which is perhaps the earliest landscape without figures in European art – was acquired anyway. By 1980, however, when the Art Fund was requested to help the gallery acquire this master-piece by the artist, the tide had changed and the fund gave its second largest grant ever – one surpassed only by the £100,000 it had awarded in 1972 for Titian's *Death of Actaeon* (fig. 12).

Christ Taking Leave of His Mother came from the collection of the diamond millionaire, Sir Julius Wernher, at Luton Hoo and was the most important work in his collection.

Its unusual subject derives from the fourteenth century and was regularly re-enacted in Easter and Passion plays, not least in Altdorfer's native Regensburg. Christ, accompanied by Peter and St John the Evangelist, is implored by the Holy Women to delay his journey to Jerusalem and prevent his own death. Recognizing that he has come to the earth for the salvation of mankind, he rejects their pleas.

Altdorfer equates humanity's earthly struggles and death with the rocky and arid foreground, upon which the Virgin swoons and the other Holy Women grieve. The joys of the after-life are reflected in the idyllic forest landscape behind Christ and his disciples, with its luxurious vegetation. Nothing is known of the diminutive family kneeling at the lower right, who presumably commissioned the panel.

References: Franz Winzinger, *Albrecht Altdorfer: Die Gemälde*, Munich and Zürich, 1975, pp. 83-84, no. 26; Alistair Smith, *Albrecht Altdorfer: 'Christ Taking Leave of His Mother'*, National Gallery, London, (Acquisition in Focus), 1983.

134
Christopher Dresser (1834–1904)
Electroplated Teapot, 1880
electroplated silver on base metal; 11 x 19 cm
1127/1980 / AF Review no. 2879
Portsmouth City Museums and Records Service
Acquired in 1980 for £1,100 from the Fine Art Society with a contribution
of £275 from the Art Fund and additional support from the Victoria and
Albert Museum Purchase Grant Fund

One of the most remarkable men of his day, Dresser was a
genuine polymath. He trained as a botanist and lectured in
this field before becoming a designer of metalwork, ceramics,
glass and furniture. He was also in advance of his time, embrac-
ing the advent of the machine and rejecting the notion that
design should be based on historical precedent. In addition,
he was a passionate admirer of the decorative arts of Japan,
spending four months there in 1877 to carry out a detailed
survey of the country's arts and industries, the first by a
European designer.

This handsome and completely unadorned teapot reflects
many of his interests, its plain, geometric shape recalling the
structural symmetry of plants and its bar-shaped ebonized
wooden handle attesting to the impact of his visit to Japan.
These features lend to the teapot, which was made by James
Dixon and Sons, a remarkably modern appearance.

Acquired for a museum that specializes in the decorative arts,
this is one of seven works by Dresser to have entered the
nation's collections with the support of the Art Fund.

Reference: 'An Electroplated Teapot', in *National Art-Collections Fund
Annual Review*, 1980, pp. 95-96.

135
Charles Robert Ashbee (1863–1942)
Writing Cabinet, c. 1902
ebony and holly veneer with decorative painting and leather work,
wrought iron and silver-plate fittings; 135.2 x 107.9 x 54.2 cm
1982-194 / AF Review no. 2913
Cheltenham Art Gallery and Museum
Acquired in 1981 for £29,000 from Sotheby's with a contribution of
£4,000 from the Art Fund and additional support from the Victoria and
Albert Museum Purchase Grant Fund, National Heritage Memorial Fund,
William A. Cadbury Charitable Trust and two other private charitable trusts

One of the most ambitious works by a leading figure of the
Arts and Crafts movement, this handsome cabinet is modelled
on popular late nineteenth-century Spanish cabinets known
as *varguenos*. They likewise look heavy and severe when closed,
but when opened reveal an expanse of light and colour. In
this cabinet, Ashbee has employed dark, close-grained ebony
veneer for the austere exterior and lighter woods, floral
decoration, silver-plated handles and crimson leather in the
interior. This contains a honeycomb of drawers for keeping
writing equipment and stamps.

First exhibited at the Woodbury Gallery, London, in the
autumn of 1902, the cabinet was either executed in the capital
or in the new workshops Ashbee established in Chipping
Camden in 1902. Appropriately, it was acquired for nearby
Cheltenham, which boasts an outstanding collection of works
from the Arts and Crafts movement. It is first recorded in
the collection of the designer's mother, Mrs H.S. Ashbee of
37 Cheyne Walk, London, to whom it was presumably given
as a gift.

References: Alan Crawford, *C.R. Ashbee, Architect, Designer and
Romantic Socialist*, New Haven and London, 1985, pp. 292-94; Annette
Carruthers and Mary Greenstead, *Good Citizen's Furniture: the Arts and
Crafts Collections at Cheltenham*, London, 1994, pp. 72 and 75-78.

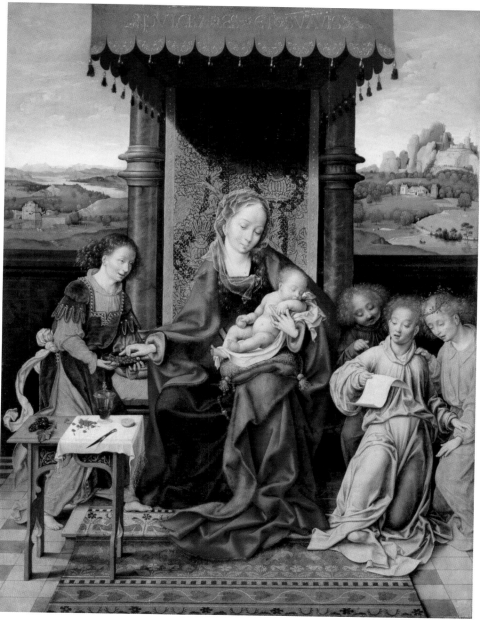

136

Joos van Cleve (*c.*1485 – *c.*1540)
*Virgin and Child with Angels, c.*1520–25

Inscribed: *PULCRA ES ET SUAVIS*
oil on panel; 85 x 65.5 cm
WAG 9864 / AF Review no. 2930
National Museums Liverpool
Acquired in 1981 for £225,000 from the Trustees of Colonel Sir Joseph Weld with a contribution of £20,000 from the Art Fund and additional support from the Victoria and Albert Museum Purchase Grant Fund, National Heritage Memorial Fund, Friends of Merseyside County Museums and Galleries, and various other donors

Once owned by Charles Blundell of Ince Hall near Liverpool, this immaculately preserved picture is now among the undisputed gems of the city's art gallery. It depicts three angels serenading the Christ Child, who holds an apple, fruit of salvation. On the left, another angel offers the Virgin a bowl of cherries, symbol of the delights awaiting the blessed. On the table is a carafe of wine and bunch of grapes – both eucharistic symbols – together with some cherries, a knife and half a lemon. The inscription on the canopy derives from the Song of Solomon (4:7; 6:3) and is a reference to Christ's love for the Church.

The picture originally had an arched top and probably formed part of a small triptych. Its landscape is derived from Joachim Patinier, a contemporary of van Cleve, also active in Antwerp. A more surprising influence is that of Leonardo, evident in the ecstatic expression and wavy hair of the angel at the left and in the delicate shading employed throughout the picture.

References: M.J. Friedländer, *Early Netherlandish Painting,* Leiden, IXa, 1972, p. 65, no. 67; M. Evans, 'An Early Altarpiece by Joos van Cleve', in *The Burlington Magazine,* CXXIV, 955, 1982, pp. 623-24.

137
Bernardo Bellotto (1720–80), *A View of Verona*, 1745–47
oil on canvas; 133 x 231 cm
POW.P.32 / AF Review no. 2936
Powis Castle, The Powis Collection (The National Trust)
Acquired in 1981 for £300,000 from the Powis Trustees with a
contribution of £45,000 from the Art Fund (including £25,000 from the
Wolfson Foundation) and additional support from the National Heritage
Memorial Fund

When this masterpiece was acquired for Powis Castle in 1981 it
was widely trumpeted as 'by far the most important in which
the fund has assisted the National Trust' – a claim that arguably
still holds true. Purchased by Clive of India at a Christie's sale
in 1770, it had been on loan to the Castle since it was
acquired by the National Trust in 1952.

The picture depicts a panoramic view of the city of Verona,
where Bellotto – the nephew and pupil of Canaletto (see cat.
130) – spent two years between 1745 and 1747 en route to
northern Europe. On the left of the River Adige is the tower
of Sant'Anastasia and at the far right, on the east bank, the
Palazzo della Seta, decorated with sixteenth-century frescoes.
A pendant picture, looking downstream with the Ponte delle
Navi, is on loan to the National Gallery of Scotland. Both
works are substantially larger than any that had preceded them
in the artist's career and herald the mature topographical views
Bellotto was to execute in Dresden and Warsaw.

The picture is one of three, large-scale landscapes by Bellotto
that the Art Fund has helped the nation acquire in recent years.
In 1983–84, it supported the acquisition of two important
views of Königstein Castle, near Dresden, by the Manchester
Art Gallery.

References: Stefan Kozakiewicz, *Bernardo Bellotto*, London, 1972,
II, p. 79, no. 98; *Treasure Houses of Britain*, National Gallery of Art,
Washington, 1985, pp. 272-73, no. 193; Edgar Peters Bowron (ed.),
Bernardo Bellotto and the Capitals of Europe, Museum of Fine Arts,
Houston, 2001, p. 142, no. 37.

138

Max Beckmann (1884–1950), *Carnival*, 1920

Inscribed upper right: *Beckmann F. 20*
oil on canvas; 186.4 x 91.8 cm
T032294 / AF Review no. 2968
Tate
Acquired in 1983 for £400,000 from Klaus Hegewisch with a contribution
of £6,000 from the Art Fund and additional support from the Friends of
the Tate Gallery and Mercedes-Benz (UK) Ltd

The greatest twentieth-century German picture in Britain,
this is also a key painting in Beckmann's career. It is the first
of several works in which he explored the theme of carnival,
traditionally a cause for celebration, which Beckmann turns
instead into an exploration of the isolation and loneliness of
the human condition.

The picture was painted in Frankfurt, where Beckmann had
been living in exile from his family after suffering a complete
mental and physical collapse in 1915 while working in the
army medical corps. Portrayed in it are Fridel Battenberg, the
wife of a friend, dressed as Pierette and Israel Ber Neumann,

Beckmann's first dealer and the earliest owner of *Carnival*.
The wretched figure at their feet – dressed as a clown yet
writhing in agony – is the artist himself.

The spiky shapes, claustrophobic setting and acidic colouring
reveal Beckmann's debt to Gothic art, but the mood of soul-
lessness and spiritual dereliction is his own and, in this work,
makes even a trumpet or candle appear like a menacing object
of torture.

This is only the second painting by Beckmann to be acquired
for a British collection, the first being his *Prunier* of 1944,
which Tate bought in 1979. But it is not the first major German
painting of the period purchased with assistance from the Art
Fund. That distinction belongs to George Grosz's *Suicide* of
1916, acquired by Tate in 1976.

References: Erhard Göpel and Barbara Göpel, *Max Beckmann, Katalog
der Gemälde*, Bern, 1976, I, pp. 146-48, no. 206; Richard Calvocoressi,
'Max Beckmann's "Carnival"', in *National Art Collections Fund Review*,
1983, p. 89.

139

Nottingham (England), *The Passion of Christ*, 1450–75

5 alabaster panels with traces of original paint and gilding in a
contemporary wood frame with gilt gesso decoration; 70 x 165 cm
NCM 1982-641 / AF Review no. 3013
Nottingham City Museums and Galleries
Acquired in 1983 for £49,500 from Sotheby's with a contribution of
£12,375 from the Art Fund (William Leng Bequest) and additional support
from the Victoria & Albert Museum Purchase Grant Fund

One of only two near-complete Nottingham alabaster altar-
pieces in the UK – the other is the *Swansea Altarpiece* in the
Victoria and Albert Museum – this is dominated by a central
panel depicting the Holy Trinity. To either side are scenes from
the Passion – the Betrayal and Flagellation on the left and

the Entombment and Resurrection on the right. Each panel
is topped with a pierced canopy. Missing, however, are the two
flanking saints usually included in such works of the late
fifteenth century, among them the *Swansea Altarpiece*.

The altarpiece has suffered some damage and restoration, and
although the wooden framework is contemporary, it is not
the original. In conservation tests, traces of the original painting
and gilding were discovered; and the altarpiece was cleaned
and restored after its acquisition by the museum in 1983.

Reference: Ann V. Gunn, 'A Medieval Nottingham Alabaster', in *National
Art-Collections Fund Review*, 1983, p. 101.

140
George Romney (1734–1802)
John Howard Visiting a Lazaretto, 1780s or 1790s
pencil, pen, grey ink and grey wash on paper; 37 x 51.5 cm
AH2468/83 / AF Review no. 3058
Abbot Hall Art Gallery, Kendal, Cumbria
Acquired in 1984 for £4,800 from Spink with a contribution of £1,200
from the Art Fund and additional support from the Victoria & Albert
Museum Purchase Grant Fund and the Friends of Abbot Hall

The philanthropist and social reformer John Howard (1726–90)
visited prisons and hospitals in Britain and Europe throughout
his life, seeking to expose the horrors they revealed. These
were eventually fully documented in his book, *The Principal
Lazarettos of Europe*, published in 1789, one year before Howard
succumbed to jail fever in the Ukraine.

This drawing is one of a group of works by Romney pitting
the heroic valour of Howard against the disease and desperation
of the prisoners. Here he emerges from a dark arch, his hands
held up in horror, as the jailer (far left) recoils in fear of his
accuser. At the right a woman dies in the arms of a fellow-
prisoner; and, in the centre, others appear shackled and
seemingly deranged as a result of their ordeals.

The impassioned style of the drawing intensifies its drama
and typifies Romney's last years, when drawing became the
chief vehicle of his art. It is not clear whether the John Howard
drawings were intended as studies for a painting that was
never executed, but what is unquestionable is that the theme
obsessed Romney and elicited some of his most fervently
emotional works.

Along with Gainsborough's House in Sudbury (see cat. 185),
Abbot Hall Art Gallery is a small museum that has amassed
an astonishing group of acquisitions in recent years with
the aid of the Art Fund. In the same year as it acquired this
excoriating work it also acquired a sketchbook by Romney,
who was born in nearby Dalton-in-Furness, containing
further studies for *John Howard Visiting a Lazaretto* and other
subjects, likewise supported by the Art Fund.

References: V. Chan, *Leader of my Angels: William Hayley and his Circle*,
Edmonton Art Gallery, Alberta, 1982, pp. 61-71; Alex Kidson, *George
Romney 1734-1802*, Walker Art Gallery, Liverpool, and elsewhere, 2002,
p. 212, nos. 130-31.

141
Claude Lorrain (1604/05–82)
Landscape with St Philip Baptising the Eunuch, 1678
oil on canvas; 85 x 141 cm
NMW A4 / AF Review no. 3039
National Museums and Galleries of Wales
Acquired in 1984 for £500,000 from the Allandale 1949 Settlement with
a contribution of £40,000 from the Art Fund

One of the most hauntingly poetical of all Claude's late paint-
ings, this picture takes its subject from Acts 8: 26-40. Instructed
by an angel of the Lord, the apostle Philip journeyed from
Jerusalem to Gaza. Along the way, he met a eunuch who was
sitting in a chariot reading the prophecies of Isaiah. Urged
on by the Holy Spirit, Philip asked the man if he understood
what he was reading. When the eunuch requested that Philip
explain the significance of the text, the latter preached the
gospel of Christ, converting the eunuch, who was then
baptized by the Apostle.

The ethereal beauty of this painting is enhanced by its

panoramic view of verdant countryside converging upon
the sea, which is bedecked with sailing vessels. Adding to the
otherworldly quality of the scene is the elaborate, horse-drawn
chariot of the eunuch, who was treasurer to the Ethiopian
Queen, Candace. Painted for Cardinal Fabrizio Spada in 1678,
the picture gained the pendant *Christ Appearing to the Magdalene*
(Städelsches Kunstinstitut, Frankfurt am Main) three years
later, in 1681.

One of the most avidly collected of all the Old Masters by
travellers on the Grand Tour, Claude remains better represented
in this country than anywhere else in the world. This picture
was once owned by the Gothic novelist and creator of
Fonthill Abbey, William Beckford (1759–1844).

References: Marcel Röthlisberger, *Claude Lorrain: the Paintings*, London,
1961, 2 vols., pp. 447-49; Humphrey Wine, *Claude: the Poetic Landscape*,
National Gallery, London, 1994, p. 82, no. 33.

142

Nicolas Poussin (1594–1665)
The Ashes of Phocion collected by his Widow, 1648
oil on canvas; 118.5 x 177.6 cm
WAG 10350 / AF Review no. 3060
National Museums Liverpool
Acquired in 1984 for £1,150,000 from the Trustees of Lord Derby's
Heirlooms Settlement with a contribution of £50,000 from the Art Fund
(including £25,000 from the Wolfson Foundation) and additional support
from the National Heritage Memorial Fund and other benefactors

One of Poussin's supreme achievements, this picture takes its
theme from Plutarch's *Life of Phocion* (37). Phocion, a noble
Athenian general, was condemned to death by his enemies
and forced to drink hemlock. His body was refused burial
within the city walls and carried to the outskirts of Megara,
where it was cremated. Phocion's widow then gathered his
ashes (the scene depicted here) and transported them back to
Athens, where they were accorded an honourable burial once
the tide of political opinion had changed.

The painting's pendant is *Landscape with the Body of Phocion
carried out of Athens* (1648; the Earl of Plymouth, on loan to
the National Museum of Wales, Cardiff). Both works rank
among the greatest evocations of the order, diversity and
nobility of the natural world and are regarded as cornerstones
of the classical landscape tradition.

The picture is one of only three works by Poussin to have
been supported by the Art Fund, the others being the *Adoration
of the Golden Calf*, acquired by the National Gallery in 1945,
and the *Finding of Moses*, jointly purchased by the National
Gallery and the National Museum of Wales, Cardiff, in 1988.

References: Anthony Blunt, 'The Heroic and the Ideal Landscape in
the Work of Nicolas Poussin', in *Journal of the Warburg and Courtauld
Institutes*, VII, 1944, pp. 157-64; *Supplementary Foreign Catalogue*,
Walker Art Gallery, Liverpool, 1984, pp. 15-18; Richard Verdi, *Nicolas
Poussin, 1594-1665*, Royal Academy of Arts, London, 1995, pp. 278-79,
no. 68.

143
John Robert Cozens (1752–97), *St Peter's from the Villa Borghese, Rome,* 1776–79 or 1782–83

watercolour; 25.7 x 38 cm
D.1984.5 / AF Review no. 3133
Whitworth Art Gallery, University of Manchester
1 of 6 watercolours acquired in 1985 for £58,305 from Agnew's with a contribution of £14,500 from the Art Fund (Eugene Cremetti Fund) and with support from the Victoria & Albert Museum Purchase Grant Fund and the Friends of the Whitworth

J.R. Cozens paid two visits to Italy, the first in 1776–79 and the second in 1782–83, when he served as draughtsman to the wealthy and eccentric William Beckford, who found the heat of Rome insufferable. This watercolour has been dated to either of these visits – more recently, to the second – and depicts St Peter's from the Villa Borghese gardens in a heat haze, the orange glow that saturates the atmosphere creating an oppressive feel. Aesthetically, however, this warm light provides a perfect foil for the lacy fronds of the foreground trees and, in its delicacy and elegance, recalls a Japanese brush drawing.

'He was the greatest genius that ever touched landscape', claimed Constable of Cozens, whose works he described as 'all poetry'. Faced with this ravishing landscape watercolour, it is hard not to agree, for it is permeated with a poetry and sensibility that are worthy of Claude.

One of six watercolours by Cozens acquired by the Whitworth Art Gallery in 1985, this joined a collection which had already acquired the seven sketchbooks he created during his second visit to Italy, purchased with the support of the Art Fund in 1975.

Reference: Kim Sloan, *Alexander and John Robert Cozens, the Poetry of Landscape*, New Haven and London, 1986, p. 146.

144

Joseph Mallord William Turner (1775–1851)
Constance, 1842

watercolour and bodycolour with pen and ink over pencil with scratching-out on paper; 30.7 x 46.3 cm
YORAG R2476 / AF Review no. 3150
York Museums Trust (York Art Gallery)
Acquired in 1985 for £60,219 (tax remission) through Oscar & Peter Johnson Ltd with a contribution of £13,896 from the Art Fund and additional support from the Victoria & Albert Museum Purchase Grant Fund

Turner first visited Switzerland in 1802 and returned there often, especially towards the end of his career, when the awe-inspiring scenery of the country would have appealed to his increasingly sublime style. This ravishing view of Lake

Constance is one of ten finished watercolours of Swiss subjects that the artist made in 1842. These were done from 'samples' of compositions he had made the preceding year, in the hope of attracting commissions.

Constance was commissioned by Ruskin, Turner's greatest champion, and is in magnificent condition. In the ethereal blues of the water and sky and the luminosity of the entire scene, it is one of the most transfixingly beautiful of Turner's late watercolours.

Reference: Andrew Wilton, *The Life and Work of J.M.W. Turner*, London, 1979, p. 484, no. 1531.

145

Nicolas Poussin (1594–1665)
Study for 'A Dance to the Music of Time', c. 1634
pen and brown ink and brown wash on paper; 14.8 x 19.8 cm
D 5127 / AF Review no. 3092
National Gallery of Scotland, Edinburgh
Acquired in 1985 for £160,000 from the Christopher Loyd Charitable
Trust with a contribution of £50,000 from the Art Fund (William Leng
Bequest) and additional support from the Pilgrim Trust and the Edith
M. Ferguson Bequest

Poussin's *Dance to the Music of Time* (Wallace Collection,
London) has long been among the most admired of his works,
its popularity clinched by Anthony Powell's series of novels
of the same name. This is the sole surviving drawing for the
picture, which is a moral allegory on the subjection of all
human life to the rule of time. At the right, Father Time plays
his lyre; beneath him are two putti, one holding an hourglass
and the other blowing bubbles. In the centre four figures

dance. In the painting they will be distinguished by their
headdresses as Pleasure (wearing roses), Wealth (pearls), Labour
(unadorned) and Poverty (wreathed). To the left is a Janus-
headed term; and, above, Apollo, accompanied by the Hours,
drives his chariot across the sky, symbolizing the cycles of
night and day.

The painting was commissioned by Cardinal Giulio
Rospigliosi (later Pope Clement IX), who apparently devised
the programme. Though traditionally dated *c.* 1639, confrontation
with other works by the artist at the Royal Academy, London,
in 1995 confirmed that it dates from about five years earlier.

References: Richard Beresford, *'A Dance to the Music of Time', by
Nicolas Poussin,* Wallace Collection, London, 1995; Pierre Rosenberg
and Louis-Antoine Prat, *Nicolas Poussin 1594-1665, Catalogue raisonné
des dessins,* Milan, 1994, I, pp. 278-79, no. 144.

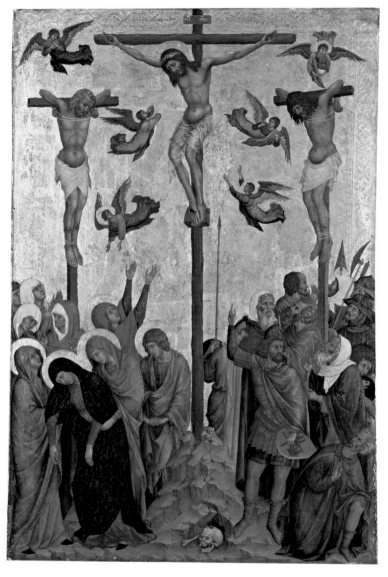

146

Attributed to Duccio di Buoninsegna (active by 1278 –
died 1318/19), *The Crucifixion, c.* 1315

oil on panel; 59.7 x 38 cm
1984.53 / AF Review no. 3132
Manchester City Galleries
Acquired in 1985 for £1,798,000 from an anonymous private collector
with a contribution of £500,000 from the Art Fund, £703,357 in dona-
tions through the Art Fund, and additional support from the National
Heritage Memorial Fund, Victoria & Albert Museum Purchase Grant Fund,
Pilgrim Trust, Manchester Art Galleries Art Fund, and various other
donors via the Corporate Patrons, Associates and Friends of Manchester
City Galleries

Bought in 1863 by the 25th Earl of Crawford, this celebrated
panel remained in the collection of his family up to his great-
great-grandson, the late Lord Crawford, Chairman of the Art
Fund (1945 to 1970). It was saved for a public collection in a
region of the country traditionally associated with his family
through the tireless efforts of Manchester Art Gallery and as a
result of an appeal in which the Art Fund played a major role.
Contributing the largest grant it had ever bestowed upon a

single acquisition, the fund saw this as an appropriate way
of celebrating its eightieth birthday and commemorating its
third chairman.

Though the attribution of the panel has been much debated –
with some scholars attributing it to Duccio, the founder of
the Sienese school of painting, and others to various of his
followers – few dispute its quality and importance. It is also
iconographically unusual in depicting the centurion standing
(right) and pointing to the crucified Christ, as he addresses the
Jews, saying 'truly this was the Son of God' (Matthew 27: 54;
Mark 15: 39), and the 'contradictory' episode of an anony-
mous soldier piercing Christ's side, from whence blood flows
down his spear (John 19: 34). Traditionally, these two actions
were combined in a single figure.

References: James H. Stubblebine, *Duccio di Buoninsegna and his
School,* Princeton, 1979, I, pp. 174-75; John White, *Duccio: Tuscan Art
and the Medieval Workshop,* London, 1979, pp. 154-57; Philip Pouncey,
'A Sienese 14th-century Crucifixion', in *National Art Collections Fund
Annual Review, 1985,* pp. 133-34.

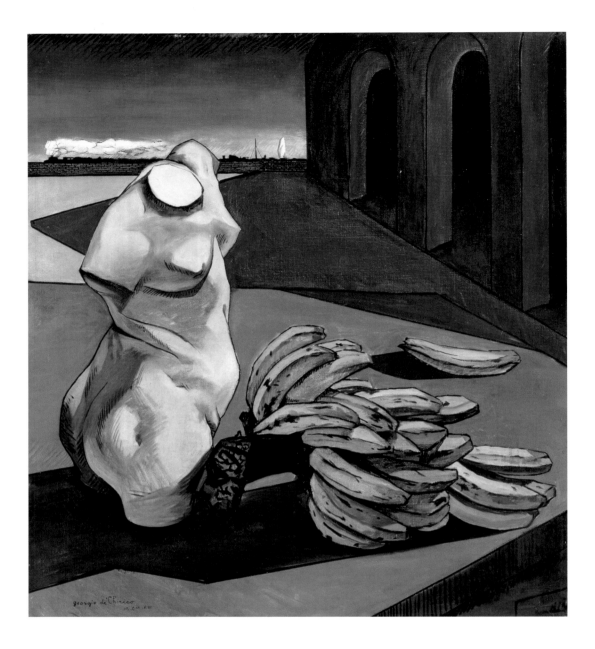

147
Giorgio de Chirico (1888—1978)
The Uncertainty of the Poet, 1913
Inscribed lower left: *Giorgio de Chirico MCMXIII*
oil on canvas; 106 x 94 cm
T04109 / AF Review no. 3158
Tate
Acquired in 1986 for £1,067,141 (tax remission) from the Executors of Sir Roland Penrose with a contribution of £50,000 from the Art Fund (Eugene Cremetti Fund) and additional support from the Carroll Donner Bequest, the Friends of the Tate Gallery and members of the public

Paradoxically, this picture enlists many of the devices of the rational art of the Renaissance to a supremely irrational end, among them the dryly descriptive painting style, the perspectival setting, and the classical architecture and sculpture. At first only the bunch of bananas and the rushing train in the background create an air of disquiet. Then one notices the shadows 'carved' into the piazza and the ominous dark arches behind them, and it becomes apparent that this is an alien and uncanny realm.

De Chirico called his pictures of this period 'metaphysical'. Employing a scrupulously factual technique to describe a dislocated – and seemingly random – group of objects, he here creates a world that defies logical analysis and is further dislocated by the enigmatic title. The result possesses a revelatory power that makes de Chirico's works of 1912–15 among the greatest masterpieces of early twentieth-century painting.

This picture was acquired for the nation from the estate of Roland Penrose, without whom Surrealism would hardly have had a champion in England and who also owned Ernst's *Joie de Vivre* (cat. 181).

Reference: James Thrall Soby, *Giorgio de Chirico*, New York, 1966, pp. 66-68.

148
Francis Frith (1822–98)
The Francis Frith & Co. Archive, 1859–1972

Robert Eaton (1819–71), *The Forum, Rome, c.* 1865
albumen print from a collidion negative mounted on paper; 16.5 x 20.3 cm

Francis Frith (1822–98), *Norman Arch, Furness Abbey,
c.* 1865 (illustrated above left)
toned albumen print from a collidion negative mounted on board;
20.3 x 16.5 cm

Goodman (dates unknown), *The Confessional, c.* 1865
(illustrated above right)
albumen print from a collidion negative mounted on board; 20.3 x 16.5 cm

Alfred Rosling (1802 – *c.* 1880), *View in Betchworth Park,
Surrey, c.* 1865
albumen print from a collidion negative mounted on paper; 20.3 x 16.5 cm

AF Review no. 3168
Birmingham Central Library
Collection (316,000 negatives and 3,000 prints) acquired in 1986 for
£302,250 from Photographic Collections UK Ltd with a contribution of
£4,000 from the Art Fund and additional support from the MGC/V&A
Purchase Grant Fund, the Friends of the National Libraries and many
generous private patrons

Francis Frith was born in Chesterfield and, at the age of
twelve, attended the Quaker Camp Hill School in Birmingham
– his only connection with the city that was eventually to
acquire the most important collection of his works. After an
apprenticeship to a cutlery firm in Sheffield, he moved to
Liverpool to begin a wholesale grocery business, but by 1850

he had established a printing firm in the city. Already pursuing
photography as a hobby by this time, Frith sold his business
in 1856 and made it his lifetime's work.

In 1860 he married Mary Ann Rosling – daughter of one
of the photographers represented in the Frith archive – and
established a photographic business in Reigate, which became
the largest such company in the world. Having already travelled
extensively throughout the Middle East, Frith toured Europe
in the 1860s and eventually set out to photograph every town
and site of interest in the British Isles, often publishing the
photographs of others, such as Goodman and Eaton, under
his firm's imprint.

The firm flourished long after his death in 1898, furnishing
postcards and topographical prints to the masses before it went
into voluntary liquidation in 1972. Thirteen years later, about
316,000 negatives and 3,000 prints from it were purchased by
Birmingham Central Reference Library, assisted by (among
others) the Art Fund – a miraculous rescue given that the
archive was worth roughly one million pounds and otherwise
destined for America.

References: Derek Wilson, *Francis Frith's Travels: A photographic journey
through Victorian Britain*, London, 1985; Michael Hallett, 'Francis Frith
goes to Birmingham', in *The British Journal of Photography*, 13 December
1985, pp. 1394-97, 1403 and 1409.

150
James Hadley (1837–1903)
Double Character Teapot, 1882 (left)
bone china, Royal Worcester; 15.7 x 17.6 cm
C.1261 / AF Review no. 3251
Trustees of the Cecil Higgins Art Gallery, Bedford
Acquired in 1987 for £1,800 from Fischer Fine Art with a contribution
of £300 from the Art Fund and additional support from the MGC/V&A
Purchase Grant Fund

Bearing a droll male figure on one side and a morose female
(illustrated) on the other, this amusing teapot has a fascinating
and complex ancestry. The costumes of the figures are based
upon those worn in the first production of Gilbert and Sullivan's
comic opera, *Patience*, of April 1881, which is a satire on the
aesthetic movement. It includes a description of a pallid and
haggard young man – 'a greenery-yallery, Grosvenor Gallery,
Foot-in-the-grave young man.' Both figures wear 'yallery
green' and puce hats and sport fashionable red hair, and their
effeteness is enhanced by their limp-wristed arms, which
form the handle and spout of the teapot.

Inscribed beneath the teapot is the legend: 'Fearful conse-
quences – through laws of Natural Selection and Evolution
of Living up to one's Teapot', and is signed 'Budge'. This is
based on a cartoon by George Du Maurier that appeared in
Punch on 30 October 1880 depicting an aesthetic bridegroom,
Algernon, and his bride, gazing rapturously at a blue and white
teapot. 'Oh Algernon', exclaims his wife, 'let us live up to it!'
A satire on the mania for china characteristic of aesthetic taste,
this cartoon may also have been inspired by Oscar Wilde's
caustic quip: 'I hope I can live up to my blue.'

References: Elizabeth Aslin, *The Aesthetic Movement: Prelude to Art
Nouveau*, New York and Washington, 1969, pp. 126-27; Henry Sandon,
Royal Worcester Porcelain, London, 1973, pp. 19-23.

149
Celtic (Scotland), *The Achavrail Armlet*, 1st–2nd century
(right)
patinated bronze; 9 x 10 cm
INVMG 1987.050 / AF Review no. 3248
Inverness Museum and Art Gallery
Acquired in 1987 for £100,000 from Christie's with a contribution of
£7,500 from the Art Fund and additional support from the National
Heritage Memorial Fund

This massive armlet was found in April 1901 by a crofter
ploughing a field at Achavrail, Rogart, Sutherland, in north-
eastern Scotland. For a long time on display at Dunrobin
Castle museum, it was sold by the Sutherland Trust in 1986
and seemed certain to go abroad, when its export licence was
temporarily deferred and it was saved for Inverness.

About twenty comparable armlets are known or recorded,
all of them originating in eastern Scotland. Their date is not
easy to determine, but one of them was found with a denarius
of Nerva (96–98 AD) coin, suggesting that such ornaments
were popular during the first and second century.

The Achavrail armlet is decorated with swag- and ribbon-
shaped forms and others that resemble a tear-drop. When
freshly burnished, it would have been a rich gold colour.
The armlet weighs 792 g and is in excellent condition.

References: Mona Simpson, 'Massive armlets in the North British Iron
Age' in *Studies in Ancient Europe*, J.M. Coles and D.A.A. Simpson (eds),
Leicester, 1968, pp. 233-54; N. MacGregor, *Early Celtic Art in North
Britain*, Leicester, 1976, I, pp. 106-10 and 234; Catherine Niven, 'Acquiring
the Achavrail Armlet', in *Scottish Museum News*, Winter 1987, pp. 2-3.

151

David Jones (1895–1974)

Epiphany 1941: Britannia and Germania Embracing, 1941

Inscribed below: *O Sisters two, what may we do Epiphany 1941*
pencil, ink and watercolour; 30.5 x 24.5 cm
IWM:ART:16095 / AF Review no. 3225
Imperial War Museum, London
Acquired in 1987 for £10,000 from Anthony d'Offay Ltd with a contribution
of £5,000 from the Art Fund (Mrs Beatrice N. Stuart Bequest)

David Jones served in the Royal Welch Fusiliers during the First World War and many years later, in 1937, published a book about his experiences, entitled *In Parenthesis*. It is dedicated to (among others) 'the enemy front-fighters who shared our pains against whom we found ourselves by misadventure'– a clear indication of his solidarity with the enemy that finds further expression in the present drawing, executed in the early years of the Second World War.

Epiphany 1941 depicts Britain and Germany embracing and is inscribed with a line from the Coventry Carol, an allusion to the bombing of that city that occurred on the night of 14 November 1940. At the left, a Gothic cathedral in flames is about to lose its spire. At the right, the leopard of England howls alongside a toppled Ionic capital – another symbol of the destruction of Europe's cultural heritage. Surrounding the couple are the dogs of war, baying. The antlers crowning Germany and the broken tree spears borne by both figures may be a reference to ancient tree-cults familiar from early German folk-tales.

Though the Coventry Carol was associated with the theme of the Massacre of the Innocents, the title *Epiphany* recalls the moment when the Messiah was revealed to the Gentiles and is a further allusion to the unity of all nations.

Reference: Paul Hills, *David Jones*, Tate Gallery, London, 1981, pp. 59–60 and 109, no. 113.

152
The Richard Boys Lewis Collection of Coins, 5th–3rd
century BC
gold, silver or electrum; diameters vary between 1.7 – 4.1cm

Carthaginian (Tunisia):
Silver coin of Carthage, minted probably at Carthage, c. 410–390 BC
(CM 1987-6-49-292)

Gold coin of Carthage, mint of Carthage, c. 350–320 BC
(CM 1987-6-49-203)

Silver tetratdrachm of Carthage, minted in Sicily, c. 315 – 305 BC
(CM 1987-6-49-303) (illustrated above left)

Silver decadrachm of Carthage, minted in Sicily, c. 270–260 BC
(CM 1987-6-49-270)

Electrum coin of Carthage, mint of Carthage, c. 255–241 BC
(CM 1987-6-49-253)

*Silver half and quarter shekels of Carthage, uncertain Spanish or Italian
mint, c. 220–210 BC* (CM1987-6-49-343 and 344)

Ptolemaic (Egypt):
Silver tetradrachm of Ptolemy I Soter, King of Egypt, 305–283/82 BC
(CM 1987-6-49-509)

Silver tetradrachm of Ptolemy I Soter, King of Egypt, 305–283/82 BC
(CM 1987-6-49-518) (illustrated above right)

Gold mnaieion (100 drachma) of Ptolemy II Philadelphus, 283/82–246 BC
(CM 1987-6-49-135)

AF Review no. 3391
Trustees of the British Museum
Collection (600 coins) bequeathed in 1988 by Mrs G.E.M. Lewis through
the Art Fund

In 1988 the widow of Richard Boys Lewis bequeathed the
major part of his collection of 600 Greek coins to the British

Museum. They came through the Art Fund and constitute
one of the most important donations of their kind in the
twentieth century.

Lewis had been a regular visitor to the Department of
Coins and Medals at the museum, where he acquired an
interest in Carthaginian coinage, eventually co-authoring a
book on the subject with the Keeper of the department,
Kenneth Jenkins.

Seven of these coins are Carthaginian and derive from the
fourth to the third centuries BC. Though the city of Carthage
(in present day Tunisia) was founded in the late ninth century,
and grew to control much of North Africa, Sicily and Spain, it
only began minting coins in the late fifth century BC. These
were heavily influenced by the designs and minting techniques of
the Greek cities on Sicily and limited to a small stock of images.

The other three coins are issues of the Ptolemaic kings of
Egypt. When Alexander the Great conquered the country, he
made Ptolemy, one of his most loyal generals, its governor.
After Alexander's death in 323 BC, Ptolemy claimed Egypt as
his kingdom, founding a dynasty there that lasted until the
death of Cleopatra VII in 30 BC.

Ptolemaic coinage often featured portraits of Alexander and,
later, of the Ptolemaic kings, one of whom – Ptolemy II –
revived an ancient Egyptian custom by marrying his sister,
Arsinoë, commemorated in one of the coins exhibited with
the name Arsinoë II Phildelphus – or 'brother-loving'.

Reference: Martin Price, 'Showing their metal', in *Bulletin, British
Museum Society*, Autumn 1987, no. 56, pp. 6-7 and 9.

153
Isaac Charles Ginner (1878–1952)
Plymouth Pier from the Hoe, 1923
Signed lower right: *C. Ginner*
oil on canvas; 76.3 x 61.4 cm
Plymouth City Museum and Art Gallery
1987.5 / AF Review no. 3361
Acquired in 1988 for £40,000 from Richard Green with a contribution of £10,000 from the Art Fund (Eugene Cremetti Fund) and additional support from the MGC/V&A Purchase Grant Fund

Built between 1884 and 1891, Plymouth Pier was a popular centre for the city's social life, especially in the 1920s. It was destroyed during the Blitz in 1941 and has never been rebuilt.

Though London-based, Ginner was born in Cannes of Anglo-Scottish parents. He studied in Paris before settling in London in 1909. Here he joined the association of artists, led by Sickert which, in 1911, became the Camden Town Group.

Though the majority of his works portray London subjects, this is one of his rare West-Country scenes. In its brilliant colourism and thickly inlaid paint surface, it reveals the deep impression that the art of Van Gogh, Gauguin and Cézanne had made upon him during his studies at the Académie Vitti and the Ecole des Beaux Arts, Paris, between 1904 and 1908. Not surprisingly, the dense meshwork of Ginner's paintings has been likened to knitting or embroidery.

Reference: *Monet to Freud, A National Art-Collections Fund Loan Exhibition*, Sotheby's, London, 1988, no. 119.

154
Pablo Picasso (1881–1973), *Weeping Woman*, 1937
oil on canvas; 60.8 x 50 cm
T06929 / AF Review no. 3322
Tate
Acquired in 1988 for £1,915,000 (AIL hybrid arrangement) from a private collection with a contribution of £50,000 from the Art Fund and additional support from the National Heritage Memorial Fund and the Friends of the Tate Gallery

The greatest of Picasso's many studies of weeping women, this picture was purchased from the artist by Roland Penrose as soon as it was painted, on 26 October 1937. Executed four months after *Guernica*, it is among Picasso's most emotionally harrowing attempts to exorcize the demons aroused in him by Franco's destruction of the Basque town in April 1937.

Roland Penrose – who eventually amassed probably the greatest collection of twentieth century art in Britain – has left an unforgettable account of this picture in his biography of Picasso:

'The result of using colour in a manner so totally unassociated with grief, for a face in which sorrow is evident in every line, is highly disconcerting. As though the tragedy had arrived with no warning, the red and blue hat is decked with a blue flower. The white handkerchief pressed to her face hides nothing of the agonised grimace on her lips: it serves merely to bleach her cheeks with the colour of death. Her fumbling hands knotted with the pain of her emotion join the teardrops that pour from her eyes.'

Sixty-one years later, those teardrops were to inspire Wendy Ramshaw (see cat. 212).

Reference: Roland Penrose, *Picasso, his Life and Work*, London, 3rd ed., 1981, pp. 314-15; Judi Freeman, *Picasso and the Weeping Women*, Los Angeles County Museum of Art, 1994, pp. 116-17.

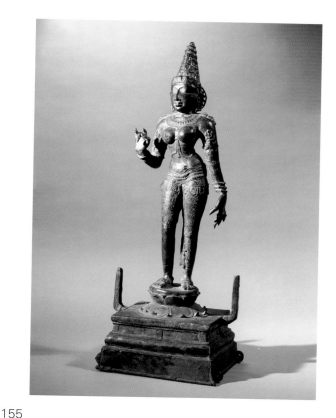

155
Indian, early Chola period
Figure of Standing Pārvatī, c. 950 AD
bronze; height 61 cm (including base)
EA1987.13 / AF Review no. 3360
Ashmolean Museum, Oxford
Acquired in 1988 for £33,000 from Spink with a contribution of £8,250
from the Art Fund (Eugene Cremetti Fund) and additional support from
the MGC/V&A Purchase Grant Fund and the Eric North Bequest

Bronzes of the early Chola period (*c.* ninth–tenth centuries) are among the most celebrated creations of Indian art. The Ashmolean Museum lacked any example from this phase until it acquired this beguiling work in the year of retirement of its Keeper of Eastern Art, J.C. Harle.

The sculpture probably depicts Pārvatī, Śiva's wife, or Srī Devī (or Bhū Devī), the consorts of Vishnu. She is shown with her weight resting on her left leg and her right leg flexed. Her right hand makes a gesture called *kataka hasta*, which is suitable for the insertion of a bud or blossom; and sometimes a bronze flower is actually held. Her left arm rests by her side in what is termed the *lola hasta* position. She is dressed in a long patterned *dhoti* and wears five stylized blossoms on each shoulder. Further adornments include a necklace, armlets, bracelets, rings and anklets.

The most unusual features of the bronze are the prongs at either side, which indicate that it once had a surround that is now missing. There are also two rings on each side of the base so that rods could be passed through it, enabling the sculpture to be carried in a procession.

Reference: J.C. Harle, 'An Early Chola Bronze', in *The Ashmolean*, no. 13, Winter 1987/88, pp. 2-3.

156
The Philip Miller Collection of Teapots, c. 1780 – c. 1980
British (Minton), *Teapot (Vulture and Snakes), c. 1880*
(illustrated)
porcelain, painted in green, iron red, yellow, blue; 18 x 19 x 10 cm
British (unattributed), *Teapot (Fish), c. 1880*
earthenware, maiolica glazes in grey, yellow, green and brown with
cream inside; 16 x 28 x 14 cm
NWHCM: 1992.226.1291 D and 1142 D / AF Review no. 3450 and 3815
Norwich Castle Museum and Art Gallery
Collection (over 2,000 teapots) acquired in 1989 and 1992 for £146,000
from Philip Miller with a contribution of £26,625 from the Art Fund
(Eugene Cremetti Fund) and additional support from the MGC/V&A
Purchase Grant Fund, National Heritage Memorial Fund, Friends of the
Norwich Museums, Norwich Town Close Estate Charity and Marsh Ltd

Philip Miller's collection of more than 2,000 teapots was brought together to include the work of as many different English factories as possible. At Norwich Castle Museum it joined the Bulwer Collection of over 600 British ceramic teapots. Since this covers the early eighteenth century and the Miller Collection embraces the years from *c.* 1780 to *c.* 1980, the two complement one another perfectly. A selection of this – the largest specialist ceramic teapot collection in Britain – is regularly displayed in Twining Teapot Gallery at the museum.

The two teapots included here date from the late nineteenth-century and represent the Miller Collection at its most bizarre.

References: Philip Miller and Michael Berthoud, *An Anthology of British Teapots*, Wingham, Kent, 1985; Robin Emmerson, *British Teapots and Tea Drinking*, London, (HMSO), 1992.

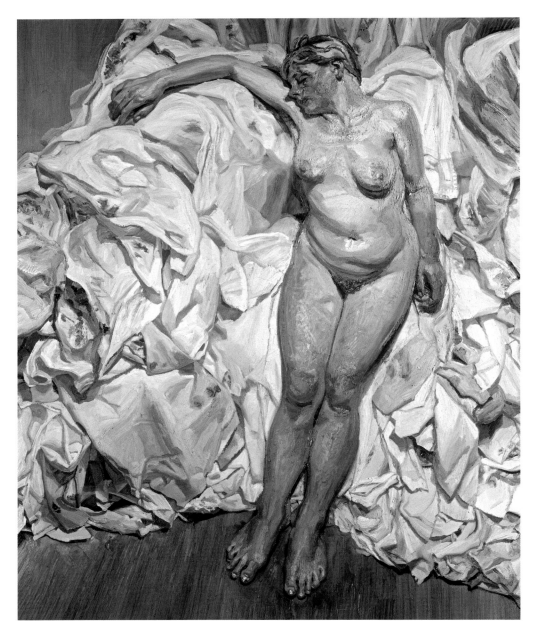

157
Lucian Freud (b. 1922), *Standing by the Rags*, 1988–89
oil on canvas; 168.9 x 138.4 cm
T05722 / AF Review no. 3485
Tate
Acquired in 1989 for £920,000 from James Kirkman Ltd with a contribution of £100,000 from the Art Fund and additional support from the Friends of the Tate Gallery and anonymous donors

One of Freud's largest and most ambitious paintings of the nude, this work depicts a female model leaning against a pile of rags heaped on top of a radiator in the artist's studio. Though she is standing, her abandoned pose and closed eyes suggest instead a sleeping figure. To avoid the semblance of contrivance, Freud asked the model to assume the pose of her choice. As has been noted, however, the motif of a female figure with one arm limply outstretched against a shallow background also occurs in Ingres' *Angelica saved by Ruggiero* in the National

Gallery, which Freud chose for his *Artist's Eye* exhibition there in 1987.

The technique of portraying flesh with such substantial materiality calls to mind another artist much admired by Freud – Courbet – whose 'shamelessness' attracts him. 'I'm really interested in people as animals', the artist has confessed; and he here plays the coarse physicality of the figure against the convoluted curves of the paint-stained rags to devastating effect. 'God's greatest creation' becomes one with the detritus of the studio. Since 1989, the Art Fund has supported the acquisition of six works by Freud, of which this was by far the most expensive.

References: Jeremy Lewison, 'Lucian Freud's "Standing by the Rags"', in *Annual Review*, 1990, p. 91; William Feaver, *Lucian Freud*, Tate, London, 2002, p. 222, no. 114.

158
Georg Baselitz (b. 1938)
Untitled (Figure with Raised Arm), 1982–84
limewood and oil paint; 253 x 71 x 46 cm
GMA 3530 / AF Review no. 3538
Scottish National Gallery of Modern Art
Acquired in 1990 for £242,000 from the Galerie Michael Werner with a
contribution of £20,000 from the Art Fund (William Leng Bequest)

Born Georg Kern in Deutschbaselitz near Dresden in East Germany, Baselitz adopted the name of his birthplace in 1961, the year of the building of the Berlin Wall. By this time, he was already studying in West Berlin. He began his career as a painter poised between abstract and figurative art and concerned always to reconnect modern German art with its historical and visual roots. In his best-known canvases, he typically paints his motif upside down, a technique he has employed since 1969.

Around 1979, Baselitz turned to sculpting in wood, a medium that was in accord with his early desire to work in forestry. In this work, he has modelled the figure by direct hacking and gouging and then painted it, echoing a tradition that descends from comparable sculptures by Ernst Ludwig Kirchner (1880–1938) and, ultimately, from German Renaissance limewood sculpture. But the motif of the raised arm derives from African carvings of figures raising their arms to signal surrender in battle.

When this menacing figure came before the Committee of the Art Fund it gave rise to such heated dispute that it was eventually decided that any work of art evoking such strong feelings deserved to be awarded a grant.

Reference: *Georg Baselitz,* Scottish National Gallery of Modern Art, Edinburgh, 1992, no. 44.

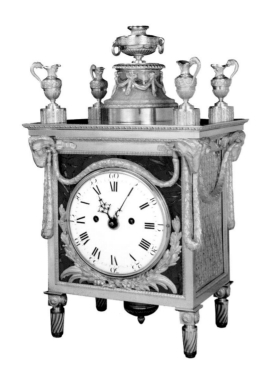

159
Matthew Boulton (1728–1809) and William Chambers (1723–96), *The King's Clock,* **1772**
ormolu, glass, enamel and Derbyshire spar; 47 x 27.5 x 21 cm
O.1991.XX.1 / AF Review no. 3556
Courtauld Institute Gallery, London
Acquired in 1991 for £440,000 from Hotspur Ltd with a contribution of £100,000 from the Art Fund (including £35,000 from the Wolfson Foundation) and additional support from the National Heritage Memorial Fund and the MGC/V&A Purchase Grant Fund

In 1770 William Chambers designed a clock case for George III, which was made at Matthew Boulton's Soho factory in Birmingham and delivered to the King in the spring of 1771. This has been at Windsor Castle since 1829. Brazenly – and without seeking the King's permission – Boulton made other versions of the clock case soon after, one of which he intended to auction, capitalizing on the prestige from the royal commission. The present clock, sold in 1772 to 'Mr Amyand' and sent to Moccas Court, Hertfordshire, differs only in minor details from that made for the King, the most important being the substitution of blue and gold painted glass for the blue john panels of the original. The movement of the clock probably originated in the workshop of Eardley Norton (*fl.*1760–94) of Clerkenwell, but is signed (erroneously) 'John Whitehouse, Derby', presumably for 'John Whitehurst, Derby'.

Fittingly, this handsome clock case is now displayed in Chambers's most important building, Somerset House, in London.

Reference: Nicholas Goodison, *Matthew Boulton, Ormolu*, London, 2nd ed., 2002, pp. 207-15.

160
William Dyce (1806–64), *Pegwell Bay,* **1857**
watercolour on paper; 24.4 x 34.4 cm
ABDAG 9563 / AF Review no. 3620
Aberdeen Art Gallery and Museums Collections
Acquired in 1991 for £86,800 from Agnew's with a contribution of £10,000 from the Art Fund (Scottish Fund and Ramsay Dyce Bequest) and additional support from the National Fund for Acquisitions, National Heritage Memorial Fund, Pilgrim Trust, Webster Bequest and the Common Good Fund

Dyce was born in Aberdeen but worked mainly in London and southeast England. It is appropriate that this watercolour, which portrays Pegwell Bay, near Ramsgate, should have been acquired for his native city, which has the most comprehensive collection of his work in the world.

The watercolour is a preparatory study for the well-known canvas of the same name (Tate), which was exhibited at the Royal Academy in 1860 and bears the title *Pegwell Bay: a Recollection of October 5ᵗʰ, 1858*. This is the date when Donati's Comet appeared in the sky at its most brilliant, attracting astronomers from throughout Europe. Though the comet is visible in the painting, it is not included in the watercolour.

In both works, however, Dyce compares the infinity of the sky with the rugged cliffs of the bay, testimonies to the vast geological change wrought by time. These are then contrasted with the fleeting and insignificant nature of human life, symbolized by the anonymous figures on the shore.

Reference: Marcia Pointon, *William Dyce 1806-1864*, Oxford, 1979, pp. 169-73.

161

Joan Miró (1893–1983), *Maternity*, 1924
Inscribed lower right: *Miró/1924*
oil on canvas; 92.1 x 73.1 cm
GMA 3589 / AF Review no. 3724
Scottish National Gallery of Modern Art
Acquired in 1992 for £1,750,000 (tax remission) from the Mayor Gallery
with a contribution of £100,000 from the Art Fund (William Leng Bequest)
and additional support from the National Heritage Memorial Fund and
public donations

Maternity is one of the first great masterpieces of Miró's early
maturity. In the paintings of the previous years, the artist had
worked within a largely representational style, but in this
picture he turns to a kind of pictorial sign language. The
work depicts an ideogram of a woman suspended in a void –
in short, maternity at its most universal. Her head reduced to
a polyp bearing seven strands of hair, she wears a flared black
skirt perforated by a hole, a reference to her procreative pow-
ers. To either side are her breasts, one in profile and the other

shown frontally. Approaching them to suckle are her offspring,
a male above and a female below. Swimming across the picture
is a sperm-like shape – the only other thing that is needed in
this witty exploration of the realm of human reproduction.

The picture was among fourteen works by Miró exhibited
at the Zwemmer Gallery, London, in 1937, along with eleven
de Chiricos and sixteen Picassos. When none of these sold,
Roland Penrose – one of the great British collectors of twen-
tieth-century art – was persuaded to buy them all. Another
great Miró, the *Head of a Catalan Peasant*, 1925, was acquired
jointly by the Scottish National Portrait Gallery and Tate in
1999, also with support from the Art Fund.

References: Richard Calvocoressi, 'Joan Miró: "Maternity"', in *National
Art Collections Fund Annual Report, 88th Year*, 1992, pp. 53-55; Carolyn
Lanchner, *Joan Miró*, Museum of Modern Art, New York, 1993, p. 377,
no. 35.

162

Raphael (1483–1520)
*Study for the 'Madonna del Pesce', c.*1512–14
brush and brown wash heightened with white, over black chalk,
on paper; 25.8 x 21.3 cm
D 5342 / AF Review no. 3844
National Gallery of Scotland, Edinburgh
Acquired in 1992 for £775,000 (tax remission) through Christie's with a
contribution of £50,000 from the Art Fund (including £30,000 from the
Wolfson Foundation) and additional support from the estates of Keith
and Rene Andrews and the National Heritage Memorial Fund

The final surviving study for an altarpiece in the Prado, this
drawing depicts Tobias (holding a fish) being presented to the
Virgin and Child by the Archangel Raphael. At the right is
St Jerome, reading a book.

The altarpiece was painted for the church of San Domenico
in Naples and may have been intended for victims of eye diseases,
which would explain the presence of Tobias, who cured his
father of blindness by rubbing his eyes with the gall of a fish.

The sheet formed part of the great collection of drawings
amassed by Sir Thomas Lawrence in the early nineteenth
century and tragically dispersed after his death. Among its
subsequent owners were the Prince of Orange, later King
William II of the Netherlands, and the Duke of Saxe-Weimar.

Although the National Gallery of Scotland acquired many
important Old Master pictures after the Second World War
on the advice of the 28th Earl of Crawford, Chairman of the
Art Fund, only comparatively recently has it begun to acquire
major drawings of this period, including the one by Poussin
illustrated here (cat. 142).

References: J.A. Gere and Nicholas Turner, *Drawings by Raphael,* British
Museum, London, 1983, p. 166, no. 136; Eckhart Knab, Erwin Mitsch
and Konrad Oberhuber, *Raphael: Die Zeichnungen,* Stuttgart, 1983,
p. 600, no. 459.

163
Francesco Primaticcio (1504–70)
Ulysses Winning the Archery Contest in the Presence of Penelope's Suitors, c. 1555
red chalk heightened with pink on paper; 24.5 x 32.4 cm
WAG 10843 / AF Review no. 3697
National Museums Liverpool
Acquired in 1992 for £245,300 from Christie's with a contribution of £60,000 from the Art Fund (Eugene Cremetti Fund)

In the *Odyssey* (21: 30-434), Homer describes how Ulysses returns home in disguise after an absence of twenty years in the Trojan War and wins an archery contest to prove that he is the best suitor for Penelope's hand in marriage. Without leaving his seat, he shoots his arrow through a row of rings watched by his son Telemachus (extreme right), his divine guardian Athene, who stands behind him holding a shield, and other potential suitors.

This drawing was the modello for the thirty-ninth fresco in a series of fifty-eight depicting the story of Ulysses (Odysseus) in the Galerie d'Ulysse commissioned by the French King Francis I and his successors for the palace at Fontainebleau between 1537 and 1570. The meticulous execution of the modello may be explained by the fact that the fresco was to be executed by Primaticcio's Italian assistant, Niccolò dell'Abate. The gallery was destroyed in 1738–39.

Once owned by Sir Joshua Reynolds, this drawing was next in the collection of William Roscoe, the Liverpool banker and historian, and was appropriately reunited with other paintings and drawings from his collection in the Walker Art Gallery.

References: D. Ekserdjian, 'Francesco Primaticcio: An Old Master Drawing returns to Merseyside', in *National Art Collections Fund Review*, 1992, pp. 10-11; Xanthe Brooke, *Mantegna to Rubens: The Weld-Blundell Drawings Collection*, London, 1998, pp. 90-91, no. 43.

164
Pietro da Cortona (1596–1669)
Wooded River Landscape, c. 1650

black chalk, brush and grey ink, grey wash on paper; 28.5 x 42.5 cm
1992P6 / AF Review no. 3641
Trustees of the Barber Institute of Fine Arts, The University of
Birmingham and Birmingham Museums and Art Gallery
Acquired jointly in 1992 for £268,000 through Hazlitt, Gooden and Fox
Ltd with a contribution of £26,800 from the Art Fund and additional
support from the National Heritage Memorial Fund

This was one of sixty-six drawings sold at auction from the
Earl of Leicester's collection in 1991. The last aristocratic
collection of drawings formed in the eighteenth century and
still intact, this was sold by the Trustees of Holkham Hall after
their refusal to accept an offer of £1,600,000 by private treaty
for the entire collection made by four British museums. In
the end, a consortium of eight institutions succeeded in
acquiring eighteen of the most outstanding drawings, aided
by substantial outside donations, including that of the Art
Fund. The present drawing was the finest (and most expensive)
work in this group and was jointly purchased by the two
Birmingham museums to prevent it from going abroad.

After Bernini, Pietro da Cortona was the greatest genius
of the Roman Baroque and excelled as a painter, decorator
and architect. Though he painted few pure landscapes, nature
features prominently as a background to his religious pictures
and he also made a number of independent landscape drawings.
Pride of place among these belongs to this magnificently
preserved sheet, with its romantic vision of uncultivated nature,
inhabited by rustic figures and lit by glowing shafts of sunlight.

References: Richard Verdi, 'A Landscape for the City', in *Art Quarterly*,
Autumn 1993, pp. 23-25; *Art Treasures of England*, Royal Academy of
Arts, London, 1998, p. 169, no. 94.

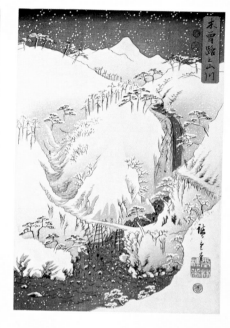

165

Ando Hiroshige (1797–1858)
Mountains and Rivers of Kiso (Snow), 1857
Inscribed lower left: *Hiroshige hitsu*, sealed *Bokurin shoko, aratame*
seal, and a date seal of the eighth month of 1857
coloured woodblock print triptych; 36.6 x 24 cm each
P.1.1993 / AF Review no. 3764
Syndics of the Fitzwilliam Museum, Cambridge
Acquired in 1992 for £24,585 from Christie's with a contribution of
£6,146 from the Art Fund

One of three landscape triptychs on the traditional theme of
'Snow, Moon and Flowers', this was purchased by the
Fitzwilliam Museum – which already owned the other two –
from the collection of Hans Popper, famous for its outstanding
holdings of works by Hiroshige.

The print depicts a rugged section of the Kisokaidō Road,
which links Kyoto and Edo (later Tokyo). This was an inland
road that had lost much of its popularity since the seventeenth
century, when a shorter route that ran along the coast – the

Tōkaidō Road – was built. Hiroshige had celebrated both
of these in two of his best-known series of prints, *Fifty-three
Stations of the Tōkaidō Road* (*c.* 1831–34) and *Sixty-nine Stations
of the Kisokaidō Road* (*c.* 1834–42).

The other two triptychs in this group are *View of the Whirlpools
at Naruto in Awa Province (Flowers)* and *Night View of Eight
Excellent Sceneries of Kanazawa in Musashi Province (Moon)*, also
of 1857. Since the former depicts summer, the latter autumn,
and the present print winter, it may be that they were intended
to form part of a series of the Four Seasons that Hiroshige
was prevented from completing by his death one year later.

References: Craig Hartley, *Prints of the Floating World, Japanese
Woodcuts from the Fitzwilliam Museum*, Cambridge, 1997, p. 118, no. 48;
Matthi Forrer, *Hiroshige: Prints and Drawings*, Royal Academy of Arts,
London, 1997, no. 120; Matthi Forrer, 'A Traveller's Tale', in *Art Quarterly*,
Autumn 2001, pp. 26-29.

166
English, Norwich Illuminator
The Helmingham Breviary, c.1420
leather bound manuscript (ink and gold leaf on vellum); 43.5 x 31 x 10 cm
NWHCM: 1993.196:A / AF Review no. 3951
Norwich Castle Museum and Art Gallery
Acquired in 1993 for £102,338 from Sotheby's with a contribution of
£25,000 from the Art Fund (including £4,000 from NADFAS members'
societies) and additional support from the MGC/V&A Purchase Grant
Fund, Friends of the National Libraries, Sotheby's and a local appeal

The Helmingham Breviary derives its name from Helmingham
Hall in Suffolk, where it had been from the early sixteenth
century until 1955, but it was almost certainly made for
Norwich, an important religious centre in the late Middle Ages.

The manuscript consists of 205 leaves arranged in two
columns, and its Latin text contains the material necessary for
reciting the eight services that make up the daily office arranged
according to the liturgical year. This is followed by a psalter
and a *sanctorale* for the second half of the year, providing the

variable parts of the office for the saints' feast days between that
of St Dunstan (19 May) and St Saturninus (29 November).
The page included here heads the psalms and portrays the
figure of King David, who is traditionally believed to have
composed them, seated and playing the harp.

The circumstances in which the manuscript was produced
are uncertain but it has been identified with a large breviary
presented to the Benedictine Priory of St Leonard, Norwich,
by a man named Robert, which is first recorded in 1422. It
was purchased by Norwich Castle Museum at the sale of the
personal collection of Alan Thomas, a well-known antiquarian
book dealer, thereby returning it after nearly five centuries to
the city of its birth.

References: Alan Thomas Sale, Sotheby's, London, 21 June 1993, no. 24;
Janet Backhouse, 'The Helmingham Breviary, the reinstatement of a
Norwich masterpiece', in *1993 Review*, National Art Collections Fund,
pp. 23-25.

167
French, *Fashion Doll's Court Dress*, 1765–75 (left)
woven silk brocade; height 60 cm
BATMC 93.436 to B / AF Review no. 3874
Bath and North East Somerset Council, Museum of Costume Bath
Acquired in 1993 for £16,500 from Christie's with a contribution of £3,750 from the Art Fund (William Leng Bequest) and additional support from the MGC/V&A Purchase Grant Fund

A rare surviving example of its kind, this miniature court dress was intended to 'advertise' the latest style in fashion to an international audience. Originally it would have been worn by a doll which was correctly dressed from head to foot, with an appropriate hairstyle and headdress, a complete set of underwear and stockings, garters and shoes. Once assembled it would have been sent from Paris to a fashionable dressmaker in London who would have shown it to his wealthiest customers, hoping that they might place an order.

Fashion dolls' dresses were constructed in the same way as full-sized garments. This one consists of a corset bodice covered in silk, a petticoat and a separate train. All are in yellow and white striped silk and coloured silk floral sprays, and further decorated by rosettes made out of pink silk ribbon.

Reference: Avril Hart, 'Court Dress for a French Fashion Doll, 1765-1775', in *Annual Review,* National Art Collections Fund, 1993, pp. 2-5.

168
Elizabeth Fritsch (b. 1940)
Stoneware Vase: Collision of Particles, 1993 (right)
stoneware, incised, slip-decorated and multi-fired; 51 x 21 cm
Hove 45.1993 / AF Review no. 3915
Royal Pavilion, Libraries and Museums, Brighton and Hove
Acquired in 1993 for £7,200 from Elizabeth Fritsch with a contribution of £1,800 from the Art Fund (William Leng Bequest) and additional support from the MGC/V&A Purchase Grant Fund

Elizabeth Fritsch has been described as 'Britain's greatest living studio potter', but her initial training hardly prepared her for this role. She studied harp and piano at the Royal Academy of Music (1958–64), before taking up ceramics under Hans Coper at the Royal College of Art (1968–71). During this time she emerged as one of the major women ceramicists in the country, specializing in hand-built vessels, which are often asymmetrical in shape.

In this vase – which leans slightly to one side – red, green and blue cubes and oblongs, seen in distorted perspective, appear to float above a matt and mottled blue slip surface. The interplay between depth and flatness that results, coupled with the mutating appearance of the cubes, presumably inspired the 'collision of particles' of the title.

One year after supporting this acquisition, the Art Fund provided another grant towards the purchase of Fritsch's closely related *Blown Away Vase: Collision of Particles*, also of 1993, for the Laing Art Gallery, Newcastle upon Tyne.

Reference: 'Elizabeth Fritsch, Stoneware Vase: Collision of Particles', in *Annual Review,* National Art Collections Fund, 1993, pp. 78-79.

169
Flemish, *The Chirk Cabinet, c.* 1640–50
ebony, tortoiseshell, silver, oil paintings on copper on a later ebonized
wood stand; 136 × 115 × 53 cm
CHI.F.64 / AF Review no. 3990
Chirk Castle, The Myddelton Collection (The National Trust)
Acquired in 1993 for £280,000 from Captain David Myddelton with a
contribution of £35,000 from the Art Fund (William Leng Bequest) and
additional support from the National Heritage Memorial Fund and the
MGC/V&A Purchase Grant Fund

According to a nineteenth-century tradition, this magnificent
cabinet was given by Charles II in 1661 to Sir Thomas
Myddelton (1586–1666) in gratitude for his support for the
Royalist cause during the Civil War and Interregnum.

Elaborately decorated cabinets made of precious materials
were a speciality of Antwerp – chief commercial centre of
the Spanish Netherlands – and often destined for the Iberian
market. This cabinet has double doors and an internal drop-
front concealing drawers behind it. These are adorned with
scenes from the life of Christ and depictions of the Seven Acts
of Mercy from the studio of Frans Francken II or his son
Frans Francken III. Taken together these portray the actual
deeds of Christ and those he inspired, which exemplify
Christian behaviour based on his teachings.

Reference: Simon Jervis, *Cabinets in Britain,* Grosvenor House
Antiques Fair Handbook, London, 1993, pp. 26-27.

170
Alberto Giacometti (1901–66)
Composition (Man and Woman), 1927, cast ?1964
Signed near base: *Giacometti 'E.I.'*
bronze; 39.5 x 45.5 x 15 cm
T06737 / AF Review no. 3934
Tate
Acquired in 1993 for £165,796 from Acquavella Modern Art with a
contribution of £30,000 from the Art Fund (William Leng Bequest) and
additional support from the Cynthia Fraser Fund through the Friends
of the Tate Gallery

Though Giacometti made the plaster original of this work in
1927, it was acquired by a friend and largely forgotten. When
it was rediscovered thirty years later the artist agreed to have an
edition of six bronzes and two additional artist's proofs cast
from it. This one was originally with the Pierre Matisse
Gallery, New York, and was purchased to strengthen still further
Tate's outstanding Giacometti collection.

Inspired by Cubism and African and Oceanic art, the sculptor
executed a group of works in the mid 1920s which treat the
human figure in a geometrically abstract manner. Heads are
suggested by hollow hemispheres, and zigzag forms are asso-
ciated with the female figure. This work presents two entirely
different views. Seen from the front it appears predominantly
vertical and geometric. But from the rear, it looks far more
undulating and curvilinear. Complex and enigmatic, it draws
not only upon the hermetic language of Cubism but also on
the ambiguities of Surrealism.

References: *Giacometti 1901-1966*, Hirshhorn Museum and Sculpture
Garden, Washington, 1988, p. 78, no. 6; Christian Klemm et al., *Alberto
Giacometti*, Museum of Modern Art, New York, and Kunsthaus, Zürich,
2001, p. 268.

171
Edward Burra (1905–76), *Blue Baby: Blitz over Britain*, 1941
watercolour and gouache on paper; 67.5 x 100.5 cm
IWM:ART:16500 / AF Review no. 3927
Imperial War Museum
Acquired in 1993 for £81,000 from Lefevre Contemporary Art with a
contribution of £20,000 from the Art Fund (William Leng Bequest) and
additional support from the National Heritage Memorial Fund and the
MGC/V&A Purchase Grant Fund

A menacing complement to Jones' *Epiphany* (cat. 151), this
watercolour was unknown to scholars until comparatively
recently. It is first recorded in the collection of the American
poet Conrad Aitken (1889–1973), who was introduced to
Burra by Paul Nash in 1931. The two subsequently became
close friends, and when Aitken returned to live in America
after the Second World War, Burra visited him twice. Further
testimony to their friendship is the artist's *John Deth* of 1931,
which is inscribed on the back *Homage to Conrad Aitken* and
was acquired for the Whitworth Art Gallery, Manchester, in
1982, also with the support of the Art Fund.

This work depicts a monstrous harpy with red eyes and claws,
descending from a red sky. Its features tormented with rage,
it blasts the landscape below – an image of aggression and
vengeance that encapsulates Burra's own fury at the Luftwaffe
bombing of Rye, where he lived in 1940–41.

The apocalyptic theme of this watercolour is common in
Burra's art of the war years, and evident at its most moving
in his *Agony in the Garden* of 1938–39, which was acquired
in 2000 by Birmingham Museum and Art Gallery, likewise
with assistance from the fund.

Reference: 'Edward Burra, *Blue Baby: Blitz over Britain*', in *Annual
Review*, National Art Collections Fund, 1993, pp. 88-89.

172
Jan van de Cappelle (1626–79), *A Calm*, 1654
oil on canvas; 111 x 148 cm
NMW A 2754 / AF Review no. 3989
National Museums and Galleries of Wales
Acquired in 1993 for £3,850,000 (tax remission) from the Marquess
of Zetland through Robert Holden Ltd with a contribution of £250,000
from the Art Fund (including £20,000 from the Wolfson Foundation)
and additional support from the National Heritage Memorial Fund and
anonymous donors

Widely regarded as the masterpiece of the greatest Dutch
marine painter, this picture is first recorded in the collection
of Sir Lawrence Dundas (c.1710–81), who had his portrait
painted by Zoffany with this canvas in the background. It
remained in the collection of his descendants until acquired
by Cardiff in 1993 for a price that reflects its unparalleled
stature among the artist's achievements.

The picture portrays sailing ships on a calm sea; to the far
right is a fortified town. Particularly remarkable are the subtle
gradations of light and tone, which evoke the moist and limpid
atmosphere, and the ravishing depiction of the reflections on
the sea and of the overhanging clouds. These reveal van de
Cappelle's exquisite sensitivity and his masterly illusionism.

Little is known of van de Cappelle, who painted about 200
works, one quarter of which are winter landscapes and the
remainder marines. He worked in Amsterdam, where he
amassed a fortune, eventually boasting a private art collection
of 200 paintings and 6,000 drawings, including many by
Rembrandt. According to one of his contemporaries, he 'taught
himself to paint out of his own desire'.

References: Margarita Russell, *Jan van de Cappelle, 1624/6-1679*,
Leigh-on-Sea, 1975, pp. 25 and 68, no. 52; *Treasure Houses of Britain*,
National Gallery of Art, Washington, 1985, p. 357, no. 282.

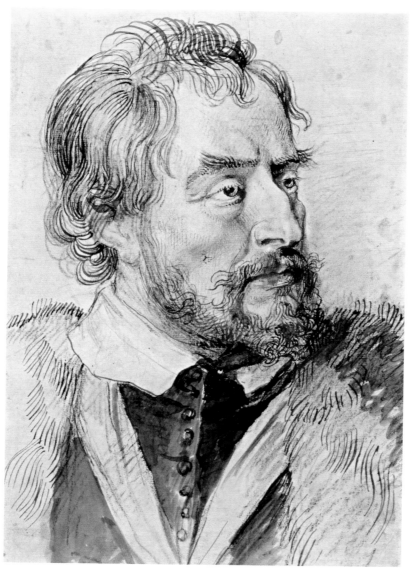

173

Peter Paul Rubens (1577–1640)
Portrait of the Earl of Arundel, c.1629–30
pen and brush in brown ink over black and red chalk; 27.5 x 19.3 cm
WA1994.27 / AF Review no. 3952
Ashmolean Museum, Oxford
Acquired in 1993 for £900,000 from Hôtel Drouot, Paris with a contribution
of £172,750 from the Art Fund (including £30,000 from the Wolfson
Foundation) and additional support from the France, Blakiston and Madan
Funds, National Heritage Memorial Fund, MGC/V&A Purchase Grant
Fund, Michael Marks Charitable Trust and the Friends of the Ashmolean

Thomas Howard (1585–1646), 2nd Earl of Arundel, was among the greatest collectors of his age and characterized by Rubens as 'one of the four evangelists of our art'. His wife was painted by Rubens in Antwerp in 1620, but it was not until the artist's visit to England in 1629–30 that he met Arundel himself.

During his stay in London, he executed three painted portraits of Arundel and two drawings, one of which is a preparatory study for a painting. The other is this magnificent sheet, which was clearly made as an independent work of art and was subsequently engraved. Executed in brown ink and red and black chalk, it portrays Arundel in a richly colouristic manner, which ranges from the subtle shading of his flesh tones to the broad and vigorous strokes of his costume. Scarcely less remarkable is the warmth and humanity of the characterization, which movingly portrays the sensitivity, intelligence and discernment of the sitter.

One of the supreme Old Master drawings acquired by a British collection in recent years, this work was the object of two top-up grants by the Art Fund, which initially offered £50,000 for it and subsequently raised this to £150,000 and, finally, £172,750. It is appropriate that it should have been acquired by the Ashmolean Museum, which also owns many of the classical antiquities formerly in the Earl of Arundel's collection.

Reference: Corpus Rubenianum Ludwig Burchard, Part XIX, Frances Huemer, *Portraits I*, Brussels, 1977, p. 107, no. 4a.

237

174
English (Chamberlain's of Worcester), 19th century
The Nelson Teapot, 1802–05 (right)

soft paste porcelain; 18 x 25.5 cm (teapot); 17 x 11 cm (stand)
M5329 / AF Review no. 4109
The Museum of Worcester Porcelain
Acquired in 1994 for £12,000 from John Cook with a contribution of
£3,000 from the Art Fund and additional support from the MGC/V&A
Purchase Grant Fund

In 1802, Admiral Lord Nelson visited Worcester; he received
the Freedom of the City and visited Chamberlain's, one
of the chief porcelain manufacturers of the day, where he
ordered a service. By the time of his death in 1805, only the
breakfast service had been completed. It included two teapots
and stands. Emma Hamilton purchased the service in 1806,
and the rest of it is now scattered all over the world.

 This teapot is decorated with a large coat of arms. On
its sides appear the arms of Vice-Admiral Horatio Viscount
Nelson of the Nile within the sash of the Order of the Bath.
To either side are the Orders of St Ferdinand and Merit
of Naples and St Joachim of Leiningen, with the star of the
Crescent of Turkey below. The arms are surmounted by a
ducal coronet and that of a viscount, with a naval crest to
the left and Nelson's own crest to the right. All of these refer
to honours recently awarded to Nelson.

References: Geoffrey A. Godden, *Chamberlain's Worcester Porcelain,
1788-1852*, Wigston, Leicester, 1982, pp. 109-13; John Sandon,
The Dictionary of Worcester Porcelain, Vol. I, 1751-1851, Woodbridge,
Suffolk, 1993, pp. 243-45.

175
British, *The Oxborough Dirk*, c.1500–1350 BC (left)

bronze; height 70.9 cm
P&E 1994.10-3.1 / AF Review no. 4054
Trustees of the British Museum
Acquired in 1994 for £52,050 from Robin Symes with a contribution of
£20,000 from the Art Fund

This enormous dagger-like blade was accidentally discovered
in My Lord's Wood near Oxborough Hall, Norfolk, by a
walker who stubbed his toe on its butt end and pulled it out
of peaty soil without difficulty. One of the most magnificent
Bronze Age objects ever unearthed in Britain, the dirk is one
of only five of its type known, joining two each found in
France and the Netherlands ('Plougrescant-Ommerschans'
blades). All have blunt edges and lack any means of attachment
to a hilt, suggesting that they were intended to serve ceremonial
and display purposes rather than to be used as weapons.

 Scientific analysis of *The Oxborough Dirk* and one of those
found in France – *The Beaune Dirk*, also in the British Museum
– suggests that they share a common origin, but their date
remains uncertain. Apparently inspired by functional dirks
dating from the early Middle Bronze Age (*c.*1500–1350 BC),
they are unlikely to be much later.

Reference: Stuart Needham, 'Middle Bronze Age Ceremonial Weapons:
New Finds from Oxborough, Norfolk and Essex / Kent', in *The Antiquaries
Journal*, LXX, Part II, 1990, pp. 239-51.

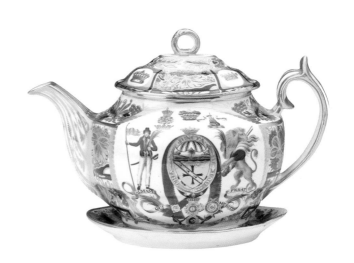

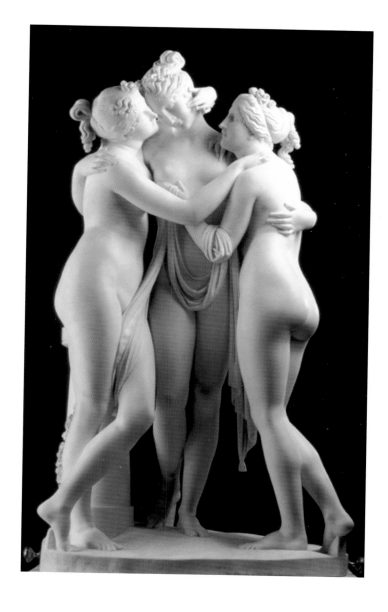

176
Antonio Canova (1757–1822), *The Three Graces*, 1814–17
marble; 173 x 97.2 x 57 cm
A.4-1994/NG 2626 / AF Review no. 4074
Victoria and Albert Museum, London, and National Gallery of Scotland, Edinburgh
Acquired jointly in 1994 for £7,600,000 from Fine Art Investment and Display Ltd with a contribution of £500,000 from the Art Fund (including £250,000 from the William Leng Bequest) and additional support from the National Heritage Memorial Fund, John Paul Getty II, Baron Hans Heinrich Thyssen-Bornemisza, the Friends of the V&A, an independent charity, and numerous donations from members of the public

The Three Graces first came to public attention in the mid 1980s, when it was the subject of an appeal to prevent it from being sold abroad. The Art Fund pledged £250,000 towards the £1,000,000 needed, but the appeal was unsuccessful. In 1994, when the work was acquired by the Getty Museum and export-stopped, a second appeal was launched. The Art Fund doubled its support and, together with the National Heritage Memorial Fund, J. Paul Getty II, Baron Hans Heinrich Thyssen-Bornemisza and countless members of the public, enabled the National Galleries of Scotland and the Victoria and Albert Museum to acquire it jointly. It was the third major work by Canova to receive Art Fund support, the others being the *Sleeping Nymph* (acquired 1930) and *Theseus and the Minotaur* (1962), both also in the Victoria and Albert Museum. In 1996 the fund also helped the Ashmolean Museum, Oxford, to acquire an *Ideal Head* by the artist.

The sculpture was executed for John Russell, 6th Duke of Bedford, who saw an earlier version of it (now in the Hermitage, St Petersburg) in Rome in 1814. This had been commissioned two years before by the Empress Josephine, who died in 1814. When her heirs refused to sell the work, the Duke commissioned a second version from Canova. This was delivered to the Duke's residence, Woburn Abbey, by 1819, and was installed in a specially designed setting, the Temple of the Graces, partly under Canova's supervision, where it remained until 1985.

The Three Graces were the daughters of Zeus and companions to the Muses in bestowing their gifts upon humanity. From Euphrosyne came mirth, from Aglaio, elegance, and from Thalia, youth and beauty. Canova depicts them in this order, from left to right.

References: *The Age of Neo-classicism*, Royal Academy of Arts, Victoria and Albert Museum, London, and Arts Council of Great Britain, 1972, pp. 207-08, no. 322; *Treasure Houses of Britain*, National Gallery of Art, Washington, 1985, pp. 541-42, no. 480; *The Three Graces, Antonio Canova*, National Gallery of Scotland, Edinburgh, 1995; Bruce Boucher, 'A New Ideal of Beauty', in *Art Quarterly*, Winter 2002, pp. 32-37.

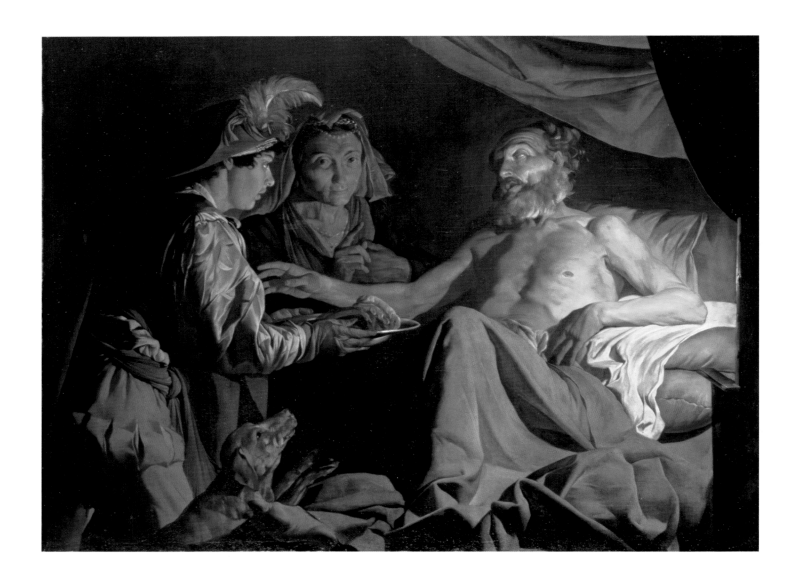

177

Matthias Stom (*c*. 1600 – *c*. 1652)
Isaac Blessing Jacob, c. 1635
oil on canvas; 136.5 x 182 cm
94.2 / AF Review no. 4010
The Trustees of the Barber Institute of Fine Arts, The University of Birmingham
Acquired in 1994 for £485,000 from Trafalgar Galleries with a contribution of £100,000 from the Art Fund (including a donation of £1,500 from the Matthieson Foundation in honour of Sir Denis Mahon) and additional support from the MGC/ V&A Purchase Grant Fund

The subject is from Genesis (27: 1-29). The aged Isaac, nearly blind, has summoned his elder son, Esau, to prepare him a meal and receive the paternal blessing. Isaac's wife Rebecca substitutes her own favourite son, Jacob, putting goatskin gloves on his hands so that he might resemble the hairy Esau. As Isaac reaches out to bless Jacob, the latter approaches warily and offers his father a plate of meat. In the centre the wily Rebecca enjoins the viewer not to divulge the ruse.

The picture also contains references to the five senses: sight (through its absence in Isaac), touch (the blessing), hearing (again through its opposite – i.e. the silence demanded by Rebecca), taste (the meal), and smell (the leaping dog).

Born in Amersfoort, Stom settled in Italy around 1630, working in Rome, Naples and Sicily, where he died sometime after 1652. His style is modelled on that of Caravaggio and his Dutch followers in its dramatic immediacy, realistic figure types and strong contrasts of light and shade. This is the only painting by him ever supported by the Art Fund and the first painting for which the Barber Institute of Fine Arts had ever applied to it for financial assistance.

Reference: Richard Verdi, *Matthias Stom, 'Isaac blessing Jacob'*, The Barber Institute of Fine Arts, The University of Birmingham, 1999.

178
Barbara Hepworth (1903–75), *Preparation*, 1947
Inscribed upper left: *Barbara Hepworth 10/12/47*
blue oil and pencil on board; 36.8 x 26.7 cm
106/1994 / AF Review no. 4030
Exeter City Museums and Art Gallery
Acquired in 1994 for £12,725 (tax remission) from Cecily Capener with
a contribution of £3,181 from the Art Fund and additional support from
the MGC/V&A Purchase Grant Fund

Between 1947 and 1949, Hepworth executed a series of drawings of surgeons at work, inspired by her visits to operating theatres in Exeter and London.

This is one of the earliest works in the series and was executed in Exeter, where it has now found a permanent home. It superbly captures the air of concentration – and dedication – that characterizes the surgeon's task. Depicted as a weighty and monumental figure, rendered anonymous by the medical mask, the surgeon contemplates the impending operation, his hands meeting as he mentally prepares them for action.

Hepworth was permitted to sketch in the operating theatre using a sterilized notebook and pen, but the finished drawings were completed later, many employing the blue and white of this work, which evokes the clinical cleanliness of a hospital environment.

The gravity and seriousness of all of these works have led some critics to regard them as Hepworth's greatest achievement as a draughtsman.

Reference: Penelope Curtis and Alan G. Wilkinson, *Barbara Hepworth: A Retrospective*, Tate Gallery, Liverpool, and Art Gallery of Ontario, Toronto, 1994, pp. 90-92.

179
Teke People (Republic of Congo)
Power Figure, late 19th century
wood, metal and European buttons; 46 x 15 x 19 cm
Ethno 1995 / AF Review no. 4195
Trustees of the British Museum
Acquired in 1995 for £100,000 (tax remission) from H. Hottot with
a contribution of £40,000 from the Art Fund

This Teke figure was bought from the Basisse clan in Luoko village, Bula N'tangu in September 1906 by Dr R. Hottot, who was then serving as a doctor in the Congo.

The original function of the sculpture is unclear. Although it may have served as an ancestral figure, it is more likely to have had a ritual function, with a magical substance deposited in the cavity of its chest. Since that cavity is now empty, it has been suggested that it had been retired from its ritualistic duties, which would also account for the willingness to sell it to Hottot.

The figure possesses an incantatory power through the fixity of its pose and expression, its penetrating eyes being made of European buttons, and through its elevated hairstyle, which is an exaggerated version of that common to this area of Africa. The excessively large beard likewise indicates a being both venerable and vigorous – ideal for interceding with the spiritual world on behalf of 'ordinary' humanity.

References: William Fagg, *The Tribal Image*, British Museum, London, 1970, no. 35; John Mack, 'Squatting Male Figure', in *Annual Review*, National Art Collections Fund, 1995, pp. 122-23.

180
Egyptian, *Lintel of Senusret III, King of Egypt,* 1874 – 55 BC
white quartzite; 53 x 143 x 21.4 cm
AES 74753 / AF Review no. 4179
Trustees of the British Museum
Acquired in 1995 for £109,000 from Frederick Elghanayan with a
contribution of £24,000 from the Art Fund and additional support from
the Sackler Foundation

Unrecorded until early in the twentieth century, when it emerged in the garden of a manor house near Southampton, this lintel originally decorated a temple doorway for the Egyptian King Senusret III (1874 – 55 BC). It was paired with another lintel in the British Museum (AES 145), acquired in 1805, inscribed for the same king and formerly employed beneath Pompey's Pillar, the commemorative column erected at Alexandria by the Roman Emperor Diocletian (reigned 284 – 305 AD). The latter lintel remained there until 1801 but, as early as 1737, was blown up, severing the lower legs of the deities depicted. Since this lintel has suffered in a similar way, it was probably also a part of this construction.

When the lintel was sold at auction to a private collector in December 1994, the British Museum recommended against its export and, soon after, purchased it and reunited it with its twin. According to an article in the 1995 *Review*, the export ban placed on this work was 'the first ... in a generation for an Egyptian antiquity.'

Reference: Stephen Quirke, 'The Quartzite Lintels of Senusret III, King of Egypt', in *British Museum Magazine*, 23, Winter 1995, pp. 16-17.

181

Max Ernst (1891–1976)
The Joy of Life (*La Joie de Vivre*), 1936
oil on canvas; 73.5 x 92.5 cm
GMA 3886 / AF Review no. 4236
Scottish National Gallery of Modern Art
Part of the collection of Sir Roland Penrose (10 paintings, 1 collage,
15 drawings) acquired in 1995 for £850,000 from a private collector
with a contribution of £150,000 from the Art Fund and additional support
from the National Heritage Memorial Fund

Ernst's predatory jungles are among his many expressions of outrage at the worsening political situation in Europe during the 1930s, which culminated in what the artist himself described as 'the worst filth of the twentieth century', the Second World War. This one derives its bitterly ironic title by alluding to a glorious work by Matisse of 1905–06, which is genuinely joyous. In contrast, Ernst spreads his entangled leaves and tendrils across the picture, so that they appear locked in combat, and populates this death trap with praying mantises – themselves vicious predators.

Lost in this sinister world is a diminutive human being (upper right) alongside a crouching beast, both seemingly easy prey for the devouring plants and insects that surround them.

This is one of the works purchased by the Scottish National Gallery of Modern Art from the collection of Roland Penrose, one of the greatest champions of modern art in Britain in the twentieth century. It was the first picture acquired for his collection in 1935 (in his own words) 'even before it was finished'. Three other masterpieces from his outstanding collection – by Giorgio de Chirico (cat. 147), Picasso (cat. 154) and Dorothea Tanning (cat. 197), who became Ernst's wife in 1946 – are also reproduced here.

References: John Russell, *Max Ernst: Life and Work,* London, 1967, p. 116; *Creation, Modern Art and Nature,* Scottish National Gallery of Modern Art, Edinburgh, 1984, p. 51, no. 47.

182
Jeff Wall (b. 1946)
A Sudden Gust of Wind (After Hokusai), 1993
photographic transparency and illuminated display case; 250 x 397 x 34 cm
T06951 / AF Review no. 4202
Tate
Acquired in 1995 for £102,813 from Galerie Roger Pailhas, Marseilles
with a contribution of £10,000 from the Art Fund and additional support
from the Patrons of New Art through the Tate Gallery

The first work by the influential Canadian artist to be acquired
for a British public collection, this gigantic photographic image,
mounted in a light box, is based on Hokusai's woodcut *A
Strong Gust of Wind at Ejiri* of *c.* 1831, one of his *Thirty-six
Views of Mt. Fuji*. Hokusai's woodcut is set in the typhoon
season in Japan and depicts travellers struggling to hold on
to their hats and other possessions in a raging gale.

Jeff Wall has transplanted this scene to the landscape around
his home town, Vancouver, and shows a group of figures, some
of them dressed as businessmen, caught off-guard by a sudden
gust, which sends sheets of paper flying, like falling leaves. The

result is a reminder of how unpredictable events in nature
can affect ordinary lives.

The work is constructed from parts of more than fifty
images shot over a year – in Wall's own words 'at a certain
density and only at a certain time of day – otherwise the
various pieces wouldn't match'. These were then scanned
and digitally processed. The result took so long to assemble
that Wall himself likened the procedure to cinematography
rather than photography.

Described as 'a representation of a representation of real life',
Wall's *Sudden Gust of Wind* departs from Hokusai's source in
showing its figures caught up in the wind rather than subju-
gating themselves to it, suggesting a less harmonious accord
between man and nature.

References: Patricia Bickers, 'Wall Pieces', in *Art Monthly*, 179,
September 1994, pp. 3-7; Richard Morphet, *Encounters: New Art from
Old*, National Gallery, London, 2000, pp. 332-33.

183

Marco Zoppo (1433–98), *The Dead Christ Supported by Angels* (recto, above left); *St James on his Way to Execution* (verso, above right), *c.* 1455–57

recto: pen and brown ink with brown and red wash on vellum; verso: brown and olive green wash; 35 x 28 cm
PD 1995-5-6-7 / AF Review no. 4176
Trustees of the British Museum
Acquired in 1995 for £445,000 (tax remission) from the heirs of Colonel Norman Colville through Christie's with a contribution of £100,000 from the Art Fund and additional support from the National Lottery through the Heritage Lottery Fund

The most expensive acquisition ever made by the Department of Prints and Drawings of the British Museum, this double-sided drawing is executed on vellum and may have been intended as a presentation work, to be used for private devotion.

The *recto* depicts the broken figure of the dead Christ supported by angels. Framing him is a classical tabernacle supporting additional angels, a familiar device in paintings of this period executed in Padua, where Zoppo worked *c.* 1453–55. Particularly moving are the anguished face of Christ and the wailing expressions of certain of the angels.

The *verso* portrays St James being led to his execution and is based on a (destroyed) fresco by Mantegna of *c.* 1457 in the Ovetari Chapel of the church of the Eremitani, Padua. This reveals the young Zoppo's skills in portraying the male nude in a variety of complex poses and is set against a triumphal arch festooned with swags and enlivened by the cantankerous actions of a group of putti. Whether riding a horse or wielding a club, these have nothing to do with the principal subject and were presumably included as a demonstration of the artist's inventiveness.

Born in Bologna, Zoppo studied in Padua with Francesco Squarcione, who also taught Mantegna and inspired both artists with a passion for the antique, evident here in the intensely sculpturesque drawing style and relief-like design of the *Dead Christ*.

Reference: Hugo Chapman, *Padua in the 1450s, Marco Zoppo and his Contemporaries*, British Museum, London, 1998, pp. 51-54, no. 8.

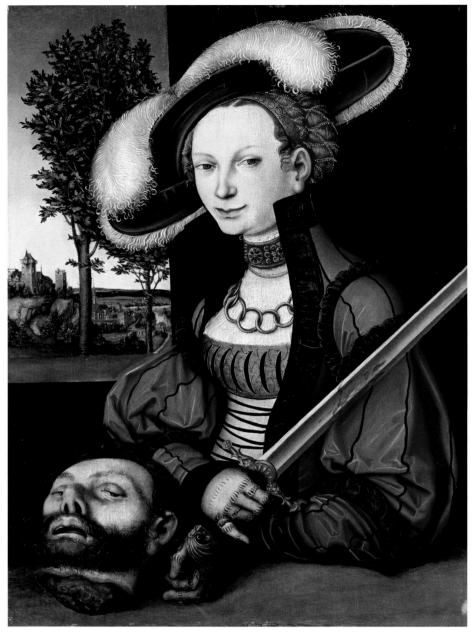

184

Lucas Cranach the Elder (1472–1553)
Judith with the Head of Holofernes, 1530

oil on panel; 76.7 x 55.8 cm
35.671 / AF Review no. 4238
Glasgow Museums: The Burrell Collection
Acquired in 1995 for £314,663 from an anonymous vendor through
Citybank N.A. Art Advisory Service with a contribution of £50,000 from
the Art Fund (Scottish Fund) and additional support from the National
Lottery through the Heritage Lottery Fund

In the Apocrypha of the Old Testament (Judith 10–13), the Bible relates how the Jewish heroine, Judith, saved her people in a war with the Assyrians by seducing their general Holofernes, and, when he was overcome with alcohol, cutting off his head. Though this story has been variously interpreted, it is most often seen as a triumph of virtue over vice.

Cranach portrays Judith as a wise and self-assured woman, elegantly clad and holding the blood-stained sword in a restrained but triumphant manner. She wears contemporary dress; and the landscape visible in the distance contains buildings consistent with Cranach's own surroundings, as court painter at Wittenberg, where he successively served three Electors of Saxony.

An outstanding example of a theme depicted more than once by the artist, the picture is treated like a portrait rather than a history painting. But why? – and of whom? – we will almost certainly never know.

Reference: M. J. Friedländer and J. Rosenberg, *The Paintings of Lucas Cranach,* London and New York, 1978, p. 115, no. 230.

185

Thomas Gainsborough (1727–88)
Study for 'Diana and Actaeon', c. 1784–86
black and white chalk with grey and grey-black washes and gouache on
buff paper; 27.4 x 36.4 cm
1996.038 / AF Review no. 4350
Trustees of Gainsborough's House, Sudbury
Acquired in 1996 for an undisclosed sum (tax remission) from Henry
Wemyss through Hazlitt, Gooden and Fox with a contribution of £31,000
from the Art Fund and additional support from Suffolk County Council,
the National Heritage Memorial Fund, Gainsborough's House Society
Development Trust and the MGC/V&A Purchase Grant Fund

The earliest of three surviving studies for Gainsborough's only
mythological picture (Royal Collection), this impassioned
drawing depicts the familiar subject from Ovid's *Metamorphoses*
(3: 138–253). The hunter Actaeon has inadvertently happened
upon the goddess Diana bathing with her nymphs. Enraged
that a mortal has espied her naked, Diana throws water at
Actaeon, transforming him into a stag, which is subsequently
devoured by his hunting hounds.

The subject was often depicted and was definitively treated
by Titian (National Gallery of Scotland, on loan from the
Duke of Sutherland) in a painting of 1559.

The drawing is one of a host of remarkable acquisitions
made since the 1980s by the museum at Gainsborough's House,
where the artist was born, many of them with assistance from
the Art Fund.

References: John Hayes, *The Drawings of Thomas Gainsborough*, London,
1970, I, p. 295, no. 810; *Gainsborough*, Tate, London, 2002, p. 280, no. 175.

186

Nicholas Homoky (b. 1950), *Abstract Teapot*, 1994 (above)
porcelain; 13.7 x 19.5 x 8 cm
NWHCM 1998.61.6:D / AF Review no. 4335
Norwich Castle Museum and Art Gallery
Acquired in 1996 for £700 from Nicholas Homoky with a contribution
of £188 from the Art Fund (Wakefield Fund) and additional support from
the MGC/V&A Purchase Grant Fund and Eastern Arts Board

A contemporary addition to Norwich's world-renowned
collection of British teapots (see cat. 156), this work recalls the
Constructivist style of Russian ceramics of the early 1920s.
Homoky, who was born in Hungary and moved to England
six years later, is well-known for producing minimalist white
ceramic designs with black inlaid decoration. He studied at
Bristol Polytechnic, and later taught there and at the Royal
College of Art, in the 1970s. Much influenced by the Bauhaus,
the works of Ben Nicholson and the ceramics of Lucie Rie
and Hans Coper, Homoky develops his jaunty and engaging
designs through drawings and specializes in making vases,
bottles and bowls, in addition to teapots. This example, which
is essentially non-functional, is notable for the lively counter-
point established between the multi-directional black strokes
that animate the surface and for the whimsical handle and spout.

Reference: Chloe Archer, *Teapotmania: the Story of the Craft Teapot
and Teacosy*, Norfolk Museums Service National Touring Exhibition,
1995-97, pp. 72-73, no. 77.

187

Thomas Mudge (1715–94)
Quarter Repeating Watch, 1756–57 (below)
Signed: *Thomas Mudge, London No.366*
gold case, enamel dial, brass, steel and silver movement;
diameter 5 cm, height 6 cm
P&E 1996, 0906.1 / AF Review no. 4301
Trustees of the British Museum
Acquired in 1996 for £90,000 from Terence Cuss with a contribution of
£25,000 from the Art Fund (including £10,500 from the Daytime Committee)
and additional support from the National Heritage Memorial Fund

Born in Plymouth and apprenticed to the Clockmakers'
Company, London, in 1730, Thomas Mudge specialized in
making high precision watches and clocks, following in the
tradition of his master, the celebrated clock and watch maker,
George Graham.

This rare watch is made in two tiers and strikes both the
hours and the quarters, repeating them on demand. It was
originally designed to fit into the end of a walking cane but,
by 1842, had been transferred instead to a gold basket.

Though the early history of the watch is unknown, hand-
written inscriptions in the case indicate that it was in Spain
in the mid-nineteenth century. This is intriguing, for Mudge
made watches for John Ellicott (1704– 72), one of whose major
clients was King Ferdinand VI of Spain (reigned 1746– 59).
When the latter realized that Mudge was capable of making
machines that excelled those of any of his contemporaries, he
commissioned the clockmaker on a regular basis to make such
works for the Spanish court.

This is not the only timepiece by Mudge to be acquired for
the nation with the help of the Art Fund. Two years earlier,
in 1994, his *Lord Polwarth's Travelling Clock* was purchased by
the British Museum for £220,750 with a grant of £50,000
from the fund.

References: T.P. Camerer Cuss, 'Mudge and the King of Spain', in
Horological Journal, no. 107, July 1964, pp. 21-23; David Thompson,
'Thomas Mudge, Grande-Sonnerie Striking and Quarter Repeating
Watch', in *1996 Review*, National Art Collections Fund, p. 104.

188

Limoges (France), *The Becket Casket, c.*1180

gilt-copper, rock crystal, enamel, oak core; 30.5 x 29.9 x 11.4 cm
M.66-1997 / AF Review no. 4328
Victoria and Albert Museum
Acquired in 1996 for £4,286,038 from Sotheby's with a contribution of
£100,000 from the Art Fund (Miss Mary Melville Bequest) and £51,500
in donations through the Art Fund, including £50,000 from Mrs Valerie
Eliot, £500 from the Drapers Company and £300 from A.I. Packe, and
additional support from the National Heritage Memorial Fund and many
other funds and private donors

On the night of 29 December 1170, four knights in the
service of King Henry II broke into Canterbury Cathedral
and murdered Thomas Becket. All of Europe was horrified
and the place of his murder became a pilgrimage site within
weeks of his death. Three years later he was canonized, and
his shrine remained among the most famous in Christendom
until it was destroyed under Henry VIII in 1538.

This casket is probably the earliest, largest and finest example
of Limoges enamel depicting Becket's martyrdom. The murder

is shown on the front, which also portrays the haloed soul of
the saint being carried away above the altar. The sloping roof
depicts the burial of the saint and the ascent of his haloed
body to heaven. The back of the casket depicts four saints or
cardinal virtues, and on one side Christ in Majesty seated on
a rainbow. The other side is missing, as are the casket's floor
and contents.

The casket was possibly made to contain relics of the saint
known to have been taken to Peterborough Abbey in 1177
by his friend the Abbot Benedict. In English collections since
the mid-eighteenth century, it spent forty years in Paris and
Lucerne in the middle of the twentieth century, but returned
to Britain when it was bought by the British Rail Pension Fund
in 1979 and eventually acquired for the nation after a vigorous
campaign in which the Art Fund played a crucial role.

References: *Enamels of Limoges 1100-1350*, 1996, Metropolitan Museum
of Art, New York, pp. 162-64, no. 39; Paul Williamson (ed.), *The Medieval
Treasury*, London, new ed., 1998, p. 178.

189
Joanna Constantinidis (1927–2000)
Tall Flattened Pot with Lines, 1976 (above right)
Lustre Pot with Extended Rim, 1984 (above left)
Leaning Lustre Bottle, 1990–91 (above centre)
stoneware; heights 46 cm, 46 cm, 44 cm
1996.187, 188 and 189 / AF Review no. 4272
Chelmsford Museum (Chelmsford Borough Council)
Acquired in 1996 for £2,500 from Joanna Constantinidis with a contribution
of £875 from the Art Fund and additional support from the MGC/V&A
Purchase Grant Fund

Though Joanna Constantinidis was born in York, she taught
at the Chelmsford School of Art in England from 1951 and
resided in the town for the rest of her life. It is therefore fit-
ting that these three pots by her were acquired by her local
museum, which hitherto had only one example of her art.

Chosen at a retrospective exhibition of the potter's work at
the University of Derby in 1995, the ceramics illustrate her
consistent concerns over three decades. All are large, non-
functional vessels made of stoneware, her favourite material.
The *Tall Flattened Pot* has textured lines, a narrow opening
and gravity-defying height. The *Lustre Pot with Extended Rim*
also defies gravity – this time optically – with its tapering
wide lid. And the *Leaning Lustre Bottle* appears to undulate
mysteriously around a tilted axis. In their contrasting shapes,
the three works complement one another, while all exhibit
the lustrous surface that is a feature of Constantinidis' studio
pottery.

The Art Fund has supported contemporary ceramics from its
very earliest days. Among its first benefactors in this field was
Kenneth Dingwall, who presented modern oriental ceramics
to the Victoria and Albert Museum through the fund from
1910 to 1914. Its most recent benefactors include Sir Nicholas
Goodison, Chairman of the fund between 1986 and 2002, and
his wife, Judith, who have bequeathed numerous contemporary
ceramics to the Fitzwilliam Museum (see also cat. 198).

References: *Joanna Constantinidis: Ceramics from Twenty-Five Years,*
The Ballantyne Collection, University of Derby and elsewhere, 1995-96,
p. 20, no. 22, p. 23, no. 36, and p. 24, no. 48; 'Joanna Constantinidis,
Three Pots', in *1996 Review,* National Art Collections Fund, p. 77.

190
James Cromar Watt (1862–1940), *Necklace, c.* 1909
gold, enamel, turquoise, pearl; length 41 cm
ABDAG8910 / AF Review no. 4362
Aberdeen Art Gallery and Museums Collections
Acquired in 1996 for £19,000 from S. and D. Newell-Smith with a
contribution of £4,250 from the Art Fund (Scottish Fund) and additional
support from the National Fund for Acquisitions

The Aberdeen artist James Cromar Watt had a varied career.
He trained as an architect and had a deep interest in foreign
decorative art and botany, but his chief importance was as
an artist-craftsman whose greatest passion was enamelling,
especially jewellery.

In the intensity and brilliance of its colour, this magnificent
necklace reveals Watt's enamelling skills in his maturity. It is
constructed from festooned chains interspersed with freshwater
pearls and drops of turquoise, which are suspended from
foiled enamel plaques.

The necklace's original leather and silk case is inscribed with
the names of G.B. Duff and Hatton. The latter is a small village
about thirty miles north of Aberdeen and the former refers
to the Duff family, who presumably commissioned the piece.

Reference: Christine Rew, 'James Cromar Watt, Aberdeen Architect
and Designer', in *Journal of the Scottish Society for Art History,* V,
2000, p. 33.

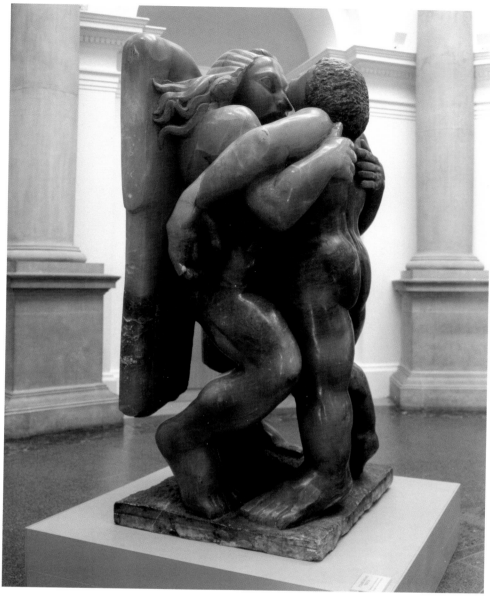

191

Jacob Epstein (1880–1959), *Jacob and the Angel*, 1940–41
alabaster; 214 x 110 x 92 cm
T07139 / AF Review no. 4326
Tate
Acquired in 1996 for £500,000 from the Granada Foundation with a contribution of £25,000 from the Art Fund and additional support from the National Lottery through the Heritage Lottery Fund and the Henry Moore Foundation

In the late 1990s, the Granada Foundation – established in 1965 to further the arts and sciences, especially in north-west England – sold two major sculptures by Epstein: this one and *Genesis* of 1929–30, which was acquired by the Whitworth Art Gallery, Manchester, in 1999, also with support from the Art Fund.

This monumental work depicts the well-known theme from the Book of Genesis (32: 24-32). Jacob is wrestling with a stranger in a struggle that will last throughout the night. In the morning, his assailant reveals himself to be an angel of the Lord and blesses Jacob for not abandoning the struggle. Though apparently locked in combat, the figures here seem to embrace and kiss, adding a charged sexual undertone to the sculpture. The work was carved from a single block of coloured alabaster and may owe its inspiration to Brancusi's famous sculpture, *The Kiss*, of 1906–08. Epstein had visited Brancusi in Paris only a few years earlier and this encounter may have rekindled his enthusiasm for the sculptor's work.

Jacob and the Angel is a deeply personal work on the part of a man who shared its hero's name. But it is also an awesome technical achievement and, coming in the midst of the Second World War, a bold and impassioned reminder of the titanic, spiritual struggle that mankind must endure on earth.

References: R. Buckle, *Jacob Epstein Sculptor*, London, 1963, pp. 254-64; Evelyn Silber, *The Sculpture of Epstein*, Oxford, 1986, pp. 54 and 188, no. 312.

192
Pablo Picasso (1881–1973)
Study of a Seated Nude and Head of a Woman for the painting 'Les Demoiselles d'Avignon', 1906–07
red, orange and pink bodycolour and watercolour; 62.6 x 46 cm
PD 1996-2-16-3 / AF Review no. 4298
Trustees of the British Museum
Acquired in 1996 for £210,000 from Sotheby's with a contribution of £60,000 from the Art Fund

One of a large number of studies executed by Picasso in the winter of 1906–07 that led to his epoch-making canvas, *Les Demoiselles d'Avignon* (Museum of Modern Art, New York), this is among the most important Picasso drawings in a public collection in Britain. It was formerly in the possession of Douglas Cooper (1911–84), the art historian and collector of twentieth-century art, who lived in France and was a close friend of Picasso. Along with Roland Penrose (see cat. 154, 161, 181, 197), Cooper was a guiding force in making the great masters of early twentieth-century art better known in the UK.

Les Demoiselles d'Avignon began as a brothel scene showing a male youth surrounded by five nude women. The youth was eventually omitted and the picture altered to depict only the female figures in a sequence of highly confrontational poses, their features brutally distorted. This drawing relates to the figure second from the left, who was originally shown seated. It bears the generalized features of Fernande Olivier, Picasso's mistress during these years, but also reveals the influence of ancient Iberian sculpture, to which Picasso had been introduced in the Louvre in the spring of 1906.

References: Christian Zervos, *Pablo Picasso*, Paris, 1932-78, XXVI, no.13; *Les Demoiselles d'Avignon*, Musée Picasso, Paris, 1988, vol. I, p. 140, ill. 4.

193
Melkoy People (Melanesia, Papua New Guinea, New Britain), *Uvol Dance Crest,* 1983
cane, pith, vegetable fibres and pigments; height 226 cm, diameter 77 cm
1997.92 / AF Review no. 4311
Horniman Museum, London
1 of a group of 8 crests acquired in 1996 for £13,400 from Kevin Conru with a contribution of £5,550 from the Art Fund

The Melkoy people of Uvol, Cape Dampier, in southern New Britain number only about 1,200, but they have been successful in preserving their ritual customs, despite the influence of Christianity. This dance crest originates in a ceremony that takes place about every twenty-five years and represents the *Rupau*, friendly spirits that inhabit the coasts of Uvol and a small uninhabited island that faces it.

The ceremony begins with the women serenading the spirits until they have emerged from hiding and entered the village. Then the men dance wearing elaborate crests, and the ceremony concludes with a feast at which future marriage plans are discussed and local gossip exchanged.

The dance crests are normally destroyed after each ceremony, but in 1987 Joel van Bussel was able to acquire seventy-five of them after spending a long time with the Melkoy people, who allowed him to document these events through photographs and video recordings. Thirteen of these were eventually sold to the Royal Albert Memorial Museum, Exeter, and the Horniman Museum, London, in both cases with the support of the Art Fund. The remainder went abroad.

Reference: Anthony Shelton, 'Group of Dance Crests', in *1996 Review*, National Art Collections Fund, p. 114.

194
Alexander Cozens (1717–86), *Setting Sun*, c.1770
oil on paper; 24.2 x 30.8 cm
O.1997.3 / AF Review no. 4467
Whitworth Art Gallery, University of Manchester
Acquired in 1997 for £202,913 from Sotheby's with a contribution of
£12,682 from the Art Fund and additional support from the National
Lottery through the Heritage Lottery Fund, MGC/V&A Purchase Grant
Fund and the Friends of the Whitworth

In the 1760s and 1770s, Alexander Cozens compiled a series
of etchings which he entitled *Various Species of Composition
in Nature*. These were intended to depict types of terrain
calculated to arouse a specific emotional and moral effect
in the viewer. This glorious work may be related to one of
twenty-seven 'circumstances' of landscape which affect its
atmosphere, colour and tone. Number seven of these in Cozens'
list is *Setting Sun*. It is one of only five surviving oil paintings
on paper by the artist to be related to this enterprise.

Cozens was a much respected landscape artist and theorist
who also served as a drawing master for more than forty years.
He had numerous illustrious pupils, including members of
the royal family, William Beckford, Sir George Beaumont and
his son, John Robert Cozens (see cat. 143), who ultimately
surpassed his father's achievement. This is one of more than
thirty works by both artists in the Whitworth Art Gallery, which
also boasts seven Grand Tour sketchbooks by J.R. Cozens of
1782–83.

Reference: Charles Nugent, 'Alexander Cozens, "Setting Sun"', in *1997
Review*, National Art Collections Fund, pp. 108-09.

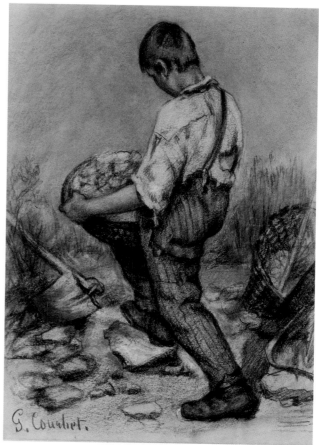

195
Gustave Courbet (1819–77)
The Young Stonebreaker, 1865
Signed lower left: *G. Courbet*
black crayon on paper; 29.5 x 21.2 cm
WA 1998.3 / AF Review no. 4474
Ashmolean Museum, Oxford
Acquired in 1997 for £49,608 (tax remission) from Renate Gross
through David Carritt Ltd with a contribution of £16,000 from the Art
Fund and additional support from the MGC/V&A Purchase Grant Fund,
Madan and France Funds and the Friends of the Ashmolean

In 1849, Courbet painted his first great picture of human
labour, *The Stonebreakers* (formerly Dresden, destroyed 1945),
which depicts an adult man and a youth mending a road – the
type of theme that was soon to brand the artist as a Social
Realist. Both figures are shown from behind, enhancing the
inhumanity of the tasks they perform. 'It's very unusual',
noted the artist, when witnessing this scene in nature, 'to come
across such a total expression of misery and destitution.'

This drawing served as the model for a lithograph published
in Firmin Gillot's *L'Autographe au Salon* in 1865 and 1872. A
rare work by Courbet, who hardly ever made preliminary
drawings for his paintings, it depicts the youth in reverse
from his position in the lost canvas and is one of only two
drawings by the artist acquired with the aid of the Art Fund.

Reference: Catherine Whistler, *Impressionist and Modern: The Art and
Collection of Fritz Gross*, Hatton Gallery, University of Newcastle and
Ashmolean Museum, Oxford, 1990, pp. 49-50, no. 8.

196
Bridget Riley (b. 1931), *Conversation*, 1992
oil and acrylic on linen; 92 x 126 cm
LAT:1996:0005 / AF Review no. 4428
Abbot Hall Art Gallery, Kendal, Cumbria
Acquired in 1997 for £15,000 from Karsten Schubert Ltd with a contribution of £3,750 from the Art Fund and additional support from the MGC/V&A Purchase Grant Fund and the Friends and Patrons of Abbot Hall

In the mid 1960s Bridget Riley introduced colour into her art after the black and white works of Op Art which had characterized it between 1961 and 1965. Some thirty years later, her earlier stripe paintings were replaced by those employing diagonal effects. In this picture, a vertical grid covers the entire canvas. But each strip is subdivided into diagonal planes of colour which traverse the surface. Sometimes large, but mostly small, these create a tension and interplay between the vertical and diagonal, and between colours and directions, that is the 'conversation' of the picture's title.

Abbot Hall Art Gallery opened in 1962, in a handsome Georgian house built in 1759. Since that time it has pursued an energetic acquisitions policy, concentrating on artists born or active in the area – such as Romney (see cat. 140) – and on twentieth-century art. The Art Fund has supported over one hundred works acquired by this enterprising museum.

Reference: Edward King, 'Bridget Riley, *Conversation*', in *1997 Review*, National Art Collections Fund, p. 76.

197
Dorothea Tanning (b. 1910), *Eine kleine Nachtmusik*, 1943
Signed bottom right: *Dorothea Tanning '43*
oil on canvas; 40.7 x 61 cm
T07346 / AF Review no. 4453
Tate
Acquired in 1997 for £156,250 from the Mayor Gallery with a contribution of £59,379 from the Art Fund and additional support from the American Fund for the Tate Gallery

This unnerving canvas derives its bitterly ironic title from Mozart's serenade of the same name. But whereas the latter is lighthearted and beguiling, this is deeply traumatic.

A giant sunflower has found its way into a seedy hotel corridor and lies there beside its broken stem. Two of its petals are on the stairs and a third is held by a doll dressed in tattered garments that is leaning against a door. Though she seems astonishingly life-like, her hairline reveals that she is a toy. Nearby stands a girl, similarly dressed, whose hair flies upwards, as though struck by a violent gust of wind. According to the artist, the threatening and aggressive sunflower represents the 'never-ending battle we wage with unknown forces'. The inexplicable – and supernatural – alone could account for this scenario.

Born in Illinois, Tanning became a member of the Surrealists in 1942 and, four years later, married Max Ernst (see cat. 181), one of its leading figures. He is superbly represented in the national collections – particularly in London and Edinburgh – but this is the first painting by Tanning to be acquired for them. It was formerly owned by Roland Penrose (see cat. 154, 161, 181), whose collection abounded in works by the Surrealists, and was purchased with the help of the Art Fund, when its export licence was temporarily deferred.

Reference: Jean-Christophe Bailly, *Dorothea Tanning*, translated by R. Howard, New York, 1995, pp. 17-20.

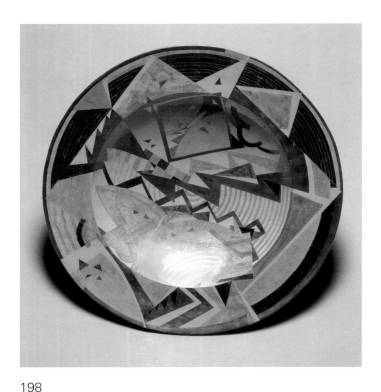

198
Judy Trim (1943–99), *Dish: Narcissus*, 1994

Market *'JT'* on the base
coiled and burnished earthenware, decorated with coloured slips and metallic lustres; 9.3 x 46.9 cm
C.17-1997 / AF Review no. 4530
Syndics of the Fitzwilliam Museum, Cambridge
Presented in 1997 as a gift by Sir Nicholas and Lady Goodison through the Art Fund

Since 1997, Sir Nicholas Goodison (see p. 58) and his wife, Judith, have donated forty-nine works of art to the Fitzwilliam Museum through the Art Fund. The majority of these have been ceramics and glass but the gifts have also included furniture, woodwork and basketwork. The works are invariably of his own choosing, though on occasion he has consulted with the museum regarding its preferred choice. This dish was purchased directly by him from Judy Trim.

Judy Trim was educated at Bath Academy of Art and exhibited throughout the world. This is one of two works by her that form part of the Goodison gift to Cambridge, the other being *Oval Dish: Blue Ceremonial* of 1989–90, donated through the Art Fund in 2000.

Reference: Julia Poole, 'Sir Nicholas Goodison and Lady Goodison Gift', in *1997 Review*, National Art Collections Fund, pp. 169-70.

199
Italian, *Collection of Wax Modelli*
mid 17th – early 19th century

*Louis XIV, c.*1670 (illustrated above left)
white wax on slate; diameter 8.5 cm

*Joseph of Leonissa, c.*1740
red wax on slate; 9.4 x 8 cm

*Apollo Musagettes, c.*1790
red wax on slate; diameter 11.8 cm

*Canova, c.*1795
red wax on slate; diameter 7.7 cm; CM 1997-10-72-1

*St Luke painting the Virgin and Child, c.*1825 (illustrated above right)
white wax on slate; diameter 6.5 cm

CM 1997-10-72-2,4,3,1 and 5 / AF Review no. 4443
Trustees of the British Museum
Collection (124 wax models) acquired in 1997 for £20,000 from Trinity Fine Art Ltd with a contribution of £10,000 from the Art Fund

These are among 124 wax *modelli* made by three generations of the Hamerani family and their associates in Rome between the last third of the seventeenth century and the beginning of the nineteenth. Originating in Germany, the Hamerani dominated medal production in Rome for more than a century.

The waxes may have served several functions. Papal medals were struck from engraved steel dies which were hardened and pressed into metal. Since the engraving process was arduous, with mistakes being very difficult to correct, waxes may have been made in advance to serve as a guide. (These might have been preceded by a preliminary drawing.) In addition, waxes may have been used to show patrons alternative or completed designs and as a relatively easy means for the medallist himself to work out a design.

All of the *modelli* in this collection are executed in white or coloured wax on slate.

Reference: Jack Hinton, 'Forming Designs, Shaping Medals: A Collection of wax models by the Hamerani', in *The Medal*, no. 41, Autumn 2002, pp. 3-57.

200
Anish Kapoor (b. 1954)
Turning the World Inside Out, 1995, cast 1997
stainless steel cast; 148 x 184 x 188 cm
F1997.1 / AF Review no. 4406
Bradford Art Galleries and Museums
Acquired in 1997 for £90,000 from Anish Kapoor with a contribution of
£20,000 from the Art Fund and additional support from the National
Lottery through the Arts Council of England and the Henry Moore
Foundation

The Indian-born Kapoor is among Britain's foremost living
sculptors, winner of a prize at the Venice Biennale in 1990
and of the Turner Prize one year later. This is one of his rare
works in stainless steel and immediately poses a contradiction.

Its title implies anarchy and chaos, yet its appearance is still
and serene. A smooth, shimmering sphere, it calls to mind a
cosmic symbol and inhabits a realm at once timeless and eternal.
 But the indentation in the centre of the sphere resembles
a navel depression and reminds one that, in Hindu creation-
myths, Vishnu is depicted asleep with a burgeoning lotus
emanating from his navel, on top of which is the four-headed
god Brahma. In this way Kapoor subtly combines Hindu
elements with those of a more universal nature.

References: Germano Celant, *Anish Kapoor*, London, 1996, pp. 206-07;
Anish Kapoor, Hayward Gallery, London, 1998, p. 67.

201
Joseph Mallord William Turner (1775–1851)
The Loss of an East Indiaman, c. 1818
watercolour on paper; 28 x 39.5 cm
P.902 / AF Review no. 4394
Trustees of the Cecil Higgins Art Gallery, Bedford
Acquired in 1997 for £300,757 from Sotheby's with a contribution
of £75,189 from the Art Fund (including £30,000 from the Wolfson
Foundation) and additional support from the National Lottery through
the Heritage Lottery Fund

On 6 January 1786, the *Halsewell* sank off Seacombe, Dorset,
with the loss of around 170 lives. The accounts of its few
survivors reverberated for decades, with Lord Byron even
drawing upon them for the famous shipwreck episode in
Don Juan (1819).

 Around one year earlier, Turner made this watercolour for his
great friend and patron Walter Fawkes of Farnley Hall, near
Otley in Yorkshire. It depicts the ship at its most desperate
moment, thrashed by a colossal wave that will soon engulf
most of the crew.

 The watercolour was exhibited at Walter Fawkes's London
residence at Grosvenor Place in 1819 along with its pendant,
A First-Rate, Taking in Stores, which has been in the Cecil
Higgins Art Gallery since 1953, making the acquisition of this
work a natural choice for the museum. The two works com-
plement one another perfectly, one showing a warship at
peace and the other a merchant vessel in a cataclysmic
encounter with the sea.

References: *Turner: the Great Watercolours*, Royal Academy of Arts,
London, 2000, p. 135, no. 48; Eric Shanes, 'Turner and the creation of
his "First-Rate" in a few hours, a kind of frenzy?' in *Apollo*, CLIII, 469,
March 2001, pp. 13-15.

202

Hugh Douglas Hamilton (1736–1808)
Antonio Canova in his Studio with Henry Tresham and a Plaster Model for the 'Cupid and Psyche', c.1788–89

pastel on paper; 75 x 100 cm
E. 406-1998 / AF Review no. 4624
Victoria and Albert Museum
Acquired in 1998 for £525,400 (tax remission) from Francis Farmar through Hazlitt, Gooden and Fox with a contribution of £262,700 from the Art Fund in honour of Sir Brinsley Ford

Widely regarded as the greatest of all British pastels – a status reflected in its high price – this was acquired for the nation in honour of Sir Brinsley Ford, a former chairman of the Art Fund and a great enthusiast of the art of the Grand Tour, which is the subject of this picture.

The pastel depicts the sculptor Antonio Canova (1757–1822) in his studio in conversation with the Irish painter and art dealer Henry Tresham (1752–1841). The latter had gone to Rome as a protégé of Colonel John Campbell (later 1st Baron Cawdor), who commissioned the statue of *Cupid and Psyche* from Canova that the two men are discussing. This is now in the Louvre, having been appropriated by Napoleon in the early nineteenth century.

The work was exhibited at the Royal Academy in 1791 and is remarkable for its astonishing sensitivity, precision and finish. It is not the only Grand Tour masterpiece by the Irish-born Hamilton to have been acquired with the support of the Art Fund. In 1994, it also assisted in the acquisition of another pastel, the *Portrait of Frederick Augustus Hervey, 4th Earl of Bristol and Bishop of Derry*, shown seated on the Janiculum hill outside Rome. This is at Ickworth, Suffolk (National Trust).

References: Anne Crookshank and the Knight of Glin, *The Watercolours of Ireland: Works in Pencil, Pastel and Paint*, London, 1994, p. 71; Anne Crookshank and the Knight of Glin, 'Some Italian Pastels by Hugh Douglas Hamilton', in *Irish Arts Review*, 13, 1997, p. 69.

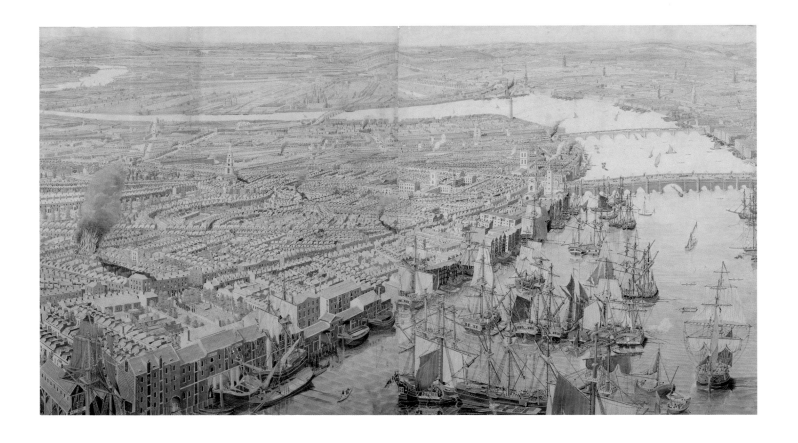

203

English, *The Rhinebeck Panorama of London*, 1806–11
(2 left-hand panels illustrated above)

watercolour, pen, ink, pencil and gold paint on paper mounted on
4 panels; 71 x 262 cm
98.57/AF Review no. 4585
Museum of London
Acquired in 1998 for £199,500 from Sotheby's with a contribution of
£40,000 from the Art Fund and additional support from the National
Lottery through the Heritage Lottery Fund and the MGC/V&A Purchase
Grant Fund

Discovered rolled up and discarded, lining a barrel of pistols in
Rhinebeck, New York, this is one of the key works repatriated
to the United Kingdom with the help of the Art Fund. It
depicts a panoramic view of the city of London around 1810
from a vantage point in the middle of the Thames. Though it
is essentially accurate, it has been noted by one specialist that

it is 'an illusionistic scene designed to thrill and excite'. This
may explain why it shows a building on fire (far left) and so
many barges and sailing ships on the river.

The drawing may have been intended to be viewed with
a mechanical or optical aid and is related to the 360 degree
panoramas that were exhibited in specially designed buildings
in the late eighteenth and early nineteenth centuries. In 1831
this work also provided the model for a smaller print by the
watercolourist Robert Havell Jr, who emigrated to America
in 1839, taking this panorama with him.

References: Ralph Hyde, *The 'Rhinebeck' Panorama of London*, London,
1981; *Panoramania*, Barbican Art Gallery, London, 1988, pp. 76 and
100-01, no. 53.

204
George Margetts (1748–1804) and Thomas Earnshaw
(1749–1829), *Astronomical Chronometer, c.* 1783
gilt brass, steel, gold, enamel, glass; 41 x 33 x 31 cm
ABA1219 / AF Review no. 4601
National Maritime Museum
Acquired in 1998 for £46,637 from Christie's with a contribution of
£24,000 from the Art Fund

Bought at auction for a very low sum – because no one else
realized what it was – this astronomical chronometer is the
only complete example of its type known. Stamped with
the 'Wright's Patent' mark and the number twenty-four, it is
signed by George Margetts and bears Margetts' serial number
342. The escapement of the movement, which does the actual
time-keeping, is by Thomas Earnshaw, whose invention was
patented with funds from the watch retailer Thomas Wright
in 1783. The first one hundred watches were marked with
the stamp and cost one guinea extra, to repay Wright's money.
A similar timekeeper, bearing Margetts' serial number 341, but
lacking the patent mark and tripod, has been on loan to the
National Maritime Museum for many years, and must also
have had its escapement made by Earnshaw.

The rotating dial of the clock is made of enamel and painted
in grisaille with the constellations. Against this, moving gold
symbols indicate the positions of the sun and moon. As
Jonathan Betts has observed: 'Such extravagant novelties were
… popular with East India Company officers and … were
almost certainly made … for the far eastern market.'

References: Jonathan Betts, 'Arnold and Earnshaw, the Practicable
Solution', in *The Quest for Longitude*, W. Andrewes (ed.), Cambridge,
Massachusetts, 1997, pp. 324-25; W. Andrewes (ed.), 'New Acquisition',
in *Antiquarian Horology*, vol. XXIV, no. 5, Spring 1999, pp. 413-14.

205
Charles Voysey (1857–1941), *Clock, c.* 1896
mahogany case with painted and gilded decoration, movement of brass
and steel; 50.8 x 27.1 x 17.2 cm
W.5-1998 / AF Review no. 4627
Victoria and Albert Museum
Acquired in 1998 for £112,000 (tax remission) from John Jesse with a
contribution of £30,000 from the Art Fund (including £25,000 from the
London Projects Committee) and additional support from the Friends
of the V&A

Bought in Portobello Road Market by Mr and Mrs John Jesse
and on loan to the Victoria and Albert Museum since 1970,
this handsome clock was eventually purchased for the museum
twenty-eight years later.

The original design for the work is in the Royal Institute
of British Architects and dates from 1895. It has conventional
Roman numerals but, by 1901, Voysey had replaced these
with the words 'Tempus Fugit' on a version of the clock he
owned himself. Only one other version of the clock (Museum
of Fine Arts, Richmond, Virginia) possesses a similar face. It is
uncertain which of the two was owned by Voysey, though the
Richmond version is inscribed with the name of Mary,
Countess of Lovelace, an early and loyal patron of Voysey.

A notable architect and designer of furniture, textiles and
wallpapers, Voysey also designed numerous clocks during his
long and productive career. His design for this one identifies
the maker as Frederick Coote, a cabinet-maker of Tottenham
Court Road. The name of Camerer Kuss and Co. of New
Oxford Street is stamped on the clock movement.

Reference: *CFA Voysey, 1857-1941*, Museum and Art Gallery, Brighton,
1978, p. 75, C3.

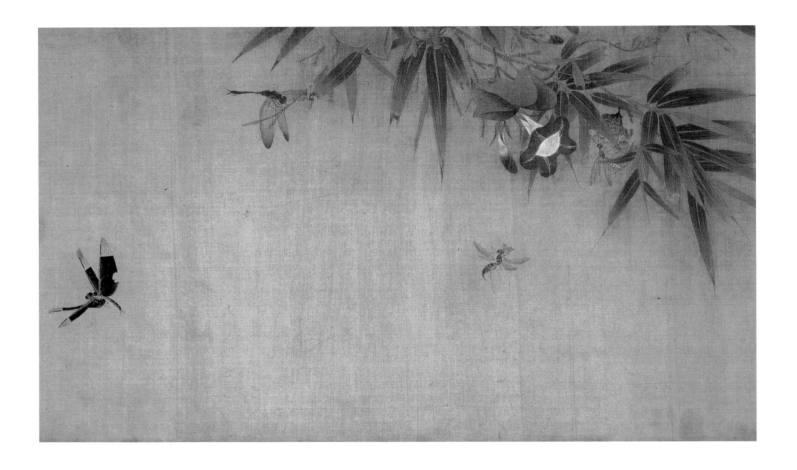

206
Xie Chufang (active late 13th – early 14th century)
Fascination of Nature, 1321 (detail)
ink and colour on silk; 28.1 x 661 cm
Asia 1998.11-12.01 / AF Review no. 4548
Trustees of the British Museum
Acquired in 1998 for £380,000 from the Philip and Marjorie Robinson
Charitable Trust with a contribution of £198,000 from the Art Fund
(including £16,400 from Patron members)

The earliest documented Chinese painting in a British collection, this magnificent scroll is first recorded in the possession of William Butler, a writing master in London, in 1797 (see Whitfield, pp. 198–202). It then passed to Sir Thomas Phillipps, perhaps the greatest of all collectors of manuscripts. Seals and inscriptions on the scroll itself also document its history in China from 1321 to the early eighteenth century.

A rare dated painting of the Yuan Dynasty (1279–1368), this is the only known work by Xie Chufang, whose signature and seal it bears. The artist is mentioned in a contemporary poem by a writer from the area of Piling in Jiangsu province to the west of Shanghai. This was an area well-known for the production of paintings depicting flowers, birds and insects to which the *Fascination of Nature* – with its depiction of plants and insects – relates in subject matter, composition and style. Mentioned as early as the beginning of the twelfth century, this category of painting flourished in the vicinity of Piling in the thirteenth and fourteenth centuries.

Reference: Roderick Whitfield, *Fascination of Nature: Plants and Insects in Chinese Painting and Ceramics of the Yuan Dynasty (1279-1368)*, Seoul, 1993.

207
Arthur Hughes (1832–1915)
Portrait of Mrs Leathart and her Three Children, 1863–65
oil on canvas; 54.7 x 92.7 cm
TWM 1997.129 / AF Review no. 4579
Laing Art Gallery, Newcastle upon Tyne (Tyne and Wear Museums)
Acquired in 1998 for £283,960 (AIL hybrid arrangement) through Christie's
from an anonymous vendor with a contribution of £17,727 from the Art
Fund and additional support from the National Lottery through the
Heritage Lottery Fund and the MGC/V&A Purchase Grant Fund

Rightly acclaimed when it was exhibited at the Royal Academy
in 1865, this captivating portrait was commissioned by the
industrialist and Pre-Raphaelite collector, James Leathart of
Newcastle. It depicts his young wife, Marcia, and three of
their children: Edith, aged four, Margaret, who was two, and
the baby, Mary Beatrice. They are shown on a balcony feeding
pigeons. This motif had its inspiration in a family group Hughes

saw on a balcony in St Mark's Square, Venice, in 1863.

Other details in the picture – such as the slashed sleeves of
the mother and the intertwining poses of her and her daughter –
confirm the inspiration of Italian Renaissance painting. The
exquisite precision of the handling and the sumptuous colour
are also reminiscent of this.

Hughes painted only the heads in Newcastle and finished
the picture in London, imbuing it with an air of calculated
informality through the distracted poses of the children and
the daring cropping of the pigeons.

References: *Arthur Hughes: Pre-Raphaelite Painter*, National Museum
of Wales, Cardiff, and Leighton House, London, 1971, no. 12; Leonard
Roberts, *Arthur Hughes, his Life and Works,* Woodbridge, 1997, pp.159-69,
no. 61.

208
Johann Heinrich Füssli (known as Henry Fuseli) (1741–1825),
*Edgar, Feigning Madness, approaches King Lear supported
by Kent and the Fool on the Heath* (recto, top left);
The Prophet Balaam Blessing the People of Israel, 1772
(verso, bottom right)
pencil, ink and wash with white chalk on laid paper; 62.5 x 96 cm
1999P35 / AF Review no. 4652
Birmingham Museums and Art Gallery
Acquired in 1999 for £130,000 from Hobart and Maclean with a
contribution of £50,000 from the Art Fund and additional support from
the National Lottery through the Heritage Lottery Fund, MGC/V&A
Purchase Grant Fund, Rowlands Trust, Public Picture Gallery Fund and
donations from John Kenrick and Pinsent Curtis

This spectacular double-sided drawing depicts two of Fuseli's
favourite themes. The recto, showing Edgar feigning madness
(*King Lear*, Act 3, Scene 4) is one of over 200 works the artist

produced of Shakespearean subjects and closely related to two
others in the Kunsthaus, Zürich, Fuseli's native city. It was
probably a preliminary study for a lost painting.

The verso depicts a biblical scene from Numbers (23: 7-12).
Balaam, sent to curse Israel before the Moabites, blesses it
instead – a symbol of heroic rebellion, enhanced by Fuseli's
Michelangelesque drawing style.

Though Fuseli spent most of his career in England, where he
was Professor of Painting at the Royal Academy, this drawing
was executed in Rome, where he lived from 1770 to 1778.

References: Gert Schiff, *Johann Heinrich Füssli*, Zürich and Munich, 1973,
I, p. 453, no. 464; *Art in Rome in the Eighteenth Century*, Philadelphia
Museum of Art, and London, 2000, pp. 506-07, no. 349.

209
Sandro Botticelli (1444–1510)
The Virgin Adoring the Sleeping Christ Child, c.1485

tempera on canvas; 122 x 80.5 cm
NG 2709 / AF Review no. 4716
National Gallery of Scotland, Edinburgh
Acquired in 1999 for £10,250,000 (tax remission) from the Wemyss
Heirlooms Trust through Simon C. Dickinson with a contribution of
£550,000 from the Art Fund (including £25,000 from the Wolfson
Foundation) and additional support from the National Lottery through
the Heritage Lottery Fund, a private bequest, the Scottish Executive,
and other corporate and private contributors

Rescued for the nation in little over a month, with the help
of the largest grant the Art Fund had ever provided, this is
among the greatest Renaissance paintings acquired for any
museum in the UK since the Second World War. It was about
to be sold to the Kimbell Art Museum, Fort Worth, when the
fund learned of its imminent export from an article in the press.
Working closely with the director of the Edinburgh gallery,
the Art Fund sprung into action, eventually agreeing to top up
its original grant for the picture from £500,000 to £550,000.

The picture depicts the Virgin adoring the sleeping Christ
Child, who lies in swaddling clothes on the ground – a pre-
figuration of the dead Christ wrapped in the burial shroud.
Behind Mary an outcrop of rock acts both as a simple shelter
and as a reference to the tomb. To the left of her, a magnificent
display of thornless pink roses alludes to her purity as the
'rose without thorns'. The exquisitely executed foreground
depicts a variety of other flora, including a strawberry plant
and a sweet violet.

Having fallen into obscurity for more than a century, the
picture re-emerged in the 1980s and has appropriately joined
a collection that contains another great Quattrocento Madonna
and Child acquired with the assistance of the Art Fund,
Verrocchio's *'Ruskin' Madonna*, purchased in 1975.

Reference: Paul Jeromack, 'The Forgotten Botticelli', in *Art Quarterly*,
Spring 2000, pp. 38-44.

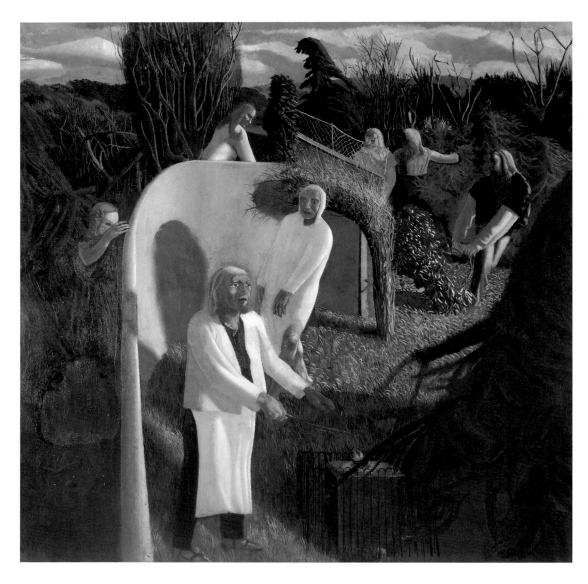

210
Stanley Spencer (1891–1959)
Zacharias and Elizabeth, 1913–14
oil and pencil on canvas; 142.6 x 142.8 cm
T07486 / AF Review no. 4697
Tate and Sheffield Galleries and Museums
Acquired jointly in 1999 for £1,141,578 (tax remission) from the Bone family through Sotheby's with a contribution of £200,000 from the Art Fund and additional support from the National Lottery through the Heritage Lottery Fund, the Friends of the Tate Gallery, Howard and Roberta Ahmanson and private benefactors

'When I left the Slade [School of Art] and went back to Cookham I entered a kind of earthly paradise', confessed Spencer late in life. 'Everything seemed fresh and to belong to the morning. My ideas were beginning to unfold in fine order when along comes the war and smashes everything.'

Zacharias and Elizabeth was conceived in such paradisiacal circumstances, at Cookham, and portrays Zacharias and his wife Elizabeth, parents of the future Baptist (Luke 1: 5-20). In the foreground Zacharias burns incense; behind him the angel Gabriel descends to announce the forthcoming birth of his son. Elizabeth is depicted above the wall, left of centre; and the couple appear again to the right, Elizabeth with her back to the viewer and her crooked arm resting on a yew. The standing man at the background right and the kneeling figure behind the wall are unidentified.

Spencer himself rightly attached great importance to this work, which possesses the gravity and solemnity of the early Italian masters he so much admired, together with a trance-like and vertiginous quality that are the artist's own.

Purchased from Spencer by the artist Muirhead Bone *c.* 1920, this picture was on loan to Sheffield by one of Bone's descendants until 1995. When it came up for sale both Sheffield and Tate wanted it and agreed to purchase it jointly, an arrangement that has become increasingly common in recent years and was also adopted for the works by Canova (cat. 176) and Pietro da Cortona (cat. 164) reproduced here.

References: Keith Bell, *Stanley Spencer: A Complete Catalogue of the Paintings*, London, 1992, p. 387, no. 16; *Stanley Spencer: A Sort of Heaven*, Tate Gallery, Liverpool, 1992, pp. 14, 17 and 29.

211
Piet Mondrian (1872–1944)
Composition B with Red, 1935

oil on canvas; 118.2 × 101 cm
T07560 / AF Review no. 4750
Tate
Acquired in 1999 for £1,551,707 (AIL hybrid arrangement) from the Estate of Nicolete Gray through Christie's with a contribution of £150,000 from the Art Fund (including £18,600 from Patron members) and additional support from the National Lottery through the Heritage Lottery Fund, the Friends of the Tate Gallery and the Dr V.J. Daniel Bequest

Mondrian's abstract grids are works of great purity and symmetry, but their dynamic equilibrium never ceases to challenge the eye – witness the two black lines in this picture that don't quite reach the edge, confounding expectations. The same may be said for the entire arrangement here. Though the black grid is nearly symmetrical, it is only *nearly* so, and is further unbalanced by the additional vertical at the left edge which holds the red square in place and 'complicates' the rhythm.

This picture has an interesting history. In 1936, it was borrowed from the artist by Nicolete Gray – a passionate advocate of contemporary art – for an exhibition entitled *Abstract and Concrete*, which was seen in Oxford and London. Her friend, the collector Helen Sutherland, bought it from this exhibition and, thirty years later, bequeathed it to Gray, in whose estate it remained until acquired by Tate. It is one of two works by Mondrian supported by the Art Fund and one of only six in British collections.

References: Michel Seuphor, *Piet Mondrian: Life and Work*, New York, 1957, p. 390, no. 376; Joop M. Joosten, *Piet Mondrian: Catalogue Raisonné of the Work of 1911-1944*, II, New York, 1998, pp. 376-77, B254.

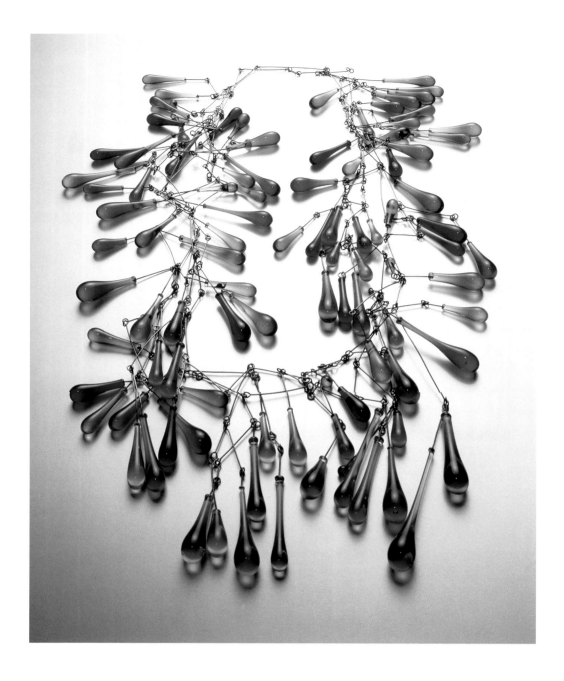

212
Wendy Ramshaw (b. 1939)
Chain of Glass Tears for 'Weeping Woman', 1998
steel and glass; 41 x 9 cm
ABDAG11132 / AF Review no. 4640
Aberdeen Art Gallery and Museums Collections
Acquired in 1999 for £4,000 from Wendy Ramshaw with a contribution of
£1,000 from the Art Fund and additional support from the National Fund
for Acquisitions and the Friends of Aberdeen Art Gallery and Museums

Since the 1980s the artist-jeweller Wendy Ramshaw has
devoted much of her time to making jewellery inspired by
Picasso's women. This elegant necklace is based on a *Weeping
Woman* of 1937 (National Gallery of Victoria, Melbourne)
closely comparable to the one reproduced here (cat. 154). The
model for this was Picasso's mistress at the time, Dora Maar,
who is depicted weeping in anguish over the worsening
political situation throughout Europe.

Ramshaw based the shape of the tears in this exquisite work
on a droplet-like segment of mauve glass in a Victorian
chandelier. Over one hundred of these glass droplets, coloured
green and blue, and hung on the steel of the necklace, create
a seemingly random cascade which is arguably more beautiful
than sorrowful.

Reference: E. Turner, P. Greenhalgh, M. Vaizey et al., *Picasso's Ladies:
Jewellery by Wendy Ramshaw*, American Craft Museum, New York, and
Victoria and Albert Museum, London, and Stuttgart, 1998, p. 166, no. 60.

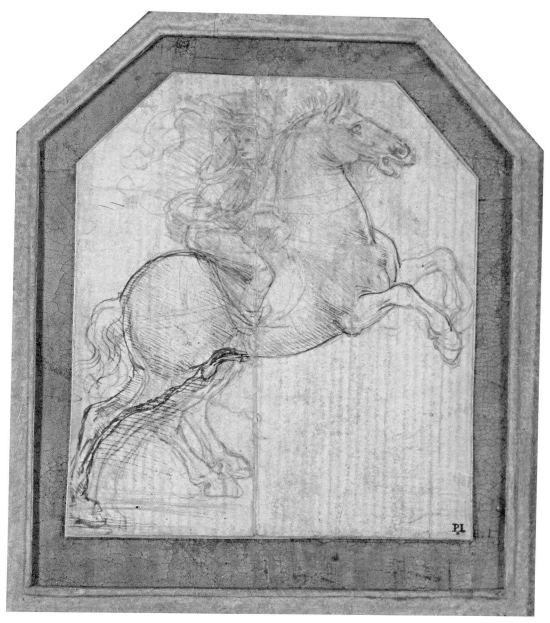

213
Leonardo da Vinci (1452–1519)
*A Rider on a Rearing Horse, c.*1481
metalpoint reworked with pen and dark brown ink on a pink-beige prepared paper; 11.4 x 11.9 cm
PD.44-1999 / AF Review no. 4684
Syndics of the Fitzwilliam Museum, Cambridge
Acquired in 1999 for £1,508,475 (tax remission) from the Trustees of Colonel Norman Colville with a contribution of £200,000 from the Art Fund (including £46,000 from a charity Gala at Holland Park Opera, June 1999) and additional support from the National Lottery through the Heritage Lottery Fund, Pilgrim Trust and contributions from the Gow, Cunliffe, Leverton Harris, Perrins and Reitlinger Funds, Monica Beck, David Scrase and an anonymous donor

In 1481, Leonardo was commissioned to paint an *Adoration of the Magi* (Uffizi, Florence) for the convent of San Donato a Scopeto, near Florence. The picture, which was left unfinished when Leonardo moved to Milan between 1481 and 1483, is one of his greatest creations, combining a trance-like poetry with an emotional and psychological depth rarely equalled, even by Leonardo, and prefiguring the work of Rembrandt.

This vigorous drawing is probably a study for a rearing horseman who appears at the background right of the composition, his abstracted and dreamlike gaze contrasting with the dynamism of the action. It was one of two drawings by Leonardo owned by the painter Sir Peter Lely (1618–80). The other, of two horsemen, is also for the *Adoration of the Magi* and was bequeathed to the Fitzwilliam in 1960. It is identical in technique and cut in the same way from a larger sheet, possibly by Lely, whose Leonardos are now reunited in the same collection.

References: A.E. Popham, *The Drawings of Leonardo da Vinci*, London, 1946, p. 72, no. 64; *Leonardo, Master Draftsman*, Metropolitan Museum of Art, New York, 2003, pp. 353-55, no. 40.

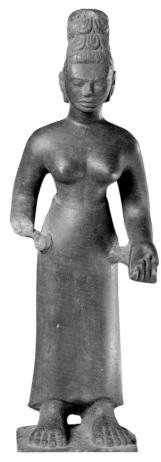

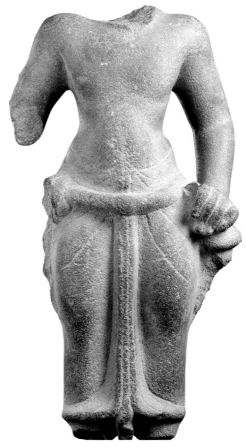

214
Pre-Angkorian (Vietnam)
Standing Female Deity, probably Uma, *c.*7th century
polished brown sandstone; height 58.5 cm
IS.1-2002 / AF Review no. 5011
Victoria and Albert Museum
Acquired in 2001 for £83,000 from Theresa McCullough Ltd with a
contribution of £60,000 from the Art Fund and additional support from
anonymous donors

One of the most important works of Southeast Asian sculpture
to appear on the art market in recent years, this standing female
figure originated in the Mekong Delta of southern Vietnam.
Historically this region was ethnically Khmer and formed part
of the state of Funan, which was the earliest documented
kingdom in Southeast Asia.

The figure is carved from a single block of fine-grained
sandstone and depicts a Hindu goddess. With one hand
missing – and in the absence of any attributes – it is impossible
to be certain about her exact identity, but her balanced and
upright pose suggests that she may be Śiva's consort, Uma.
What is undeniable, however, is her rarity. Though male figures
of Śiva, Vishnu and their composite form, Harihara, occur
with some frequency in pre-Angkorian art, female figures are
much more unusual, making this acquisition a major one for
the country's greatest collection of Southeast Asian art.

Reference: John Guy, 'Standing female deity, probably Uma', in *2001
Review*, National Art Collections Fund, p. 119.

215
Cambodian, Funan period, *Torso of Vishnu*, 6th–7th century
sandstone; height 34.5 cm
EA2001.15 / AF Review no. 4908
Ashmolean Museum, Oxford
Acquired in 2001 for £28,000 from Spink with a contribution of £17,000
from the Art Fund

The Hindu god Vishnu, Preserver of the Universe, is depicted
in this rare statue dating from the earliest phase of stone
sculpture in Cambodia, the pre-Angkor or Funan period. He
wears a long diaphanous *dhoti*, with a vertical pleat and a thick,
rope-like securing sash. Originally four-armed, this sculpture
now lacks the lower right arm and the two posterior arms.
The left hand rests on the rounded top of a mace, one of
the attributes of Vishnu.

Even in its fragmentary state, the sculpture possesses a
commanding presence through its authoritative pose, subtle
modelling and the swelling rhythms of its chest, belly and
thighs. Formerly in private collections in America, where it
was on long-term loan to the Denver Art Museum between
1967 and 1983, it was bought by a London dealer in the 1990s.
Though comparable images of Vishnu exist in Southeast
Asian collections, this is apparently the only one in a public
collection in the West.

References: S.E. Lee, *Ancient Cambodian Sculpture*, New York, 1969,
p. 101 and fig. 4; Pratapaditya Pal, *The Ideal Image: the Gupta Sculptural
Tradition and its Influence*, New York, 1978, p. 132; *A Divine Art,
Sculpture of South East Asia*, Spink & Son, London, 1997, p. 23, no. 3.

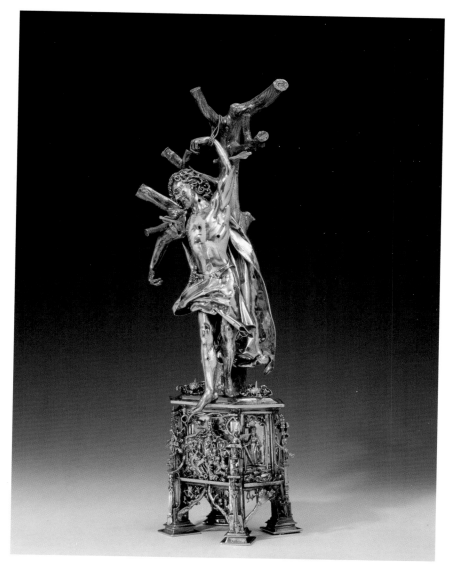

216

German, *Reliquary of St Sebastian*, 1497
silver (parcel-gilt), pearls, sapphires, rubies; height 49.5 cm
M. 27-2001 / AF Review no. 5010
Victoria and Albert Museum
Acquired in 2001 for £1,455,536 (tax remission) from Christie's with a contribution of £282,947 from the Art Fund and additional support from the National Heritage Memorial Fund

Destined for America, when its export licence was temporarily deferred, this remarkable reliquary is one of the most prestigious objects with which the Art Fund has been associated in recent years and, like Altdorfer's *Christ Taking Leave of His Mother* (cat. 133), came from the Werner Collection at Luton Hoo.

Considering its age, it is also among the best documented works. According to a Latin inscription on the base, it was commissioned by the Abbot Georg Kastner of the Cistercian monastery of Kaisheim, near Augsburg, in 1497, during a time when the monastery was suffering from plague. The third-century Roman soldier St Sebastian, who was martyred for his Christian faith, was frequently invoked as a protector against this affliction, not least by Grünewald, who may have

known this reliquary. A later chronicle of the monastery, written in 1531, describes the generosity of the Abbot and mentions this work, noting that it was partly paid for by Duke Frederick III (the Wise) of Saxony.

The reliquary contains 'remains' of the saint, wrapped in silk, in its base, and was designed by Hans Holbein the Elder (*c.* 1460–1534), father of the celebrated painter of the court of Henry VIII, an artist indelibly associated with the Art Fund. In 1493, the elder Holbein moved from Ulm to Augsburg, where his talents were immediately recognized and, nine years later, he was commissioned to paint the high altarpiece for Kaisheim. A preparatory drawing by him for the *Reliquary of St Sebastian* is in the British Museum.

References: Theodor Müller, *Sculpture in the Netherlands, Germany, France, and Spain: 1400-1500*, Harmondsworth, 1966, p. 175; Johann Michael Fritz, *Goldschmiedekunst der Gotik in Mitteleuropa*, Munich, 1982, pp. 286-87; John Rowlands, *Drawings by German Artists ... in the Department of Prints and Drawings in the British Museum*, London, 1993, I, p. 138, no. 300.

217

Julian Opie (b. 1958)
Four Portraits of the Members of Blur, 2000

c-type prints on paper laid on panel; 86.8 x 75.8 cm each
NPG 6593 (1-4) / AF Review no. 4989
National Portrait Gallery, London
Presented in 2001 as a gift by the Art Fund (Modern Art Fund); acquired
for £12,000 (special discounted museum price) from the Lisson Gallery

Commissioned for the cover and promotional material of the album *Blur: the best of* (2000), these portraits of the enormously successful pop group were made by feeding photos of the performers into a computer to make digital drawings that reduce the subjects to black outlines and unmodulated colours, like all Opie's portraits. They were reproduced in four sets,

each one differing in size and, therefore, unique. Nevertheless, the commercialization of the images through advertising and the media does question the traditional distinction between high art and commercial art.

Opie studied at Goldsmiths College in London (1979—82) and began as a sculptor, but soon diversified. Coincidentally, both David Coxon and Alex James of Blur also studied there in the late 1980s, making the college a crucible of both Britpop and Britart.

Reference: Sarah Howgate, 'Julian Opie, "Blur: Damon Albarn, David Rowntree, Alex James, Graham Coxon"', in *2001 Review*, National Art Collections Fund, pp. 102-03.

218
Federico Barocci (*c.*1528/35–1612)
Study for 'The Institution of the Eucharist', 1604
pen and brown ink, brown wash over black chalk, heightened in white, grisaille oil; 51.5 x 35.5 cm
PD.1.2002 / AF Review no. 4948
Syndics of the Fitzwilliam Museum, Cambridge
Acquired in 2001 for £945,000 from a private collector through Sotheby's with a contribution of £225,000 from the Art Fund (including £100,000 from the legacy of Kenneth Balfour) and additional support from the National Lottery through the Heritage Lottery Fund

In 1603, Pope Clement VIII commissioned Barocci to execute an altarpiece of *The Institution of the Eucharist* for a new chapel in the church of Santa Maria sopra Minerva, Rome. This elaborate and highly finished drawing was the second compositional study submitted for the painting. It portrays Christ, having arisen from the table of the Last Supper, giving communion to his apostles, accompanied in the foreground and distance by servants.

Barocci spent most of his career in Urbino, his home town, and was much in demand as a painter of religious works executed with the clarity, piety and emotional directness advocated by the Counter-Reformation church. Patronized by the Holy Roman Emperor Rudolf II and King Philip II of Spain, among others, he was also much admired by fellow artists, not least Rubens. This drawing was once in the collection of the painter and avid collector, Sir Peter Lely (1618–80).

References: Andrea Emiliani, *Federico Barocci,* Bologna, 1985, vol. II, pp. 377-85; Nicholas Turner, *Federico Barocci,* Paris, 2000, p. 131.

219
Greek, *The Braganza Brooch*, 3rd century BC
gold with traces of blue enamel; diameter 14.1 cm
GR 2001.5-1.1 / AF Review no. 4920
Trustees of the British Museum
Acquired in 2001 for £1,121,906 from Christie's with a contribution
of £178,808 from the Art Fund (including £50,000 from the Wolfson
Foundation) and additional support from the National Lottery through
the Heritage Lottery Fund, the Friends of the British Museum, Dr Roy
Lennox and Joan Weberman

Reputedly once owned by the Portuguese royal family of
Braganza (hence its name), and brought to this country from
America in the late twentieth century, this brooch is one of
the most spectacular examples in recent years of the Art
Fund's – and the nation's – success in acquiring major works
on the international art market that have no connection with
Britain's heritage. Another, with only slightly stronger claims,
is the *Warren Cup*, acquired for the British Museum in 1999,
also with the support of the fund.

The brooch depicts a nude male figure wearing a Celtic
helmet and holding a shield of a distinctive type. In front of
him a hunting dog jumps up at his shield, while the head of
a second dog serves as an additional decorative element. The
sliding catch for the pin (now missing) takes the form of a
boar's head, the hunter's quarry. Taken together, these motifs
refer to the elite pastime of hunting.

The genealogy of the brooch is extraordinary. Though it
depicts a Celtic aristocrat, its style and technique indicate that
it is of Greek origin, made in the third century BC. The only
brooches of comparable form and similar iconography come
from the Iberian peninsula and are made in silver. This unique
gold example was presumably made by a Greek or Greek-
trained jeweller working for a Celt living in Iberia. As Dyfri
Williams has observed, this makes it 'the only witness to a
Greek jeweller's journey beyond the Pillars of Hercules in
search of such wealthy, far western clients'.

References: I.M. Stead and N.D. Meeks, 'The Celtic Warrior Fibula', in
The Antiquaries Journal, no. 76, 1996, pp. 1-16; *The Celtic Warrior
Fibula, Fine Antiquities*, Christie's sale, London, 25 April 2001, pp. 4-10,
no. 293; Dyfri Williams, 'The Celtic Warrior Brooch', in *Minerva*, vol. 12,
no. 4, July/August 2001, pp. 38-39.

220
Thomas Barry (1756 – *c.* 1820) and James Moorcroft
(1759 – 1816), *Astronomical Clock*, 1787
mahogany, brass and steel; 91 x 42 x 42 cm
WAG 2003.6 / AF Review no. 5157
National Museums Liverpool
Acquired in 2002 for £250,000 from Raffety & Walwyn with a contribution
of £42,500 from the Art Fund and additional support from the National
Lottery through the Heritage Lottery Fund

This magnificent clock had been sold to a foreign buyer
when its export licence was deferred, giving a museum in
this country a chance to match the price. Liverpool was the
obvious choice as the city was a centre of the clock-making
industry in the eighteenth century and its museum holds an
important collection of clocks from the north west. This one
was made in Ormskirk, just outside Liverpool.

The clock has three dials on different faces, its fourth face
glazed to reveal its complex movement. This and the case are
signed respectively by Thomas Barry and James Moorcroft.
Only five other clocks by Barry are known and no other case
by the cabinetmaker, Moorcroft, is in a public collection in
this country. This clock is therefore of the greatest rarity.

The first dial gives the time and the phase of the moon and
has shutters in the arch above showing the varying length of
the day and night. The second dial gives the date in the form
of a perpetual calendar, with automatic adjustments for leap
years. Above it is a painted panel showing the movements of
the principal stars. The third dial takes the form of a planetarium
tracing the orbits of the moon and the planets.

Accompanying the clock was an advertisement for its sale by
raffle at Mr Forshaw's Hotel, Lord Street, Liverpool in *c.* 1787.
One hundred and fifty tickets were offered at one guinea
(£1.05) each – apparently a common way to publicize excep-
tional objects of manufacture in the late eighteenth century.

Reference: Robin Emmerson, 'Astronomical Clock', in *2002 Review*,
National Art Collections Fund, p. 119.

221

Danzig (Poland), *The Weld Blundell Amber Cabinet*, c. 1700
amber and ivory on an oak structure with brass fittings; 46 x 34 x 25 cm
WAG 2002.12 / AF Review no. 5156
National Museums Liverpool
Acquired in 2002 for £539,755 from Harris Lindsay and Mallet with a
contribution of £104,939 from the Art Fund (including £30,000 from the
Wolfson Foundation) and additional support from the National Lottery
through the Heritage Lottery Fund

Formerly in the collection at Ince Blundell Hall, near Liverpool,
this is one of a number of works from that source that the Art
Fund has helped the Liverpool museums to acquire in recent
years, another being the Primaticcio drawing illustrated here
(cat. 163).

The cabinet is made of amber, the fossilized resin of certain
species of now-extinct conifers. Much prized, initially for its
allegedly magical healing powers, it was later used for making

precious objects such as caskets and shrines. The principal
centres of its production were Königsberg (Kaliningrad) and
Danzig (Gdańsk), where this cabinet was made *c.* 1700. Richly
decorated in a variety of colours and textures, its two doors
open to reveal nine drawers around a central architectural
recess. Each of these has carved ivory plaques on the subject
of love, suggesting that the cabinet may originally have served
a marital – or at least amorous – function.

Unusually, the interiors of the drawers are also lined in amber,
rather than the more customarily used wood. This – together
with the wealth of carved ivory reliefs – makes it a particularly
sumptuous example of its type.

Reference: Julian Treuherz, 'The Weld Blundell Amber Cabinet', in *2002
Review*, National Art Collections Fund, p. 118.

222
Reverend Charles Lutwidge Dodgson (known as Lewis Carroll) (1832–98), *Edith, Ina and Alice Liddell on a Sofa*, 1858

albumen print; 15.6 x 17.6 cm
NPG P991(4) / AF Review no. 5111
National Museum of Photography, Film and Television, Bradford, and National Portrait Gallery, London
1 of 8 photographs acquired in 2002 from the Trustees of the Alice Settlement for £270,092 with a contribution of £56,622 from the Art Fund and additional support from the National Heritage Memorial Fund and individual donors

Like Julia Margaret Cameron (see cat. 122), Lewis Carroll – the author of Alice's *Adventures in Wonderland* (1865) and *Through the Looking Glass* (1871) – was a celebrated amateur photographer. Educated at Rugby and Christ Church, Oxford, Carroll here depicts the daughters of the Dean of that college, Henry Liddell (1811–98), one of whom was to inspire his celebrated works. Edith, Ina and Alice Liddell are shown seated or reclining on a sofa, wearing contrasting expressions – sulking, seer-like or seductive.

A gift to Alice by Carroll, this photograph was one of eight preserved by her and her family over several generations, which were sold in 2001 and destined for export to America. Thanks in part to the Art Fund, they were jointly saved by two museums, who recognized them as an essential part of Britain's heritage.

References: Russell Roberts, 'Charles Lutwidge Dodgson (1832-98), "8 photographs of the Liddell children"', in *2002 Review*, National Art Collections Fund, p. 89; Douglas R. Nickel, *Dreaming in Pictures: The Photography of Lewis Carroll*, San Francisco Museum of Art, New Haven, and London, 2002, pp. 14-21.

223
Frank Auerbach (b. 1931), *Self Portrait*, 1994–2001

pencil and charcoal on paper; 76.4 x 57.7 cm
NPG 6611 / AF Review no. 5114
National Portrait Gallery, London
Presented in 2002 as a gift by the Art Fund; acquired for £17,500 (special discounted museum price) from Marlborough Fine Art

One of Britain's most distinguished living painters, Auerbach was born in Berlin but came to England in 1939 as a refugee from Nazi Germany and never saw his parents again. He studied at St Martin's School of Art and the Royal College of Art, and has spent his adult life in Camden Town and Primrose Hill, London. Rarely leaving this area, he normally ventures beyond it only to study the works of the Old Masters in the National Gallery or Royal Academy.

Rembrandt is Auerbach's favourite artist and this intense and introspective self-portrait makes it easy to see why. It took more than six years to complete and is one of only five such works by Auerbach, who has noted of the difficulties of self-portraiture: 'One doesn't ever really know what one looks like. One never sees oneself in action and if you look in the mirror you stay the same age in your own eyes until you are eighty.'

This complex and enigmatic work was purchased outright by the Art Fund and presented to the gallery in 2002. It joins Julian Opie's portraits of Blur (cat. 217), also presented to the gallery by the Art Fund, testifying to the fund's appreciation of the wide-ranging remit of the National Portrait Gallery.

Reference: Sarah Howgate, 'Frank Auerbach, *Self-portrait*', in *2002 Review*, National Art Collections Fund, pp. 92-93.

224
Johan Christian Dahl (1788–1857)
Mother and Child by the Sea, 1840
oil on canvas; 21 x 31 cm
2002.5 / AF Review no. 5047
Trustees of the Barber Institute of Fine Arts, University of Birmingham
Acquired in 2002 for £297,203 from Faber & Day with a contribution
of £33,500 from the Art Fund and additional support from the National
Lottery through the Heritage Lottery Fund, Resource / V&A Purchase
Grant Fund and the R.D. Turner Charitable Trust

This bewitching landscape depicts a mother and child gazing
out over a moonlit sea towards a boat on the horizon. According
to an explanation provided by the artist himself, the boat
bears 'a close relation' – almost certainly the child's father,
heading for shore at the end of a day's fishing expedition.

Dahl was Norwegian by birth but worked mainly in Dresden,
where he was much influenced by the great German

Romantic master, Caspar David Friedrich (1774–1840). This
picture was painted in the year of the latter's death and may
have been intended as a conscious homage to him in its
haunting poetry and ravishing nuances of light and colour.
But it also contains an autobiographical reference, as Dahl's
own father was a fisherman. Thus, the mood of mystery and
ineffable longing explored here may ultimately derive from
the artist's own childhood experience.

This is only the second painting by Dahl to be acquired by
a national collection. It was preceded by his *Neapolitan Coast
with Vesuvius in Eruption* of 1820, purchased by the Fitzwilliam
Museum, Cambridge, in 1986.

Reference: Richard Verdi, 'Johan Christian Dahl, *Mother and Child by
the Sea*', in *2002 Review*, National Art Collections Fund, p. 52.

225
Arabic (Egypt or greater Syria), Circular World Map from
*'The Book of Curiosities of the Sciences and Marvels for
the Eyes' (Kitāb Gharā'ib al-funūn wa-mulah al-ūyun)*, late
12th or early 13th century

paper with pasteboards and leather binding; 32.5 x 25 cm
MS Arab.c.90, fols 27b-28a / AF Review no. 5055
Bodleian Library, Oxford
Acquired in 2002 for £400,000 from Sam Fogg with a contribution of
£100,000 from the Art Fund and additional support from the National
Lottery through the Heritage Lottery Fund, the Friends of the Bodleian
Library, Saudi Aramco, a number of colleges of the University of Oxford
and other donors

Probably written in Egypt or Syria, this recently-discovered
manuscript consists of forty-eight folios (ninety-six pages) of
brightly coloured maps, both astronomical and terrestrial, the
majority of which are otherwise unknown in any surviving
Greek, Latin or Arabic sources. These include two world maps
and what are believed to be the earliest known maps of Sicily and
Cyprus. There are also maps of the Mediterranean and Caspian

seas, the Indian Ocean and the sources and course of the Nile.

The treatise on which the manuscript is based appears to
date from the late eleventh or early twelfth century but the
work itself was probably made a century later. Unusually, it
also contains drawings of comets and diagrams of star groups
and of the lunar mansions. The circular world map exhibited
here depicts the inhabited world surrounded by a dark ring
representing the sea. The south is at the top, with Africa
extending eastwards so that it encompasses virtually the whole
of the southern hemisphere. Near the bottom of the map,
England is shown as a small, oval island bearing the Arabic
name *Anqltirah*, or Angle-Terre – possibly the earliest reference
to the country employing this description.

References: Lesley Forbes, 'The Book of Curiosities of the Sciences and
Marvels for the Eyes', in *2002 Review*, National Art Collections Fund,
p. 58; J. Johns and E. Savage-Smith, '*The Book of Curiosities*: A Newly
Discovered Series of Islamic Maps', in *Imago Mundi*, LV, 2003,
forthcoming.

226
Rachel Whiteread (b. 1963), *Untitled (History)*, 2002
plaster, polystyrene and steel; 129 x 70 x 26 cm
NMW A 23288 / AF Review no. 5109
National Museums and Galleries of Wales
Acquired in 2002 for £120,000 from Anthony d'Offay Gallery with a
contribution of £40,000 from the Art Fund and additional support from
the Derek Williams Trust

In January 1996, Rachel Whiteread won an international competition for a Holocaust Memorial for the Judenplatz in Vienna, which was installed there in 2000. Her design was for an inverted and hermetic library filled with endless copies of the same book, a reference to the myriad victims of the holocaust whose life stories were closed forever. Rather than being cast in plaster, as is much of her work, it is made in concrete, as a tomb might be.

In the following years Whiteread explored the theme of shelves of books – symbols of our collective memory – in both negative and positive forms. These vary greatly in size, from casts of whole rooms to smaller units such as the present work, which depicts only four shelves. More accurately, it portrays the space around four shelves from which the books are 'missing', wrenched from their surroundings, creating an eerie silence.

This is the first work by Whiteread acquired for Cardiff's growing collection of contemporary art, but not the first supported by the Art Fund. In 1992 it helped Southampton City Art Gallery acquire her *Untitled (Freestanding Bed)* and in 2000 and 2002, it supported the acquisition of her *Untitled (Pair)* and *Untitled (Stairs)* respectively for the Scottish National Gallery of Modern Art, Edinburgh, and Tate.

References: *Rachel Whiteread*, Serpentine Gallery, London, 2001, pp. 7-9; Louisa Briggs, 'Rachel Whiteread, *Untitled (History)*', in *2002 Review*, National Art Collections Fund, p. 88.

227

Eugène Boudin (1824–98), *Portrieux. The Port at Low Tide* (*Portrieux. Le Port Marée Basse*), 1873

Signed lower left: *E. Boudin*; inscribed lower right: *Portrieux 73*
oil on canvas; 31.5 x 46.5 cm
2/2003 / AF Review no. 5167
Southampton City Art Gallery
Bequeathed in 2002 by Norah Davidson through the Art Fund

Boudin spent much of his career painting his favourite sites in Normandy and Brittany, typically inscribing them with both location and date, as in this canvas. It depicts the port at Portrieux in Brittany at low tide and is one of a group of works on this theme that the artist executed in 1873. Typical of his style are the cool tonality, flickering brushwork and spontaneous handling of the picture, all of which exerted an important influence on Monet, with whom Boudin exhibited at the first Impressionist exhibition in 1874.

Southampton City Art Gallery was generously endowed with two major legacies early in the twentieth century, by Robert Chipperfield and Frederick William Smith, which have made it less dependent upon the Art Fund than many other regional museums. With these financial resources it has acquired major works by Monet, Sisley, Forain and others, only the first of these with additional support from the Art Fund. The present picture is one of two works by Boudin bequeathed to Southampton in 2002 through the Art Fund, which has supported the artist from its earliest years. In 1906 and 1910 it helped the National Gallery to acquire its first two canvases by Boudin.

Reference: Robert Schmit, *Eugène Boudin, 1824-1898*, Paris, 1973, I, no. 920.

228

Japanese, *Sword Blade*, early 13th century

steel; length 79 cm
Asia 2002, 0508.1 / AF Review no. 5063
Trustees of the British Museum
Acquired in 2002 for £65,774 from Hitoshi Yamada with a contribution of £45,774 from the Art Fund

This curved Japanese 'samurai' sword is probably the oldest to survive in a British collection and is datable to the early thirteenth century or before. It was made using a technique introduced into Japan from China around the fourth century. Initially such swords were straight, like their Chinese originals, but during the Heian period (794–1185) they developed the elegant curve that has characterized Japanese swords ever since.

The sword is signed on the *tang* (the part of the blade that fits into the hilt) with the name of the maker, Sueyuki, and has cut marks on the blade showing that it was used in ancient combat. In the collection of Major Caldwell in 1985, it was purchased from the Japanese sword dealer, Hitoshi Yamada, in Tokyo in 2002.

Reference: Victor Harris, 'Japanese sword blade', in *2002 Review*, National Art Collections Fund, p. 63.

229

Ladi Kwali (*c.* 1925–84), *Abuja Pot*, 1956

stoneware; 34.5 x 35.5 cm
C1411/02 / AF Review no. 5071
The University of Wales, Aberystwyth
Acquired in 2002 for £13,000 from Joana Bird with a contribution of
£5,000 from the Art Fund and additional support from the Resource/V&A
Purchase Grant Fund

Ladi Kwali was the leading Nigerian potter of the Abuja
Pottery Training Centre set up by Michael Cardew (1901–83)
in Nigeria in 1951. One of his most gifted disciples, she joined
his workshop in 1954. In the 1960s she gained an international
reputation through tours with Michael Cardew in Britain,
France, Germany and the USA, where she demonstrated
traditional Gwari hand-building and decoration, and, by the
end of her career, she was a major figure in Nigerian cultural
life. After her death in 1984, the Abuja Pottery was re-named
in her honour.

As a pioneer studio potter Michael Cardew was originally
noted for slipware, but in the 1940s he became involved in
pottery development projects, first in Ghana and later Nigeria,
where he worked for much of the latter part of his life. At
Abuja he introduced high-fired stoneware and his work
became increasingly influenced by African form and design.

The University of Wales has one of the finest collections of
Michael Cardew pottery from the years when he worked in
Winchcombe, between 1926 and 1939. It is therefore fitting
that it has acquired this outstanding pot by one of his most
celebrated protégés. Characteristic of Ladi Kwali is the mottled
black and brown surface with its delicate design of scorpions,
fish, lizards and snakes.

Reference: Moira Vincentelli, 'Ladi Kwali, Decorated Pot', in *2002 Review*,
National Art Collections Fund, p. 67.

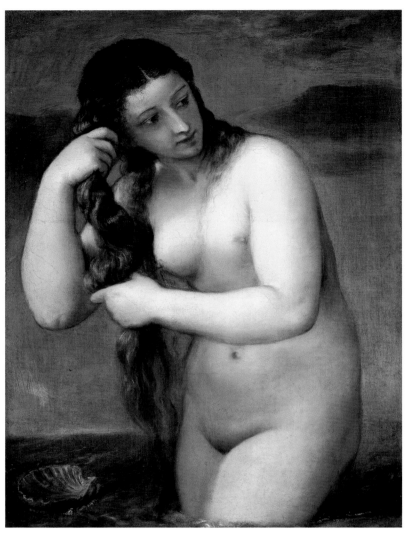

230
Titian (*c.*1485/90–1576), *Venus Anadyomene (Venus Rising from the Sea)*, *c.*1520–25

oil on canvas; 75.8 x 57.6 cm
NGL 060.46 / AF Review no. not yet allocated
National Gallery of Scotland, Edinburgh
Acquired in 2003 for £11,414,178 (AIL hybrid arrangement) from the Trustees of the Ellesmere 1939 Settlement with a contribution of £500,000 from the Art Fund and additional support from the National Lottery through the Heritage Lottery Fund and the Scottish Executive

First recorded *c.* 1662 in the collection of Queen Christina of Sweden, this unashamedly seductive canvas depicts Venus wringing her hair as she wades ashore after her birth, fully-grown, from the foam, created when the genitals of the castrated Uranus were thrown into the sea. According to Hesiod (*Theogony*, 188–206) she was blown ashore on a scallop shell – here seen by her side – landing near Paphos in Cyprus, which became an important centre of her worship in antiquity.

X-rays reveal that Titian originally painted her head turned to the left, in which form she would have closely resembled a relief of the same subject by Antonio Lombardo (1480–1516) in the Victoria and Albert Museum. Coincidentally the relief was also acquired, in 1964, with support from the Art Fund.

The Art Fund was founded in part in response to the export of Titian's *Rape of Europa* (fig. 6) to Isabella Stewart Gardner of Boston in 1896. This is the fifth major work by the artist acquired for the nation with the fund's support, of which the most celebrated are the *Vendramin Family* (acquired in 1929) and *The Death of Actaeon* (acquired in 1972, fig. 12), both in the National Gallery.

The picture formed part of the magnificent collection of some thirty works loaned to the National Gallery of Scotland by the 5th Earl of Ellesmere in 1945 and still to be seen there. When, as the 6th Duke of Sutherland, he died in 2000, the picture was offered to the gallery for sale in lieu of inheritance tax. Thanks to generous outside funding – not least from the Art Fund – this has now been achieved, making it possible for the picture to remain exactly where it was, in the company of the four other Titians, three Raphaels and eight Poussins that constitute the chief glory of the Sutherland loan to Edinburgh.

References: Harold Wethey, *The Paintings of Titian, III, The Mythological and Historical Paintings*, London, 1975, pp.187-88, no. 39; Hugh Brigstocke, *Italian and Spanish Paintings in the National Gallery of Scotland*, Edinburgh, 2nd ed., 1993, pp. 177-78.

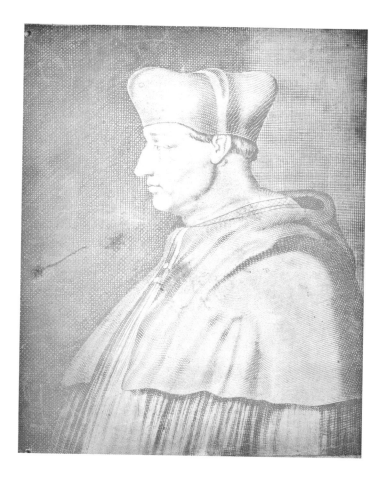

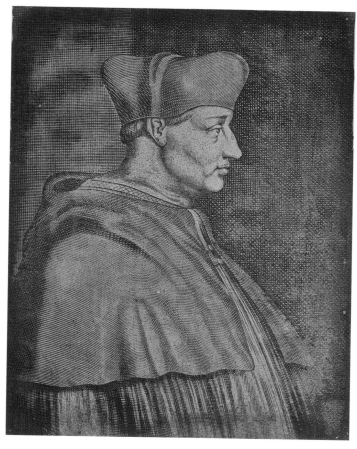

231

Joseph Nicéphore Niépce (1765–1833)

Cardinal d'Amboise, 1826 (above left)
heliograph on pewter in original frame; 27.2 x 23 x 3.5 cm (framed)

Cardinal d'Amboise, c. 1865 (above right)
print pull from heliographic plate; 13 x 19.2 cm

AF Review no. not yet allocated
Collection of the Royal Photographic Society (RPS) at the National
Museum of Photography, Film and Television, Bradford
Collection (over 270,000 photographs) acquired in 2003 for £4.5 million
with a contribution of £342,000 from the Art Fund and additional
support from the National Lottery through the Heritage Lottery Fund
and other donors

One of the most spectacular acquisitions to be supported by
the Art Fund in recent years was the purchase for the nation
of the entire collection of the Royal Photographic Society.
Founded in 1853, the Society has amassed one of the most
extraordinarily rich and diverse collections of its type in the
world. This consists of more than 270,000 images, 13,000 books
and an equally large quantity of bound periodicals, as well
as more than 6,000 items of photographic equipment, and a
large number of related documents, letters and research notes.

Lacking the resources to conserve, catalogue and display this
collection, the Society had recently consigned it to storage.
With the help of the Art Fund, it has now been acquired
en masse for the National Museum of Photography, Film and

Television in Bradford – a tremendous achievement that has
prevented it from being broken up and sold piecemeal.

This heliograph by Niépce represents one of the earliest
attempts to get light – rather than the human hand – to
draw a picture. Oiling an engraving of Cardinal d'Amboise
(1460–1510), Minister to Louis XII, to make it transparent,
Niépce then placed it on a pewter plate coated with a light
sensitive solution and exposed it to the sun. After several hours,
the solution under the light areas of the engraving hardened,
while that under the dark areas remained soft and could be
washed away, leaving an accurate copy of the engraving.
Niépce dubbed this process 'heliography' or 'sun drawing'.

The plate was then sent to an engraver, who incised the lines
left on the plate, inked them, and pulled a small edition of
prints, which reverse the image seen on the heliograph plate
(print pull).

Niépce brought his invention to England in 1827. Finding
no interest in it, he abandoned three of his heliographs at
Kew, from which they eventually made their way to the Royal
Photographic Society.

Reference: Peter Pollack, *The Picture History of Photography, from the earliest beginnings to the present day*, London, 1963, pp. 24-33.

232
Roger Fenton (1819–69)
Princesses Helena and Louise, 1856
salted paper print; 32 x 29.2 cm

The British Museum, Gallery of Antiquities, c. 1857
(illustrated)
albumen print; 29.3 x 26.2 cm

September Clouds, 1859
albumen print; 20.6 x 28.7 cm

AF Review no. not yet allocated
Collection of the Royal Photographic Society (RPS) at the National
Museum of Photography, Film and Television, Bradford
Collection (over 270,000 photographs) acquired in 2003 for £4.5 million
with a contribution of £342,000 from the Art Fund and additional support
from the National Lottery through the Heritage Lottery Fund and other
donors

One of the greatest of all Victorian photographers, Fenton
trained as a lawyer before discovering his true calling. In 1853,
he became Honorary Secretary of the Photographic Society
of London, which became the Royal Photographic Society in
1894 and still exists. Remarkably wide-ranging in his choice
of subjects – which included portraits, landscapes and still-lifes
– he is best remembered for his war photographs from the
Crimea, where he went in 1855.

The three works included here display other facets of his
skill. In the 1850s Fenton was commissioned by Queen Victoria
and Prince Albert to take a series of photographs of the royal
children, including *Princesses Helena and Louise* in tartan skirts
wearing sulky expressions and in mirroring poses, a fallen stool
at their feet.

In 1853, the trustees of the British Museum approached
Fenton for advice on photographing its collections, and even-
tually appointed him to the position of photographer. He
remained in this post until 1857, producing photographs of
individual works and views of the galleries, such as *The British
Museum, Gallery of Antiquities* (above).

September Clouds testifies to the brooding intensity of Fenton's
landscape photographs. Using only one exposure for the sky,
Fenton has left the land dark, mysterious and imperilled by
the ominous clouds above.

In 1862 Fenton left photography and returned to his career
as a solicitor, discouraged by the increased commercialization
of his once beloved profession.

References: *Roger Fenton, Photographer of the 1850s*, Hayward Gallery,
London, 1988, nos. 8, 21 and 87; Pam Roberts, *Photogenic*, London,
2001, pp. 33, 195 and 286-87.

233
William Fox Talbot (1800–77)
Articles of China, c. 1843 (illustrated)
salted paper print from calotype negative; 17.9 x 13.5 cm

Articles of Glass, c. 1843
salted paper print from calotype negative; 15 x 12.4 cm

AF Review no. not yet allocated
Collection of the Royal Photographic Society (RPS) at the National
Museum of Photography, Film and Television, Bradford
Collection (over 270,000 photographs) acquired in 2003 for £4.5 million
with a contribution of £342,000 from the Art Fund and additional
support from the National Lottery through the Heritage Lottery Fund
and other donors

Unsurprisingly, two of the first men to experiment with
photographic processes were frustrated draughtsmen. Niépce
(see cat. 231) was an avid enthusiast of the art of lithography;
but, lacking any drawing skills, relied upon his son to draw for
him. When his son was drafted into the army in 1814, he pur-
sued the path that would eventually lead him to heliography.

Talbot's epiphany occurred on 7 October 1833, at the start
of his honeymoon on Lake Como. Conscious that he was
not a skilled watercolourist like his wife, he set about exchang-
ing a drawing made with lead for one made with light,
which he later deemed 'the pencil of nature', or photography.

Talbot was well versed in botany, astronomy and archaeology,
in addition to photography, where his greatest achievement
was the production of a negative from which an infinite
number of positive images could be produced. He was also
one of the earliest practitioners in this field to highlight the
distinction between photography that is inconsequential and
that which is artful.

Articles of China and its companion *Articles of Glass* appeared
in Talbot's treatise on photography, *The Pencil of Nature*
(1844–45), as examples of how different materials reflect light
in varying ways and of the superiority of a photograph over
a written description of objects. Methodically disposed, and
obeying the strictest laws of order and symmetry, Talbot's two
photographs possess the grandeur and austerity of some of the
greatest Spanish still life paintings of the seventeenth century.

References: William Henry Fox Talbot, *The Pencil of Nature*, introduction
by Beaumont Newhall, New York, 1969 (orig. 1844-45), pls. III and IV;
Gail Buckland, *Fox Talbot and the Invention of Photography*, London,
1980, pp. 84-85.

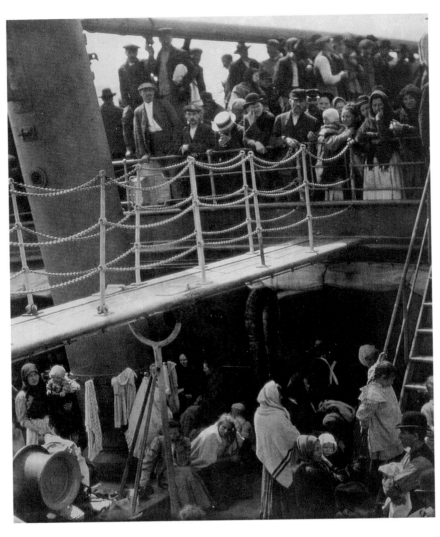

234
Alfred Stieglitz (1864–1946), *The Steerage*, 1907

photogravure; 33.3 x 26.5 cm
AF Review no. not yet allocated
Collection of the Royal Photographic Society (RPS) at the National
Museum of Photography, Film and Television, Bradford
Collection (over 270,000 photographs) acquired in 2003 for £4.5 million
with a contribution of £342,000 from the Art Fund and additional support
from the National Lottery through the Heritage Lottery Fund and other
donors

A master of 'pure' or 'abstract' photography, Alfred Stieglitz
founded the Little Galleries of the Photo-Secession at 291
Fifth Avenue, New York, in 1905, showing photography along-
side the works of Picasso, Rodin and Matisse, to emphasize its
status as high art.

The Steerage was taken on a journey between New York and
Europe in June 1907. Seated on the upper deck of a luxury
liner, Stieglitz found the atmosphere in first class insufferable:

'*By the third day out I could stand it no longer. I had to get away.
I walked as far forward as possible…
Coming to the end of the deck I stood alone, looking down. There
were men, women and children on the lower level of the steerage.
A narrow stairway led up to a small deck at the extreme bow of the
steamer. A young man in a straw hat, the shape of which was round,*

*gazed over the rail, watching a group beneath him. To the left was an
inclining funnel. A gangway bridge, glistening with fresh white paint,
led to the upper deck.*

*The scene fascinated me: A round straw hat; the funnel leaning left,
the stairway leaning right; the white drawbridge, its railings made of
chain; white suspenders crossed on the back of a man below; circular
iron machinery; a mast that cut into the sky, completing a triangle. I
stood spellbound for a while. I saw shapes related to one another — a
picture of shapes and underlying it, a new vision that held me: ship,
ocean, sky; a sense of release that I was away from the mob called
'rich'. Rembrandt came into my mind and I wondered would he
have felt as I did.'*

Rushing back to his cabin, Stieglitz grabbed his camera and
took this photograph on his only remaining plate. At once
recalling the impromptu crowd scenes of Rembrandt and the
fugitive and seemingly 'random' designs of Degas, its rhythmic
intricacy, harmony and humanity justify Stieglitz's own claim
that this was his 'best photograph'.

Reference: Dorothy Norman, *Alfred Stieglitz: an American seer*, New York,
1973, pp. 75-77.

235
Captain Alfred George Buckham (1881–1957)
The Heart of the Empire, c. 1923
gelatin silver print; 46 x 38 cm
AF Review no. not yet allocated
Collection of the Royal Photographic Society (RPS) at the National
Museum of Photography, Film and Television, Bradford
Collection (over 270,000 photographs) acquired in 2003 for £4.5 million
with a contribution of £342,000 from the Art Fund and additional support
from the National Lottery through the Heritage Lottery Fund and other
donors

Captain Alfred George Buckham was an intrepid pilot who
served in the Flying Corps in the First World War. During
the 1920s and 1930s he flew 30,000 feet over the cities and
landscapes of Britain, photographing them and their dramatic
cloud formations. Back in the studio he would print them
adding a light aircraft, either with paint or by using another
negative.

This panoramic view of London was made before the era of
large-scale commercial air travel and, as one commentator has
noted, must then 'have seemed as exotic and as thrilling as a
moon landing'.

Reference: Pam Roberts, *Photogenic*, London, 2001, pp. 266-67 and 292.

236
Edward Steichen (1879–1973)

The Little Round Mirror, Paris, 1902
platinum print; 40.5 x 21 cm

Isadora Duncan at the Portal of the Parthenon, 1921
(illustrated)
bromide print; 49.7 x 37.7 cm

AF Review no. not yet allocated
Collection of the Royal Photographic Society (RPS) at the National Museum of Photography, Film and Television, Bradford Collection (over 270,000 photographs) acquired in 2003 for £4.5 million with a contribution of £342,000 from the Art Fund and additional support from the National Lottery through the Heritage Lottery Fund and other donors

Steichen was co-founder, with Alfred Stieglitz (see cat. 234), of the Photo-Secession movement in New York in 1902 and figured prominently in its new journal, *Camera Work* (1903–17), the most celebrated of the many such publications created during these years aimed at establishing photography's legitimacy as art.

During his long career, Steichen embraced all types of photography; and, in 1947, he became the Director of the Department of Photography at the Museum of Modern Art, New York, the institution that did more than any other to elevate its status. He worked as a 'straight' photographer of nudes, landscapes, and still lifes and as a fashion photographer for both *Vanity Fair* and *Vogue*.

Included here are two contrasting examples of his art. *The Little Round Mirror, Paris* depicts his lover and muse, 'Rosa', who apparently committed suicide soon after this photograph was taken, when she learned that Steichen was engaged to another woman and about to return to New York. Though the resemblances are probably coincidental, the motif of a nude seen from behind and gazing into a mirror, unaware of the onlooker's presence, inevitably calls to mind Velázquez's *Rokeby Venus* (cat. 4), the devices of 'high art' now being appropriated by the fledgling art of photography.

In 1921, Steichen accompanied the dancer Isadora Duncan (1878–1927) to Athens, promising that he could make a motion picture of her dancing at the Parthenon. When she changed her mind, he made a photograph of her instead dancing at the portal of the temple – the grandiloquence of her stance more than matched by that of her surroundings.

Reference: Pam Roberts, *Photogenic*, London, 2001, pp. 26-27 and 241.

237
Frederick Henry Evans (1853–1943)
'The Sea of Steps' – The Stairway to the Chapter House and Vicar's Close, Wells Cathedral, 1903
platinum print; 24 x 19 cm
AF Review no. not yet allocated
Collection of the Royal Photographic Society (RPS) at the National Museum of Photography, Film and Television, Bradford
Collection (over 270,000 photographs) acquired in 2003 for £4.5 million with a contribution of £342,000 from the Art Fund and additional support from the National Lottery through the Heritage Lottery Fund and other donors

Evans retired as a bookseller in 1898, at the age of forty-five, and took up a career in photography, specializing in architecture and landscape. In both he was a subtle strategist, subjecting all elements of the scene to an abstract order and harmony that transforms the worldly into the visionary, prose into poetry.

'The Sea of Steps' depicts a subject to which Evans repeatedly returned at Wells Cathedral. Explaining its appeal for him, he observed: 'the beautiful curve of the steps on the right as they rise to the height of the Chapter House floor, is for all the world like the surge of a great wave that will presently break and subside into smaller ones like those at the top of the picture.'

Anchored below in a sequence of horizontals, the view rises slowly – and rhythmically – gradually introducing diagonals and verticals, and subtle gradations of light and shade, into an intricately interlocking sequence of lines and tones that find their resolution in the brightly lit archway at the upper left. In Goethe's well-known words, architecture here becomes 'frozen music'. Small wonder that Evans himself confessed that this photograph contented him 'more than I thought possible'.

A self-avowed purist – and perfectionist – Evans anticipates in his work the geometric abstraction of Mondrian (see cat. 211), who also found much of his inspiration in architecture.

References: Anne Hammond 'The Soul of Architecture' and F.H. Evans, 'Wells Cathedral', in *Frederick H. Evans: Selected Texts and Bibliography*, Anne Hammond (ed.), Oxford, 1992, pp. 21-24 and 131-32; Pam Roberts, *Photogenic*, London, 2001, p. 295.

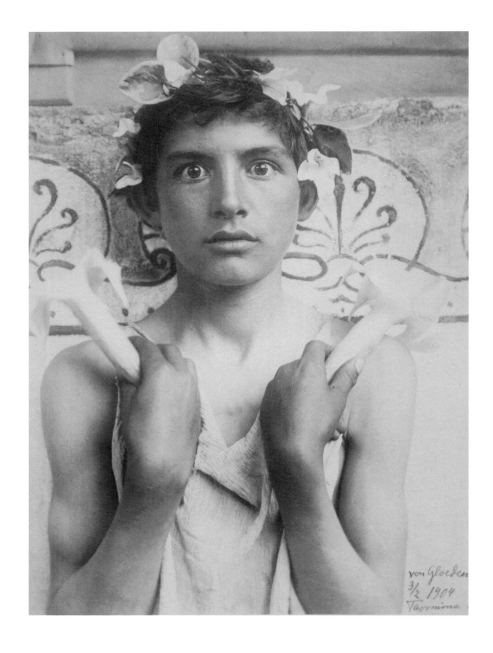

238
Wilhelm Von Gloeden (1856–1931), *Boy with Lilies*, 1904
salted paper print; 21.8 x 16 cm
AF Review no. not yet allocated
Collection of the Royal Photographic Society (RPS) at the National
Museum of Photography, Film and Television, Bradford
Collection (over 270,000 photographs) acquired in 2003 for £4.5 million
with a contribution of £342,000 from the Art Fund and additional support
from the National Lottery through the Heritage Lottery Fund and other
donors

Von Gloeden studied painting at the Academy in Wismar before
abandoning it in favour of photography in Taormina, Sicily,
where he settled in the mid 1870s. He learned photography
from a cousin in Naples and specialized in male nudes, usually
local youths posed in a theatrical manner and wearing attributes
or costumes of a pseudo-classical nature. These were clearly
intended to appeal to an audience attracted to homo-erotic
images and were sold clandestinely through a shop in Naples.

This photograph shows the head and torso of a Sicilian
youth, posed frontally and symmetrically and adorned with
lilies, traditional symbol of purity and innocence. Von Gloeden
produced over 2,000 examples of such works between 1890
and 1930. In 1939, eight years after his death, his heirs were
taken to court on charges of obscenity; and soon after, much
of his estate was destroyed by the Fascists.

References: I. Mussa and others, *Le fotografie di von Gloeden*, Milan,
1980; Pam Roberts, *Photogenic*, London, 2001, pp. 172-73.

239
Erna Lendvai-Dircksen (1883–1962)
Young Boy, 1938

gelatin silver print; 40 x 30 cm
AF Review no. not yet allocated
Collection of the Royal Photographic Society (RPS) at the National
Museum of Photography, Film and Television, Bradford
Collection (over 270,000 photographs) acquired in 2003 for £4.5 million
with a contribution of £342,000 from the Art Fund and additional support
from the National Lottery through the Heritage Lottery Fund and other
donors

240
Fred Holland Day (1864–1933)
Girl at Hampton Institute, 1905

platinum print; 24 x 18.5 cm
AF Review no. not yet allocated
Collection of the Royal Photographic Society (RPS) at the National
Museum of Photography, Film and Television, Bradford
Collection (over 270,000 photographs) acquired in 2003 for £4.5 million
with a contribution of £342,000 from the Art Fund and additional support
from the National Lottery through the Heritage Lottery Fund and other
donors

Following in the tradition of August Sander (1876–1964), who
produced over 600 photographs of a cross-section of German
society, Lendvai-Dircksen devoted much of her career to
documenting the Germany of her day. This included landscape
and popular architecture, and especially the German peasantry.
Concentrating upon vocational 'types', she specialized in close-
up views of the head and upper torso, which fill the entire
frame of her images in a defiantly confrontational manner.

Between 1930 and 1944, Lendvai-Dircksen published such
images in a series of volumes entitled *Das deutsche Volksgesicht*
(*German Folk Faces*), emphasizing the unity and continuity of
German society. This dramatic portrait of a young boy, seen
at close range and under a harsh light, was published in *Unsere
Deutschen Kinder* (*Our German Children*) in 1932.

A member of the Nazi Party, Lendvai-Dircksen was allowed
to work unimpeded throughout the Second World War, moving
from Berlin to Upper Silesia and, in 1946, Coburg, where
she became increasingly interested in photographing mineral
formations. In 1961, one year before her death, she published
Ein deutsches Menschenbild (*Image of the German People*).

References: Naomi Rosenblum, *A History of Women Photographers*,
Paris, London and New York, 1994, pp. 121-22; Pam Roberts, *Photogenic*,
London, 2001, p. 57.

A distant relative of Coburn (see cat. 241), Day was a wealthy
publisher who lived in Boston, and was an aesthete and friend
of both Oscar Wilde and Aubrey Beardsley. In 1898 he
notoriously stage-managed a series of photographs of the
Crucifixion, showing himself in the role of Christ. Starving
himself beforehand, he had himself tied to a cross wearing a
crown of thorns.

In 1904, his studio in Boston burnt down and, four months
later, Day visited Hampton Normal and Agricultural Institute
in Virginia, a training centre for African and native Americans,
where he made this haunting photograph of a young girl,
shown off-centre and in soft focus, enhancing its introspective
nature. Such works were devised to build on the efforts of his
predecessors, intent upon showing how such people could
make progress through education.

Day suffered a severe illness in 1916 and virtually stopped
photographing, being largely confined to his bed until his
death seventeen years later.

References: Estelle Jussim, *Slave to Beauty: the Eccentric Life and
Controversial Career of F. Holland Day, photographer, publisher and
aesthete*, Boston, 1981, pp. 171-72; Pam Roberts, *Photogenic*, London,
2001, p. 33.

241
Alvin Langdon Coburn (1882–1966), *The Bull (El Toro)*, 1906
gum platinum print; 18.7 x 36.3 cm
AF Review no. not yet allocated
Collection of the Royal Photographic Society (RPS) at the National
Museum of Photography, Film and Television, Bradford
Collection (over 270,000 photographs) acquired in 2003 for £4.5 million
with a contribution of £342,000 from the Art Fund and additional support
from the National Lottery through the Heritage Lottery Fund and other
donors

Born in America, Coburn became a naturalized British subject
and spent much of his life travelling between Europe and the
United States, photographing their cities and countryside.
Inspired by Stieglitz's dramatic photographs of New York,
Coburn preferred a more poetical approach to city life, stressing
its delicate effects of light and shadow and the peaceful
co-existence of humanity with its urban environment. Much
inspired, too, by Julia Margaret Cameron (see cat. 122), whose
works he collected, he also produced numerous portrait
photographs of the eminent people of his day; and, under the
influence of the Vorticist painter Wyndham Lewis (1884–1957),
he even made some abstract photographs.

This photograph of a *corrida* was taken on a trip to Spain
in 1906, probably in Cadiz. Given the swashbuckling nature
of the subject, it is extraordinary in its understatement, both
matador and bull being reduced to diminutive figures in the
ellipse of the ring and blurred by the heat haze.

References: Karl Steinorth, *Alvin Langdon Coburn: photographs 1900-1924*,
Zürich, 1998, pp. 38-39; Pam Roberts, *Photogenic*, London, 2001, p. 302.

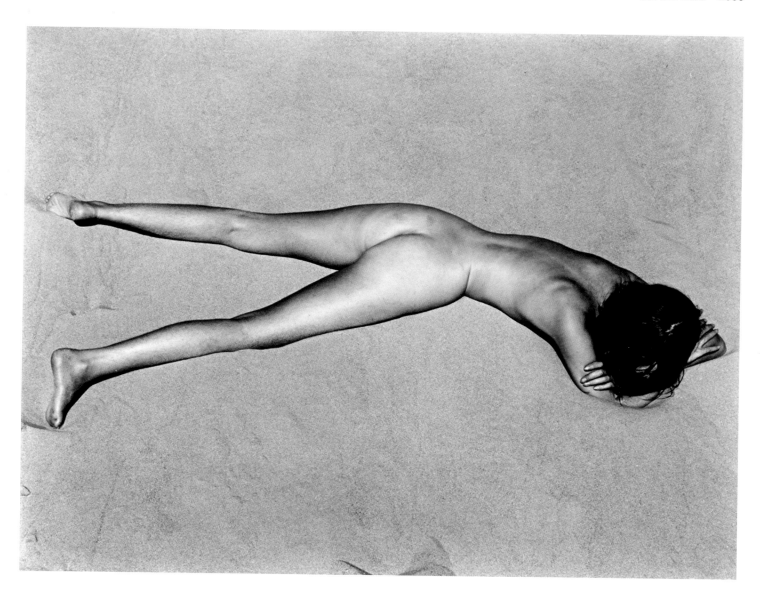

242
Edward Weston (1886–1958)
Nude on Sand – Oceano, California (Charis Wilson), 1936
gelatin silver print; 24.4 x 19.3 cm
AF Review no. not yet allocated
Collection of the Royal Photographic Society (RPS) at the National Museum of Photography, Film and Television, Bradford
Collection (over 270,000 photographs) acquired in 2003 for £4.5 million with a contribution of £342,000 from the Art Fund and additional support from the National Lottery through the Heritage Lottery Fund and other donors

At once a purist and an extremist, Weston is at his best when he isolates an image from its surroundings and sees it 'in itself'. Utterly real, and yet inevitably strange, his close-ups of ordinary things – be they a plant, a shell or a nude – acquire the force of a revelation. As he himself declared, he sought to present his subjects 'in their basic reality' – 'the very quintessence of the thing itself rather than a mood of that thing'.

In 1936 Weston took a series of photographs of his wife, Charis Wilson, rolling down the sand dunes in Oceano Beach, California, in a sequence of abandoned poses. With no horizon of sea or sky, the figure appears etched in the sand by the shadows her body creates, as though suspended in space.

When Weston sent a print of the present photograph to the painter and photographer Charles Sheeler (1883–1965), the latter wrote back appreciatively: 'if there is a more beautiful photograph of the human figure anywhere I haven't seen it. One associates it with a quality of drawing such as Ingres set forth in the Odalisque.'

Along with Julia Margaret Cameron and Paul Strand (see cat. 122, 124), Weston was the first photographer to receive major support through the Art Fund, which helped with the acquisition of thirteen photographs by him for the Victoria and Albert Museum in 1975.

References: Theodore E. Stebbins, Jr. *Weston's Westons: Portraits and Nudes*, Museum of Fine Arts, Boston, 1989, p. 30 and no. 94; Charis Wilson and Wendy Madar, *Through Another Lens: My Years with Edward Weston*, New York, 1998, pp. 108-12.

243
Claude Cahun (1894–1954)
Self portrait, 1927
gelatin silver print; 24 x 18 cm

Self portrait, 1928
gelatin silver print; 14 x 9 cm

Self portrait, 1928 (illustrated)
gelatin silver print; 14 x 9 cm
JHT/2003/1/1, 2 and 3 / AF Review no. not yet allocated
Courtesy of the Jersey Heritage Trust
Collection (13 photographs by Cahun and works on paper by Marcel
Moore) acquired in 2003 for £85,000 from a private collector with a
contribution of £60,000 from the Art Fund

Born into a wealthy Jewish family in Nantes, Claude Cahun
fled to Jersey with her stepsister, Suzanne Malherbe (known
as Marcel Moore, 1892–1972), in 1937 and remained there
throughout the Second World War. The island now owns one
of the largest collections of material relating to her career,
making it an appropriate home for this major archive of
documents and photographs relating to both Cahun and
Moore, all of it previously unseen and unpublished.

Cahun was a Surrealist photographer in Paris in the 1920s
and 1930s whose principal subject was self-portraiture.
Having changed her name from Lucy Schwob to the sexually
ambiguous Claude Cahun, she explored her own identity
and androgyny, adopting a variety of guises – and disguises –
shaving her head, donning costumes or masks, but always
obsessed with her narcissistic leanings and confused identity.
'Under this mask, another mask', she observed wryly, 'I will
never finish removing all these faces'.

Imprisoned by the Nazis in 1944 for inciting their troops to
mutiny, Cahun died ten years later, her work having vanished
from view. Only in the late 1980s were her remarkable self-
portraits unearthed. Now seen as a female parallel to Marcel
Duchamp's search for a cross-gender identity, her work has
also been compared to that of Cindy Sherman (see cat. 245).

References: Katy Kline, 'In or out of the Picture, Claude Cahun and Cindy
Sherman', in *Mirror Images: women, surrealism and self-representation*,
Whitney Chadwick (ed.), Cambridge, Massachusetts, and London, 1998,
pp. 66-81; Rosalind E. Krauss, *Bachelors*, Cambridge, Massachusetts,
and London, 1999, pp. 24-50.

244
Madame Yevonde (1893–1975)
Mrs Edward Mayer as Medusa 'Goddesses Series', 1935
Vivex colour photograph; 36.3 x 29.7 cm

Lady Milbanke (née Sheila Chisholm) as 'The Dying Amazon'. Penthesilea, Queen of the Amazons, slain in battle by Achilles. From the 'Goddesses Series', 1935 (illustrated)
Vivex colour photograph; 37.3 x 27.9 cm

AF Review no. not yet allocated
Collection of the Royal Photographic Society (RPS) at the National Museum of Photography, Film and Television, Bradford
Collection (over 270,000 photographs) acquired in 2003 for £4.5 million with a contribution of £342,000 from the Art Fund and additional support from the National Lottery through the Heritage Lottery Fund and other donors

On 5 March 1935, a charity ball was held at Claridge's in aid of the Greater London Fund for the Blind. Organized by the singer Olga Lynn, it was entitled the Olympian Party, with the guests requested to come dressed as the gods and goddesses of classical mythology. This event provided the immediate inspiration for Yevonde's *Goddesses*, a series of two dozen photographs of famous socialites of the 1930s re-enacting the roles of ancient heroines. Intense in colour, and often photographed at close range, these are among the most bizarrely beautiful photographs of the period.

At once sinister and seductive, *Medusa* casts Mrs Edward Mayer as the legendary Gorgon, toy snakes encircling her head and neck and her face painted chalk-white until she resembles (in Yevonde's words) 'a cold voluptuary and sadist'. Scarcely less arresting is Lady Milbanke as Penthesilea, Queen of the Amazons, meeting her death from Achilles' arrows with a near-orgasmic ecstasy that reputedly enflamed her killer with love.

A lifelong campaigner for female emancipation, Yevonde joined the Suffragette movement in 1910. She worked as a commercial and portrait photographer, but her finest works are those (like *Goddesses*) that align her with the Surrealist movement of the mid-1930s.

Reference: Robin Gibson and Pam Roberts, *Madame Yevonde*, National Portrait Gallery, London, 1990, pp. 31-40.

245

Cindy Sherman (b. 1954), *Untitled, #199*, 1989
Kodak, c-print framed in silver and under plexiglass; 63.5 x 45.7 cm
(80 x 62.6 cm framed)
AF Review no. not yet allocated
Victoria and Albert Museum
Presented in 2003 as a gift by the JPMorgan Chase Art Collection
through the Art Fund

In addition to their outstandingly generous sponsorship of the Art Fund's centenary exhibition, JPMorgan have presented this intriguing work to the nation to mark the occasion. It depicts a daughter of the American Revolution and forms part of Cindy Sherman's series *History Potraits*.

Since the 1970s Cindy Sherman has been photographing herself in a number of disguises and roles. She began this with *Untitled Film Stills* (1977—80), in which she portrayed herself in a variety of guises, from Hollywood B movie actress to film noir victim. Using make up, costumes and props she continued to feature herself in works that made reference to the stereotyped roles of women in films, advertising and fashion. In 1989—90, Sherman produced a group of thirty-five *History Portraits*, turning her sardonic wit to the conventions of Old Master portraiture. Though a few of these works are based on actual pictures, the majority show her in roles familiar from tradition without making reference to specific works.

Here Sherman is seen as a stern and authoritarian figure of the American colonies, posed against a tapestry of harvesters playfully gathering hay. Deliberately leaving all such works untitled, Sherman staunchly refuses to circumscribe them, permitting them instead to exist as archetypes.

History Portraits had its origins in 1988 in a commission from Artes Magnus for the French porcelain firm Limoges, who wished to produce designs from eighteenth-century moulds featuring Sherman dressed in period costume. The gift of her *Untitled, #199* to the Victoria and Albert Museum is an invaluable addition to the nation's collections of contemporary American art.

References: Arthur C. Danto, *Cindy Sherman, History Portraits*, Munich and New York, 1991, pp. 5-13 and 63, no.29; *Cindy Sherman, Retrospective,* Museum of Contemporary Art, Chicago, and the Museum of Contemporary Art, Los Angeles, and London, 1997, pp. 10-12.

246
Patrick Caulfield (b. 1936), *Reserved Table*, 2000
acrylic on canvas; 183 x 190 cm
AF Review no. not yet allocated
Collection of the St John Wilson Trust
To be presented in 2004 as a gift to Pallant House Gallery, Chichester
through the Art Fund by Professor Sir Colin St John Wilson

At once witty and intensely beautiful, this still life is typical of Patrick Caulfield's work in combining abstract 'panels' of pure colour with decorative detail and photographic realism. The lobster that forms the centrepiece of the composition appears to have strayed from out of a Dutch seventeenth-century still life, such as Wilhelm Kalf's *Still Life with the Drinking Horn of the Saint Sebastian Archers' Guild, Lobster and Glasses* of *c.*1653 in the National Gallery, so meticulously is it and its mirror reflection depicted. As the focus of the picture, it seems to have 'reserved' the table of the painting's title.

Another table, bedecked with a clean white table-cloth, is noticeably devoid of the chairs and utensils that would qualify it for this description.

Fascinated by the places where people meet and eat, Caulfield is one of the mere handful of twentieth-century British artists to have specialized in still life. He delights in including references to the Old Masters in his compositions and, in this capacity, featured prominently in the National Gallery's 2000 exhibition, *Encounters, New Art from Old*. This serene canvas is among some 500 modern British works in a variety of media recently promised to Pallant House, Chichester, by the St John Wilson Trust.

Reference: Patrick Caulfield, *Paintings and Drawings 1985-2002*, Waddington Galleries, London, 2002, pp. 6-7 and 46, no.11.

The Free Admission Campaign

Polly Toynbee

It was the National Art Collections Fund (Art Fund) that spearheaded the recent public campaign to restore free admission to all national museums and galleries in the UK. This was entirely in keeping with the Art Fund's traditional role as a champion of free access, first established in the 1920s and defended staunchly ever since, as and when successive governments have seen fit to raise revenue through admission charges.

Ever since the 1980s, when cuts in government grants, coupled with marketplace policies, pushed many previously free museums and galleries down the charging route, there had been a groundswell of protest as attendances plummeted. The then Conservative government's arguments were all too familiar to the art world: art, they said, was a pleasure for the elite and therefore the elite should pay. Why should the general taxpayer fund the entertainment of the few? This same insidious line was used against funding opera, ballet and orchestras, and it was, of course, self-fulfilling. As state funding fell, so charges rose, the numbers attending dropped and museum-visiting became a one-off 'day out' rather than an activity enjoyed in small but frequent doses.

It was never true that museums appealed only to the graduate classes: more people visit museums every week than attend football matches. The strength of popular feeling about keeping works in Britain on public view was proved by the national passion stirred by the Art Fund's appeal to save the Leonardo Cartoon, *The Virgin and Child with Saint Anne and Saint John the Baptist* (fig. 31), for the nation in 1962. Over a quarter of a million people went to see the Cartoon when it was put on show at the National Gallery, and many of them made a cash donation towards saving it (see fig. 32, and pp. 37–38).

But charging for entry to museums' and galleries' permanent collections challenged the ideals on which the Art Fund and many other great institutions were founded for the public good – to make accessible to all the glories that would, if left to the market, be available only to those able to pay. The famous philanthropists of previous centuries and the great civic builders were inspired by the value of making art available to everyone. Serious doubt was raised as to the ethics of charging the public to see works that had been donated to the nation by benefactors who expected them to be exhibited free. This aspect was given most forcible expression by the great benefactor Sir Denis Mahon, a tireless veteran of free admission campaigns. His £25 million collection of Baroque masterpieces is due to be presented after his death to various national collections through the Art Fund (which will retain title to the paintings), but he withdrew the works that were to be given to Liverpool when the National Museums and Galleries on Merseyside introduced charging.

Before coming to power in 1997, the Labour Party said that they would abolish admission charges, but it was never a manifesto pledge. In the early years of tight fiscal prudence, there was every sign of a U-turn, as ministers fudged and backtracked while the Treasury baulked at paying the price. Worse still, a growing financial crisis was threatening the ability of the Tate, National Gallery, British Museum and National Portrait Gallery to remain free, non-charging museums. At this stage, the Art Fund formed a strong alliance with the National Campaign for the Arts, the Visual Arts and Galleries Association, engage and the union BECTU to demonstrate the pernicious impact of charges on the profile and number of visitors, and the nature of the museum visit. Artists rallied round, including Patrick Heron, David Hockney, Cornelia Parker, Bridget Riley, Sean Scully and Richard Wentworth.

Victory came in stages. Chris Smith, Secretary of State for Culture, Media and Sport announced that money had been found to prevent the remaining free institutions – Tate, the British Museum, the National Gallery, the National Portrait Gallery and the Wallace Collection – from charging. At the same time, a three-year plan would be introduced to grant free admission to all national museums and galleries. The plan would begin with free

fig. 31 Leonardo da Vinci, *The Virgin and Child with Saint Anne and Saint John the Baptist*, c. 1499–1500, charcoal, black and white chalk on tinted paper, 41.5 x 104.6 cm, National Gallery, London. Art Fund assisted 1962

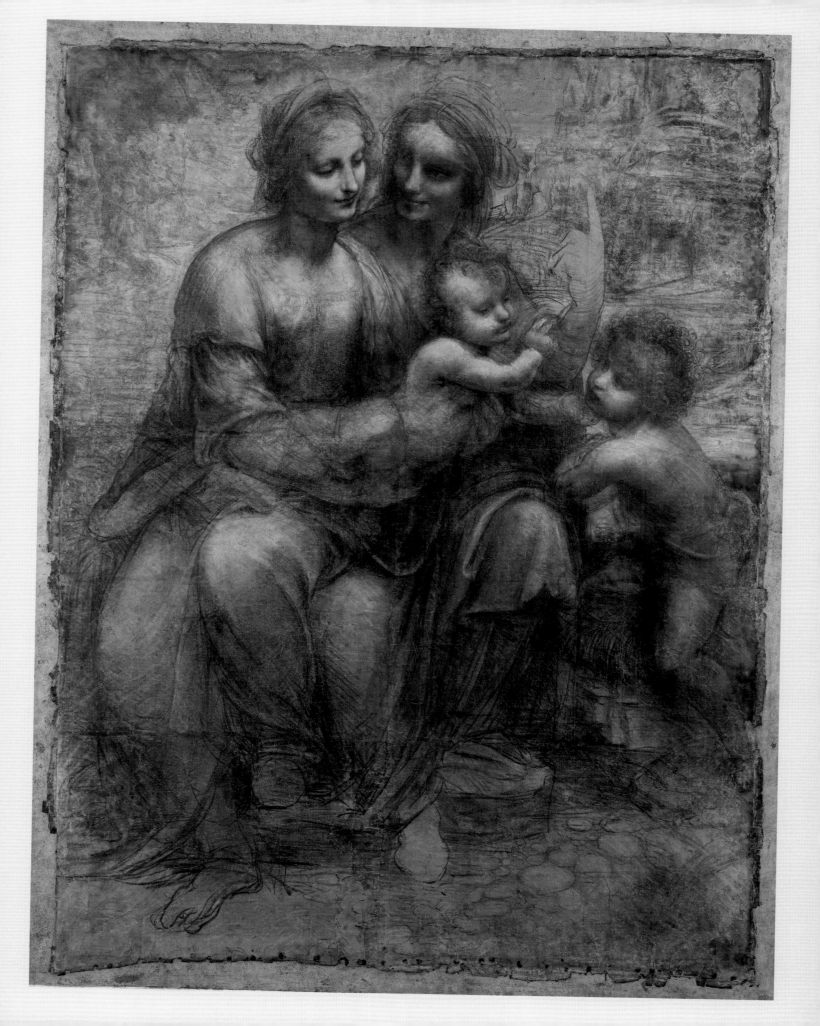

fig. 32 The 'Leonardo Cartoon' (see fig. 31) installed in the National Gallery during 'The Leonardo Appeal', 1962

admission for children as of April 1999 and would move on to include pensioners from April 2000 and everyone else from 2001.

But there still remained a serious stumbling block. The vagaries of the VAT rules meant that only those institutions that charged could claim to be in business and therefore reclaim VAT. This saving was much more significant to some museums than the cash brought in from the admission fees themselves. Customs and Excise were adamant that any free museum must pay VAT. So how could museums like the Natural History Museum and the Victoria and Albert Museum afford to drop charges?

In the autumn of 1999, the Department for Culture, Media and Sport was persuaded by Sir Hugh Leggatt (former Museums and Galleries Commissioner and a life-long campaigner for free admission) that the ideal body to lead an independent campaign to change the VAT regime would be the Art Fund, with the expert technical support of the Charities Tax Reform Group. The Art Fund duly agreed to take on this challenge and, with the support of Sir Hugh, Sir Denis Mahon and the National Museum Directors Conference, began

its highly organized, vigorous and forcibly argued campaign. The case rested on adding the National Museums and Galleries to the list of those public bodies, such as the BBC and ITN News, that were able to reclaim VAT under Section 33 of the Vat Act 1994 despite not being 'businesses'.

The Treasury was insistent that European legislation on the harmonization of VAT would prevent any such extension of Section 33 – but governments have a tendency to blame Brussels for their own decisions. Officials at the European Commission made it clear that they regarded this as a domestic matter for the UK to resolve and that the government was quite free to amend Section 33 if it wished. Sir Denis Mahon even secured confirmation of this view from Romano Prodi, the EU President of the Commission. But the Treasury still refused to accept the arguments in favour of amending Section 33, fearing that it would open the 'floodgates' and prompt calls from the rest of the not-for-profit sector to be similarly treated.

To try to get round the apparent impasse in achieving legislative change, the Secretary of State, Chris Smith,

fig. 33 Visitors to the National Gallery, London with Rembrandt's *Belshazzar's Feast*, bought with a contribution from the Art Fund in 1964 (see cat. 111)

introduced the 'Quids-In' scheme, whereby adults would pay only £1 admission to national museums and galleries. The thinking behind this scheme was that, technically, this would enable museums to remain 'businesses' for VAT purposes. This would eliminate the need for extending Section 33.

However, it rapidly emerged that Customs and Excise would not accept the 'Quids-In' scheme because the number of free visitors (children and pensioners) exceeded paying visitors (adults) and so the museums concerned could not be regarded as being properly 'in business'. This raised the prospect of charging museums having to re-introduce entry fees for children and pensioners in order not to lose their ability to reclaim VAT.

The case for change now became compelling. The Art Fund persuaded the charging museums to demonstrate their support for the campaign and, in a letter jointly signed by twenty-four museum and gallery chairmen and directors, Sir Nicholas Goodison wrote to Prime Minister Tony Blair just ahead of the Budget. Chris Smith petitioned Tony Blair and the Treasury at the same time, as did Sir Denis Mahon. The campaigners waited anxiously for the Budget – and there, at last, they were rewarded. The ability to reclaim VAT would be granted to all national museums and galleries and they would be free to the public by December 2001.

This was one of the most effective public campaigns of recent years. The participants were doubly rewarded when attendance figures soared as a result of free admission. Six months after the charges were dropped, the number of people attending national museums and galleries had risen by an astonishing 62 per cent, the public pouring in as never before to enjoy such treasures as *The Becket Casket* (cat. 188) in the Victoria and Albert Museum. This was a resounding affirmation of the Art Fund's beliefs; and since then the government has made a point of underlining its commitment to maintaining free admission, which it considers to be one of its most outstanding cultural success stories.

Polly Toynbee is a columnist for the *Guardian* newspaper.

Lenders to the Exhibition

Abbot Hall Art Gallery, Kendal, Cumbria

Aberdeen Art Gallery and Museums Collections, Scotland

Art Gallery and Museum, Royal Pump Rooms, Leamington Spa
(Warwick District Council)

Ashmolean Museum, Oxford

Barber Institute of Fine Arts, The University of Birmingham
(Trustees of the)

Bath and North East Somerset Council, Museum of Costume Bath

Birmingham Central Library

Birmingham Museums and Art Gallery

Bodleian Library, University of Oxford

Bowes Museum, County Durham

Bradford Art Galleries and Museums

Bristol Museums and Art Gallery

British Museum, London (Trustees of the)

British Library, London

Cecil Higgins Art Gallery, Bedford (Trustees of the)

Chelmsford Museum (Chelmsford Borough Council)

Cheltenham Art Gallery and Museum

Chirk Castle, The Myddelton Collection, Wrexham, Wales
(The National Trust)

Collection of the St John Wilson Trust

Courtauld Institute Gallery, London

Derby Museums and Art Gallery

Exeter City Museums and Art Gallery

Ferens Art Gallery: Hull City Museums and Art Gallery

Fife Council Museums: Kirkcaldy Museum and Art Gallery, Scotland

Gainsborough's House, Sudbury (Trustees of)

Glasgow Museums: The Burrell Collection, Scotland

Hastings Museum and Art Gallery

Horniman Museum, London

Imperial War Museum, London

Inverness Museum and Art Gallery, Scotland

Ipswich Borough Council Museums and Galleries

Jersey Heritage Trust

Jewish Museum, London

John Rylands University Library of Manchester

Laing Art Gallery, Newcastle upon Tyne (Tyne and Wear Museums)

Leeds Museums and Galleries (Temple Newsam)

Leicester City Museums Service

Manchester City Galleries

Manx National Heritage, Isle of Man

Museum of the History of Science, University of Oxford

Museum of London

Museum of Worcester Porcelain, Worcester

National Gallery, London

National Gallery of Scotland, Edinburgh

National Library of Scotland, Edinburgh (Trustees of the)

National Maritime Museum, London

National Museum of Photography, Film and Television, Bradford

National Museums and Galleries of Wales

National Museums Liverpool

National Museums of Scotland (Trustees of the)

National Portrait Gallery, London

Norwich Castle Museum and Art Gallery

Nottingham City Museums and Galleries

Plymouth City Museum and Art Gallery

Portsmouth City Museums and Records Service

Powis Castle, The Powis Collection, Wales (The National Trust)

Reading Museum Service (Reading Borough Council)

Royal Armouries, Leeds (Board of Trustees of the)

Royal Pavilion, Libraries and Museums, Brighton and Hove

Scottish National Gallery of Modern Art, Edinburgh

Sheffield Galleries and Museums

Southampton City Art Gallery

Syndics of the Fitzwilliam Museum, Cambridge

Tate, London

Ulster Museum, Belfast

University of Wales, Aberystwyth

Victoria and Albert Museum, London

Victoria Tower Gardens, The Royal Parks

Whitworth Art Gallery, University of Manchester

York Museums Trust (York Art Gallery)

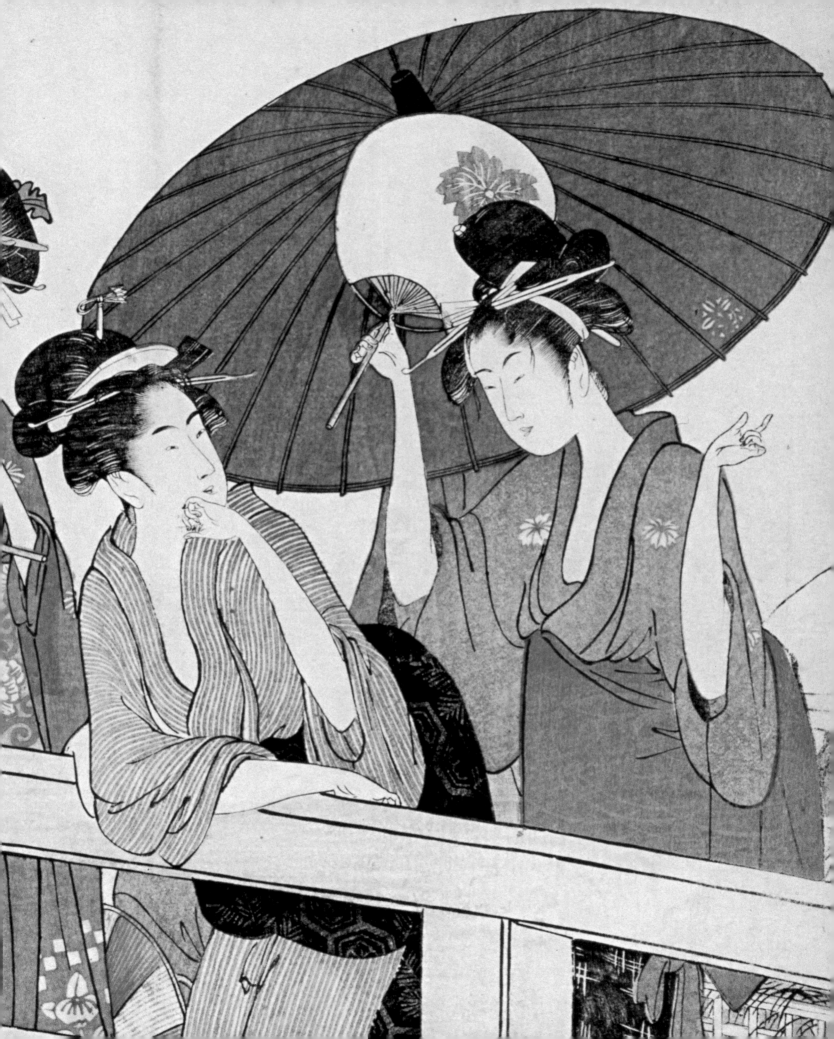

Credits and Acknowledgements

The Hayward Gallery and the National Art Collections Fund gratefully acknowledge the generosity of the lenders to this exhibition who have, over the years, supplied transparencies of acquisitions to the fund. These have been invaluable in preparing the catalogue and, although we are unable to credit all individuals by name, we thank the photographers and photographic departments who have made this catalogue possible.

Acknowledgements

Audioguide: Antenna Audio
Exhibition build: Sam Forster Ltd
Exhibition cases: Exhibitbuild
Exhibition graphics: Isabel Ryan
Framing: Geock Brown
Government Indemnity/Insurance: Alison Maun
Head of Operations: Keith Hardy
Installation Manager: Mark King
Installation: Geock Brown, Jeremy Clapman, Steve Cook, Andy Craig, Nicky Goudge
Lighting: John Johnson / Lightwaves
Registrars: Nick Rogers, Imogen Winter
Specialist object mounting: Plowden & Smith Exhibitions
Transport: Dave Bell, Steve Bullas, Jasper Blatchley, Dave Palmer, Barry Wade, John Wallace

Exhibition interns: Sarah Ciacci, Isabel Finch and Jessica Gormley
Development: Meryl Doney, Jane Lenton, Maggie Prendergast, Sarah Sawkins, Richard Stephens, Severn Taylor, Karen Whitehouse, Caroline Wood
Events: Leila Aitken, Penny Cooper, Imogen Haig, Amanda Sinke, Sophie Smith
Finance and legal: Graham Campbell, Johnny Cubitt, Paul Mason, Orsola Ricciardelli, Dawn Sugden, Kevin Teahan, Alan Wilks
Marketing: Sarah Baker, Rachel Boden, Helen Faulkner, Emmalisa Payne, Avril Scott, Richard Stephens
Merchandising: Jenny Robinson, Sam Webster
Press and communications: Tanera Astley, Ann Berni, Alison Cole, Christina Freyberg, Andy Simpson, Alison Wright
PR consultants: Erica Bolton, Jane Quinn
Public Programmes: Felicity Allen, Paul Green, Rebecca Heald, Helen Luckett, Natasha Smith

Richard Verdi would like to thank Jacques and Astrid Berthoud, John van Boolen, Godfrey John Brooks, Alfred and Ronald Cohen, Isabella Collinson, Nick Cull, Gill Fox, Norman and Jacqueline Hampson, Tina Keevil, Yvonne Locke, Monica Pendlebury, Louise Prowse, David Pulford, Paul Spencer-Longhurst, Anne Verdi, Michael Whittaker and Christopher Wright.

All of the works in this exhibition were acquired for UK museums and galleries through grants, gifts or bequests through the National Art Collections Fund.
In addition, many acquisitions were made with support from other key sources, notably:

The Henry Moore Foundation
Heritage Lottery Fund
National Fund for Acquisitions
National Heritage Memorial Fund
The Pilgrim Fund
Resource / V&A Purchase Grant Fund
The Wolfson Foundation
and many other public and private funders.

The National Art Collections Fund, Hayward Gallery and all the lenders gratefully acknowledge this vital role.

The Henry Moore Foundation

Heritage Lottery Fund

NATIONAL HERITAGE MEMORIAL FUND

Index

308